Women and Class
in Japanese History

MICHIGAN MONOGRAPH SERIES IN
JAPANESE STUDIES
NUMBER 25

CENTER FOR JAPANESE STUDIES
THE UNIVERSITY OF MICHIGAN

Women and Class in Japanese History

EDITED BY HITOMI TONOMURA, ANNE WALTHALL,
AND WAKITA HARUKO

Ann Arbor
Center for Japanese Studies
The University of Michigan
1999

Library of Congress Cataloging-in-Publication Data

Women and Class in Japanese History / edited by Hitomi Tonomura, Anne
 Walthall, and Wakita Haruko.
 x, 330 p. 23 cm. — (Michigan monograph series in Japanese studies ; 25)
 Includes index.
 ISBN 0-939512-91-2 (cloth : alk. paper)
 1. Women—Japan—History. 2. Sex role—Japan—History. I. Tonomura,
 Hitomi. II. Walthall, Anne. III. Wakita, Haruko, 1934– . IV. Series.
 HQ1762.W625 1999
 305.4'0952—dc21 99–11034
 CIP

This book was set in BauerBodoni.

Jacket and cover design: Seiko Semones

Printed in the United States of America

Contents

Acknowledgments

This volume marks an important moment not only in the study of gender and women in Japanese society, but also in the development of collaborative efforts between Japanese and Western scholars on the subject. It is an outgrowth of several years of international seminars held in Japan and in the United States among scholars of various disciplines, whose shared objective has been to promote a better understanding of historical constructions of gender in Japan. The Ann Arbor conference, organized by Hitomi Tonomura on the U.S. side, was a component of a larger, ongoing Gender and Culture Project inaugurated in 1990 by Wakita Haruko, who was also the organizer of this conference on the Japanese side. Conferences held in Japan from 1991 through 1993, which many of the Ann Arbor conference participants also attended, led to the publication of an essay collection, *Jendaa no Nihonshi* (Gender in Japanese History), in Japanese in 1994. Anne Walthall joined the two conference organizers as an editor to share the responsibility of bringing the present volume to fruition.

The chapters in this volume are based on presentations that were given at the University of Michigan in late December 1991, by thirteen Japanese, seven American, two Canadian, and two Australian scholars. They had traveled to the snow-bound Ann Arbor campus to participate in a four-day conference on "Female and Male Role Sharing in Japan." Apart from those participants whose papers appear in this volume, the Japan specialists included (in the order of panel appearance) Ronald P. Toby, Helen Hardacre, Paul Groner, Thomas Keirstead, Suzanne Gay, Gary Leupp, Mary C. Brinton, Kathleen Uno, Miriam Silverberg, Marilyn Ivy, Margaret Lock, Fujime Yuki, Iwahori Yoko, Hirota Masaki, Ueno Chizuko, and Jennifer Robertson. Unfortunately, Barbara Ruch was forced to cancel her participation at the

last moment. Diane Owen Hughes, Julia Adams, Anne Herrmann, and Sherry Ortner, from the University of Michigan, as well as Judith Allen then from Griffith University, whose expertise lie outside the fields of Japanese studies, provided exceptionally insightful and nuanced comments, often from a comparative point of view.

The conference was open to the public and attracted a roomful of observers. It was the organizers' hope to disseminate knowledge and to receive valuable feedback from an audience of varied backgrounds. Because the observers were not expected to know the Japanese language, and because the Japanese participants were not expected to understand English, papers and discussants' comments, presented either in English or Japanese, required simultaneous or consecutive translation. The formidable task of translating highly varied concepts embedded in specialized vocabulary primarily fell on Yasuo Watanabe, with assistance from Lili Selden, Richie Sakakibara, Kiyoko Ishikawa, Lisa Stout, Matthew Palmer, Robert Seaman, Eric Rath, and Blair Pollock.

In the post-conference discussion, participants noted two issues with important strategic implications for future collaborative work. First, it was realized that the dictum that Japanese scholars tend to work from the sources upward, and Western scholars from theories down, reflected more the disciplinary differences in research methods than East/West differences. The second point related to the differences between women-focused and gender-focused approaches. While this conference was originally intended to be a "gender conference," most of the papers turned out to be exclusively about women. Did this mean that we had failed to live up to our initial agenda to investigate gender relations? Japanese scholars expressed the view that, at this juncture, certain themes, such as the evolution of the concept and practice of prostitution, needed to develop a discourse from a woman's perspective and, for this reason, demanded a woman-focused analysis. All in all, it was agreed that even when focused exclusively on women, the papers nonetheless positioned them relationally to other agencies and structures of power. We ended the conference in agreement that this meeting was a major step in nurturing an internationally cooperative dialogue for furthering the study of Japanese gender constructions, and that the publication of the conference volume would contribute to Western scholarship by making available specific Japanese cases that demonstrate varied visions of what constitute male and female.

Since the conference, many years have passed before this volume finally saw the light of day. Meanwhile, Japanese bookstores have become filled with an impressive number of new books on women and gender. The appendix in this voume lists some of the major titles. We sign off with a hope that this volume will serve as a new starting point for an equally energetic English-language publication activity on Japanese gender history. The editors would like to thank the patience of contributors, their colleagues, friends, and students who maintained their faith that we would eventually come through.

The conference was made possible with funding from the Japan Society for the Promotion of Science, the Social Science Research Council, the Toyota Foundation, and several units of the University of Michigan, including the University Council on International Academic Affairs, the Center for Japanese Studies, the Department of History, the Women's Studies Program, and the Center for Education of Women. Ms. Joanne Heald of the Center for Japanese Studies played a major role in the actual planning and management of the conference, while an able group of graduate students, named below, assisted in the essential details of the entire operation, from chauffeuring guests to recording the sessions: Karen Blum, Jeffrey Dym, Adrienne Hurley, Erika Ishihara, Jeanette Kibler, Carol Kinney, William Londo, Matt Palmer, Eric Rath, Jim Reichert, Jill Shanebrook, Ted Thompson, and Tomomi Yamaguchi.

Finally, the editors wish to thank the anonymous reviewers of this manuscript for their careful reading and incisive comments, which doubtless helped to raise the overall quality of this volume. We acknowledge the sensible and meticulous editorial skills of Janet Opdyke, Robert Mory, Ellen Hartigan-O'Connor, Bruce Willoughby, and Carol Shannon at the Center for Japanese Studies Publications Program. Bruce Willoughby's golden patience and reliably pleasant sense of humor have been essential in bringing this project to long-awaited completion.

The Editors

Introduction

Hitomi TONOMURA and Anne WALTHALL

This volume, the outcome of the conference Female and Male Role Sharing in Japan, brings together the various perspectives and skills of an international and multidisciplinary group of specialists in the study of women and gender in Japanese society. From its conception, the conference owed much to recent accomplishments in the study of women and gender by the scholars of Japan and North America. In Japan, a solid body of research on women's history has been building since the late 1970s, resulting in a number of multivolume series, the first of which was published in 1982. Partly in reaction to the dominant historiographical tradition in Japan—which examined historical progress in terms of class-based *social divisions of labor* represented by the male—the early series based their mode of analysis on the *sexual division of labor*. Behind the men who represented the various classes, women had been subsumed and effaced. Giving primacy to the sexual division of labor brought women to the foreground and validated their role in the making of history. This compensatory approach, however, had its own theoretical problems, because it was still combined with the prevailing Marxist tradition, which viewed the nondomestic areas of production dominated by men as the only object worthy of investigation. The result was to reaffirm the position of women as marginalized and particularized relative to the experience of men, which remained central.

In the 1980s and 1990s, Japanese scholars have tended to move away from this approach and have grown more separatist, choosing to analyze exclusively female domains—menstruation and motherhood, for example—as legitimate subjects of historical inquiry. If the earlier effort was to reinstate women in the study of history in general, the more recent work seeks to supplant conventional historical

discourse with an autonomous investigation into the meaning of women's life cycles and their symbolic constructs.

Meanwhile, in North America in the 1980s, scholars of Japan interested in women's studies began to reformulate questions around the issue of gender relations, seeking to understand how women's and men's experiences came to be mediated through cultural and symbolic forces embedded in society. Much scholarly activity has taken place in this area, especially that concerning the social relationship between men and women and women's roles in Japanese society from 1600 through modern times. However, as the Workshop on Gender Issues in the Study of Japan, sponsored by the Social Science Research Council, pointed out in 1984, gender in Japanese history before 1600 has received relatively little notice. This imbalance has tended to set up a dichotomous paradigm of "modern" and "traditional" in which only the early modern period (1600–1868) represents the "traditional," while the multiple layers in the historical construction of gender relations in varied social locations and periods are ignored.

Taking into acount the strengths and weaknesses of past developments in women- and gender-related scholarship, the papers in this volume seek integrative methods and perspectives that will provide the critical linkages between the meaning of female domains and the workings of other social institutions. In this effort, particular attention is paid to the nature of class differences that have given shape and meaning to women's experiences. These papers seek to identify the actual processes of transformation and the specific agents of change and to render full justice to historical context.

We begin with ancient Japan, when imperial rule was in the process of being established and political power resided in a group of elite families, with the most powerful securing allegiance from other families. This period also saw significant trade with the continent as well as the importation of Buddhism and the continental philosophical and political systems that continued to play important roles in Japanese history for centuries to come. The new systems, eagerly adopted, may have provided cogent arguments why women should not rule. Drawing on historian Ron Toby's suggestive remarks concerning Joan Piggott's paper on female sovereigns between 592 and 770, we can see that both the period of female sovereignty and the subsequent male dominance of the imperial office shared strong commonalties with what was happening in Korea at roughly the same

time, when two women, Sondok (r. 632–46), daughter of the last male king, and Chindok (r. 647–53), his elder sister, assumed the throne. Both Japan and Korea practiced sibling succession, both allowed women to assume the role of ruler when no obviously suitable male was available, and in both cases the practice of female rule was largely confined to the ancient period.[1]

The practice of female sovereignty also warrants comparison with ancient Egypt, at least until Cleopatra, the last of the female monarchs, was defeated by the Romans in 30 B.C.E. Egyptian royalty and probably other members of this society practiced sibling marriage, a practice written of in Japan in ancient texts and hinted at in early tales and novels. More suggestive parallels lie in the commonality of the questions often debated by historians. Like Cleopatra and other female monarchs before her, Japanese female sovereigns have often been viewed either as usurpers of power that by rights belonged to men or as figurehead rulers who held the throne until an appropriate male could be found to replace them. Just as Mary Hamer has recently sought to reevaluate Cleopatra's political strategies in light of the rituals and symbols available to her at the time, so Piggott argues that Japan's female sovereigns were both powerful and capable, using the royal office to shape and direct events.[2] Although Japan's last ancient female sovereign, Kōken-Shōtoku (r. 764–70), never achieved Cleopatra's level of notoriety as a symbol of licentiousness, her reputed lust for a Buddhist monk, Dōkyō, proved equally effective in damning not only her but the whole idea of female sovereignty.[3] Surely it is no accident that in both cases strong women rulers ended up with the same historiographic legacy of courtly intrigue and sexual innuendo at precisely the moment when the principle of male dominance in the political realm became established.

Female rule also fits more easily within the indigenous Shinto tradition than within the religious and political systems then being imported from the continent. The oldest Japanese legends tell of the creation of the world through the copulation of brother and sister and depicts the sun deity, the progenitor of the imperial family, as a woman. Yet the same religious tradition in later times prohibited women from certain acts permitted men. While the chief priestess at the Ise shrine was always a highborn lady, usually the emperor's sister, many village communities in the medieval period excluded women from the inner precincts of shrines and from the shrine associations (*miyaza*) that played a central executive role in village affairs. As

Katō Mieko shows here, tension between honoring and containing the reaches of female power resulted in marginalizing women in most primary institutions while allowing their participation in certain ceremonies and associations of their own.

Despite the clear gender distinctions in defining legitimate expressions of political authority, ancient Japanese society under imperial rule fostered a symbolic culture of clothing that articulated class and status differences more clearly than gender differences. As Takeda Sachiko demonstrates, wearing trousers marked a high social status that symbolically and visually situated the wearer in the vertical lord-subject position with the emperor (*tennō*). Wearing a certain color could serve as a marker of social status. The color red in ancient and medieval Japan signified an avenue of self-identification for palace women, who gained a special social status through their proximity to the emperor. At the opposite end of the scale, orange clothing denoted the medieval outcasts (*hinin*).

Given the Buddhist rejection of the pleasures of this world and its creation of the monastic tradition, it comes as no surprise that it should also be misogynistic. The lust for women hindered Buddhist men's ability to seek enlightenment. The source of this problem was declared to be women, who aroused men's lust and could not control their own. It was, therefore, women who faced insurmountable doctrinal hurdles to achieving nirvana. By Japan's medieval period, however, the forms of Buddhism most popular among the commoners placed less emphasis on achieving enlightenment through one's own efforts than on relying on either the bodhisattva Amida or the *Lotus Sutra* for salvation. Nevertheless, the process of being reborn in Amida's Pure Land inevitably transformed women into men. The *Lotus Sutra* contains a section describing how a woman, the dragon princess, managed to attain Buddhahood, though whether as a woman or a newly transformed man is a matter of some debate. Sōtō Zen funerals, however, promised salvation for women as women. Thus, while it would be a mistake to claim that Japanese Buddhism treated women and men equally, it is still safe to say that it held out some hope of solace for women.

On the institutional level, the place of women in Buddhism is complicated. Unlike countries that follow the Theravada tradition—such as Thailand and Sri Lanka—which have no orders of full-fledged nuns, Japan continues to support nunneries today. This tradition goes back at least to the Nara period (710–94). The sources for early nunneries are

elusive. Using what material is available, Hosokawa Ryōichi examines Heian period (794–1185) nunneries and observes that they were the preserve of wealthy and aristocratic women, at least in terms of those ordained as abbesses. This was also the case in Western Europe, where nunneries needed both money and influence if they were to survive. Another advantage to having highborn women head an order was that this guaranteed it a certain degree of autonomy. It is significant that, even though nuns did not ordain nuns, by having ordination ceremonies performed at the nunnery instead of at the male preceptor's own temple, nuns retained considerable spatial control over the proceedings. It must be remembered that the Christian monastic tradition likewise made no provision for nuns ordaining nuns. Considerable research has already shown, of course, that by the medieval period a tradition of wandering Japanese nuns had arisen; avoiding the confines of a nunnery altogether, they roamed the country, proselytizing on behalf of their temples.

Aristocratic women who entered nunneries during the Heian period might well do so after their period of active sexuality was past. This differentiated them from men, who were ordained at an early age and were expected to remain ostensibly celibate while they pursued careers as monks in order to advance in the world, as Paul Groner pointed out in his comments on the Hosokawa paper. At the Heian court, where the emperor was now firmly enshrined as monarch, nubile women were a crucial asset in marriage politics because the emperor's maternal grandfather and uncles expected to become his closest advisers if not his puppeteers.[4] Residential practices varied considerably, from the "visiting marriage" pattern in which the husband visited the wife at her parents' residence, to a pattern in which both lived together in a residence provided by the wife's parents. The emperor's women, in contrast, always came to live with him, returning to their natal homes only to give birth. Women who continued to live with or were supported by their parents probably enjoyed considerable financial security as long as they had fathers and brothers to look after their interests. However, the fiction and diaries of the time are filled with evidence that they lacked emotional security, for it was entirely possible, if not expected, that a man would "visit" more than one woman. Women who lost out in the competition for their husbands' affection often expressed a desire to enter a nunnery; other women might be ordained after a crisis of some sort, such as the death or political defeat of a husband or son.

Heian literature is still regarded as the epitome of women's writing in Japan, and the quality of their written work was once taken to be a reflection of their status. While it is true that women often received an education in Chinese, in addition to Japanese poetry and aesthetics, for the most part they were barred from writing in Chinese, and from the public offices modeled after those found in imperial China, that thus became the prerogative of men. Furthermore, the higher ranking the woman, the more she was expected to remain secluded as long as she was still considered to be sexually active. So what did women do? Reading poetic diaries leaves the impression that all they did was pine for absent lovers, but in fact running the households of the time required tremendous effort on the part of every member, from the mistress down to the lowest servant. Even the emperor's attendants were kept busy preparing the goods that he needed in ritual and everyday life. Life for the women of the Heian court was thus characterized by responsibility, prestige, and confinement.

Most research on ancient practices pertaining to women has been hindered by the available sources, which are limited to those of the aristocracy. Almost no evidence exists for how ordinary women lived their daily lives. Scattered mention of their barbaric behavior in the diaries and observations of court ladies suggests that they enjoyed considerably more freedom of movement. Once the warriors begin to assert their presence in politics, however, we find records showing that warrior wives took a more active and visible role in the direct management of household affairs than did women of the court aristocracy, and it is often assumed that they had done so even in the Heian period.

The establishment of the Kamakura bakufu by Minamoto no Yoritomo (1147–99) in the late twelfth century marked not the end of imperial authority so much as its supplement by warrior rule. Yoritomo's own wife, Hōjō Masako (1156–1225), continued the aristocratic tradition of putting the interests of her natal family above those of her husband's lineage at the same time that she used her position as Yoritomo's chief (and only) wife to speak in his name to disinherit his sons after his death. By the time she died, she had successfully maintained the warrior alliance in the face of an attempt by the court to reassert its authority. Furthermore, she had guaranteed that a Hōjō would always be regent to puppet shoguns imported from Kyoto as Yoritomo's adopted successors.

Inheritance practices during the Kamakura period (1185–1333) confirm the impression that warrior women exercised considerable authority within the household. Women might inherit the military responsibilities that went with their inherited land. Both mothers and fathers bestowed rights to income and obligations for service on sons as well as daughters. Wives continued to own these rights and obligations after they were married, although, as was often the case in Europe as well, husbands might take over the actual management of the land. When a husband was away or if he died before his son reached adulthood, a wife had the authority to speak in his name. Like Hōjō Masako, she had a role in deciding who would become his successor. Insofar as a warrior recognized a chief wife, with whom he lived, Kamakura women in military families enjoyed considerable emotional security in that their position was more clearly defined than was true for aristocratic women of the imperial court. In terms of household authority and property rights, then, Kamakura practices may well have allowed women more latitude than they had before or after.

Only in the late Kamakura period do we begin to see the prevalence of strictly male-dominant family relations. The Mongol invasions of the late twelfth century and the fear that the Mongols might invade again brought about a crisis of control for the Kamakura rulers. These events forced ordinary warrior families to reconsider inheritance practices that divided property rights. The shift to unigeniture disadvantaged some sons and all daughters, and it caused a transformation in the structure of the family closer to what most Japanese mean by the term for "house" (*ie*). Nevertheless, as historian Thomas Keirstead pointed out in his comments, Wakita Haruko's descriptions of the different kinds of medieval houses and the many roles women assumed within and outside them argue against a simple equation of the development of "the family" and gender disparities. Instead, we need to understand the family not as a "universal" institution that was somehow isolated from the change and variety that affect all other social institutions but as contingent, historical, and bound by class. Even though the trend was toward couple-centered households, for a very long time the application of this concept remained fluid and the range of activities encompassed by the house remained broad enough to allow women significant social and economic roles.

By the Muromachi period (1336–1573), several conflicting trends were at work. Established in Kyoto by the Ashikaga shoguns as a

replacement for the military rule of Kamakura, the Muromachi bakufu never managed to maintain social stability for any length of time. Women in high-ranking military houses used their newly solidified positions as chief wives to consolidate their authority within the household, but, with the exception of extraordinary women like Hino Tomiko (1440–96), they became increasingly invisible outside of it. Inheritance rights for women had shrunk. As Hitomi Tonomura points out, in the Kamakura period women could both have and be property; by the Muromachi period, they had become the property first of their parents and then of their husbands. Tabata Yasuko demonstrates that in the countryside women contributed to the household economy largely through working alongside their husbands; in the cities, however, they played a more autonomous role, and the expansion of the medieval economy brought them new economic opportunities at the same time that they became increasingly excluded from the political field.

In part, the increasingly narrow definition of the house and the ever more restricted place of women inside it, in political if not economic terms, resulted from the exigencies of warfare and the desire on the part of the authorities for social stability. Certainly Tonomura sees the fear of renewed fighting as the immediate reason why the Muromachi bakufu imposed a punitive measure that was the harshest to date for adultery (which implied a wife's consent) and rape without distinguishing between the two. Yet there is another intellectual tradition that entered Japan from the continent at much the same time as Buddhism. It provided an intellectual justification for both narrowing the public role allowed to women and treating them as family property. While we would not want to deny the many differences in the various branches of the Confucian tradition or its rich legacy of philosophical speculation, it is still safe to say that it is much less forgiving of female autonomy than either the Shinto or Buddhist traditions, at least as they are practiced in Japan.

An appeal to Confucian concepts in the Tokugawa period (1600–1868) undergirded the establishment of "the patriarchal house" as it is understood in modern Japan. The most important of these is the notion of hierarchy, which circumscribed the function and the possibility of action for everyone in society in accordance with rank and status. In the idealized discourse, women were expected to obey their fathers when young, their husbands when they were married, and their sons when they were widowed. Just as a retainer could not serve

two masters, so a woman ought never to serve more than one husband. Extreme formulations of the place of women in this tradition emphasized their disposability: if a woman was nothing but a womb borrowed for the sake of producing an heir, what was to prevent a man from "borrowing" as many as he needed? The extent to which these precepts had an impact on the everyday practice of commoners or even warriors is a matter of debate, as many of the papers in this volume suggest. Accordingly, *Greater Learning for Women* has recently been too easily dismissed as an ideological tract that bore little relation to the lives led by most women. Yokota Fuyuhiko forces us to come to terms with it by placing it more firmly within its social and literary context. Even in the agrarian sector of society, it undoubtedly influenced women's sphere of activities.

In the late sixteenth century, would-be rulers trying to bring order out of chaos began to put together an amalgamation of Shinto, Buddhist, and Confucian concepts to justify their rule and stabilize society from top to bottom. Through land surveys and sword hunts, they tried to pull warriors off the land into the castle towns allotted to each domain and then carefully established hereditary status distinctions between the military ruling class, the food-producing peasantry, and the urban artisans and merchants. They paid particular attention to regulating behavior within the warrior class itself, beginning with the family, partly because fratricidal strife had played a large role in destroying the Muromachi bakufu. Hino Tomiko became known as the worst villainess in Japanese history precisely because she had wielded political power, and the Tokugawa shoguns took strict measures to guarantee that none like her appeared again at any level of society. The Tokugawa shoguns' "Great Interior" (*ō-oku*) contained not only bedroom attendants but an enormous staff of women officials who ran the kitchens and the wardrobe. Nevertheless, these women rarely controlled access to the shogun's person or figured in ceremonials to the extent that the emperor's women did. In principle, samurai women produced heirs and ran the household while their men worked outside the house performing services for their lords in return for a stipend; in reality, many low-ranking samurai women, along with men, had to work in a variety of cottage industries to make ends meet. The vast majority ended up living in genteel poverty, their primary social function being to act as models of deportment, with never an expression on their faces or a hair out of place when they made one of their infrequent appearances on the street.[5]

In the discussion of commoners' practices, most recent scholar-
ship has emphasized the mutual dependence of husband and wife;
this was not a society, especially in rural areas, in which either men
or women could survive on their own. The household division of la-
bor was fluid enough to allow for male participation in domestic
chores, including child raising. Class and region constituted major
factors in determining the life cycle of farm women, and farm fami-
lies could be much more flexible in assigning responsibilities than
samurai families were.[6] While a great deal of research has been done
on the structure of the household in Japan's early modern period
(1600–1868), the materials available leave room for widely varying
interpretations.

Articles in this volume take a different approach. Instead of ana-
lyzing relations between men and women within early modern fami-
lies, they examine the kinds of work women did, under what circum-
stances, how it got represented, and how women felt about it. What
is more, their chief focus is on women in the cities, a field in which
little has previously appeared in English. Taking a highly imagina-
tive tack, Yokota juxtaposes educational literature aimed at women
with erotic literature, showing how the one was constructed in terms
of the other in that both included lists of women's occupations that
ranged from the respectable to the disreputable. Yet, insofar as this
continuum existed, a working woman was always in danger of being
categorized as "loose." It is easy to criticize the Japanese for castigat-
ing women who had to work in order to survive as little better than
harlots, but in France and other Western countries, women who
worked for wages were seen as equally "morally tainted."[7] In all cases,
women stepping outside the house were easily perceived as threaten-
ing to overturn conventional moral standards.

Many studies of the Tokugawa period have focused on its contri-
butions to Japan's industrialization by providing the necessary eco-
nomic foundation for capital and labor accumulation. The emphasis
has been on changes in rural areas that made it possible for peasants
not only to produce enough food to feed a burgeoning urban popula-
tion but to grow cash crops. By taking advantage of otherwise slack
times in the evenings and during the winter to engage in by-employ-
ment, they increased their nonagricultural productivity as well. Farm
women had a crucial role to play in this process, for in regions where
textile production came to constitute a major sideline to agriculture
they often brought in the most cash. This kind of labor diversification,

however, is usually assumed to have become prevalent in the latter half of the eighteenth century, with the most notable effects coming in the early nineteenth century, when in western Japan, at least, rural areas appear to have prospered at the expense of the cities.[8]

The papers in this volume complicate this picture with their focus on the kinds of work done by women in urban areas. Yokota points out that occupational specialization for women was already a fact of life by the end of the seventeenth century—a fact he traces to the introduction of cotton and the industrial processes it required. His lists of urban occupations may usefully be compared with those compiled by Tabata for the medieval period. Yokota argues further that, whereas it is always assumed that nothing less than the dictates of survival forced women to leave the protection of the home in order to work, not all the money they earned went for necessities; some women used their money to follow the latest fashions, a sign of self-expression and self-assertion that most likely contributed to the disdain in which they were held by Confucian moralizers. Even in the modern silk industry, whenever the workers studied by Mariko Tamanoi asserted their identity, they were accused of being immoral. Nevertheless, as Sone Hiromi's essay demonstrates, for most women work was neither pleasurable nor profitable. Economic development and a rising standard of living in urban areas also meant increased demand for, and more diversification in, the prostitution industry.

The underside of the protoindustrial economic development that enabled Japan to compete successfully with the West in the nineteenth century was already apparent a century earlier. Sone examines the participation of several parties in the construction of the prostitution industry and asks the implicit question of who benefits and who loses. She identifies five parties: the prostitutes themselves, the clients, the government and its officials, the prostitutes' agents, and the prostitutes' families. It is clear that the government viewed prostitution as a business that contributed revenue to local administrative units. Indeed, taxes on women who worked in the post stations helped maintain the transportation industry infrastructure. Considering its contribution to the economic well-being of the community, sociologist Mary Brinton has pointed out that a political scientist or economist might even be forced to see prostitution as a "public good." Another party who benefited from this industry was the employer or agent, since only under the worst circumstances would a prostitute work independently. The assumption is always that the client benefited,

although, since the transaction might threaten his pocketbook or his health or both, his participation is hard to explain in terms of "rational choice." What benefit accrued to the prostitute herself is problematic, and it is important to recognize that prostitutes were typically quite young, with the average life expectancy of even the highest ranking courtesans (*yūjo*) being about twenty-one. The families who produced these women could also be expected to benefit. Sone argues that it was because the eighteenth century saw a developing commercial economy in which proletariats and landless peasants needed to find ways to support themselves that they turned to selling their daughters into prostitution.

The other major industry that employed women during the Tokugawa period was the textile trade in both cotton and silk. Indeed, there was probably a fair degree of mobility between work in textiles and prostitution. It is easy to assume that it was all in one direction, from the respectable to the disreputable, but such was not always the case. As hired workers, the female members of the urban proletariat constituted key economic actors, even though they generally worked only for a brief, intense period prior to marriage. It appears that the rhythms of women's labor were as much informed by culturally constructed familial needs, and filtered through definitions of appropriate gender roles, as they were by the pressures and opportunities of economic development. Precisely because family needs and gendered constraints determined when and where women worked, another similarity between textiles and prostitution was the youth and economic vulnerability of the workers. In the history of enterprises that organized labor on an increasingly large scale, it is depressing to realize how early it became the norm for women to be segregated into relatively low-paying and insecure jobs, with little opportunity for advancement compared to men. It appears further that silk production became more feminized over time, while working conditions deteriorated. Certainly the kinds of conditions under which women worked in modern textile industries are sadly echoed in their early modern prototypes.

For the most part, the essays in this volume rely on sources about women, not materials written by them. While women in the aristocratic and warrior classes were highly literate, others—the vast majority—were not. In addition, the explication of historical processes requires a consideration of aggregates; the individual is far too idiosyncratic to serve as a useful point of entry into most issues concerning

historical change. Before turning to look at ways in which women and women's work are constructed under the impact of modern industry, however, it is worth noting several arenas in which women might assert their identity through the written word.

The nineteenth century marked the return of women writers to an expanded literary public sphere, although women had continued to write since the Heian period. Even before the Meiji Restoration (1868), the poet Ōtagaki Rengetsu (1791–1875) and the painter Ema Saikō (1787–1861) achieved reputations in their respective fields that extended well beyond the people they actually met.[9] Several decades later, first Higuchi Ichiyō (1872–96) and then Yosano Akiko (1878–1942) startled the literary world with their powers of expression.[10] In this volume, Nishikawa Yūko considers the various selves inscribed in Ichiyō's diaries and then goes on to reflect on the modern Japanese diary as a form that both limits what women are expected to write and opens the possibility for them to inscribe their lives. Anne Walthall examines the impact of events leading up to the Meiji Restoration on the rural entrepreneur, poet, and political activist Matsuo Taseko (1811–94). As Anne Herrmann, a specialist in English literature, pointed out, in both cases the focus is on subjectivity and discursiveness, that is, the relation between self and text and between gender and genre. Both are concerned with the relation of the female subject to biographical narrative and between Japanese and Western notions of text and subject. Both raise the issue of the status of the personal document as historical evidence. Both contrast the individuality of women's lives in history with the individualism of the masculine biographical subject. Finally, both call into question the notion of gender as a stable, unified category and insist that the personal is not only political; it is also historically relevant.

From the perspective of women's history, the middle half of the nineteenth century brought change in the midst of continuity. The spread of literacy was enhanced by the introduction of compulsory primary education, but it built on the foundation of previously existing temple schools and other privately organized instruction. Ochiai Emiko points out that the medicalization of childbirth began before the centralization of the state under the new government led by the Meiji emperor. The textile industry grew tremendously in terms of scale, but the basic pattern of employing young, low-paid women under adverse conditions had already been set. For most women, politics both before and after the Meiji Restoration of 1868 remained

irrelevant, but for a few who overcame the enormous prejudice against women having political opinions the new political public space that opened in the turmoil of the 1860s remained within reach, despite the best efforts of government bureaucrats to seal it off from as many people as possible.[11]

In premodern Japan, the silencing of women's voices could safely be left to the family and community or the private patriarchy; in the modern period, the state created new mechanisms of control and reinforced old ones in what can be seen as a public patriarchy. We end this volume with a consideration of how these mechanisms functioned and what they meant for women. Ochiai and Narita Ryūichi discuss the medicalization of women's experiences, Ochiai from the perspective of childbearing and Narita through an analysis of the development of public hygiene. In their focus on how certain results desired by the state became internalized by women in the practice of everyday life, they share a concern with Tamanoi about how power circulates to constitute subjects and regulate even the most intimate physical spaces of the body. These three essays thus speak to the issue of how diversity was suppressed in the interests of constructing a homogeneous citizenry.

Anthropologist Marilyn Ivy has argued that the essence of modernity lies in the enormous historical shift in the way subjects are constituted. Tamanoi documents this shift in her examination of how factory girls became national subjects in the silk industry. Women were constructed practically and historically through a myriad of regulatory practices and techniques that made them grow up to be "women," to be subjects sharply differentiated in role and status from modern male subjects. In the modern paradox, certain kinds of freedom came about with the advent of capitalism within what can only be described as an unprecedented system of social control—what Foucault calls a marriage of "individualization techniques" and "totalization procedures" that is the very mark of modern regimes of power.

This book is not intended to provide a coherent, comprehensive overview of women's history. Some areas of women's lives are provided with exhaustive coverage whereas others are not. There is a further contrast between the in-depth analysis in some papers and the sweeping generalizations in others. Rather than exhaust the evidence for women's participation in various walks of life, religion, and commerce in particular, these essays demonstrate possibilities for their

participation and, as Katō says, "suggest some ways in which women exploited it." The careful reader will note that some authors contradict each other on issues such as the extent of women's economic power in medieval Japan. Medievalists and early modernists tend to denigrate the range of possibilities for women not of their own period. Most take an "optimistic" view of the potential for women to act before 1868 because they see women doing things that previous scholarship had assumed they could not do. Scholars of modern Japan are relatively more pessimistic because, in contrast to the freedom promised by modernity, Japanese people suffered increasingly from oppression before World War II and women continued to suffer discrimination—especially in the workplace and in public—thereafter. To a certain extent, these differences of opinion arise from the availability of sources, but they also reflect the diverse range of interests brought by the contributors to this volume. We should emphasize, however, that premodern Japanese women and men faced constraints that were visibly differentiated according to class and status. Modernity brought most people greater opportunities for education and mobility that had been inaccessible to them earlier.

Dates before 1873 follow the traditional lunar calendar and are referred to by year first, followed by the lunar month and the day. Japanese names appear with the surname preceding the given name. Authors with a Japanese name who normally publish in English are listed with the surname following the given name. For clarification, contributors' surnames are capitalized under each chapter heading. For all cited works, publication location is Tokyo unless otherwise indicated.

NOTES

1. In the Tokugawa period, women twice assumed the throne: Meishō (r. 1630–43) and Gosakuramachi (1763–70).
2. See Mary Hamer, *Signs of Cleopatra: History, Politics, Representation* (New York: Routledge, 1993), esp. chap. 1, 5–23. Hamer argues that those elements of kingly ritual that Cleopatra used to most telling effect in staking her claim to power were precisely those that the Romans found most repugnant. In Japan, the clash of cultures between the indigenous and continental was more subtle, though it is possible that it played a role in the way some female sovereigns were later represented.
3. At the Michigan conference, Diane Hughes pointed to a similar process at work in tenth-century Rome when a mother and her two daughters ruled. For nineteenth-century historians, their rule came to symbolize a Rome without authority—an Italy without unity.

4. Peter Nickerson discusses marriage practices—in particular, the importance of brothers in a woman's career and vice versa—in "The Meaning of Matrilocality: Kinship, Property, and Politics," *Monumenta Nipponica* 48.4 (winter 1993): 429–67.

5. For a detailed depiction of everyday life among the samurai, see Yamakawa Kikue, *Women of the Mito Domain*, translated by Kate Wildman Nakai (University of Tokyo Press, 1988).

6. See Kathleen Uno, "Women and Changes in the Household Division of Labor"; Anne Walthall, "The Life Cycle of Farm Women in Tokugawa Japan"; and Laurel L. Cornell, "The Deaths of Old Women: Folklore and Differential Mortality in Nineteenth Century Japan," all in *Recreating Japanese Women, 1600–1945*, edited by Gail Bernstein (Berkeley: University of California Press, 1991), 17–87.

7. Joan Scott, "Work Identities for Men and Women: The Politics of Work," in *Gender and the Politics of History* (New York: Columbia University Press, 1988).

8. For this formulation of Japan's protoindustrial economic growth, we drew on Thomas C. Smith, "Premodern Economic Growth: Japan and the West," *Past and Present* 60 (1973): 127–60.

9. For a brief biography of Ema Saikō, see Patricia Fister, "Female *Bunjin*: The Life of Poet-Painter Ema Saikō," in *Recreating Japanese Women*, 108–30. Roger Thomas discusses Ōtagaki Rengetsu and other women poets of the Restoration period in his dissertation "Plebeian Travelers on the Way of Shikishima: Waka Theory and Practice during the Late Tokugawa Period" (University of Indiana, 1991).

10. For an extended biography of Higuchi Ichiyō and a translation of her major works, see Robert Lyons Danly, *In the Shade of Spring Leaves: The Life and Writings of Higuchi Ichiyō, a Woman of Letters in Meiji Japan* (New Haven: Yale University Press, 1981). For a recent summation in English of Yosano Akiko's accomplishments, see Laurel Rasplica Rodd, "Yosano Akiko and the Taisho Debate over the 'New Woman,'" in *Recreating Japanese Women*, 175–98.

11. The classic account in English of women activists in the early Meiji period remains Sharon Sievers's *Flowers in Salt: The Beginnings of Feminist Consciousness in Modern Japan* (Stanford: Stanford University Press, 1983).

Chieftain Pairs and Corulers: Female Sovereignty in Early Japan

Joan R. PIGGOTT

Male rulers have long been regarded as the norm in East Asia, where the influence of China has been pervasive. In the first century of the common era, the "Treatise on the Five Phases" in the *Book of Han* firmly stated the Chinese view: "Where a hen announces the dawn, the master will not prosper" and "Where women conduct government, peace will not reign." Political thinkers and historians have long honored such axioms, and the impression we draw from much of the historical writing about early Japan is that only males ruled.

However, the evidence, both written and archaeological, demonstrates that women ruled frequently in prehistoric, protohistoric, and early historical Japan. And in that crucial epoch spanning the years between 592 and 770 of the common era, when Japanese kings transformed themselves into Chinese-style sovereigns, six female rulers presided during 97 of 179 years. A study of female sovereignty is imperative for reasons beyond completing the historical record. It is also requisite for comprehending the distinctive Japanese cultural matrix within which state formation and the evolution of Japanese kingship occurred.

In this, my second study concerning the evolution of early Japanese kingship,[1] I will argue that Japan developed an indigenous tradition of rule by gender-complementary chieftain pairs during the Yayoi and Kofun periods, which tradition provided the sociocultural context from which later female sovereigns emerged. Despite advancing gender hierarchy and the normalization of male rulership at the court of Yamato kings in the fifth century, the precedent of corulership by chieftain pairs continued to provide a font of legitimacy for female rulers, empowering their participation in the routinization of dynastic succession in the sixth and seventh centuries. I will also demonstrate that seventh-century Yamato rulers tended to replicate the

17

archaic pattern of paired chieftaincy in kin-based corulership struc-
tures and that the role played by female monarchs was of great im-
portance in early Japanese history. For the focus of the second half of
this study, I have chosen two of Japan's most dynamic female sover-
eigns, Suiko (r. 592–628) and Jitō (r. 690–97), both of whom ruled
when Yamato Great Kings were refashioning themselves as Chinese-
style sovereigns. The stories of their reigns provide significant in-
sights into the role played by female sovereigns in the evolution of
the structures and practices of Japanese kingship.

CHIEFTAIN PAIRS IN PREHISTORIC AND PROTOHISTORIC JAPAN

Queen Himiko, who ruled somewhere in the Japanese islands in the
first half of the third century, is the earliest of the known female
rulers of the archipelago. Emissaries' records in the official Chinese
annal known as the *Wei chih* (Records of Wei) are quoted as follows:

> The people of Wa live in the middle of the sea on mountainous
> islands southeast of Tai-fang. Of old there were one hundred coun-
> tries [*kuo*], and during the Han dynasty, their emissaries appeared
> at [the Han] court. Now some thirty communities maintain rela-
> tions with us. . . . The country had a king [*wang*], but then for
> some seventy or eighty years there was war, and the people agreed
> upon a queen [*nii-wang*] as their ruler. Her name was Himiko. She
> was skilled at theurgy and enchanted the people. Though mature in
> age, she remained unmarried. She had a younger brother who helped
> rule the country. After she became queen, few saw her. She was
> served by a thousand female servants while one man gave her food
> and drink and acted as her steward. She lived in a palace with
> towers and stockades where there were always armed guards in
> attendance.[2]

Concerning gender relations, the Chinese observed: "Father and
mother, elder and younger brothers, live separately, but at meetings
there is no discrimination as to sex." Further, the Chinese could de-
tect "no distinction between father and son or between men and
women,"[3] although social stratification had resulted in fairly elabo-
rate rituals of subordination.

Regardless of whether the queen's realm of Wa was situated in
Kyushu or in central Honshu, of greatest interest to us here is the
depiction of Himiko as a wonder-working priestess-ruler assisted by
a younger brother who managed affairs outside the palace. Such an
arrangement suggests a corulership structure with a contrapuntal

mutuality between sacral and administrative duties.⁴ Since authority was exercised by both a man and a woman, it might also be termed "gender complementary."⁵ To Chinese eyes, mid-Yayoi society had developed little gender hierarchy—the association of social authority with maleness—despite the foregoing period of intense warfare.

After these Chinese reports from the third century, there is a considerable time gap before eighth-century Japanese sources, such as the *Kojiki* and *Nihon shoki* from Yamato and gazetteers (*fudoki*) from various provinces, provide additional references to protohistoric female rulers. We are fortunate because the six extant gazetteers cover a variety of regions beyond the Kinai, including Harima on the Inland Sea, Hitachi in eastern Japan, Bungo and Hizen in Kyushu, and Izumo on the Japan Sea coast. The methodological challenge presented by such sources must be considered, of course. They are compendia of legend, myth, and folk memory for which chronology and even historicity is often questioned. But anthropologists Jack Goody and Ian Watt have argued persuasively that the written expression of folk memories culled from the oral tradition, such as that found in these compendia, can be taken to represent "the tribal past digested into the communal orientation of the present."⁶ Georges Dumezil also takes the position that "myth is often no more than the transposition into a typical and unique narrative . . . of a regular mechanism or behavior of a particular society."⁷ Even if events recorded in these compendia cannot be precisely dated, if we accept the proposition that memories preserved therein derive from homeostatic oral culture, then we can posit that memories of ruling practices recorded in seventh- and eighth-century texts represent practices of a not too distant past, perhaps dating back to the protohistoric fifth and sixth centuries.

Like Himiko, women rulers mentioned in these later sources sometimes ruled as members of chieftain pairs. Consider the case of Kitsuhiko and Kitsuhime in the *Hitachi fudoki*:

> Long ago there was a native couple, Kitsuhiko and Kitsuhime. When the Yamato ruler paid a visit, Kitsuhiko disobeyed his command, rejected his civilizing influence, and treated him exceedingly rudely. So the Yamato ruler drew his august sword and struck him down. Kitsuhime trembled and grieved, and she came out to the road waving a white flag and bowing low. The Yamato ruler pitied her and pardoned her along with her household. When his palanquin was carried to the temporary palace of Onukino, Kitsuhime brought her

elder and younger sisters and served him with her heart and soul
from morning until night in spite of wind and rain. The Yamato
ruler appreciated her hospitality and showered her with favor, call-
ing her Ono of Uruwashi.[8]

While trying to resist the Yamato paramount's authority, the male
Kitsuhiko was killed, and his mate submitted to the victor along with
her female kin. My reading of this story is that Kitsuhime and
Kitsuhiko represent a pair of chieftains. And while the gazetteer pro-
vides no dates for these events, it is well known that keyhole tomb
mounds, closely associated with Yamato, spread throughout the Kantō
during the fourth and fifth centuries.

This passage confirms not only the existence of paired rulers in
eastern Japan; it also suggests the operation of what anthropologists
call a "stranger-king" mode of integrating newly subjugated territo-
ries into Yamato's confederacy.[9] If Kitsuhime came to serve as a con-
sort to the victorious Yamato paramount—a possible reading of her
story—she would have formed a new pair, conjoining two ruling lines
in order to beget future local rulers who would represent both Kitsu
and Yamato. While on the one hand this tactic would have succeeded
in preserving the bloodline of local rulers, on the other hand since the
female chieftain's subordinated status was based on conquest, such a
pairing also provided a basis for gender hierarchy.

Like paired rulership itself, the contrapuntal division of labor
suggested in the Chinese account of Himiko's rule can also be seen to
have been a persistent feature of paired chieftaincy. The Sujin chap-
ter of the *Nihon shoki* reports, for example, that a Yamashiro female
chieftain named Atahime laid a curse on Yamato before joining her
mate for an attack thereon.[10] In the *Hitachi fudoki*, a chieftain's sis-
ter served as the priestess-consort of the local deity. And in descrip-
tions of the early Yamato court in the Sujin and Suinin chapters of
the *Kojiki* and *Nihon shoki*, sisters and daughters of rulers augured,
read dreams, and acted as consorts to local and ancestral deities. One
such princess moved the cult of the sun goddess to Ise and instituted
the office of the Ise princess-priestess (*saiō*). Well into the Heian pe-
riod, priestesses performed regular rituals for royal deities inside the
royal palace and for protective deities at the palace gates. Such evi-
dence strongly suggests that insular rulership was frequently gender
complementary and contrapuntal, with the female partner charged
with sacral duties.

Peggy Reeves Sanday has argued that a society's creation myths provide insight into gender symbolism and sexual identities.[11] Although some scholars have called early Yamato society matriarchal, according to Sanday's theory the paired deities depicted in Yamato's *Kojiki* and *Nihon shoki*—Izanagi and Izanami and Amaterasu and Susanoo are examples—probably emerged in a cognatic society wherein sex roles were complementary.[12] Similar pairs appear in the *Harima fudoki*. However, while such pairs of deities may exhibit sex-role complementarity, relations between members of these pairs were far from harmonious. Consider the illustrative case of the Iwatatsu deities of Iihibo District in Harima:

> The brother god desired to have the river flow north toward the village of Koshibe, while the sister god wanted to direct it south in the direction of the village of Izumi. The male deity broke off a ridge of the hill so that the river would flow north. Upon seeing this, the goddess used her comb to block the water and dig a ditch to direct the river southward toward the village of Izumi. Thereupon the male deity went around to the south side of the village of Izumi and devised another scheme to make the water flow toward the village of Kuwahara in the west. But the goddess never gave in. She constructed an underground water pipe so that more of the river water reached the rice fields belonging to the village of Izumi. Because of this the original river dried up.[13]

Here, brother and sister deities feuded over control of water from a nearby river. And in neighboring Sayo District the god and goddess of Tama similarly competed to discover the best technology for wet rice production:

> When the two great deities—the great goddess and the great god Tama—competed against each other expanding their territories, the goddess slaughtered a deer, cut open its bowels, and sowed rice seeds in the blood of that deer. The seedlings sprouted overnight. "You have indeed transplanted the seedlings in the evening in this early season," said the great god. Thus he left for another place.[14]

Such accounts bring to mind Mircea Eliade's observation that the rise of agriculture and settled societies is often characterized by "increased ritual antagonism between the sexes."[15] In the *Harima fudoki*, this antagonism is articulated as heroic contests between pairs of deities.

Supplementing the literary evidence, a growing body of archaeological data confirms rule by chieftain pairs and female chieftains in various locales of protohistoric Japan. Imai Akira has substantiated fourth- through sixth-century burials of dual-gender pairs of rulers in tomb mounds located in Hokuriku, along the Inland Sea, in Kyushu, in the Kinai, and in the Kantō.[16] Archeologist Mori Kōichi has also argued, on the basis of skeletal and other evidence from tomb mounds, that female rulers predominated in the Tamba-Tango-Tajima region of western Honshu during the fifth century.[17] Burials of female chieftains have also been verified in Kyushu, Harima, the Kinai, and eastern Japan. Since many such burials have been uncovered in round keyhole mounds dating from the fourth through the early sixth centuries, the interred female chieftains were Yamato confederates. The literary and archaeological data leave no doubt in my mind that gender-complementary chieftain pairs as well as single female chieftains ruled in early Japan.[18] To suggest the frequency of chieftain and deity pairs in the sources, I have appended a selected list to this essay.

YAMATO KINGS AND GENDER HIERARCHY

I have argued that prehistoric and protohistoric Japan had a tradition of rule by male-female chieftain pairs, memories of which persisted into the late seventh and early eighth centuries. Nonetheless, I would also argue that technological changes, increasing warfare, and the expansion of Yamato hegemony altered the sociocultural context in which such chieftain pairs functioned. Furthermore, increased contact with the continent and development of the courts of Yamato kings in the Kinai region during the fifth century led to the emergence of what Peggy Reeves Sanday has termed "new scripts for male dominance,"[19] resulting in the dynamic advance of gender hierarchy.

Notices of fifth-century kings of Yamato appear in the Chinese *Sung shu* (Sung History; Japanese, *Sō sho*), compiled around A.D. 500. In missives sent to southern Chinese monarchs from the 420s onward, these paramounts portrayed themselves as martial rulers glorying in conquests at home and on the Korean Peninsula.[20] This was also the epoch when round keyhole tombs dominated elite funerary culture in the Kinai and when the most monumental of those tombs were built on the Osaka Plain. These tombs were signifiers of chiefly rank in a three-tiered territorial hierarchy uniting the Yamato Basin and the Osaka Plain. Archaeologist Gina Barnes regards this "coalescent polity" as Japan's early state.[21]

The Yamato king known to us as Yūryaku, who ruled during the 460s and 470s, brushed a proud account of his ancestors' accomplishments in a letter to a southern Chinese monarch from whom he hoped to gain confirmation as ruler of Japan and parts of Korea.

> From of old our forebears have clad themselves in armor and helmet and gone across the hills and waters, sparing no time for rest. In the east, they conquered fifty-five countries of hairy men; and in the west, they brought to their knees sixty-six countries of various barbarians. Crossing the sea to the north, they subjugated ninety-five countries.[22]

Yūryaku's self-portrait emphasized military activities, but warfare was only one means by which Yamato rulers wove their confederacy together. Barnes has suggested that from the late third century onward the Kinai core attracted loyalty from chieftains in the Kantō and in Kyushu as the center of a network of marital, trading, and other elite interactions, which gradually expanded and normalized a sense of territorial hierarchy with Yamato at the apex.[23] By the fifth century, Yamato kings had established diplomatic relations with southern Chinese monarchs and sent mercenaries to fight in wars on the Korean Peninsula. They were also accepting continental émigrés, who brought a variety of advanced technological skills to their retinues and realm. Such international activities led to innovative organizational modes at home, emphasizing male roles—those of the general, diplomat, courtier, ship's captain, and specialized craftsman. Such modes, representative of Sanday's "scripts for male dominance," would have resulted in increasing gender hierarchy.

The proposition that gender hierarchy accompanies state formation has been posited definitively by such theorists as Christine Ward Gailey. She argues that in all state societies, femaleness is associated with lower status, and women, as women, have less social authority.[24] Sherry Ortner, while seeing state structures as "domesticating" both men and women, has theorized that state formations make men wardens of women to recruit male cooperation and enhance state control. As she puts it, "the notion that males are not only economically but also legally and politically responsible for the proper functioning of the family unit seems to be part of the systematic extension of principles of hierarchy, domination, and order in the evolution of states as a whole."[25] Viana Muller has traced the development of extrakin-dependent relations in medieval Europe into a military sphere dominated by

men, which ultimately transformed kin-based societies into what she terms "civil societies."[26]

To test how these insights apply to the Japanese experience, we can start from Barnes's proposition that state formation followed a gradual trajectory that became more dynamic in the fifth century. When Yamato kings like Yūryaku gained investiture by Chinese emperors, relations between the king and his domestic allies became increasingly hierarchical.[27] Indeed, by the later fifth century, King Yūryaku was using a new royal title, that of "Great King" (ōkimi), found inscribed on a sword in eastern Japan.

> Inscribed in the seventh month of the year [471?]. The ancestor of Ōwake-no-Omi was Ohohiko. His son was Takari-no-Sukune. His son was Teyokariwake. His son was Takahahishiwake. His son was Tasakiwake. His son was Hatehi. His son was Kasahahiyo. His son was Ōwake-no-Omi. From generation to generation, they served as heads of the Sword Bearers. When the court of Great King Wakatakeru [Yūryaku] was at Shiki, I aided in ruling over the realm, and let this hundred-times-wrought sword be made, recording the origins of my service.[28]

According to this inscription, Ōwake, chief of the Great King's Sword Bearers, was the eighth generation of his patriline to serve at the Yamato court.[29]

As Yamato kings recruited allies and followers from all over the realm, the royal retinue became a locus for the development and spread of gender hierarchy. Thus did warrior-companions like Ōwake protect the Great King's person, while others saw to the king's business in distant Kyushu whence ships set sail for the continent. Other vassals saw to the provisioning of royal storehouses, manufacture of handicrafts, and cultivation of royal estates throughout the realm. It is thought to have been about this time when the kindred known as the Mononobe took charge of the court's military affairs and the Nakatomi came to superintend ritual matters.[30] In this system still characterized by a significant degree of reciprocity between chief and followers, Great King Yūryaku rewarded such vassals with unparalleled gifts, many of which reflected the newly imported equestrian culture of the Korean Peninsula.[31] Given the martial and heroic culture of the king's court, consorts and daughters might share a man's glory—his royal title (kabane)—but the Great King's favor went to those stalwarts who oversaw his affairs and assembled from time to

time at his court. Those who remained at home, including women-folk, were of secondary importance.

Shifts in royal marriage practices also would have affected gender relations within elite families serving Yamato kings. Archaeologists have excavated grave goods suggesting that Yayoi chiefly families engaged in supraregional marital unions. And later, when the Yamato paramount took as consorts the daughters of chiefs from throughout the confederation, the resulting network of affinal relations became the sinews of the confederate polity. Initially, such relationships would have been lateral transactions between relatively equal lineages of regional chieftains. But as the king of Yamato became the Great King, royal unions would have become more hypergamous. According to the *Kojiki* and *Nihon shoki*, by Yūryaku's day provincial families had begun to send "tribute women" (*uneme*) to solicit royal favor and signal subordination while the Great King demanded signs of obsequience even from the heads of the great Kinai kindreds whose daughters entered the palace.[32] Such hypergamous marital relations would have furthered gender hierarchy throughout chiefly society across the archipelago.[33]

The results are graphically depicted in Yūryaku's chapter of the *Nihon shoki*.[34] This "greatly wicked" monarch, as later chroniclers dubbed Yūryaku, reportedly possessed large numbers of consorts of varying ranks whom he subjected to violent tantrums. The chronicle also suggests a heightened concern with sexual transgression and new demands for virginity and exclusive sexual use in the late fifth-century palace. Yūryaku even attacked his Katsuragi and Kibi in-laws. For Yūryaku, marital relations no longer signified alliances between relative equals—he insisted on subordinating affines. In the face of her mate's fearsome temper, only the Great King's senior consort (*kisaki*), the daughter of a former monarch, remained unabashed. Their "double royal" union was unique in the palace because it recalled paired chieftaincy: it conjoined two royal lines and guaranteed bilineal—double royal—offspring.[35] Like female chieftains of old, Yūryaku's royal consort may well have performed sacral duties—her title, *kisaki*, is thought to have derived from the expression "facing the sun."[36]

When Yūryaku died in 479, however, the two sons who battled to succeed him were not sons of that royal consort. Apparently no system of determinate succession had yet developed. First, Prince Hoshikawa, born of a Kibi woman, tried unsuccessfully to seize the

royal storehouses. Then, according to the *Kojiki* and *Nihon shoki*, Prince Shiraga (Seinei, r. 480–84) was enthroned, only to die heir-less. Historians even question his historicity. The fact is, there were likely multiple claimants to the Great King's throne.[37] It was in the midst of such disorder that Yamato's first recorded female monarch emerged. While we know little about Iitoyo, the story of her brief reign indicates that even after male rule had become normative (by the time of Yūryaku's martial age) a woman of royal blood could still rule, just as had female chieftains in past memory.

FEMALE SOVEREIGNS OF YAMATO

Iitoyo (r. Late Fifth Century)

After the death of this monarch [Seinei] there was no suitable prince to rule the kingdom. When they [the great ministers] sought a prince to carry on the sun lineage, they heard that the younger sister of Prince Ichibe Oshiha, the Princess Iitoyo, dwelt in the palace of Tsunosashi of Takaki at Oshinumi in Katsuragi.[38]

> The Great King Seinei died. In this month the Senior Prince and the [future] Great King ceded the throne one to the other, and for a long time neither took it. So in the interim, at Oshinumitsunosashi palace, the [future] Great King's elder sister, the Princess Iitoyo Ao, administered government.[39]

Official genealogies portray Iitoyo as Prince Ichibe's sister and the granddaughter of Richū, thought to have been the earliest Yamato king to seek confirmation from a Chinese emperor in the fifth century. Prince Ichibe reportedly had been assassinated by Yūryaku, leav-ing Ichibe's supporters little choice but to back Iitoyo as his surviving sibling.[40] There is much about Princess Iitoyo's succession that is remi-niscent of paired chieftaincy, in which a brother and sister shared rule and then, after the death of one partner, the survivor continued to rule alone. In addition, the *Nihon shoki* indicates that the princess was unmarried when she acceded, a point that Ueda Masaaki has interpreted to mean that, like Himiko, Iitoyo was originally a celi-bate priestess. But she reportedly took her first lover, to experience the "way of a woman" (*onna no michi*), while Seinei was still alive.[41] Iitoyo's name does not appear in official king lists, but there seems little reason to doubt her historicity. And according to the *Fusō ryakki*, a late Heian period annal, she was recognized by the Nara court in

712 as a monarch of Yamato.[42] However vague the details, her reign at the end of the fifth century suggests that even after a century of advancing gender hierarchy a woman could still administer social authority. Later female sovereigns, including Suiko and Jitō, would have relied on the precedent Iitoyo's brief tenure afforded.

Suiko (r. 592–628)

We turn now to the second of Yamato's female monarchs, Suiko, whose reign also marked an epochal moment in the development of Japanese kingship. Her long reign spanned thirty-six years and deserves close scrutiny, not least to discover how and why a woman could serve as Yamato's Great King in an age when the court was otherwise appropriating Chinese court practices with great alacrity. Fortunately, we know a good deal about Great King Suiko, who reigned a century after Iitoyo. By the end of the sixth century, there had been a sea change in record keeping.[43] Moreover, the confederacy over which Suiko presided had developed substantially beyond the coalescent polity of Yūryaku's day. The habits of alliance linking the Great King and vassals throughout the realm, now known as country chieftains (*kuni-no-miyatsuko*), had become increasingly routinized; even a full-scale rebellion like that of the powerful Iwai chieftain of Kyushu in 527 ended in victory for the Great King, who gained ever greater wealth and influence from newly incorporated royal estates (*miyake*) and service communities (*be*) in every part of the realm.[44] Despite such progress, however, the indeterminacy of royal succession practices remained a source of serious instability. At the same time, conditions on the continent posed a diplomatic crisis that necessitated greater unity at home.

The historical backdrop to Suiko's emergence included developments dating back to the sixth century, when Great King Kinmei (r. 539–71) and his heirs, aided by Soga affines and Korean advisers, initiated a strategy of rank consolidation by royal endogamy—"close-in marriage"—designed to provide "double-royal" heirs to the throne from within the dynasty. Thereby was royal blood to be monopolized and increasingly ennobled while the center was strengthened. In Jack Goody's terms, Kinmei and his heirs were creating a "corporate dynasty" whose members would dominate succession. By narrowing the pool of potential claimants to the throne to members of the dynasty, they increased the determinacy of succession. Still there were numerous rival claimants due to royal polygyny and tensions between brothers

and sons of the Great King as potential heirs. Moreover, within
Kinmei's corporate dynasty, all double-royal offspring, whether male
or female, enjoyed high status. But there was a difference: in the first
two generations of this system influenced by Korean and Chinese
models, only men succeeded to the Great King's throne. Royal women,
particularly double-royal women, nonetheless maintained high
ascriptive status, and that status was further heightened by their par-
ticipation in what Audrey Richards has called the "continuity chain"
of kingship.[45] As wives and mothers, royal women gave birth to kings,
they performed sacral duties tied to the prosperity and legitimacy of
royal rulership, and when a king died his chief consort presided over
funerary rites and participated in the installment of a successor. Even
though females in Kinmei's corporate dynasty did serve as Great Kings,
their role in the business of kingship was of profound significance.

It is in this light that Suiko's reign should be viewed. When she
assumed that throne in 592, her installment was meant to maximize
dynastic unity and legitimacy at a time when generational transition
threatened the court. Suiko was Great King Kinmei's daughter by a
Soga consort. In 576, she had become senior royal consort to her half
brother, Great King Bidatsu. According to the *Nihon shoki*, another
brother, Yōmei, succeeded after Bidatsu's death. And subsequent to
Yōmei's demise and a period of violent contention, Suiko's youngest
half brother took the throne as Sushun.[46] As this chronology demon-
strates, royal succession in Kinmei's line was generally fraternal—
Bidatsu, Yōmei, and Sushun were all sons of Kinmei by two consorts,
a granddaughter of Great King Keitai and a daughter of the powerful
minister Soga Iname.[47]

The preeminence of these two consorts demonstrates the repro-
ductive strategy of the dynasty: primary unions between the mon-
arch and royal women were supplemented by secondary unions with
nonroyal consorts from the Soga ministerial house. Prior to 586, only
Bidatsu, son of the royal consort, had assumed the throne. But, as the
Soga grew more powerful and the threat of generational transition
loomed, Yōmei and Sushun, born of Soga mothers, succeeded. Then
Sushun was assassinated by his own Soga uncle, Umako, in 592. At
that point, since Sushun was the last of the fraternal cohort of his
generation and there was no consensus as to which of the numerous
princes born of Bidatsu and Yōmei should succeed, leading courtiers
turned to Suiko, who had just completed her husband's six-year-long
funerary rites (*mogari*), and persuaded her to take the throne. But

she was not to rule alone. She was joined by Yōmei's son, Prince Shōtoku, in a corulership structure that resembled the paired chieftaincies of the past.

Pairing Suiko and Shōtoku was a brilliant tactic. Suiko's stature as the senior royal of Kinmei's lineage commanded great respect, while her matrilineal link with the Soga guaranteed their cooperation. Having officiated at her husband's funerary services, she was seen to possess a special ritual bond with her deceased mate, and she may well have been considered numinous because of sacral functions she performed as senior consort—*kisaki*—during Bidatsu's reign.[48] Suiko also had a popular son by Bidatsu named Takeda, whom many viewed as a potential successor to the throne.[49] On the other hand, Senior Prince Shōtoku's appointment as coruler pleased supporters of Yōmei's lineage, and the prince, too, had Soga grandparents and in-laws. The new royal couple thus conjoined two royal lines—like chieftain pairs in the past—and made peace at court.

The partnership of Suiko and Shōtoku may well have also derived legitimacy from its replication of a form of corulership common at the Chinese court, that of empress-dowager regency. Since Han times, when the emperor's heir was too young to rule alone, an empress-dowager, often the boy's mother, ruled by his side.[50] In Yamato, however, the king had always been an adult, so any Japanese resort to this practice would have taken a slightly different form, as it did in the partnership of Suiko and Shōtoku.

The fact that Chinese practices were being adopted with alacrity in Suiko's era is hardly surprising considering the primacy of diplomatic concerns for Yamato elites at the time. The reunification of China by the Sui dynasty in 589 after centuries of division was an event of overwhelming concern for the Yamato court.[51] Moreover, contemporaneous warfare in Korea increasingly threatened Paekche, Japan's ally since Yūryaku's day.[52] In response to both developments, some at court called for an attack on Silla; others urged establishment of diplomatic relations with Sui China. Groups of immigrants from all of the Korean kingdoms had settled in Japan during previous centuries, monks and advisers from all the kingdoms served at court and in elite households, and various regions of the Yamato confederacy had varying perspectives on Korean affairs based on history and geography.

It was in this context that the corulers Suiko and Shōtoku made the decision to send Yamato's first embassy to Sui China in 600 while

forging a middle path between the warring kingdoms on the Korean Peninsula. Their diplomatic efforts also proved beneficial at home. Familiarity with new modes of courtly practice facilitated sophisticated organizational efforts such as Shōtoku's twelve-rank cap system and his code of courtly propriety, the *Seventeen Articles*.[53] Classical Chinese correspondences between heaven and earth, lord and minister, and ruler and subject were now systematically applied in the Great King's quest for greater transcendence at home. Whether Suiko was the first insular monarch to be called "heavenly sovereign" (*ten'ō* or *tennō*) is still debated, but the *Seventeen Articles* certainly reflected familiarity with the Confucian *Analects*, wherein is found the locus classicus for the "ruler as polestar" metaphor to which the appellation *tennō* ultimately refers.[54]

Our apprehension of the organization of corulership at Suiko's court is less than clear. The following explanation is attributed to envoys to the Sui court:

> The King of Wa deems heaven to be elder brother and the sun, younger brother. Before break of dawn the king attends the Court, and, sitting cross-legged, listens to appeals. Just as soon as the sun rises, the king ceases these duties, saying that he hands them over to his brother.[55]

Numerous commentators have, understandably, found this passage to be ambiguous. Historian Kadowaki Teiji has even argued that since the Sui dynastic annal, the *Sui shu*, makes no mention of a female sovereign at the Wa court, Prince Shōtoku may have actually been the Great King.[56] But why should later Japanese archivists have invented the fiction of Suiko's reign? Moreover, two sources thought to predate the *Nihon shoki* refer to Suiko as *ōkimi, sumeramikoto*, and *ōōkimi*, all variant styles for Great King.[57] As far as Suiko's absence from the Sui annal is concerned, it seems entirely plausible that the prince might well have stood in for the Great King in diplomatic meetings with continental emissaries who objected to female participation in public life.[58]

Regarding Senior Prince Shōtoku's responsibilities, the *Nihon shoki* reports simply: "He administered the affairs of government and was entrusted with every prerogative (*banki*)."[59] A number of scholars have interpreted this to mean that Shōtoku ruled as administrative paramount while Suiko was the sacerdos. But that is certainly

not the only possible reading. Suiko's activities are described in some detail in her chapter in the *Nihon shoki*, and therein she appears neither passive nor retiring. Just because Shōtoku exercised "full powers" (*banki*) need not mean that the Great King herself did not rule with full power as well. From close scrutiny of all the extant sources, I view Suiko and Shōtoku as corulers.

Nevertheless, it was Suiko who bore the title "child of heaven" (*tenshi*), which in China carried with it sovereign responsibility for overseeing worship of the gods. Consider, for instance, this proclamation recorded in the *Nihon shoki* and dated 607:

> I hear that in ancient times my ancestors who reigned bent reverently before Heaven and tiptoed carefully across the earth, greatly revering the deities of Heaven and earth. So did they broadly propitiate mountains and rivers, communing [with the natural forces] of the northwest and southwest in mysterious recesses. As a result, yin and yang were activated and balanced, and creative forces worked in concert. Now that it is my reign there shall be no faltering whatever in worshipping and propitiating the deities of Heaven and earth.[60]

While recognizing that an eighth-century scribe's hand could have put some of these quite Chinese-sounding words in Suiko's mouth, there is no reason to doubt that ancient ways of worshipping the gods were in fact taking on increased sinic coloration by Suiko's era.[61] Here the reference to the cosmic dialectic of yin and yang reflects growing familiarity with Chinese texts and courtly practice at the early-seventh-century Yamato court.[62]

In addition to propitiating indigenous deities of earth and sky, Suiko and Senior Prince Shōtoku also patronized Buddhism.[63] Rulers in China and Korea had long since developed their images as Buddhist monarchs (*cakravartin*) and organized the Buddhist clergy of their realms as official ritualists. Following such precedents, Suiko and Shōtoku energetically supported the construction of new temples. As a female sovereign, Suiko would understandably have been drawn to two scriptures, the *Shōmangyō* (True Lion's Roar of Queen Srimala) and the *Hokkekyō* (Lotus Sutra), on which Senior Prince Shōtoku reportedly lectured at court. Queen Srimala had been a brilliant and pious Buddhist queen in India whose understanding of the Buddha's teachings astounded even the Buddha, while the *Lotus Sutra* proclaimed that a bodhisattva might inhabit even a female body. Both

scriptures taught that sex was no impediment to either rulership or enlightenment, and both glorified the Buddhist monarch as savior of the realm.[64]

Far from being Soga puppets, as they are often cast, corulers Suiko and Senior Prince Shōtoku can be seen to have balanced the interests of the corporate dynasty against the competing and divisive interests of great kindreds.[65] Suiko's comprehension of the fundamental tension between the demands of kinship and more universal rulership was reflected in the *Nihon shoki*'s description of a meeting with her uncle, Soga Umako, in 624. Umako had requested the return to his hands of a unit of the royal domain, which petition Suiko denied as follows:

> "I was born of the Soga. Moreover, the great minister is my uncle. So when he speaks at night, before dawn his requests are fulfilled. And if he speaks during the day, before evening I do as he asks. But now in my reign if I irresponsibly lose this parcel (*agata*) of the royal domain, later rulers will proclaim: 'That foolish woman gave away that parcel while she was ruling All under Heaven.' It would not be me alone who would be judged lacking. You my minister would also be judged disloyal. In later ages you would surely have a bad name." So did she respond, and she refused his petition.[66]

By the late sixth century, it had become clear that a more unified Yamato confederacy required a transcendent monarch, a ruler apart, who could be viewed as representing society at large.[67] The new culture of Suiko's palace—where book, writing brush, and courtliness reigned—could not have been further removed from the martial, equestrian culture of former ages. A transformation in the discourse of rulership had taken place while a new syllabus of aristocratic culture had been installed. The accession of a woman, a dowager and a ritualist, may well have hastened that transformation. But for the most part the need for unity at home and dignity abroad compelled the emergence of a "heavenly" ruler. So was Suiko as Yamato paramount sacralized as the "child of heaven" while Shōtoku's *Articles* cosmologized her reign by proclaiming: "The lord is heaven, the vassal is earth."[68] New court rituals were also initiated to give visible form to the polestar metaphor. One hundred twenty provincial lords ruling over the Eight Islands were urged thereby to make the "heavenly ruler" their pivot. As they did, so would they become pivots in their own bailiwicks, for through their association with the court

Suiko's vassals became the beneficent bearers of civilization to the most remote corners of "all under heaven." Meanwhile, at the court itself, the vision of Suiko as a Yamato version of Queen Srimala, teacher and savior of her people, underwrote one more claim to sacred legitimacy on the part of Kinmei's daughter.

Despite these notable successes, Suiko's death in 628 plunged the realm into disorder yet again. The liminality of interregnum was worsened by quarrels in many of the great families, in which the collision between fraternal and patrilineal modes of succession resulted in violent competition over family headships.[69] Disputes in the great families, whose service to the throne and relations with regional rulers formed the very sinews of the Great King's realm, posed a clear danger to Yamato leadership in the confederacy. For greater stability at the center, the overloaded kinship structure had to be reformed.[70] At the apex, that meant further narrowing of the pool of candidates for royal succession as well as routinizing the process itself. Such would be the objectives of late-seventh-century monarchs.

By 644, growing tension between royal princes and Soga ministers seeking to control the succession resulted in the assassination of Soga Iruka. That crisis was followed by new corulerships in the hands of the third and fourth generations of Bidatsu's line. The female sovereign Kōgyoku-Saimei—like Suiko before her, a senior consort to former Great King Jomei—took the throne twice to unify the court when factions threatened to weaken it.[71] She relied largely on the precedents of Suiko's age and showed little disposition to innovate. During her second reign in the late 650s, however, she and several members of the royal family literally moved to Kyushu to recruit an armada to battle Silla. But after her sudden death her navy suffered a dismal defeat in Paekchon Bay in 663. As fears of a retaliatory strike by the Chinese surged in the islands and as forts and signal fires were readied, her son and heir, Senior Prince Naka, utilized this fear of invasion to push through unprecedented centralizing stratagems.[72] Inviting royal refugees from Paekche to join his new court in Ōmi, Senior Prince Naka created an environment in which rapid sinification was eagerly supported.

When he finally took the throne as Great King Tenji in 668, after a long interregnum, Naka and his brother Prince Ōama (who would later take the throne as Great King Tenmu) had effectively merged their two collateral lines by means of a series of endogamous marriages to avoid later conflict over succession. But in 671 Tenji replaced

his brother as senior prince with a son born of a nonroyal consort. Civil war soon followed, a conflict won by Prince Ōama because of support from disgruntled chieftains in Yamato, eastern Japan, and Hokuriku.[73] Broad dissatisfaction with Tenji's choice of heir seems to have ignited the fight, for only a double-royal offspring of a monarch and his princess-consort was considered an acceptable choice as monarch. Blood, not the ruler's dictum, still determined rank in Yamato society. Even so, Tenji's line did not lose out completely. Four of his daughters were Ōama's consorts, and one of their sons would eventually become Ōama's heir. It was thus a daughter, not a son, who transmitted Tenji's blood to the next generation of Yamato sovereigns.

Jitō (r. 690–97)

Princess Uno (the future sovereign Jitō) was Tenji's daughter by a Soga consort. Following the endogamous marital practices of Kinmei's corporate dynasty, she was both Prince Ōama's niece and his consort. According to the *Nihon shoki*, she remained at her husband's side throughout the civil war of 672 and became one of his royal consorts (*kisaki*) when he took the throne in 673. We know him by his posthumous name, Tenmu. However, as Naoki Kōjirō has argued, court archivists—or possibly Ōama and Uno themselves—may well have modeled the royal couple's "public" relationship on that of the founding couple of China's Han dynasty, Kao Tsu and Empress Lu, who had lived and ruled in China nine centuries earlier.[74] I also doubt that Uno actually became senior consort immediately after Tenmu's accession. That status would have made her son, Kusakabe, crown prince, and such an early choice of heir by the monarch would have been impolitic. Tenmu would most likely have found it prudent to wait some time before deciding which of his double-royal sons could best serve as his heir.

In fact, the *Nihon shoki* actually records the beginning of Tenmu's preparations for the succession only in 679, when he solicited oaths from his sons and Uno, pledging that all would accept his decision. Two years later, Uno's son was proclaimed crown prince. With that appointment went the same full exercise of the powers of the throne enjoyed by Senior Prince Shōtoku a century earlier. But in this case Tenmu promoted another double-royal prince named Ōtsu to the post of prime minister (*daijōdaijin*). Tenmu thus instituted a corulership in which monarch, chief consort, crown prince, and prince-prime minister all participated. Replacing the corporate dynasty of old, in

which brothers and sons had competed as heirs, was a royal authority to be shared by members of a narrower group, Tenmu's own stem lineage. Just as in China, succession was henceforth to pass patrilineally from father to son, according to the father's decree. The heir's mother, who would normally outlive the father, was to serve as the natural champion and protector of this "continuity chain" of stem dynastic kingship.

Tenmu's choice of two double-royal princes as crown prince and prince-prime minister did avert a second civil war, but the relationship between the two princes remained tense. After Tenmu's death in 686, Ōtsu, whose royal mother had died earlier, found himself lacking sufficient support at court. He was accused of treason and executed. Empress Uno then placed the court under an interim regency (*shōsei*) without enthroning Kusakabe, probably planning to complete Tenmu's funerary rites before the prince's installation. But that interregnum lasted two years, an unusually long time, suggesting that Kusakabe's accession was delayed by succession politics.[75] Aside from the issue of Kusakabe's known poor health, a heroic and popular prince-general named Takechi, who had led his father's troops during the Jinshin War of 672, apparently presented an obstacle. Indeed, Takechi's elegy in the *Man'yōshū* suggests popularity second only to Tenmu's own, even though he had not been chosen as heir because his mother was a nonroyal woman from Kyushu. Uno waited for support to gather behind her son, but then Kusakabe's sudden death in the summer of 689 left the throne heirless. The resulting crisis was a monumental one for Tenmu's fledging stem dynasty, and responsibility for finding a solution was in Uno's hands. Utilizing precedents set earlier by Suiko and Kōgyoku-Saimei, Uno took the throne herself in early 690. Her intent, unannounced at this early date, was to hold the throne until the majority of Kusakabe's infant son, Prince Karu.

As monarch, Jitō's task went far beyond guarding the continuity chain. It was up to her to routinize "heavenly kingship" by transforming her husband's battlefield-won charisma into an enduring institution of sovereignty. As Tenmu's coruler during the last years of his reign, she was well suited for the job, which entailed promulgating the Kiyomihara administrative code, constructing Japan's first complete Chinese-style capital city at Fujiwara, and expanding the official cult of nation-protecting Buddhism. To strengthen the cultural hegemony of the royal center, she sent out ambassadors (*mikotomochi*)—poets, scholars, and ritualists—to the provinces.[76] Her

emissaries found provincial chieftains and other local magnates willing to pledge loyalty to a regime that in return granted them a share of its burgeoning symbolic and cultural capital. Extant records, confirmed by a growing body of archaeological evidence, demonstrate how local allies of the throne constructed Buddhist temples and roads,[77] opened new rice fields, and sent tribute and laborers as requested. In the new capital city of Fujiwara, Jitō and Prince Takechi—the latter had been pressed into service as prince-prime minister—welcomed emissaries from Silla and Paekche to the newly renamed Nihon, realm of "the Sun's origin."[78] Fujiwara Fuhito, son of Tenji's old mentor, Kamatari, was active as Jitō's personal adviser—his daughter was even paired as consort with Prince Karu. Since Jitō hoped that Karu would succeed to the throne, this match represented an epochal moment in Japanese history: it finally joined the stem dynasty born of Tenmu and Jitō with Fuhito's lineage, a partnership that would endure for centuries.

Jitō's tireless efforts to transform her husband's charisma into a lasting structure of rulership explain her frequent visits to the Yoshino Mountains, where Tenmu's spirit was thought to linger. The locale thus became a potent one for Jitō's rulership as well—it was there in the pristine mountain forests that a court poet named Kakinomoto Hitomaro employed his considerable lyrical skills to conjure up the mystic vision of lady ruler as sage immortal, communing with the forces of the cosmos amid mountains and streams:

> Our Lord (*Waga Ōkimi*)
> who rules in peace,
> a very god (*kaminagara*)
> manifests her divine will
> and raises towering halls
> above the Yoshino riverland
> where waters surge,
> and climbs to the top
> to view the land.
> On the mountains
> folding upward around her
> like a sheer hedge of green,
> the mountain gods present their offerings.
> They bring her blossoms in springtime
> to decorate her hair
> and, when autumn comes,
> they garland her with scarlet leaves.

And the gods of the river
that runs alongside the mountains
make offerings for her royal feast.
They send cormorants forth
over the upper shoals,
hey cast dipper nets
across the lower shoals.
Mountain and river
draw together to serve her—
a god's reign indeed.[79]

In Hitomaro's vision, greater and lesser deities were depicted serving the monarch as a "very god" (*kamunagara*).[80] Hitomaro may well have seen in Jitō an incarnation of the royal ancestral deity, the sun goddess Amaterasu of Ise.[81] Nonetheless, it is important to note that Hitomaro's apotheosis of Jitō as a "very god" represented a clear discontinuity from earlier conceptions of Yamato kingship. Whereas Suiko had proclaimed her royal responsibility to worship the gods, now Jitō was herself proclaimed a god by Hitomaro's "iconic imagery," as Ian Levy has aptly termed it.[82] Thus was a third metaphor of sacredness coined for Tenmu's descendants: the "polestar" monarch and Buddhist king now became a "very god." In short order, Hitomaro's tropes made their way from court poetry into oral edicts (*senmyō*) and ritual invocations (*norito*), where they became repetitive and performative expressions of the sacral legitimacy of Tenmu's stem dynasty, the "sun line."

If Yoshino thus served as a "hot spot" where Jitō was able to cloak herself with the charisma of her deceased mate, Ise Shrine also was such a setting. The shrine had figured prominently in the civil war of 672, victory in which had been attributed to the sun goddess's favor.[83] Subsequently, during her reign Jitō made two royal pilgrimages to Ise, after which she proceeded further east to Tōtomi and then to Mino in the north. As she traveled, she actively promoted the cult of the sun goddess as the sacral font of the stem dynasty's authority. And wherever her carriage took her the eye of the "very god" swept over the land in the ancient rite of *kunimi*, assuring heaven's blessings of fertility and prosperity.[84] Whenever she met local officials, she dispensed promotions as shares in the political and cultural capital of her throne.[85] Such journeys were clearly meant to recruit broad support for her reign and its projects, especially for the construction of the new Chinese-style capital at Fujiwara. And, not least,

her visit to the "distant hazy sea" of Tōtomi demonstrated how far
beyond the Kinai the "heavenly realm" had expanded.

That Prince Takechi had been an obstacle to Kusakabe's acces-
sion was confirmed upon Takechi's death in 696. Only then did Jitō
call all the princes and high-ranking courtiers (kugyō) together to
discuss the future of the dynasty. When bickering broke out, a prince
named Kadono—paradoxically, the son of Prince Ōtsu, executed years
before—won the floor by proclaiming: "Ours is a realm of law. Since
the age of the gods, sons have succeeded fathers in the royal succes-
sion. Whenever fraternal succession has been tried, violence has oc-
curred. If we follow the royal will, the sagely succession will be de-
cided easily."[86] Kadono's view, however ahistorical, prevailed. In the
following year, fourteen-year-old Prince Karu took the throne as the
sovereign Monmu. Jitō resigned but did not retire. Instead, she be-
came a senior retired sovereign, committed to guiding and protecting
her heir.[87] Paradoxically, in a dynasty that had decreed adherence to
a system of patrilineal succession Jitō's creation of the office of re-
tired sovereign institutionalized female participation in the royal con-
tinuity chain to the fullest extent.

Monmu's accession edict, read out from the Fujiwara Throne Hall
(Daigokuden) before assembled officialdom, represented the charter
myth for Tenmu's stem dynasty.

> We have listened with reverence to the noble, high, broad, and warm
> command of the sovereign prince of Yamato [Jitō], a manifest god
> ruling over the Great Land of Eight Islands. As an august descen-
> dant of the "heavenly deity," she performed the labors of the high
> throne of heavenly succession obedient to the decrees of the heav-
> enly deity on the high plain of heaven, to the effect that from the
> beginning, through the reigns of our distant ancestors down to this
> day and into the future, sovereign august children should be born
> in succession, forever ruling the Great Land of Eight Islands.
>
> Humbly do I [Monmu] accept the command to bring order to this
> realm under heaven and unify the people. As a "very god" shall I be
> benevolent, soothing every subject. All you appointed officials, in-
> cluding governors appointed to administer provinces in the four
> quarters under our rule, never violate the law. Serve with bright,
> pure, and true hearts without delay or neglect.[88]

The edict proclaimed an eternal flow of sacred mana from Amaterasu
through each royal heir as a "very god" from generation to genera-
tion. The tragedy of civil war was written out of this cosmologized

history, which began in high heaven with the female deity Amaterasu; was transmitted through yet another woman, the royal grandmother, Jitō; and finally reached the reigning monarch, the royal grandchild Monmu. Jitō's reign as a female sovereign clearly enhanced the prominence of female scripts in the charter myth of Tenmu's stem dynasty. Meanwhile, additional analogies linking Amaterasu with Jitō, and Amaterasu's heir Ninigi with Monmu were being developed by the compilers of the *Nihon shoki*, which was nearing completion at this time and would be promulgated in 720.

By becoming the senior retired sovereign, Jitō instituted a new form of corulership that paired sitting and retired monarchs to ensure a more orderly succession. There had been retired monarchs in China since the Ch'in dynasty, but from Northern Wei times onward retired monarchs took the title "senior emperor" (*daijōkōtei*) and continued ruling during retirement.[89] Unfortunately, eighth-century documents tell us little about the relationship between the royal grandmother and the grandson in Monmu's era. Our single clue comes from a proclamation made in 707, five years after Jitō's death, which included the reminiscence:

> When the Sovereign Prince of Yamato [Jitō] . . . ruled the realm under Heaven from the palace of Fujiwara, she entrusted the task of ruling to the heir . . . [Monmu]. Sitting by his side she ordered and regulated the realm and together they ruled making the country peaceful and harmonious.[90]

In this light, it seems likely that Jitō remained the power behind the throne.

Promulgation of the new *Taihō ritsuryō*, the administrative and penal codes issued in 702, was an epoch-making accomplishment during Jitō's retirement. It represented the most complete statement of the principles of ruler-centered governance up to that time, and it included a chapter of inheritance regulations enshrining the principle of patrilineal succession. Together with the new metropole at Fujiwara, the magnificent palace in which she and her family resided, and the official highways that her emissaries trod, the code represented the successful climax of Jitō's efforts to transform her husband's martial charisma into enduring structures of regularized and institutionalized rulership.

A second key concern for Jitō's years as retired sovereign was assuring the future of the dynasty after the death of Karu. To this

end, Jitō made an unprecedented decision not to match her grandson with a woman of royal blood as consort. Instead, she paired Karu with the daughters of high-ranking ministers, including Miyako, a daughter of Fujiwara Fuhito.[91] For Monmu not to have had a royal princess-consort was a startling departure—the ideal of a royal woman as senior consort and of succession by double royal princes had endured for generations.[92]

Why did Jitō make a decision that meant that none of Monmu's offspring would be double-royal heirs? There are several possibilities. Chinese political thought dictated that the dynasty's legitimacy depended only on patrilineal succession. Since Chinese marital practice demanded exogamy, double royalty was not a possibility. In Jitō's Japan, a rejection of double-royal marriage would have emphasized the new principle of royal patrilineality. In addition, Kusakabe and Karu were more than Tenmu's sons. They were also Tenji's grandsons. Thus, they represented the comingling of two royal lines, a union Jitō would have been eager to preserve. If Monmu now took only nonroyal consorts, the royal blood of Tenmu and Tenji would remain undiluted. No other royal line could interfere in the succession, and if the strictures of the *Taihō Code* regarding patrilineality were adhered to, future succession by Monmu's descendants in a determinate and orderly fashion could be preserved.[93]

In retrospect, however, this abrupt change in royal marriage practice ultimately weakened the dynasty. As unilineal royals, Monmu's eighth-century successors were less than ideal monarchs in the eyes of many. At the same time, the solidarity of Kinmei's corporate dynasty had been fractured by monopolization of the throne by Tenmu's descendants. Moreover, the future would demonstrate that patrilineal succession was difficult to practice—a shortage of mature male heirs would plague the dynasty throughout the eighth century, necessitating successive reigns by female rulers.

CONCLUSION

In early Japan, pairs of chieftains expressed a significant degree of gender complementarity in the exercise of social authority. Because of that tradition, despite the advance of gender hierarchy at the courts of fifth-century Wa kings, the full repercussions—loss of social authority by women and their exclusion from civic life—were staved off until late in the eighth century, a hundred years after Jitō's reign. In

the interim, the Yamato court gained a margin of flexibility from its ability to utilize female sovereigns in times of succession crises. And, because these women were able to "hold the line" in troubled times, by the late eighth century a tradition of lineal stem dynastic succession had taken root. Female sovereignty played an important part in that accomplishment.

In his classic investigation of female sovereignty, Inoue Mitsusada characterized female sovereigns of the seventh and eighth centuries as "transitional heirs" (*nakatsugi*).[94] Embodying the lingering charisma of a dead partner, usually a husband, they could not produce or designate their own successors and so were widowed or virgins. Inoue observed that only in a single instance did a female ruler pass her throne to another female—Genmei to Genshō, in 715—while women assumed the throne only in times of succession crisis. Yamato Great Kingship, according to Inoue, was normatively male, while female sovereignty was limited and extraordinary. By way of contrast, Kobayashi Toshio has argued in a recent study that female sovereigns were no different in function, substance, or character than male sovereigns. All played the same role as heirs to the throne, and all performed common tasks of religio-political rulership (*matsurigoto*).[95] Because of the tradition of paired chieftaincy, either a man or a woman could rule. Kingship in early Japan, according to Kobayashi, was ungendered.

As we have seen in this study, however, Kobayashi's argument ignores the normalization of male rule by the time of the Yamato kings and the limits on female sovereignty that resulted. Inoue was correct—from the fifth century onward, Yamato kingship was gendered and gender hierarchy was advancing. Suiko and Jitō both came to the throne at liminal moments, moments of succession crisis. They were not "sovereigns as usual"; they were indeed transitional figures. However, Inoue's characterization of their sovereignty as limited must not mislead us. Both Suiko and Jitō exercised the full authority of the throne with vigor and innovation.

The tradition of gender complementarity implicit in prehistoric and protohistoric male-female chieftain pairs continued to empower female rulers well into historical times. Yamato court leaders synthesized native and continental practices to cast female rulers successively as regents, Great Kings, or retired sovereigns. Corulership by pairs of royals—a female ruler together with associated princes as

potential heirs to the throne—was common from Suiko's reign onward. Even during the reign of a victorious martial ruler like Tenmu, corulership persisted.

While an exploration of the next phase of female sovereignty in the eighth century must await another opportunity, a brief word concerning the outcome seems necessary here. It was only in the late eighth century that the full effects of Chinese *ritsuryō* law, with its privileging of male roles in the civil sphere and the narrowing of the official eligibility pool to exclude women, finally ended the practice of female sovereignty. In the 760s, Shōmu's daughter, Heavenly Sovereign Kōken-Shōtoku, failed in a valiant fight to nullify the limits of female sovereignty and choose her own heir. For almost a millennium thereafter, no woman occupied the throne in Kyoto. Nonetheless, rule by the *tennō* had been profoundly marked by its history of female sovereignty. The royal court long remained a locus where female scripts—those of mothers, consorts, priestesses, and female deities— retained high status and authority. Witness the epoch of the Fujiwara regents, when female ties to the throne dictated selection of the regent and *tennō*, and the subsequent age of retired sovereigns, when consorts and daughters of retired rulers assembled miniature courts and wielded considerable influence and wealth. Two rulers considered here, Suiko and Jitō, did not simply set the parameters of female rulership. They also made decisive contributions to the enduring structures of sovereignty writ large over the course of Japanese premodern history.

APPENDIX

Selected References to Dual-gender Pairs

Pair	Source	Nature of Relationship
Chieftains		
Kibitsuhiko, Kibitsuhime	*Harima fudoki*	brother/sister
Kitsuhiko, Kitsuhime	*Hitachi fudoki*	mates (stranger-king marriage)*
Nukahiko, Nukahime	*Hitachi fudoki*	uncle/niece (deity consort)
Shinoka-oki, Shinoka-omi	*Bungo fudoki*	
Sahohiko, Sahohime	*Nihon shoki*	brother/sister of Yamashiro
Yamato Takeru, Yamatohime	*Nihon shoki*	brother/sister (priestess)

Pair	Source	Nature of Relationship
Sarutahiko, Sarume	*Kogo shūi*	male and female clan members
Karunomiko, Karunohime	*Kojiki*	brother/sister (priestess), mates
Tomibiko, Tomihime	*Kojiki*	brother/sister (stranger-king marriage)*
Takehaniyasuhiko, Abehime	*Nihon shoki*	mates, wife a sorceress
Isakahiko, Isakahime	*Nihon shoki*	father/daughter

Deities

Agahiko, Agahime	*Harima fudoki*	brother/sister
Isetsuhiko, Isetsuhime	*Harima fudoki*	
Iwatatsu god and goddess	*Harima fudoki*	feuding
Izanami, Izanagi	*Nihon shoki* and *Kojiki*	brother/sister, mates, feuding
Amaterasu, Susanoo	*Nihon shoki* and *Kojiki*	brother/sister, mates, feuding
Izumo god and goddess	*Harima fudoki*	feuding
Tama great god and goddess	*Harima fudoki*	feuding
Hinanami and wife	*Harima fudoki*	
Kuninomi, Amenomi	*Norito*	wind deities of Tatsuta
Yabune, Yabunetoyoukehime	*Norito*	deities of the royal palace
Yachimatahiko, Yachimatahime	*Norito*	deities of the suburban festival
Sovereign Ancestral Gods & Goddesses	*Norito*	
Iwatsuhiko, Iwatsuhime	*Nihon shoki*	
Toyotamahiko, Toyotamahime	*Nihon shoki*	father/daughter, gods of the sea

Ruler/Priestesses

Sujin, Yamatohime	*Nihon shoki*	nephew/aunt (Ise priestess)
Sahohiko, Sahohime		brother (Okinawa ruler) /sister (priestess)
Yamato Takeru, Tachibana Hime	*Kojiki*	mates, Hime as priestess
Chūai, Senior Consort Jingō	*Kojiki*	mates, senior consort as priestess

*Female partner became consort of Yamato leader.

Selected Yamato Royal Genealogy in the Official Annals

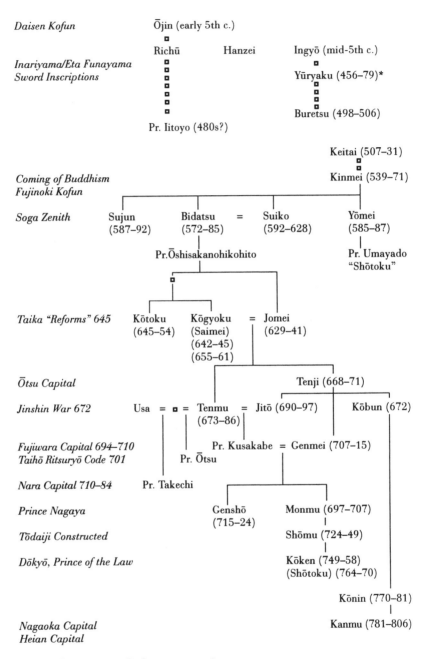

Daisen Kofun Ōjin (early 5th c.)

 Richū Hanzei Ingyō (mid-5th c.)
Inariyama/Eta Funayama
Sword Inscriptions Yūryaku (456–79)*

 Buretsu (498–506)
 Pr. Iitoyo (480s?)

 Keitai (507–31)

Coming of Buddhism Kinmei (539–71)
Fujinoki Kofun

Soga Zenith Sujun Bidatsu = Suiko Yōmei
 (587–92) (572–85) (592–628) (585–87)

 Pr. Ōshisakanohikohito Pr. Umayado
 "Shōtoku"

Taika "Reforms" 645 Kōtoku Kōgyoku = Jomei
 (645–54) (Saimei) (629–41)
 (642–45)
 (655–61)

Ōtsu Capital Tenji (668–71)

Jinshin War 672 Usa = □ = Tenmu = Jitō (690–97) Kōbun (672)
 (673–86)

Fujiwara Capital 694–710 Pr. Kusakabe = Genmei (707–15)
Taihō Ritsuryō Code 701 Pr. Ōtsu

Nara Capital 710–84 Pr. Takechi

Prince Nagaya Genshō Monmu (697–707)
 (715–24)

Tōdaiji Constructed Shōmu (724–49)

Dōkyō, Prince of the Law Kōken (749–58)
 (Shōtoku) (764–70)

 Kōnin (770–81)

Nagaoka Capital Kanmu (781–806)
Heian Capital

*Reign dates prior to Suiko are approximate.

NOTES

All translations not otherwise noted are my own. It is my practice to compare the *kanbun* with at least one annotated edition in modern Japanese whenever possible. Readers may be surprised to find that I do not use the designations "emperor" or "imperial" to refer to Japanese rulers in this essay. After the promulgation of the *Taihō ritsuryō* code in 701, the common title in Chinese used for Japanese kings was *tennō*, which has often been translated "emperor." However, for a host of reasons that I will not elaborate upon here, I prefer the more literal translation of "heavenly sovereign." *Tennō* may have been used during Jitō's reign (690–97), but the evidence is not conclusive. Therefore, I use *tennō* only for those who ruled after 701. Since this essay mostly concerns events and rulers that predate 701, I have used the title "Great King," which, according to extant evidence, was first employed for Yamato paramounts in the late fifth century. For rulers before that, I use the title "king," as used by Chinese emissaries. Similarly, *taishi* should not be read "crown prince" until 681, when Tenmu tried to mandate determinate succession and named Prince Kusakabe crown prince, declaring him heir to the throne. Prior to that, *taishi* should be read "senior prince"—the leading prince in the court but not declared to be heir.

1. The first study was my "Sacred Kingship in Early Izumo," *Monumenta Nipponica* 44.1 (1989): 45–74.
2. This passage comes from the *Wajinden*, or *Accounts of the People of Wa*, in the *Records of Wei*. The *Records of Wei* comprises a section of the official history of the Wei dynasty (220–64 C.E.) in the larger *San kuo chih* and is thought to have been completed around the year 429. For the translation, I have used the annotated version of the *Wajinden* found in Nihon Shiryō Shūsei Hensankai, ed., *Chūgoku, Chōsen no shiryō ni okeru Nihon shiryō shūsei*, Seishi 1 (Kokusho Kankōkai, 1975), 6–10. An English translation can be found in Ryūsaku Tsunoda, trans., and L. Carrington Goodrich, ed., *Japan in the Chinese Dynastic Histories* (South Pasadena, Ca.: D. and Ione Perkins, 1951), 8–16. This work is henceforth cited as Tsunoda, *Japan*.
3. Tsunoda, *Japan*, 8–9.
4. I have used Jack Goody's terminology from *Succession to High Office* (Cambridge: Cambridge University Press, 1966). The term *priestess-ruler* comes from Ueda Masaaki, *Nihon no jotei* (Kōdansha, 1973).
5. The term *gender complementary* comes from Irene Silverblatt, *Moon, Sun, and Witches: Gender Ideologies and Class in Inca and Colonial Peru* (Princeton: Princeton University Press, 1987). Peggy Reeves Sanday also argues that where dual-gender pairs take important roles in rule and worship sex roles are integrated and equal. See her *Female Power and Male Dominance: On the Origins of Sexual Inequality* (Cambridge: Cambridge University Press, 1981), 86.
6. On the homeostatic nature of oral tradition in nonliterate societies, see Jack Goody and Ian Watt, "The Consequences of Literacy," *Comparative Studies in Society and History* 5.3 (1963): 304–45.
7. Georges Dumezil, *Mitra-Varuna* (New York: Zone Books, 1988), 110.
8. "*Hitachi fudoki*," in Akimoto Kichirō, ed., *Fudoki*, vol. 2 of *Nihon koten bungaku taikei* (Iwanami Shoten, 1958), 63 (henceforth cited as *Fudoki*). An English translation of the *Hitachi fudoki* by Kōno Shōzō was published in *Cultural Nippon* 81 (1940): 145–86. See especially pages 145 and 153. A new partial translation by Mark Funke may be found in *Monumenta Nipponica* 49.1 (1994): 1–29.
9. See Marshall Sahlins, "The Stranger-King," in *Islands of History* (Chicago: Chicago University Press, 1985), 73–103. Ueno Chizuko has described the "stranger-king"

mode in "'Gaibu' no bunsetsu," in *Taikei bukkyō to Nihonjin*, edited by Sakurai Yoshirō (Shunjūsha, 1985), 1:261–310.

10. *Nihon shoki* (Chronicles of Japan), Sujin chapter, tenth year, 9.27. The standard edition that I have used is the two-volume text in *Nihon koten bungaku taikei*, edited by Sakamoto Tarō et al. and first published by Iwanami Shoten in 1967. For the story of Atahime, see volume 1, pages 244–25.

11. Sanday, *Female Power*, 28–33, 56.

12. Robert Ellwood frequently refers to early Japan as a matriarchal society. See, for example, his *Feast of Kingship* (Sophia University, 1973), 83. However, current scholarship in Japan argues that early Japan was cognatic. See Nishimura Hiroko, "The Family, Communal Ties, and Women in Ancient Times," in *Historical Studies in Japan*, edited by the National Committee of Japanese Historians, 1983–87 (Yamakawa Shuppan, 1990), 7:161–88.

13. *Fudoki*, 257–354, esp. 307. In English, see Michiko Y. Aoki, *Records of Wind and Earth: A Translation of Fudoki*, Monographs and Occasional Papers (Ann Arbor: Association for Asian Studies, 1997).

14. *Fudoki*, 309.

15. Mircea Eliade, "Structures and Changes in the History of Religion," in *City Invincible*, edited by Carl H. Kraeling and Robert M. Adams (Chicago: University of Chicago Press, 1960), 359–60.

16. Imai Akira, "Kofun jidai zenki ni okeru josei no chii," *Rekishi hyōron* 383 (March 1982): 2–24.

17. Mori Kōichi, *Josei no chikara* (Chūō Kōronsha, 1987), 81–107.

18. Ikebe Wataru has assembled a more complete list of dual-gender pairs in "Hikohimesei shiryō shūsei," *Seijō Daigaku tanki daigaku kiyō* 1 (1970): 21–64.

19. Sanday, *Female Power*, 35ff.

20. See Tsunoda, *Japan*, 22–24.

21. Gina L. Barnes, *Protohistoric Yamato: Archaeology of the First Japanese State* (Ann Arbor: The University of Michigan, Center for Japanese Studies, 1988), 192–205.

22. Tsunoda, *Japan*, 23.

23. Gina L. Barnes, "Jiehao, Tonghao: Peer Relations in East Asia," in *Peer Polity Interaction and Socio-political Change*, edited by Colin Renfrew and John F. Cherry (Cambridge: Cambridge University Press, 1986), 79–91.

24. Christine Ward Gailey, *Kinship to Kingship* (Austin: University of Texas Press, 1987), ix–xii, 24–38. Also see Rayna Rapp, "Gender and Class: An Archaeology of Knowledge Concerning the Origin of the State," *Dialectical Anthropology* 2.4 (1973): 309–16; Christine Ward Gailey, "The State of the State of Anthropology," *Dialectical Anthropology* 9 (1985): 65–89; and Christine Ward Gailey with Thomas C. Patterson, "Power Relations and State Formation," in *Power Relations and State Formation*, edited by Christine Ward Gailey and Thomas C. Patterson (Washington, D.C.: American Anthropological Association, 1987), 1–27.

25. Sherry B. Ortner, "Virgin and the State," *Feminist Studies* 4.3 (1978): 19–35, esp. 29.

26. Viana Muller, "Origins of Class and Gender Hierarchy in Northwest Europe," *Dialectical Anthropology* 10 (1985): 93–105. Also useful is JoAnn McNamara and Suzanne Wemple, "Power of Women through the Family in Medieval Europe, 500–1100," *Feminist Studies* 1.3–4 (1973): 126–41.

27. Two useful interpretive studies of the process are Ronald Cohen, "The Evolution of Hierarchical Institutions," *Savanna* 3.2 (1974): 153–74; and Viana Muller, "The Formation of the State and the Oppression of Women," *Review of Radical Political Economics* 9.3 (1977): 7–21.

28. The sword was found in the Saitama-Inariyama Kofun in Saitama Prefecture. The translation here is based on Inaoka Kōji's reading. See W. Anazawa and J. Manome, "Two Inscribed Swords," in *Windows on the Japanese Past*, edited by Richard Pearson (Ann Arbor: The University of Michigan, Center for Japanese Studies, 1986), 375–94, esp. 376–85.

29. Yoshie Akiko, *Nihon kodai no uji no kōzō* (Yoshikawa Kōbunkan, 1986), 3–6. Yoshie has argued that the patri-genealogy inscribed on Ōwake's sword may have been specially constructed to record the loyalty of Ōwake's male ancestors vis-à-vis the Yamato king. She suspects that a genealogy for local use, as opposed to one for use at the Yamato court, would have probably recorded Ōwake's patriline and matriline because local society was still bilineal.

30. Robert Ellwood has characterized such events as Yamato's "patriarchal religious revolution." See his "Patriarchal Revolution in Ancient Japan," *Journal of Feminist Studies in Religion* 2.2 (1986): 23–37; and "The Sujin Religious Revolution," *Japanese Journal of Religious Studies* 17.2–3 (1990): 202. However, apparently relying on the *Nihon shoki* chronology, he dates this transformation much earlier than I do. Just because the eighth-century compilers of the *Nihon shoki* assigned these events to the Sujin and Suinin chapters, which were written very late, there is no reason to assign a third- or fourth-century date to them. The fifth century, and possibly the late fifth century, is more appropriate.

31. Walter Edwards, "Event and Process in the Founding of Japan," *Journal of Japanese Studies* 9.2 (1983): 265–95. Plentiful numbers of horse trappings have been found in tombs of the late fifth century and later.

32. Isogai Masayoshi, *Gunji oyobi uneme seido no kenkyū* (Yoshikawa Kōbunkan, 1978), 179–246.

33. See Ortner, "Virgin and the State," 31–32.

34. Concerning the general credibility of Yūryaku's chapter in the *Nihon shoki*, see Yoshii Jirō, "Yūryaku tennō no kōi keishō o megutte," *Shisen* 32 (1977): 20–31; and Kishi Toshio, "Ōken to gōzoku," in *Ōken o meguru arasoi*, vol. 6 of *Nihon no kodai* (Chūō Kōronsha, 1986), 68–69. Yoshii and Isogai suggest that while there may be mistakes in the details, general trends in the chapter are credible. Since the late-sixth-century *Teiki*, a royal genealogy, is thought to have been a source for the chapters on Keitai through Kinmei, historians consider these chapters to be more credible than the earlier ones, including Yūryaku's. Kishi Toshio and Kamada Motoichi have proposed that other portions of the *Nihon shoki* were compiled in two stages: chapters 14–21 and 24–27 were compiled in the mid-seventh century, while chapters 3–13 and 22–23 were written in the late seventh or early eighth centuries. See Kishi, "Ōken to gōzoku," esp. 27–28. Yūryaku's chapter is the fourteenth and thus would have been compiled in the mid-seventh century according to their theory.

35. James Grayson has noted that in early Silla as well "women play important connective roles in royal succession. A new king will have as wife a close female relative of the former king" ("Some Structural Patterns of the Royal Families of Ancient Korea," *Korea Journal* 16.6 [1976]: 32).

36. See Kobayashi Toshio, *Kodai jotei no jidai* (Azekura Shobō, 1987), 91. Takamure Itsue was the first to propose this theory, and it has been widely accepted. Yamao Yukihisa also emphasizes this function of the Great King's senior consort. See his *Nihon kodai ōken keisei shiron* (Iwanami Shoten, 1983), 182–83. Specifically, he sees the head wife inheriting the functions of the female partner of chieftaincy pairs. Kobayashi and others agree.

37. Cornelius Kiley, "Archaic Yamato," *Journal of Asian Studies* 33.1 (1973): 25–50. Kiley explains that Mizuno Yū rejects the historicity of Seinei, Kenzō, and Ninken,

arguing that Iitoyo reigned for fifteen years, from the end of Yūryaku's reign to the beginning of Keitai's. Also provocative is Tanaka Hisao, "Kenzō, Ninken tennō Oshinbe-shi, Kibi-shi to higashi Harima," *Migake shigaku ronshū* 8 (1983): 1–9; and Teranishi Sadahiro, "Kodai no kōi keishō ni tsuite," in *Nihon shoki kenkyū*, edited by Yokoda Ken'ichi (Hanawa Shobō, 1979), 11:139–74, esp. 149.

38. Translated from Ogihara Asao and Kōnosu Hayao, eds., *Kojiki, Jōdai kayō*, vol. 1 of *Nihon koten bungaku zenshū* (Shōgakkan, 1973), 331–32.

39. *Nihon shoki*, Kenzō chapter, fifth year, first month (vol. 1, p. 514). The *Harima fudoki* suggests that Prince Ichibe ruled prior to his assassination, but parts of the story are clearly unreliable. For instance, the princes' mother is mistakenly identified as Princess Tashiraga, commonly thought to have been a daughter of Keitai and main consort to Kinmei (see *Fudoki*, 349–53).

40. According to variant accounts, prince-nephews (or younger brothers) of Iitoyo were "discovered" in Harima, whence they had fled to escape Yūryaku's assassins. Tanaka Hisao has suggested that the princes had ties to Kibi and the Katsuragi. Many scholars believe that unity in the Yamato confederacy was re-established only in the early sixth century by Great King Keitai. His accession date is traditionally thought to have been 507, but his palace was not established in Yamato until 526. Prior to that, Keitai ruled in Kawachi and Yamashiro. He had kin in Ōmi and Koshi. Kitagō Miho'o has recently argued that Keitai's rivals included both Iitoyo and the Harima princes, who may have maintained separate courts. See Tanaka Hisao, "Kenzō, Ninken sokui denshō zōkō," in *Nihon kodaishi ronkō*, edited by Saeki Arikiyo (Yoshikawa Kōbunkan, 1980), 91–127.

41. *Nihon shoki*, Seinei chapter, third year, seventh month (vol. 1, p. 506). The suggestion above reflects the interpretation of many scholars, but the entire incident is obscure.

42. The source, the *Fusō ryakki*, was compiled in the late Heian period. It covers the age of the gods through Emperor Horikawa's reign. It notes that a memorial was presented to the throne in 712 on Iitoyo's behalf, after which time her story was added to the *Nihon shoki*.

43. Specialists believe that Suiko's chapter in the *Nihon shoki* is based on court records because the entries are quite regular and detailed. Frequent contacts with China and the Korean kingdoms during Suiko's reign made the court increasingly aware of record-keeping procedures in continental courts, and compilation of a royal genealogy in the late sixth century had taught court scribes much about record keeping. While scholars still proceed cautiously when interpreting material from her chapter in the *Nihon shoki*—it was, after all, compiled a century after Suiko's lifetime—her chapter is still considered more credible than the earlier ones. There are also substantiating documents, including the *Kamitsumiya ki* and the *Gangōji engi*.

44. The Iwai revolt is a historical event of great significance that has not yet been examined in Western historiography. It seems to have established the military preeminence of Yamato over the archipelago. See Oda Fujio, *Kodai o kangaeru: Iwai no ran* (Yoshikawa Kōbunkan, 1991). On the worker corporations known as *be*, see Gina L. Barnes, "Role of the *Be* in State Formation," in *Production, Exchange, and Complex Societies*, edited by E. Brumfiel and T. Earle (Cambridge: Cambridge University Press, 1987), 86–101; and Lars Vargo, "The *Bemin* System in Early Japan," in *European Studies on Japan*, edited by Ian Nish and Charles Dunn (Tenterden, Kent: Paul Norbury Public, 1979), 10–15.

45. Audrey Richards, "Keeping the King Divine," *Proceedings of the Royal Anthropological Institute for Great Britain and Ireland for 1967* (1968): 23–35, esp. 28.

Gillian Feeley-Harnik also observes: "The role of women as queens, queen-mothers, and king-makers should be compared with their roles as relic and tomb guardians and as spirit mediums, the principle means by which kingships are legitimated and kings kept alive after death" ("Issues in Divine Kingship," *Annual Review of Anthropology* 14 [1985]: 299).

46. Kishi Masahiro has argued that Yōmei and Sushun never became Great Kings. He believes that Suiko conducted an interim government from the time of Bidatsu's death in 585 until her formal accession in 592. Kishi notes inconsistencies in the dates given in various sources for the death of Bidatsu and the reigns of his successors ("Yōmei, Sushunki no seiji katei," *Nihonshi kenkyū* 148 [1975]: 30–50). The argument is plausible but has not been widely embraced.

47. Narikiyo Hirokazu, "Taikō ni tsuite no shiryōteki saikentō," in *Nihon shoki kenkyū*, edited by Yokoda Ken'ichi, 11:175–202, esp. 190–95.

48. Ishimoda Shō and Yoshida Akira have both embraced this view. That a mate or sister could "beckon the spirit back" is clear from poems in the *Man'yōshū* and from passages in the *Kojiki* and *Nihon shoki*. Kishi Masahiro and Wada Atsumu have both insisted that the senior consort enjoyed special powers during the funerary services, a point discussed by Gary Ebersole in *Ritual Poetry and the Politics of Death in Early Japan* (Princeton: Princeton University Press, 1989), 127–29. See also Wada Atsumu, "Mogari no kisoteki kōsatsu," *Shirin* 52.5 (1969): 32–90. Kobayashi Toshio sees the Great King and his senior consort as replicating a chieftain pair: "Prehistoric chieftaincy with its dual-gender pairs (*hime-hikosei*) must have influenced the formation of the later dual system of rulership amalgamating religious and secular rulership in the two persons of the *tennō* and senior consort" (Kobayashi, *Kodai jotei*, 86).

49. Prince Takeda predeceased Suiko. See Nanbu Noboru, "Jotei to chokkei kōi keishō," *Nihon rekishi* 282 (1971): 10–21, esp. 12.

50. See Taniguchi Yasuyo, "Kandai no taikō rinchō," *Rekishi hyōron* 359 (1980): 86–98. In English, see Lien-Sheng Yang, "Female Rulers in Imperial China," *Harvard Journal of Asiatic Studies* 23 (1961): 55; and Tao Tien-yi, "System of Imperial Succession during China's Former Han Dynasty, 206 B.C.–9 A.D.," *Papers on Far Eastern History* (September 1978): 171–91. Ishimoda Shō and Kobayashi Toshio have also noted that corporate exercise of royal authority was customary in both Paekche and Silla, which undoubtedly influenced the operation of Suiko's court.

51. The best overview remains Ishimoda Shō, "Kokka seiritsushi ni okeru kokusaiteki keiki," in *Nihon no kodai kokka* (Iwanami Shoten, 1989), 1–82, esp. 27–47.

52. On Paekche, see Jonathan Best, "Diplomatic and Cultural Contacts between Paekche and China," *Harvard Journal of Asiatic Studies* 42 (1982): 443–89.

53. An English translation of the *Seventeen Articles* can be found in Theodore de Bary, ed., *Sources of the Japanese Tradition* (New York: Columbia University Press, 1958), 1:47–51.

54. The text in the *Analects* reads: "He who exercises government by means of his virtue may be compared to the north polar star, which keeps its place and all the stars turn towards it." My translation is based on the Chinese from *Analects* 2.1, in James Legge, ed., *The Chinese Classics: Confucian Analects* (Taipei: SMC Publishing, 1991), 145. As Fukunaga Mitsuji has argued, *tennō* (*tenkō*) was used to refer to the polestar in Han and post-Han astronomical texts and could have been picked up and used as a form of address for Great King Suiko in her day, even if it was not adopted formally until Tenmu's reign. See *Dōkyō to kodai Nihon* (Kyoto: Jinbun Shoten, 1987), 14–15; and *Dōkyō to Nihon bunka* (Kyoto: Jinbun Shoin, 1982), 74–82. Zhen-Ping Wang has argued, however,

PIGGOTT

that *tennō* was used by T'ang monarchs and adopted by the Japanese court
during Tenmu's reign ("Sino-Japanese Relations Before the Eleventh Century"
[Ph.D. diss., Yale University, 1989], 246–50). For an overview of the documen-
tary evidence, see Tōno Haruyuki, "Tennō gō no seiritsu nendai ni tsuite," in
Shōsōin monjo to mokkan no kenkyū (Hanawa Shobō, 1977), 397–420. It is
Tōno's opinion that the title *tennō* was formally adopted into the Kiyomihara
Code late in Tenmu's reign.

55. Tsunoda, *Japan*, 29.
56. Kadowaki Teiji, "Kodai no jotei," in *Jotei no seiki* (Mainichi Shinbunsha, 1978),
 15–52. Yoshida Akira supports this view.
57. These are the *Kamitsumiya Shōtoku hōō teisetsu*, a genealogy of Prince Shōtoku,
 thought to date from the late seventh century in part, and the *Gangōji engi*, a
 history of Gangōji compiled in the eighth century but containing earlier materi-
 als. For the *Teisetsu*, see *Shōtoku taishishū*, vol. 2 of *Nihon shisō taikei* (Iwanami
 Shoten, 1975), 353–78, esp. 363. For the *Engi*, see Sakurai Tokutarō et al.,
 eds., *Jisha engi*, vol. 20 of *Nihon shisō taikei* (Iwanami Shoten, 1975), 7–22.
58. This attitude is clear in a letter written by the T'ang monarch to a female ruler of
 Silla after Suiko's death. He opined that neighboring countries would never
 respect a female ruler. See Pu-sik Kim, *Samguk sagi*, vol. 372 of *Tōyō bunko*
 (Heibonsha, 1980), 1:141 (entry for the year 643).
59. *Nihon shoki*, Suiko chapter, first year (593).4.10 (vol. 2, pp. 172–73).
60. *Nihon shoki*, Suiko chapter, fifteenth year (607).2.9 (vol. 2, p. 188).
61. Suiko's decree should be considered in light of a description of Han imperial
 ritual from Ssu-ma Ch'ien's *Records of the Historian*, composed circa 90 B.C.E.:
 "At the winter solstice a sacrifice shall be made to Heaven in the southern sub-
 urbs in order to greet the arrival of lengthening days. At the summer solstice a
 sacrifice shall be made to the Earth God. At both ceremonies music and dance
 shall be performed. Thus one may pay respect to the spirits" (Burton Watson,
 trans., *Records of the Historian* [New York: Columbia University Press, 1961],
 2:16).
62. Ueda Masaaki believes that Suiko's role was largely sacral. He chronologizes fe-
 male sovereignty in three stages: those of the priestess-ruler (Himiko), of fe-
 male king (Suiko), and female sovereign (Jitō). See Ueda, *Nihon no jotei*.
63. The *Kamitsumiya Shōtoku hōō teisetsu* records that Suiko and Shōtoku were
 advocates of Buddhism even during Great King Bidatsu's lifetime (Bidatsu died
 in 585). On Suiko's Buddhist policies, see Yasui Ryōzō, "Suiko jotei to bukkyō,"
 in *Nihon shoki kenkyū*, edited by Yokoda Ken'ichi (Hanawa Shobō, 1978),
 10:245.
64. A translation of the *True Lion's Roar* is available in Garma C. C. Chang, ed., *A
 Treasury of Mahāyāna Sutras* (University Park: Pennsylvania State University
 Press, 1983), 363–86. For the *Lotus Sutra*, see Bunnō Katō et al., eds., *The
 Threefold Lotus Sutra* (New York: Weatherhill, 1975), 316–17.
65. In Western historiography, Sir George Sansom did not describe the politics of the
 corporate dynasty responsible for Suiko's accession, and he overestimated the
 role of Soga Umako in *A History of Japan to 1334* (Stanford: Stanford Univer-
 sity Press, 1958), 50–53. John Whitney Hall recognized the importance of
 Shōtoku's *Seventeen Articles* as a support for royal authority, but he utterly
 ignored Suiko's role. See his *Government and Local Power in Japan, 500–1700*
 (Princeton: Princeton University Press, 1966), 55–56.
66. *Nihon shoki*, Suiko chapter, thirty-second year (623).10.1 (vol. 2, pp. 210–11).
67. An interesting comparison can be found in Ottonian Germany in the tenth cen-
 tury. See K. J. Leyser, *Rule and Conflict in an Early Medieval Society* (Oxford:

Blackwell, 1979), 47. Leyser discusses the evolution of kingship in the Ottonian realm with a helpful discussion of anthropological materials.

68. De Bary, *Sources*, 48.

69. Such a conflict occurred in the Soga family between Iname's heir, Umako, and Iname's younger brother, Sakaibe Marise. The affair is recorded in the eighth-century *Kamatari den*, the biography of Fujiwara Kamatari. See Takeuchi Rizō, ed., *Nara ibun* (Tōkyōdō Shuppan, 1962), 3:875–81.

70. Hall, *Government*, 50.

71. Nitō Atsushi has noted that Kōgyoku-Saimei's interim title, "royal parent," pre-saged Jitō's later creation of the office of retired sovereign. See "Ritsuryōsei seiritsuki ni okeru daijōtennō to tennō," *Bungei* (Bessatsu 1990: *Tennō, rekishi, ōken, daijōsai*): 56–61.

72. Bruce Batten, "Foreign Threat and Domestic Reform," *Monumenta Nipponica* 41.2 (1986): 199–219. For a particularly suggestive discussion of the process of centralization during times of stress, see Kent Flannery, "The Cultural Evolution of Civilizations," *Annual Review of Ecology and Systematics* 3 (1972): 399–436.

73. Kitayama Shigeo, "Jitō tennō ron," in *Nihon kodai seijishi no kenkyū* (Iwanami Shoten, 1959), 118–233, esp. 121–34; Naoki Kōjirō, *Jitō tennō* (Yoshikawa Kōbunkan, 1960), 96–126. Tenji's unpopular policies included greater central-ization, removing the capital to Ōmi, and the choice of a unilinear royal prince as successor.

74. See Naoki Kōjirō, "Jitō Tennō to Ro Taikō," in *Nihon shoki kenkyū*, edited by Mishima Shōei (Hanawa Shobō, 1964), 1:217–38.

75. Kobayashi, *Kodai jotei*, 148–77.

76. Historians have traditionally viewed these provincial governors as administrators rather than emissaries (see, e.g., Hall, *Government*, 72–73). Their cultural role was extremely important, however. To cite two early-eighth-century examples, Inbe no Sukune Obito went to Izumo in 708 and Kose no Ason Kōoji served in Harima in the first decade of the eighth century. Inbe was a ritualist and scholar. Kose was a scholar of Chinese lore who became head of the Royal University after his return to the capital.

77. The sites of more than 500 temples dating from 645 to 700, from Kyushu to the Kantō, have been located by archaeologists.

78. The *New Tang History* reports that a Japanese ambassador to China in 670 in-formed Tang officials that the name Wa had been changed to Nihon. Tsunoda, *Japan*, 40.

79. Ian Levy, trans., *Ten Thousand Leaves* (Princeton: Princeton University Press, 1981), 57–58.

80. Scholars generally agree that the expression translated as "very god" (Japanese *kami ni shimaseba, kamunagara*, or *arahitogami*) came into use during the reigns of Tenmu and Jitō. See Kōnoshi Takamitsu, "'Kami ni shimaseba' to 'kamunagara'—Hitomaro no hyōgen e no shiten," in *Matsuda Yoshio Sensei tsuitō ronbunshū: Man'yōgaku ronkō*, edited by Zoku Gunsho Ruijū Kanseikai (Zoku Gunsho Ruiju Kanseikai, 1990), 562–84.

81. Ebersole, *Ritual Poetry*, 217.

82. See Ian Hideo Levy, *Hitomaro and the Birth of Japanese Lyricism* (Princeton: Princeton University Press, 1984).

83. Tamura Enchō, "'Amaterasu ōmikami' to Tenmu tennō," *Kodai bunka* 67 (1991): 2–23.

84. On *kunimi*, see Ebersole, *Ritual Poetry*, 23–29.

85. *Nihon shoki*, Jitō chapter, sixth year (692).3.3 (vol. 2, 514).

86. This event is recorded in the *Kaifūsō*, an anthology of Chinese poems by Japanese courtiers compiled in the late Nara period. See Kojima Noriyuki, ed., *Kaifūsō*, vol. 69 of *Nihon koten bungaku taikei* (Iwanami Shoten, 1964), esp. 81.

87. G. Cameron Hurst discusses Jitō's abdication in *Insei* (New York: Columbia University Press, 1976), 39–42.

88. *Shoku Nihongi* (Chronicles of Japan continued), Monmu 1 (697).8.17, 3–5. I have used the new annotated edition in the *Shin Nihon koten bungaku taikei* series, vols. 12–16, published by Iwanami Shoten, of which five volumes have appeared to date.

89. Inoue Mitsusada argued that there was no Chinese equivalent for Jitō's post as retired sovereign. See *Ritsuryō*, vol. 3 of *Nihon shisō taikei* (Iwanami Shoten, 1976), 630. However, Haruna Hiroaki has recently demonstrated that senior emperors were active rulers in China from the Northern Wei dynasty onward. See Haruna Hiroaki, "Daijōtennōsei no seiritsu," *Shigaku zasshi* 92 (1990): 1–38, esp. 1–2.

90. *Shoku Nihongi*, Genmei 1 (707).7.17, 119–21.

91. Besides Fujiwara Miyako, who bore the rank of second-rank consort (*fujin*), Monmu had two consorts of the lower third-rank (*hin*) status. These were Ki no Ason Kamado no Iratsume and Ishikawa no Ason Tosu no Iratsume, both daughters of courtiers. Sons of these consorts would have been eligible to succeed, but both consorts were banished from the court in 713.

92. Bidatsu, Jomei, Kōgyoku-Saimei, Kōtoku, Tenji, and Tenmu were all double royals. Suiko, Yōmei, and Sushun were not.

93. See the *Keishi ryō*, in *Ritsuryō*, 281–82. For all officials of the third rank or above, the first son of the first wife was to be the heir (*chakushi*). Should that heir predecease the father, the son's heir would succeed. This was precisely the line of succession by which Karu acceded to the throne—he was Prince Kusakabe's heir.

94. Inoue Mitsusada, "Kodai no jotei," in *Inoue Mitsusada chosakushū* (Iwanami Shoten, 1986), 1:223–54. Also see Hurst, *Insei*, 37–47. E. Patricia Tsurumi criticized Inoue in "The Male Present versus the Female Past," *Bulletin of Concerned Asian Scholars* 14.1 (1982): 71–75. As I have indicated, however, Inoue was right about the extraordinary and limited nature of female sovereignty.

95. Kobayashi, *Kodai jotei*, 138. Ueda Masaaki seconds Kobayashi's view.

Trousers: Status and Gender in Ancient Dress Codes

TAKEDA Sachiko

Translated by Joan R. PIGGOTT and Hitomi TONOMURA

Every society places formal and informal restrictions on what people wear in accordance with the wearer's gender, class, age, occupation, and particular social and personal circumstances. Beyond the fundamental need to protect the body from meteorological and environmental elements, governmental and social pressures also contribute to defining how and with what people veil their bodies.[1] For this reason clothing is a powerful and distilled marker of complex relations between a person and the society around her. This chapter discusses the social and political meanings of ancient Japanese clothing by focusing on the wearing of trousers (*hakama*) by men and women. We will first trace the advent and circumstances of the wearing of trousers in relation to Japan's position in East Asia and then examine the meaning of *hakama* wearing by Heian court women.

SKIRT-WEARING AND TROUSER-WEARING CULTURES

In his *Fukusō no rekishi* (History of Clothing), Murakami Nobuhiko traces the history of trouser and skirt wearing in Japan and argues that shifts in clothing style paralleled changes in the social status of women.[2] His study is valuable because it articulates the connection between clothes and the wearer's social status. It nonetheless demands reexamination because his interpretation relies excessively on the trouser- and skirt-wearing practices of Europe, for which, moreover, he fails to consider regional and class differences. From his understanding of ecological conditions, Murakami characterizes Asia as a trouser-wearing and Europe as a skirt-wearing society. In Asia, trousers came to be worn because agriculture, which developed relatively early, made available the kinds of plant fibers that were easy to cut and sew. In Europe, animal skins—which were difficult to cut and sew—were

more common than plant fibers, and thus coverall clothing came to be used, leading to the development of the skirt-type clothing represented by the Greek chiton and Roman toga. Assuming that the introduction of trousers in Europe took place in the fifth and sixth centuries into a society that was already patriarchal,[3] Murakami reasons that trousers, a garment that allowed freedom of movement, became the monopoly of men, while skirts remained women's attire. This leads him to argue that it took more than fifteen hundred years for European women to turn trousers into something of their own, despite such mid-nineteenth-century sartorial reform movements as Saint-Simonism and Bloomerism, which were partly directed toward women's liberation.

In contrast, Murakami stresses, Japan belonged to the trouser-wearing culture. In ancient times both Japanese men and women wore baggy, wide-bottomed trousers called *hakama*. These were often worn over kimonos. In medieval times, however, the declining status of women limited their ability to wear trousers and confined them to wearing only the skirt—the kimono.

My investigation into Japan's protohistoric attire, represented in archaeological and Chinese textual evidence, has found no indigenous signs of trouser-type clothing worn by Japanese men and women. Hardly supporting Murakami's formulation—trousers in Asia, skirts in Europe—available evidence points to the Japanese practice of wearing skirt-type clothes in pre- and protohistoric times. Trousers were the garb of Asian nomadic horse riders. I argue that early dwellers on the Japanese archipelago, with no indigenous practice of riding horses, had no custom of wearing trousers.[4] Human figures inscribed on Yayoi-period bronze bells (*dōtaku*) are clothed in straight, dresslike outfits, and a description in the Chinese *Wei chih* (Wei Chronicle, recording events from A.D. 220–65), states:

> The men wear a band of cloth around their heads, exposing the top. Their clothing is fastened around the body with little sewing. The women wear their hair in loops. Their clothing is like an unlined coverlet and is worn by slipping the head through an opening in the center.[5]

Some clay *haniwa* images dating from about the fourth and fifth centuries do display trouser-type clothing, but this representation was not based on indigenous custom. Trousers had been introduced from the continent, via Korea, along with the custom of horse riding and

were worn only by such chieftains as would be buried in tumuli, and their retainers. These *haniwa* figures are regionally specific, found mostly in Japan's Kantō (northeastern) region. Moreover, figurines with tunic-type outfits are found alongside those with trousers, suggesting a form of social distinction marked by differentiated clothing types. Even in the eighth century, the common man and woman in Japan apparently still wore pullover tunics made from cloth with a hole for the head. It is safe to conclude that Japan was an indigenously skirt-wearing society.

Origins of Trouser Wearing in Japan

The early history of Japan is closely intertwined with the complex history of East Asia. To put it simply, in China the traditional clothing of the Han populace was robe and skirt (*ishō*, or *i-shang* in Chinese), in other words, skirt-type apparel. With the rise of such northern horse-riding dynasties as the Sui and Tang (A.D. 580–617, 618–906), however, trouser-type attire came to be stipulated as the court's official clothing. It was then that Japan's emerging monarchy adopted many features of continental civilization, including clothing that would meet international standards. Violations of protocol in clothing among East Asian states, which were hierarchically ordered in terms of tributary relations, apparently risked grave consequences. In the late fifth century, during the so-called period of the Northern and Southern dynasties (386–581), for example, the Southern Qi court denied an imperial audience to ambassadors from Northern Wei because the latter were wearing improper attire.[6] As a newly rising state, it was imperative for Japan to demonstrate that its officials' dress was appropriate to the occasion. This was the context in which robe and trousers (*ikō*) came to be established as the official clothing of Japan's bureaucracy, which was staffed mainly by men. By the middle of the eighth century, *hakama* were firmly established as the appropriate attire for officials serving in the royal bureaucracy because they were the keepers of the Chinese-style institutions adopted by the Japanese state.[7]

Trousers in Japan's first state-making epoch spoke to the uniform subordination and unequivocal service of the *hakama* wearers to the throne. This is why trouser wearing was applied even to the people who were personally attached to the royal family and categorized as unfree "slaves" (*nuhi*). Whether the wearers were bureaucrats or slaves, trousers symbolically stood for the authority and prestige of

the newly centralized institution that sought to raise its international image through governance by means of Chinese-style law. Within the vertical structure defined by control and subordination between the throne, occupied by the sovereign (*tennō*) and all vassals, trousers visibly symbolized uniformity in subjugation among their wearers. At the same time, however, this uniformity was finely differentiated according to status and rank within officialdom. As early as 603, the cap rank system stratified officials into ranks that were identifiable by different hat colors—purple, blue, red, yellow, white, and black.[8] Despite these differences, officials shared in common the newly established requirement to wear trousers as servants of the *tennō*. Ordinary people who were only indirectly connected to the government (as taxpayers) continued to wear clothing of the pullover tunic variety. Contrary to the claim made by Murakami, ancient Japan was not originally and universally a trouser-wearing country.

Once trousers became the formal clothing of the country's elite, however, they gradually diffused among a broader segment of population. By the medieval period, *hakama* wearing was habitual among warriors and also among commoners for formal occasions. Men who were situated below the commoners—the *hinin*, for example, as well as those who took the tonsure, normally donned just the kimono. A story in the *Konjaku monogatarishū* (Tales of Times Now Past) describes a lowly servant in a knee-length tunic who "harvested grass for horses and gathered and cleaned up their droppings" at the Ninna temple. The story notes that he wore a sleeveless tunic in the summer and layered two tunics in the winter.[9] Thus, the type of tunic routinely worn by peasants in the eighth century had turned into a marker of men situated below or outside the status of ordinary commoners.

Among men, *hakama*-wearing practice lasted until the beginning of the Tokugawa period (1603). In Tokugawa times, those who were not warriors (*bushi*) abandoned trousers; even warriors often donned just the kimono for daily, private wear. Under the Tokugawa regime, warriors received explicit instructions touching on the length and color of their trousers along with other matters of protocol. Only after Western clothing came to be worn as daily attire did men begin to wear trousers in their daily, as well as official, spheres. Even so, they often continued to wear kimonos at home. These modern trousers were styled more severely than the pleated *hakama*. Work leggings (*momohiki*), which closely resemble women's tights of today, may fall into the trouser category as well. *Momohiki* were also inspired by the

Western costumes worn by the "southern barbarians" (Europeans) who made their appearance in sixteenth-century Japan.

The official regulations for trouser wearing adopted by Japan originated in China, where clothing was differentiated by gender and trousers were worn exclusively by men. This does not mean that trouser wearing in premodern Japan was adopted as a *male* custom, however. Instead of gender differentiation per se, it was differentiation in status that determined who wore trousers. The preponderance of male officials in the newly established, Chinese-style bureaucracy obscures the fact that the Japanese court adopted not trousers for men but trousers for all people serving certain governmental functions. The common people, men and women alike, continued to wear clothing of the pullover tunic variety.

Generally speaking, since women, despite the presence of female rulers, remained largely outside the formal bureaucratic structure, they continued to wear skirts. But women who actually served the *tennō*, or the royal institution represented by him, began to wear trousers just as men did. According to a later record, Kanmu Tennō in the eighth century demanded that all female palace attendants (*uneme*) wear *hakama* for their formal attire in order to "facilitate their serving duties."[10] Scenes in medieval scrolls that depict the early official shrines at Ise and Miwa invariably show priestesses, shrine attendants, and the shrine princess (*saiō*, particular to Ise) wearing red trousers and robes.[11] They, too, were participants in official rites and ceremonies. Priestesses in China, according to Fukunaga Mitsuji's findings, also wore trousers. Quoting from the *Han shu* (History of the Han Dynasty), he describes the shrine priestesses of southern China in pre-Han and former Han times (202 B.C.–A.D. 8) wearing red trousers as a ritual costume. This practice may well have been exported to Japan.[12]

THE SPREAD OF RED TROUSERS

Despite the singular meaning of *hakama* wearing associated with the ancient state, the shape and styles of *hakama* varied greatly. Depending on the wearer's age and status, the cloth used to make *hakama*, for example, varied in material, size, quality, color, and decoration. Where and how the tie string was fastened by men and women differed as well. *Hakama* were worn against the skin or layered over

another garment. In the Heian period, court women (*nyōbō*) began wearing silk *hakama* that were usually red, extremely baggy, and long. Their *hakama* were worn as part of the twelve-layered robes, the regulation court attire for ladies-in-waiting at the court.[13] The trousers filled the front of the layered, unclosed robes, which trailed behind along with the women's long hair. This development was an expanded, more general application of the earlier regulation stipulated by Kanmu Tennō, which had previously been limited to palace attendants, the *uneme*. Again, the general understanding that these women were in the service of the throne doubtless lay behind this development. It was also in about the eleventh century that girls began donning trousers instead of a robe in a ceremony that signaled their coming of age. At that time, boys were already wearing trousers (*sashinuki*). This rite of passage took place when boys and girls were between three and seven years of age.

The wearing of red trousers soon spread beyond its initially intended sphere. Female entertainers (*yūjo*) who, according to Gotō Norihiko, learned music and dancing at the court conservatory (*naikyōbō*), also wore red trousers.[14] Nevertheless, some Heian-period court women regarded red trousers as apparel that ought to be specific to their class. A sharp-tongued court woman, Sei Shōnagon, remarked in her *Makura no sōshi* (Pillow Book): "Unsuitable things: . . . A woman of the lower classes dressed in a scarlet trouser-skirt. The sight is all too common these days."[15] This class-conscious lament by an upper-class woman provides a glimpse of the gradual diffusion downward in the social strata of the groups wearing trousers.[16] Court women considered themselves an integral part of the trouser-wearing group, associated with the bureaucracy, that embodied the prestige emanating from it. Red trousers became so essential for court women that the price of red dye began to rise.[17]

WHAT'S IN THE COLOR RED?

If the fact of wearing trousers integrated court women into the prestigious group associated with the royal bureaucracy, what did the wearing of the color red signify, particularly in the Heian period? To complicate this issue, in the Kamakura period women sometimes wore purple trousers instead of red ones. The significance of red is something for which we have no ready explanation. To go back to the time of Kanmu Tennō, we may assume that perhaps red symbolized the sacred power invested in the person of the *tennō*. At that time, the

Japanese may have simply imitated the Chinese precedent, according to which shrine maidens wore red, though this begs the question of why the Chinese chose red. The vividness of the color also may have been favored by elites to set them apart from ordinary humans and support a sense of exclusiveness that was doubtless reinforced by the high price of red dye.

The wearing of red was not limited to women. Male courtiers also wore red trousers as underwear beneath their white trousers. A picture scroll, the *Ban dainagon ekotoba* (The Illustrated Story of the Tomo Major Counsellor), dating from the twelfth century but describing scenes from the ninth, depicts Seiwa Tennō giving an audience to a noble in his sleeping quarters while wearing a pair of long, trailing, red trousers and a wadded jacket that is usually worn under other clothing.[18]

Men's red trousers relied on cutting and sewing techniques similar to those used for women's red trousers. It is possible that women's red trousers also started out as an undergarment worn underneath their skirts. If so, the dress code for court women perhaps demanded that they expose their undergarments. This would not have been a sign of degradation within the context of ancient Japanese society, where sexuality, politics, and sacrality were often only ambiguously distinguished. Red trousers, which were worn against women's flesh and surely had some association with their sexuality, could express the wearers' position of privilege within the inner court, in particular, their proximity to the sacral and sexual power of the monarch.

What Red Trousers Meant for Women Wearers

After the Kamakura period, women gradually abandoned trousers, turning to wearing kimonos without *hakama* in the so-called *kinagashi* style. It seems that until modern times skirts—Japan's indigenous style—were worn over imported trousers as a fashion among all classes. In hindsight, we can say that red trousers were a formal costume that characterized the court women of the Heian and early medieval periods, though women of lower status apparently also adopted them for a shorter period of time and less consistently.

For the women of the aristocratic class, red trousers in these early periods held important social and personal significance that went beyond symbolic ties to the court. Let us now explore the wider meanings of red trousers by examining their representations in popular tales and scroll paintings.

Red trousers appear in diverse settings and seem to convey varied meanings. A story in the *Konjaku monogatarishū,* compiled in the early twelfth century, concerns a young woman of Tsuruga in Echizen Province who, bereft of her parents and not blessed with a happy marriage, has used up her inheritance and is hard pressed for clothing and food. But she has kept one item of clothing—her red trousers—"just in case" she might need them. She gives this precious possession to a woman who has been kind to her in her time of need. The following day, she finds her trousers on the shoulders of the Kannon (Bodhisattva of Mercy) statue in the family Buddha hall behind her house. This discovery leads her to realize that the kind woman was in fact the Kannon personified.[19]

We can only speculate what the woman in the story wishes to convey with the phrase "just in case." One possibility is that red trousers had property value and thus would come in handy in a moment of adversity. The high price of red dye would support this speculation. But another story suggests that red trousers may not have been valuable enough to steal, at least not for the thief in this tale. The second story begins with a burglar, who breaks into the mansion of the governor of Shimotsuke Province and abducts a female attendant. On the road, the burglar strips his hostage of her clothing—all but the red trousers—and flees with them. The woman is abandoned under the wintry sky. She falls into a river, crawls out, and cries for help, but no one responds. On the following morning, her body is found. The tale reports that tatters of her long hair and red trousers could be seen frozen in the ice.[20] It seems possible to read the plot line of this story to mean that red trousers were not economically valuable enough for the burglar to strip the woman of her last shred of dignity.

Red trousers also appear in a story in which two women become Buddhist nuns. *Kokawadera engi* (The Origins of Kokawa Temple), a picture scroll (painted between 1176 and 1234?) depicts young women who take religious vows after discovering that a little boy who cured their illnesses was the embodiment of the thousand-armed Bodhisattva of Kokawa Temple. Their decision to take vows is symbolically expressed by the removal of their red trousers.[21]

Finally, red trousers stand out in scenes of hell. Hell was the place to which those who committed crimes during their lives went after death. *Kitano tenjin* engi (The Origins of Kitano Tenjin), an anonymous picture scroll from the early thirteenth century, portrays those

in hell as sinners who are deprived of their dignity as human beings. Men are usually depicted as naked or wearing only loincloths and with their topknots exposed. That is, they lack their *eboshi* hats, an occupation-specific mark of human dignity that was rarely removed, even in bed.[22] In contradistinction to the naked men, women are portrayed wearing red trousers and undergoing torture.[23]

What meanings are invested in these representations of red trousers? On the basis of these stories, we can propose that red trousers served as the symbolic code for meanings involving status, desire, and female-specific sinfulness. In the first story, if not for their economic value, how might the red trousers serve to help the woman "just in case"? For this impoverished upper-class woman, the red trousers most likely symbolized her social status, an essential mark of dignity denoting her self-perceived station. The wording "just in case" suggests a situation, such as a marriage proposal or an opportunity to return to court, in which her former social station would matter. It would seem that red trousers were an indispensable habiliment for women in certain status categories.

The story of the nuns suggests the symbolic function of the red trousers in making the transition from the secular to the Buddhist holy world. Their removal signifies the abandonment of attachments pertaining to this world—most importantly, physical and material desires.

The scroll of hell suggests a third meaning. In hell, where men are deprived of all that they had before death, hatless and bared to their loincloths, the women are wearing red trousers. Just as red trousers symbolized secular womanhood—a thing to be given up as a nun—they also served as an integral part of the sinful woman's body and selfhood in hell. We might say, on the one hand, that women bared to the waist and wearing red trousers were as naked as the men in their loincloths; on the other hand, the red trousers graphically displayed those aspects of womanhood that demanded suffering in hell. In Heian and Kamakura Japan, red trousers ironically became so closely integrated into the wearer's essential selfhood that they could mark her as naked and secular.

These fictional situations suggest that the significance of red trousers transcended their initially prescribed function as an indicator of specific social and official positions—as a marker of royal servitude—and became not only a self-conscious social code for upper-class women but an integral element of their secular personhood. Meanwhile,

sacrality was still an embedded meaning in red trousers when they were worn by shrine priestesses. Perhaps for elite women the wearing of trousers was accepted a priori; similar to a man's *eboshi* hat, trousers came to be a signifier of human dignity, an item one never took off, even while sleeping, without which one could not walk on a public road without inviting derision.

Although, from the fourteenth century on, women gradually abandoned trousers and turned to wearing kimonos alone, red trousers seem to have retained symbolic social power, especially for courtiers. An entry in a late-fifteenth-century diary, the *Kaneaki-kyōki* (Record of Lord Kaneaki), illustrates this point. It remarks that Hino Tomiko (1440–96), wife of the eighth Muromachi shogun, Ashikaga Yoshimasa, received an invitation to visit the royal palace. In responding, she requested that, because she possessed no trousers, she might be permitted to appear in a kimono (actually a *uchikake*, an outer garment worn over the kimono). Her request was granted.[24] Tomiko's request is a testimonial to the convention that trousers continued to be seen as appropriate formal attire at the royal court. Whether or not she lacked the means to obtain them—an unlikely prospect considering her notoriety as a financier—Hino Tomiko at least recognized that trousers were the appropriate garment to wear when visiting the royal court. Perhaps she also sought to flaunt the attire of warrior-class women and defy courtly fashion.

CONCLUSION AND AFTERTHOUGHTS

The inhabitants of the Japanese archipelago did not initially wear trousers. When the state dictated that all officials wear trousers at court, the legal authority behind the order drew those wearing trousers into positions of shared subordination and service to the *tennō*. *Hakama* initially represented the symbolic uniformity of servants before the idealized authority vested in the monarch; whether the wearer was a male or female, high or low, *hakama* wearing masked the reality of social and economic stratification. As the prescribed outfit of ladies-in-waiting, red trousers thus began as a mark of official servitude whose meaning was connected to the *tennō*-centered polity; they were a symbol of the relationship of control and subordination between the *tennō* and his servants. Their use was initially limited to the interior of the court, or, to use a contemporary political term, to the space designated as *kumon* (the public gate, i.e.,

officialdom). The downward diffusion of red trousers worn by women diluted the exclusive meaning originally attached to the wearer's official status. Gradually, they developed into a symbol of secular womanhood without losing their original symbolic significance as a status marker for aristocrats.

Initially, aristocratic women readily adopted the practice of trouser wearing probably because they clearly demarcated the *tennō*'s servants from the rest of the population. I suggest, however, that underlying this practice there was also the "unisex base" of indigenous Japanese clothing, whereby men and women alike wore single-piece robes (*kantōi*) that obfuscated gender differentiation. My belief that trouser wearing was a marker of status rather than gender is also informed by the prevalence of shared clothing among women and men as well as of cross-dressing in Japanese history and society, both past and present.

At around the same time that *hakama* were being adopted by the first Japanese government, Japan's earliest myth was being compiled. The myth described the sun goddess, Amaterasu, donning male attire to confront her rambunctious brother, Susanoo, and Prince Yamato Takeru masquerading as a woman before murdering his rival. Outside these moments of theatrical "performance," Japanese society has historically established few explicit taboos against cross-dressing. Throughout the premodern period, we find numerous instances of women and men exchanging clothes as a sign of intimacy and mutual affection. This was easily done because male and female clothing tended to be similar. While Japan's ancient and early modern governments, in particular, defined "official" clothing for their aristocratic and warrior servants, gender crossing in clothing was one area left untouched by any formal governmental regulations or religious prescriptions. This lack of concern for the practice of wearing clothes of the opposite sex contrasts with the dictates found in certain texts in other societies, such as those of China and the West.[25] As a result, medieval and early modern female and male entertainers could frequently cross gender boundaries to entice the audience. Today's kabuki, whose performers are all male, and the Takarazuka Revue Company, whose performers are all female, are firmly embedded in this historical tradition. The deeper significance of trouser wearing, therefore, may lie in the relationship between gender signification and the history of the body and sexuality in Japan.

NOTES

1. This paper is based on my *Kodai kokka no keisei to ifukusei* (Yoshikawa Kōbunken, 1984).
2. Murakami Nobuhiko, *Fukusō no rekishi*, 5 vols. (Rironsha, 1956), esp. vol. 3.
3. Although urban elites did not adopt trousers until the fifth or sixth century, "barbarian men" in Europe wore trousers as early as the second century, as demonstrated by the reliefs in the arch of Septimius Severus in Rome. The editors thank an anonymous reviewer for providing this information and clarifying the status-based differences.
4. For my criticism of Murakami's theory, see Takeda, *Kodai*, 3–128.
5. *Wei chih*, a Chinese historical chronicle compiled circa A.D. 292. Its translation appears as *History of the Kingdom of Wei*, in Ryusaku Tsunoda, trans., and L. Carrington Goodrich, ed., *Japan in the Chinese Dynastic Histories* (South Pasadena, Ca.: P. D. and Ione Perkins, 1951), 10, 11. Wa was the early Chinese name for Japan.
6. Later, in 489, Northern Wei retaliated. At a meeting hosted by Northern Wei, ambassadors from Southern Qi were seated on a par with its tributary state, Koguryŏ, of Korea. These events are described in the *Nan Qi shu* (Records of southern Qi), cited in Takeda, *Kodai*, 272–73.
7. This apparently did not happen overnight. Initially, in the early seventh century, items such as red fasteners were prescribed for officials, without any mention of trousers. See Takeda, *Kodai*, 272–333, for a discussion of the changing stipulations regarding official clothing in the Kiyomihara, Taihō, and Yōrō Codes.
8. From which country Japan learned of the system that differentiated ranks according to color has been a focus of much scholarly debate. Some believe that the Chinese expressed rank differences by means of ornaments worn with trousers rather than by cap color. Meanwhile, there is evidence that the Chinese dynasties that preceded the Sui—the Northern Wei and Northern Zhou—had already differentiated the color of officials' clothing. Korea used color-differentiated clothes, caps, or belts during the Three Dynasties period in the sixth century. The resolution of this debate has much relevance to the question of how and to what extent various East Asian countries helped to shape Japanese political culture. I tend to support the view that Japan adopted the dress code from China. See Takeda, *Kodai*, 130–82 (on China), 185–248 (on other East Asian countries).
9. *Konjaku monogatarishū*, chap. 15, story 54, cited in Takeda, *Kodai*, 329.
10. Uda Tennō's *Kanpyō no gyoyuikai* (Kanpyō imperial testament of 897), a "testament" written at the time of his retirement for the young Daigo Tennō, mentions that Kanmu Tennō decreed that all court dancers would wear trousers as their formal costume. See Yamagishi Tokuhei et al., eds., *Nihon shisō taikei: Kodai seiji shakai shisō* (Iwanami Shoten, 1979), 109.
11. An early example is a variant Kamakura manuscript of the *Ise monogatari emaki* in the collection of the Saiku Rekishi Hakubutsukan in Mie Prefecture.
12. Fukunaga Mitsuji, *Dōkyō to kodai Nihon* (Kyoto: Jinbun Shoin, 1987), 57–58.
13. Young women wore a deeper shade of red than did mature women. For a photograph of the twelve-layered ceremonial court dress of the Heian period, including red trousers, see Felicia Gressitt Bock, *Engi-shiki: Procedures of the Engi Era*, bks. 1–4 (Sophia University, 1970), frontispiece.
14. Gotō Norihiko, "Yūjo to chōtei kizoku: chūsei zenki no yūjotachi," *Shūkan Asahi hyakka, Nihon no rekishi 3, Chūsei* 1 (27 April 1985): 72–85.
15. Ivan Morris, trans., *The Pillow Book of Sei Shōnagon* (London: Penguin, 1967), 71, sec. 32.

16. Some scholars suggest that Sei Shōnagon was low enough in the court hierarchy that she would have been particularly sensitive to the violation of status markers.
17. "Miyoshi Kiyoyuki sōjō," in *Seiji yōryaku*, vol. 67 of Kuroita Katsumi, ed., *Kokushi taikei* (Yoshikawa Kōbunkan, 1981), entry for Engi 17 (917).12.25.
18. Komatsu Shigemi, ed., *Ban dainagon ekotoba*, vol. 2 of *Nihon no emaki* (Chūō Kōronsha, 1987), 30.
19. Yamada Takeo et al., eds., *Konjaku monogatarishū*, vols. 21–24 of *Nihon koten bungaku taikei* (Iwanami Shoten, 1971–76), chap. 16, story 7.
20. Yamada et al., *Konjaku monogatarishū*, chap. 29, story 8. For an analysis of this tale from a different angle, see Hitomi Tonomura, "Black Hair and Red Trousers: Gendering the Flesh in Medieval Japan," *American Historical Review* 99.1 (February 1994): 129–42.
21. Komatsu Shigemi, ed., *Kokawadera engi emaki*, vol. 5 of *Nihon no emaki* (Chūō Kōronsha, 1987), 45, 68, chap. 4. Hotate Michihisa describes and interprets this scene in his *Chūsei no ai to jūzoku* (Heibonsha, 1986), 18.
22. In the *Ban dainagon ekotoba*, the *tennō* is depicted wearing red trousers but not an *eboshi* hat. Apparently his superordinary position, the significance of which included the power to grant hats to his subjects, allowed him to appear hatless and in underwear. At any rate, hats coded nobles as the *tennō*'s subjects while the *tennō* was both grantor of hats and the hats' giver of meaning.
23. Komatsu Shigemi, ed., *Kitano tenjin emaki*, vol. 15 of *Zoku Nihon no emaki taisei* (Chūō Kōronsha, 1991), 8:36.
24. Tōkyō Daigaku Shiryō Hensanjo, ed., *Kaneaki-kyōki* (Tōkyō Daigaku Shuppankai, 1969), entry for Bunmei 11 (1479).1.19, 246–48.
25. Amaterasu and Yamato Takeru appear in the *Kojiki* (Records of ancient matters). *Shirabyōshi* dancers of Heian Japan performed in male clothing; young boys (*chigo*) dressed as girls to participate in festivals; all-female Okuni kabuki troops of the sixteenth century sang and danced in men's costumes; and the all-male *yarō* kabuki troops did the same in women's costumes in the early Tokugawa period. Exchanges of clothing between a man and a woman are recorded, for example, in the *Man'yōshū* (Collection of ten thousand leaves) an eighth-century anthology of Japanese poetry, and in *Towazugatari* (The confessions of Lady Nijō), an autobiographical memoir from the fourteenth century. I found restrictions against cross-dressing in such texts as China' Confucian classic, the *Li Ji* (Books of rites), which states: "Men and women should not exchange clothing"; and in the Old Testament (Deut. 22:5), which is explicit in forbidding men and women to dress in the clothing of the opposite sex.

Medieval Nuns and Nunneries: The Case of Hokkeji

HOSOKAWA Ryōichi

Translated by Paul GRONER

The revival of the order of nuns at the Hokkeji nunnery in Nara during the Kamakura period (1180–1336) is one of the more striking events in the history of women within the framework of institutional Japanese Buddhism.[1] Most medieval sources and modern studies credit Eison (1201–90), the architect of the revival of the Vinaya school (of Ritsu Buddhism), centered at the Saidaiji monastery in Nara, for re-establishing the Hokkeji nunnery during the thirteenth century. It is known that the Vinaya school played a crucial role in creating a place for women within clerical Japanese Buddhism. Eison's autobiography (*Kanjin gakushōki*) states that in the fourth month of 1245, he conferred the precepts for novices (*shamini*) on three women at Hokkeji.[2] The autobiography naturally emphasizes Eison's role in rebuilding Hokkeji from this point on.

This chapter is an attempt to write against this accepted understanding of the revival of Hokkeji. Using other fragmentary sources, I focus on the initiative of the women themselves. These women had entered the nunnery before Eison's arrival; he provided a male imprimatur for its revival. This, then, is the "behind the scenes" story of a group of energetic and devoted women who met the institutional challenge embedded in a religious order that structurally and spiritually privileged men.

THE NUTS AND BOLTS OF BECOMING NUNS

Hokkeji's history began in 741, when Empress Kōmyō promoted its establishment in Yamato Province as one of the most important of the state-sponsored provincial nunneries (*kokubunniji*). At that time, monks and nuns had relative parity; they sat together at official gatherings and national religious ceremonies. By the ninth century, however,

nuns had come to be seen as hindrances to the proper performance of rituals meant to guard the state. The court was no longer willing to sponsor ordination ceremonies for nuns, and women were forced to improvise their own modes of religious behavior in ways that differed from men's. Hokkeji declined to the point that the nuns' ordination lineage lapsed.[3]

According to the *Vinaya*, the basic text on monastic discipline and ordination procedures, a preexisting order of nuns was required if women were to be ordained as novices or full-fledged nuns (*bikuni*). The lapse in nuns' ordination could have had a dire consequence. In many countries, once the ordination lineage of nuns had been interrupted, so that correctly ordained nuns could no longer be found, the religious order ceased to exist; nor could it be reestablished.[4] The Japanese, however, reestablished nunneries even when the ordination lineage had been terminated.

It was a standard practice for the nuns' ordination process to take several years. The *Vinaya* prescribed that they first accept the ten precepts of a novice, including prohibitions against killing, stealing, sexual intercourse, and alcohol, and then experience life in a nunnery before they took the full vows. Following their initiation as novices, candidates for full ordination as nuns were to spend approximately two years as probationary nuns (*shikishani*) before they could be ordained in full, to ensure that they had not become pregnant while they were lay believers. The *Vinaya* precepts for fully ordained nuns prescribed behavior in great detail, from the manufacture, quality, and number of robes and begging bowls to the assignment of rooms and the settlement of disputes. One year of seniority was awarded after each successfully completed rainy season retreat. Because a rainy season retreat lasted three months, two years of seniority were required to make sure that no one had become pregnant. Once fully ordained as nuns, the women were required to participate in a fortnightly assembly to ensure that they had not violated any rules of the order. At these assemblies, they recited all of the precepts with which they had been ordained, reminding them that they were expected to treat the precepts as actual guides for conduct.

After conferring the precepts for novices on three women in 1245, Eison moved quickly to reestablish the hierarchy of nuns. During the same year, he conferred the precepts for novices on an additional ten women. Several years later, in 1247, following the three-month rainy season retreat, he lectured at Hokkeji on the basic text (*Shibunritsu*

bikuni kaihon) that contained the 348 precepts that fully ordained nuns would be expected to follow. In the twelfth month of that year, he conferred the precepts for probationary nuns on eleven women. After the women had completed this probationary period, Eison ordained twelve women as full-fledged nuns at Hokkeji on the sixth day of the second month of 1249. Eight days later, he conducted a fortnightly assembly for the new nuns (*bikuni fusatsu*).

WOMEN WHO ASPIRED TO BE NUNS

In the Kamakura period, women of all classes followed the Buddhist way. Those from lower walks of life often did so without the benefit of formally recognized institutional settings. Some wealthy women, however, garnered the financial support to live in seclusion at a temple or in their own homes. In some cases, widows and orphaned young women who had lost husbands and fathers in the battles and internecine conflicts of the twelfth and thirteenth centuries retreated and prayed for the salvation of the souls of the dead, but they did so without undergoing formal ordination ceremonies. Such refuges often lasted only a single generation, subsequently falling into disuse or being converted into monasteries. The early to mid-Kamakura period saw the establishment and revival of a number of nunneries. Hokkeji was the first of fourteen nunneries to be revived under the auspices of the Saidaiji branch of Ritsu Buddhism. More than forty nunneries were affiliated with the Zen sect, and a few established later belonged to the Jōdo, or Pure Land, sect. The older, orthodox Tendai-Shingon establishment generally ignored nunneries during this period.[5]

It is difficult to determine the background of the women who arrived in Hokkeji before Eison guided their ordination as nuns, and, indeed, the sources for the study of medieval nuns are frustratingly fragmentary. Fortunately, one document survives: the "Hokke metsuzaiji engi" (The Origins of the Lotus Nunnery for Eliminating the Karmic Effects of Wrongdoing). Sugiyama Jirō has described it as "a document revealing the private passions of women and the beauty of nuns' beliefs," but it also enables the modern researcher to investigate their social backgrounds and make surmises about their motivations.[6] According to this document, dated 1304 in a colophon,[7] women came from eastern and western Japan to enter Hokkeji; among them were ladies-in-waiting (*nyōbō*) and lesser female attendants (*nyokan*), who had served at the imperial court as well as at the courts

of retired emperors, princes, and empress dowagers (*nyoin*). The author of the text emphasized that some of them were also the wives, consorts, or daughters of nobles. These were members of elite society. Given the nunnery's lack of financial resources, at first it accepted only women with independent means of support, never the poor except for servants.

THE CASE OF SHŌENBŌ JIZEN

The names of sixteen women who decided to abandon their lay lives and revive the Buddhist precepts for nuns at Hokkeji are listed in the "Origins of the Lotus Nunnery," but the early lay life of only one of them is recorded, that for Shōenbō Jizen, who later became its first medieval abbess (*chōrō*). According to the text, Jizen had the rank of a lady-in-waiting at the imperial palace, but she lived in the Shunkamon quarter, where she served Princess Shōshi (1195–1211), also known as Shunkamon'in after her residence. Shōshi's biological father was the retired emperor Gotoba (r. 1184–98; ret. 1198–1221), and her mother, Fujiwara Ninshi (also called Senshūmon'in), was a daughter of a high-ranking aristocrat, Kujō Kanezane (1149–1207). Shortly after her birth, however, Shōshi was sent to be raised as an adopted daughter of Hachijō'in (d. 1211), daughter of the retired emperor Toba (r. 1107–23; ret. 1129–56). Princess Shōshi died at the age of sixteen, following the death of her adoptive mother by only five months in 1211.[8] Thus, although Jizen was not herself of imperial birth, she had served a young woman of impeccable lineage.

Another important piece of information regarding a woman identified by modern scholars as Jizen appears in Fujiwara Teika's (1162–1241) diary, "Meigetsuki" (Memoirs of the Bright Moon).[9] It is possible that Teika may have known Jizen personally because he had an older sister, Takegozen, who had served Shunkamon'in (Shōshi) as a nurse while the latter lived at the mansion of her adoptive mother, Hachijō'in. Doubtless Jizen was known to Takegozen because both had served the same woman.[10] At any rate, an entry for the twenty-third day of the twelfth month in 1211—one and one-half months after Shunkamon'in's death—describes one of the deceased's ladies-in-waiting, called Shunkamon'in-no-kami (Jizen's sobriquet before she took her monastic name), announcing her desire to purify herself through bathing and, borrowing a palanquin, withdrawing from the Hachijō mansion to Kujō. (Kujō was the location of Shunkamon'in's mother's residence and thus not subject to the same restrictions mourning had

placed on the Hachijō mansion.) She was supposed to return two days later, on the twenty-fifth day of the twelfth month (the day before the beginning of winter), avoiding the taboos on traveling at the change of seasons (*setsubun-tagae*). However, that same night she secretly visited the quarters of a monk in Nara who granted permission for her to be ordained. The monk's name was Jirenbō, and because he officiated at her ordination, at which she cut her hair and received the precepts (*jukai*), she took the character *ji* as part of her monastic name, Jizen. It was Teika's older sister, Takegozen, who informed him of this incident. At the time of her ordination, Jizen was twenty-five years old; it appears that she determined to take this step owing to her grief at the death of Shunkamon'in. Teika records his admiration for her efforts to guard her virtue and remain loyal to her mistress.[11] Thus ordained in 1211, Jizen seems to have congregated at Hokkeji with several other nuns by 1243 at the latest. This was several years before Eison arrived to reconstruct the order.

THE SPIRIT OF EMPRESS KŌMYŌ AND KANNON

Jizen's companions included Kyōmyōbō Shakunen (later Hokkeji's third abbess), Hōnyōbō Jinen (later Hokkeji's fourth abbess), and Monkyōbō Kinin. Although all of them were to become Eison's disciples, it is important to recognize their role in renovating Hokkeji before his arrival. When Hokkeji was founded in the eighth century, it had probably been headed by a woman. In the Heian period, however, monks took over the key administrative positions in nunneries, and the nuns lost an important part of their autonomy. The Kamakura-period revival thus harked back to an earlier time. The following events recorded in the "Origins of the Lotus Nunnery" hint at how these developments took place.

In the Lecture Hall at Hokkeji stood an eleven-faced image of Kannon dating from the ninth century that was said to be the figure of Empress Kōmyō, the temple's founder. It was believed that atop this Kannon there had once been a small image of a Buddha (*kebutsu*). It was missing, and Monkyōbō Kinin told the others that she found this odd. On the twelfth day of the sixth month of 1243, Shakunen and Jinen simultaneously dreamed that they saw light issuing from the shrine of the eleven-faced Kannon. The two women told Jizen about it. Afterward, Kinin was lecturing on Kannon in front of the image, and when she looked up at the image's face, she saw a protrusion the color of Buddhist robes, about a quarter of an inch high,

emerging from the top of the head. Thinking that this was extraordinary, she and the others examined it more closely, only to discover that it was an image of the Buddha. Then it changed itself into a white image more than an inch tall. When the nuns reverently tried to touch it, the image disappeared behind the eleven faces. Later, the novice Zuikyōbō Shinmyō fell into a trance and spoke as an oracle for the spirit of Empress Kōmyō. According to the oracle, the image had originally been installed in a box kept closed on the altar, but when the nunnery had fallen into disrepair, the box had been opened in order to benefit all sentient beings. Now that the nunnery was being renovated, the image should be sealed back in the box. From then on, the image was placed in the box and treated as a hidden Buddha (*hibutsu*).

It is clear that these women gathered at Hokkeji before 1245, the year Eison made them his disciples and formally incorporated Hokkeji into the Saidaiji tradition of Ritsu Buddhism. Probably by 1243, when Zuikyōbō Shinmyō served as an oracle for the spirit of Empress Kōmyō, the women had already become disciples of the Tendai monk Tankū (1176–1253), who lived at Nison-in in Saga on the outskirts of present-day Kyoto. They had received the "perfect and immediate Mahāyāna precepts" (*endonkai*) from him and begun the renovation of Hokkeji. According to the "Origins of the Lotus Nunnery," when Tankū visited Hokkeji, Jizen and Jinen asked him to stay long enough to build a gate and fences because they lacked the necessary resources to patch the holes in the temple's four walls or make the door fit properly. They made this request even though Hokkeji had originally been a nunnery and men were not supposed to stay there. Initially, Tankū firmly declined. But later, when he was performing ordinations for the nuns on the raised seat before the altar in the Lecture Hall, as part of this ceremony he bowed down three times. Upon looking up, he saw dewdroplike tears streaming down the eleven faces of Kannon. Although no one else saw them, Tankū choked back his own and built the gate and the fences to restore Hokkeji as a nunnery.

Other women contributed to the revival of this nunnery. A nun (*zenni*) named Kūnyo, who was originally called Takakura no tsubone or Daigo-dono, served as Jizen's teacher. She played a major role in providing Jizen and others with the opportunity to become disciples of Tankū, and Eison thought she had died by the time he began to incorporate Hokkeji as a nunnery into the Saidaiji branch of Ritsu Buddhism. According to Eison's "Hokke shari engi" (Account of the

Relics of the Hokkeji), Kūnyo had been very intelligent even as a child and had become a monastic while still young.[12] She was conversant with both esoteric and exoteric Buddhist teachings, as well as Chinese and Japanese scholarship. In her old age, she resolved to live in accordance with Empress Kōmyō's achievements and sequestered herself in the Angobō, a set of rooms at the Hokkeji complex. Sometime before 1243, Kūnyo went to Tōshōdaiji for a period of confinement, along with her disciples Jizen and Shakunen, to establish karmic ties with the Buddha by performing the recitation of the Buddha's name (*nenbutsu*) for Śākyamuni. There she declared that she wanted to test the authenticity of the Buddha relics that she had received at Tōji, another temple. She placed the relics on a rock and struck them with a metal hammer. They had not broken when she hit them three times, but when she hit them five times they shattered into small pieces with light emanating from each. Kūnyo then repented her doubts about the authenticity of the relics, gathered up the pieces, and fervently worshipped them. This is how Hokkeji acquired these relics, giving it additional standing in the Buddhist world of the time.

A NUNNERY FOR LADIES-IN-WAITING

Kūnyo's background has attracted much recent scholarly attention. According to an entry in Eison's autobiography for 1251, after Kūnyo died she appeared in Jizen's dreams and told Jizen that because no relative was alive who could hold a memorial service for her, she wished to have such a service performed during the offerings to the sixteen holy men (*arhats*). In the space beside this entry, Eison noted that Kūnyo was a princess whose mother was Takamatsu'in (1141–76, Emperor Nijō's wife). Tanaka Takako has clarified much about Kūnyo's birth, demonstrating that she was the daughter of a secret liaison between Takamatsu'in and the monk Chōken of the Angoin.[13] (Takamatsu'in may have died soon after giving birth to Kūnyo in 1176.) Takamatsu'in's older sister by the same mother was Hachijō'in (1137–1211), already mentioned as the adoptive mother of Jizen's mistress. When Takamatsu'in died, Hachijō'in had Kūnyo raised by the famous poet (and Teika's father) Fujiwara no Shunzei (1114–1204). Later, when Kūnyo was older, Hachijō'in had her placed in service as her lady-in-waiting in order to watch over her. These arrangements were made not only because of the responsibility Hachijō'in felt for her niece but because she wished to conceal the scandal in which her younger sister had been involved. Hachijō'in

Takakura, a poetess mentioned in the *Shinchokusen wakashū* (New Imperial Collection of Japanese Poetry), compiled by Teika at the order of the retired emperor Gohorikawa in 1234, was none other than Kūnyo. With Hachijō'in's death, Kūnyo lost her major supporter. She was subsequently ordained and lived near Daigoji, later moving to Hokkeji. The year of her death is not known, but the last recorded date for her as the poetess Takakura is 1237.

The circumstances of Kūnyo's ordination were similar to those of Jizen; moreover, both women served Hachijō'in and Shunkamon'in. According to research conducted by Wakita Haruko, ladies-in-waiting during the Kamakura period could only get ahead if they became favorites of the emperor and then gave birth to children. Yet women who served other women would have little opportunity to attract his attention. During the medieval period, women and their children came to be viewed as a single unit, leading to an increasing tendency to value women solely for their maternal roles.[14] Medieval nunneries such as Hokkeji must be considered against this background of progressively greater restrictions on women's activities. The death of a noblewoman released her ladies-in-waiting, such as Jizen and Kūnyo, from their lives of service, but at the same time it deprived them of a patron. Nunneries, formalized or not, provided a site where such women could live apart from their families, independent of any maternal function they might have performed.

It thus appears that the ladies-in-waiting around Hachijō'in played the major role in reviving the medieval order of nuns at the Hokkeji nunnery. As the "Account of the Relics of the Hokkeji" makes clear, Kūnyo and Jizen knew each other when they were ladies-in-waiting at Hachijō'in's palace before they were ordained. Ties among women who served at court were important factors in bringing other women to Hokkeji as well, as the famous Abutsuni, author of the "Izayoi nikki" (Diary of the Waning Moon), serves to illustrate.[15] She lived temporarily at Hokkeji around 1252; she had also served as a lady-in-waiting to Ankamon'in, granddaughter of Emperor Takakura, where she was known as Ankamon'in no Echizen. Her personal ties with other women at court probably facilitated her entry into Hokkeji.[16]

This is not to say that all nuns who assembled at Hokkeji came from a small network of ladies-in-waiting already familiar with each other. Nothing is mentioned about the preordination lives of other nuns—for example, Kūnyo's disciple Shakunen, who is mentioned in the "Origins of the Lotus Nunnery."

NUNNERIES FOR WIDOWS AND SINGLE WOMEN

What sort of family background did these other women have? According to the "Origins of the Lotus Nunnery," Kakuinbō Nyoen, the second abbess of Hokkeji, was the mother of two scholar-monks from Tōdaiji, Chūdōbō Shōshu (1219–91) and Jissōbō Enshō (1221–77). Nyoen had a daughter, Nyoshinbō Enshō, who was between the two sons in age. This daughter lived at Hokkeji, as did her daughter Nichienbō Sonnyo. Sonnyo later became abbess of the Tōrinji in Higashiyama, Kyoto, another nunnery in the Saidaiji branch of Ritsu Buddhism.[17] The nuns Nyoen and Enshō had both been married and widowed; Sonnyo had become a nun at an early age without marrying. In this way, Hokkeji served as a refuge for a line of widows and single women associated with the monks at Tōdaiji.

Women from outside the imperial court and its immediate environs also became nuns at Hokkeji. The "Origins of the Lotus Nunnery" lists at least one woman associated with the Kamakura bakufu.[18] Ryōshōbō Shingen, who entered Hokkeji to become a nun, was the daughter of Nikaidō Yukifuji (d. 1302), an official (*shitsuji*) in the executive chancellery (*mandokoro*) of the Kamakura bakufu. Women who formerly had been courtesans (*yūgimi*) probably also entered Hokkeji as nuns. This can be surmised because, according to the same source, offerings were made on the death anniversaries of family members of the female leaders of various groups of entertainers. Among those mentioned are the leader of the entertainers at the Kagami Post Station in Ōmi Province; her father and her mother, known as Myōshin; and the entertainers' leader and her daughter, located at the Hashimoto Post Station in Tōtomi. According to legend, the famous dancer-singer (*shirabyōshi*) Shizuka, the favorite concubine of Minamoto no Yoshitsune, became a nun and took the name Saishō upon learning of Yoshitsune's suicide. First she entered Kōdaiji at Saga, another nunnery associated with the Saidaiji branch of Ritsu Buddhism; later she went to Hokkeji, where she died at the age of twenty-four.[19] Such stories would seem to indicate that more than a few entertainers and courtesans became nuns at Hokkeji.

PERSISTENCE OF THE WORLDLY HIERARCHY IN THE NUNNERY

Given the status and rank consciousness of medieval society, it seems probable that women's status before entering the temple affected their positions thereafter. Indeed, to me, it seems plausible that the hierarchy of the secular world would have persisted in the

nunnery. We know, after all, that the abbesses were formerly ladies-in-waiting to members of the imperial family. The tenth book of the *Tale of the Heike* describes Yokobue, a low-ranking maid serving the ladies-in-waiting in Kenreimon'in's household.[20] She becomes intimate with Saitō Takiguchi Tokiyori, a retainer of Taira Shigemori. Takiguchi's father, however, opposes a liaison with a woman of such low status. Yokobue parts with Takiguchi, enters Hokkeji, and dies shortly afterward. We may assume that at Hokkeji a woman like Yokobue would probably have ministered to the needs of the former ladies-in-waiting of the court, the likes of Jizen and Kūnyo. In addition, maids of low status probably followed their mistresses into Hokkeji and continued to serve them as nuns' attendants. Yokobue's situation predates the formal establishment of the nunnery at Hokkeji by about half a century, but it raises the question of hierarchy in the nunnery, a place that is supposedly devoid of secular concerns. It is entirely possible that women of low status such as Yokobue could not become fully ordained nuns.

Primary sources do not address this issue directly. Instead, we must take a roundabout approach, using a variety of situational inferences. We begin by noting the number of novices on whom Eison conferred the precepts—thirteen—versus the number of women he ordained as full-fledged nuns—twelve. The one woman excluded from full ordination was Zuikyōbō Shinmyō, mentioned in the "Origins of the Lotus Nunnery" as having served as an oracle for Empress Kōmyō's spirit. A list, dating from 1280, of women who had received bodhisattva ordinations earlier mentions Shinmyō as a deceased probationary nun, corroborating the evidence found in the "Origins" that she never became a full-fledged nun.[21] She does not appear on the list of nuns who participated in the efforts to revive Hokkeji from the beginning, although she was residing at Hokkeji before Eison began his efforts to reestablish the hierarchy of nuns under the control of Saidaiji. I would argue that Shinmyō probably received less than equal treatment because of her social station. This possibility is reinforced by her oracular function. Hori Ichirō has pointed out that serving as an oracle or being possessed by a spirit (*kami*) or a Buddhist figure was a function fulfilled by shamans of the lower classes.[22] The documents connected with the nuns of Hokkeji employ rank-differentiated terms to describe women's experiences with spirits. Women of the lower classes such as Shinmyō received oracles (*takusen*) and were possessed (*hyōi*) by *kami* and Buddhist deities. However, when

nuns from the higher classes had revelations from the *kami* and Buddhist deities, they had dreams (*yume*) or received the words of sages or divinities (*seigen*). Novice Shinmyō's function as a shamaness (*miko*) and oracle for the words of *kami* and Buddhas can most easily be explained by her having been born into a lower class. In addition, it seems likely that Shinmyō's origins limited her ability to become a full-fledged nun, and thus she died a probationary nun despite her contributions to the order.

Shinmyō nonetheless fervently sought a salvation that could transcend her socially imposed limitations. How could this be done? When Eison and the other monks from Saidaiji taught the nuns of Hokkeji, their message was the same as that disseminated by other monks in the Buddhist establishment. In other words, they taught that women bore heavy karmic burdens that prevented them from attaining five high spiritual goals, including Buddhahood. Women could only be saved by being transformed into men (*henjō nanshi*) after death for their rebirth into the Pure Land. Shinmyō firmly believed in this formula. She wrote a vow on the eighth day of the sixth month of 1247, stating her wish that all women, including her mother and herself, would abandon their female bodies, obtain male bodies, and attain rebirth in the Pure Land. Her wish was included in documents that came to be preserved in a statue of Eison that was dedicated at Saidaiji.[23]

The notion that women had to be reborn as men to enter the Pure Land or realize Buddhahood was widely propagated at this time. The activities of Nichijōbō Sōji, who was Eison's nephew and the abbot of Sairinji in Kawachi Province, illustrate how this was done. On the fifth day of the twelfth month of 1256, at Sōji's recommendation, the nuns at Hokkeji and their female supporters published a text on the transformation of women's bodies, the *Tennyo shinkyō* (Sutra on Transforming the Female Body).[24] Sōji hoped that the publication of this text would serve as a guide to salvation for women with heavy karmic burdens. Indeed, women flocked to help with its publication, using their donations as an opportunity to vow that their female bodies would be transformed into male ones.[25] In this doctrinal construction, women were not barred from salvation, but it was nevertheless premised on the supposition that the male body was superior.

A woman's lifelong desire to change her gender at death could only invite a loss of self-identity and confidence. Some women chose not to follow this path. In a letter to her daughter, Shinran's wife

Eshinni (1182–1268), for example, spoke of waiting to go to the Pure Land with her current body, without referring to the necessity of transformation into a male for rebirth.[26]

CONCLUSION

Nowhere in the history of Japanese women is reading against the grain more important than in issues pertaining to religion. Eison's autobiography gives him full credit for reviving the Hokkeji nunnery in 1245, yet the document's internal evidence and suggestions that can be gleaned piecemeal from other sources show clearly that women were leading religious lives at the temple well before he arrived. In some cases, they had performed a self-ordination, simply cutting their hair; in others, they had received private ordination with a conferral of precepts at the hands of a monk. By reviving the nunnery according to the *Vinaya*, Eison made it possible for them to receive a full formal ordination and the recognition that went with it. This was a move that both brought the women closer to the Buddha and provided the institutional stability that made it possible for Hokkeji to survive the vicissitudes of the succeeding centuries. Women became nuns for a variety of reasons; some freely chose the vocation out of religious devotion, while others had it forced upon them as an aspect of their role as servants or due to the lack of an alternative livelihood. They sought salvation, but even that goal was hedged by status distinctions carried over from the secular world and beliefs prevalent at the time regarding the impediments of womanly flesh. The nuns of Hokkeji were able to find a place in Japanese society where they could live respectably and independently, yet they were never able to entirely free themselves of the constraints placed on them by medieval Japanese society.

NOTES

1. For more details on this subject, see my "Kamakura jidai no ama to amadera," in *Chūsei no Risshū jiin to minshū* (Yoshikawa Kōbunkan, 1987); and *Onna no chūsei* (Editaasukūru Shuppanbu, 1989).
2. Nara Kokuritsu Bunkazai Kenkyūjo, ed., *Saidaiji Eison denki shūsei* (Kyoto: Hōzōkan, 1977), 20.
3. For details regarding religious practices in the Nara and Heian periods, see Paul Groner, "Nara jidai makki oyobi Heian jidai shoki no nisō jukai no henyō," translated by Shōyama Noriko, in *Jendaa no Nihonshi*, edited by Wakita Haruko and S.B. Hanley (Tokyo Daigaku Shuppankai, 1994) 1:3–25.
4. This meant that, although women could and did continue to renounce the world by cutting their hair—whether a snippet or the whole head—they did so without

the benefit of officially sponsored ordination ceremonies or affiliation with a formal hierarchy of religious practitioners based on a convent.

5. See Ushiyama Yoshiyuki, "Chūsei no amadera to ama," in *Shiriizu josei to bukkyō: ama to amadera*, edited by Ōsumi Kazuo and Nishiguchi Junko (Heibonsha, 1989), esp. 233–37. A comprehensive list of medieval nunneries, organized according to provinces, appears on pp. 264–69.

6. Sugiyama Jirō, *Karaa Yamatoji no miryoku: Nara* (Tankōsha, 1972), 21.

7. Ota Hirotarō et al., eds., *Yamato koji taikan* (Iwanami Shoten, 1978), 5:140–43.

8. Princess Shōshi received the title of *junbo* (substitute mother) for Emperor Juntoku (r. 1210–21).

9. The complex proof that this woman was Jizen is discussed in detail in Hosokawa, "Kamakura," 127–33. I have benefited from Ōtsuka Jitsuchū's study, "Hokke metsuzaiji chūkō Shōeibō Jizen," *Nihon bukkyō* 28 (1968): 14.

10. Takegozen's diary, "Tamakiharu," or "Kenshunmon'in chūnagon nikki," was written as a memoir about her days with Shunkamon'in. Before she served Shunkamon'in, Takegozen had been a lady-in-waiting for Kenshunmon'in, a wife of the retired emperor Goshirakawa, until her death in 1176.

11. Imagawa Fumio, *Kundoku Meigetsuki* (Kawade Shobō Shinsha, 1978), 3:98.

12. Ota et al., *Yamato koji taikan*, 5:143–44.

13. Tanaka Takako, "Hokkeji no Hachijō'in Takakura," in *Gehō to aihō no chūsei* (Sunakoya Shobō, 1993), 176–98.

14. Wakita Haruko, "Bosei sonjō shisō to zaigōkan," in *Nihon chūsei joseishi no kenkyū* (Tōkyō Daigaku Shuppankai, 1992), 129–56.

15. Edwin O. Reischauer, trans., "The Izayoi Nikki," in *Translations from Early Japanese Literature*, edited by Edwin O. Reischauer and Joseph K. Yamagiwa (Cambridge: Harvard University Press, 1972), 1–136.

16. Hosokawa Ryōichi, "Abutsuni-den no issetsu," in Hosakawa, *Onna no chūsei*, 163–98.

17. *Tōdaiji Enshō shōnin gyōjō*, vol. 3 of Kosho Hozonkai, ed., *Zoku zoku gunsho ruijū* (Zokugunsho Ruijū Kanseikai, 1970), 477.

18. Ota et al., *Yamato koji taikan*, 5:86–87.

19. This legend is a variation of the one told in *Gikeiki*. See Hosokawa Ryōichi, "Shizuka shōron," *Kyōto Tachibana joshi daigaku kenkyū kiyō* 16 (1989): 59–85.

20. Takagi Ichinosuke et al., eds., *Heike monogatari*, vol. 33 of *Nihon koten bungaku taikei* (Iwanami Shoten, 1960), 2:267–70. Kenreimon'in was the wife of Emperor Takakura, daughter of Taira Kiyomori, and mother of the tragic emperor Antoku (r. 1180–83).

21. "Jūbosatsukai deshi kōmyō," in Nara Kokuritsu Bunkazai Kenkyūjo, ed., *Saidaiji Eison denki shūsei*, 370. The list includes probationary nuns as part of the broader category of novices.

22. Hori Ichirō, "Nihon no shamanizumu," in *Minkan shinkōshi no shomondai* (Miraisha, 1971), 158–63.

23. Nara Kokuritsu Bunkazai Kenkyūjo, ed., *Saidaiji Eison denki shūsei*, 393.

24. Hosokawa Ryōichi, "Sairinji Sōji to ama," in *Sukui to oshie*, vol. 2 of *Shirizu josei to bukkyō*, edited by Ōsumi Kazuo and Nishiguchi Junko (Heibonsha, 1989), 147–53.

25. Ōya Tokujō, "Nara kankyōshi," in *Ōya Tokujō chosaku senshū* (Kokusho Kankōkai, 1987), 8:189–90.

26. Kikumura Norihiko, *Eshinni kara mita Shinran* (Suzuki Shuppan, 1988), 134.

The Medieval Household and Gender Roles within the Imperial Family, Nobility, Merchants, and Commoners

WAKITA Haruko

Translated by Gary P. LEUPP

Coresidential marriage only became the norm in Japan around the early twelfth century (the beginning of the medieval period) when patrilocal marriage became common among nobles and commoners alike. In this marriage system, or *yometorikon*, a man took a wife and brought her into his home. From that time until the present, Japanese married couples have formed families or households in which husbands and wives live together. Given this continuity, it is easy to assume that the medieval household (*ie*) is identical to the contemporary family or household. In reality, however, the contemporary family or household differs appreciably from its premodern predecessor.

One of the special features of the medieval household was that it functioned as a unit of political and economic organization in ways that distinguish it from the modern household. It was the basic managerial unit among merchants, artisans, peasants, entertainers, and other groups, and within it no distinction was made between what we would consider domestic labor (*kanai rōdō*) and social labor (*shakai rōdō*), two categories based on the presumed separation of the domestic and extradomestic spheres. For example, noblewomen of the court, women in the families of imperial princes, and women in the Fujiwara Regent's household performed domestic tasks, such as tending to meals, clothing, and baths, as a form of social labor. This was the case with male courtiers as well, although their specific tasks differed from those handled by women. In examining the male-female division of labor in medieval times, then, it is essential that we first understand the shape and meaning of the medieval household, which differed greatly from its modern counterpart.[1]

While the medieval institution of *ie* included many men and women who were employed as retainers, domestics, and other attendants, it excluded such people as entertainers and prostitutes. It even excluded men and women born into noble families if they served no useful purpose, for example, as transmitters of the descent and property line. Superfluous people were often absorbed into Buddhist institutions as monks or nuns. From the perspective of the *ie* system, then, women could be classified into three groups: those firmly situated inside the *ie* system, priestesses or nuns, and prostitutes. This chapter focuses on medieval urban society and discusses the nature of *ie* and the gendered division of labor among various classes of urban women. For our purposes, "the medieval period" refers to approximately the four hundred years from the twelfth to the fifteenth centuries.[2]

THE SIGNIFICANCE OF THE ESTABLISHMENT OF THE HOUSEHOLD AND ITS MANAGEMENT

Precisely how the medieval household functioned and how the gendered division of labor operated within it must be considered together with issues of status and class. Takamure Itsue (1894–1964) was the first to point out that marriage types in Japan historically evolved from the visiting marriage (*tsumadoikon*, in which the husband visits the wife) to the uxorilocal pattern (*mukotorikon*, in which the husband is adopted into the wife's household), and finally to the patrilocal pattern (*yometorikon*, in which the wife marries into the husband's household).[3] Takamure used her research to illustrate the process whereby women's position had declined since ancient times. Indeed, her sequence of stages is accurate if the social positions of the man and woman happened to be equal. In cases in which they were not, this historical progression breaks down. For example, the visiting marriage and the adopt-the-husband marriage were forms that were invoked only if the woman or her parents occupied a higher position, in terms of both status and property, than the man; few men would become the husbands (*muko*) of women who lacked them.

Research by Takamure and subsequent scholars on the historical evolution of marriage types—from visiting and uxorilocal to patrilocal unions—was rarely linked analytically to research on the establishment of the medieval household as an economic unit or of medieval landlords and serfs from the perspective of class.[4] Scholars have tended simply to equate the establishment of the medieval household with

the establishment of patriarchal authority, and they have viewed a reduction of women's status as a corollary to these two developments.[5] In the ancient and medieval periods, class and income gaps were extreme.[6] Given these disparities, can we conclude that the expansion of patriarchal authority invariably involved a corresponding diminution of the wife's authority?

The medieval household that took in a bride differed from the uxorilocal marriages and from the earlier patterns in which the couple lived apart in one fundamental sense: the central axis of the patrilocal marriage became the husband-wife pair, which served as society's basic unit represented by the patriarch. This contrasted with the earlier marriage pattern, whose central axis was the mother-children relationship. This signaled the establishment of a world in which, as the proverb went, "the relationship between parent and child extends for one generation, the relationship between man and wife for two."[7] In this context, whether or not the woman was the main wife mattered greatly. The household of medieval times and later was dependent upon the husband's resources, and it surely consolidated the husband's patriarchal authority while also stabilizing the position of the main wife (*seisai*). It is true that a man sometimes had concubines, but in contrast to the earlier polygamous pattern there was now only one woman regarded as his wife. Thus, her position was comparatively more stable. After her husband's death, this wife, now a widow (*goke*), acted in his stead as the head of the household.

I argue, then, that the strengthening of the household meant increased authority for both the patriarch *and* the mistress of the household. In premodern society, in which status and class differences existed overtly at every level, the wife in her capacity as household manager held far greater authority than did male or female servants. The difference between men and women was measurable only within— not across—a given status category. In this respect, the premodern period differed appreciably from the modern, in which the practical differences among statuses and classes have diminished considerably.

Up to now, serious studies of the position and role of women in medieval society have focused only upon such issues as childbirth and child rearing, and the nature of the resulting blood ties.[8] I have studied how motherhood was appraised in medieval society, and, while acknowledging the importance of childbirth and child rearing, I have argued that women were not confined to such roles, nor did they necessarily lead lives dependent on men.[9] Instead, I believe that the

role of the principal wife embodied three fundamental characteristics needed for the operation of the household: motherhood, household management, and sexuality. The early-eleventh-century work *Shinsarugōki* (A New Account of the Sarugaku), while fiction, nicely illustrates this.[10] The husband in this work has three wives, who exemplify the principal wifely duties. The first wife bears children, the second holds preeminent authority over the household, and the third serves as the object of sexual passion. Viewed from a clearly male perspective, this story highlights the importance of the wifely role in these three capacities to the survival of the household. The concentration of these capacities in one primary wife indeed characterizes the medieval household based on patrilocal marriage.

I have argued elsewhere that medieval society celebrated motherhood because it perpetuated the household and sexual love because it brought prosperity to the family line.[11] Without de-emphasizing the importance of motherhood and sexual love, I am primarily concerned here with the actual conditions of household management among various strata in the cities and seek to challenge the common scholarly tendency to overemphasize the subordination of female roles under patriarchal authority. *A New Account of the Sarugaku* suggests that the household management duties and responsibilities of middle-ranking samurai women included not only the obvious chores related to cooking, sewing, and the home, but even the purchase and sale of tribute payment goods (*kōnōbutsu*), the purchase of commodities, the handling of weapons, and the rewarding of servants. Even high-ranking samurai women, such as Hōjō Masako, Minamoto no Yoritomo's wife, and Oné, Toyotomi Hideyoshi's wife, took great pains to look after their husbands' retainers. The one lived at the beginning of the medieval period, the other at its end, yet in both cases the rewarding of servants was one of their major responsibilities.

Let us now turn to the nature of women's household management duties.

WOMEN'S AUTHORITY AS MANAGERS IN THE HOUSEHOLDS OF THE EMPEROR, PRINCES, AND ARISTOCRATS

Women held great responsibilities in the medieval imperial household. Throughout the period from 1477 to 1826, ladies-in-waiting at court kept an official journal, the "Oyudono no ue no nikki" (Records of the Chief of the Imperial Housekeeping Office).[12] This document, along with male courtiers' diaries, helps to clarify how these women

managed the court. At the imperial court during the late fifteenth
and sixteenth centuries, the court lady assistant to the major coun-
sellor (*dainagon no suke no tsubone*), the highest-ranking court fe-
male official of the time, handled the private affairs of the emperor's
staff. During these years, an emperor had no official wife with a title
such as "empress" (*kōgō*). The female palace attendants (*kōtō no
naishi*) managed public relations. Their responsibilities included tasks
whose modern equivalents in the imperial household fall to the of-
fices of General Affairs, Accounting, Household Management, Court
Personnel, Ceremonies, Appeals for Promotion in Rank, and Appeals
for Suits. In short, they supervised virtually all the work of the chiefs
of staff in the business offices.[13]

The "ladies' memorials" (*nyōbō hōsho*), which were issued by
the Female Palace Attendants Office in the greatest volume in the
Muromachi period, conveyed the private intentions of the emperor.
This type of document was distinguished from the "imperial orders"
(*rinji*) issued by male secretaries of the Imperial Archives (Kurōdo),
which conveyed the emperor's public statements. However, even the
latter were issued through the mediation of the Female Palace Atten-
dants Office. The authority of female officials, then, was indeed con-
siderable. What caused this emphasis on the female role in the impe-
rial palace? Was it due to the special conditions of the declining im-
perial family? Did it reflect a basic and unchanging characteristic of
the imperial family? I believe that the significant female role in this
realm defined the premodern household in general, not just that of
the emperor.[14]

The meticulous diary *Kanmon nikki* kept by Prince Fushimino-
miya Sadafusa between 1416 and 1448 reveals that a similar process
was at work in his household. The prince was surrounded by female
officials; the highest ranking among them supervised household man-
agement and, most importantly, issued documents expressing the
prince's views.[15] In the household of the Konoe family (the Fujiwara
Regent line), the female secretary for issuing proclamations (*senji no
tsubone*) also produced "ladies' statements" (*nyōbōbun*).[16]

Similarly, in the household of the Ashikaga shogun, women close
to the shogun served as his agents, issuing "ladies' statements" that
conveyed his unofficial wishes.[17] The supervisory authority rested, in
this case, in the hands of the official wife (*midaidokoro*). The power
of the famed Hino Tomiko (1440–96), wife of Ashikaga Yoshimasa,
stemmed from her authority to manage the household. Tomiko performed

all the negotiations with the Military Liaison Office (Buke Densō), the office that handled court-shogunate relations, and acted not only as an intermediary for her husband Yoshimasa, who ruled, but as an agent in her own right. The position of Tomiko in the shogunal household combined all the authority of the court lady assistant with that of the major counsellor and the Female Palace Attendants Office of the imperial household. Because of her position as the shogun's official wife, her authority, and power, were stronger than that held by the female officials in the imperial family.[18]

The medieval imperial household lacked a single "empress," instead collecting harems of court women acting as consorts.[19] Some female officials, mentioned earlier, seemed to have served the emperor sexually as well, although in what ways the managerial and sexual duties overlapped remains to be studied. This situation contrasted with the Fujiwara Regents' and the shoguns' households, which depended on the official wife's authority to manage the house. The reason for the absence of an official wife in the medieval imperial household partly stems from the new tension between, on one hand, the customary requirement for the official wife to establish her own separate household and, on the other, the historically new patrilocal reality that would have involved the wife (empress) in the managerial duties of the household of the husband (emperor) as well. Instead of reconciling the tension directly, the imperial household adopted a kind of polygamy that was a "one husband, multiple concubines" system. Under this system, the male-female relationship was one of master and servant. I believe that this model at the apex of society negatively influenced wife-husband relationships in general. Nonetheless, it goes without saying that the official wife or female officials possessed considerable authority in medieval times, when the "domestic" and "public" sectors casually overlapped and the household performed not only "domestic" tasks but also many public functions.[20]

The official wife of the middle-ranking noble Sanjōnishi Sanetaka brought with her landed properties at the time of her marriage and subsequently managed the household, including its financial affairs, in the late fifteenth century.[21] Wives in small and medium-sized samurai households during the Heian period handled household affairs in the same way as did the aristocratic wives in the *New Account of the Sarugaku* mentioned above. Thus, while the structure of the household differed in scale and in the wife's position, households of the

emperor, shogun, and aristocrats all engaged women—female offi-
cials and a wife—to supervise the responsibilities and functions nec-
essary for proper household management.

THE OCCUPATIONS AND DUTIES OF URBAN WOMEN

Large urban households of merchants and artisans that maintained
servants resembled those of the proprietary-class (ryōshu kaikyū)
samurai and aristocrats. But what of the humbler stratum of urban
commoners? Patrilocal marriage involved a man of means who built
a home to live in and then brought in a bride. Such marriages were
impossible for the tenants who settled in the back alleys of the cities.
Their marriages may be termed "marriages of mutuality" (yoriaikon).

A picture scroll, the Nakifudō riyaku engi (Account of the Ori-
gins of the Benefits of the Weeping Fudō God), produced in the
Muromachi period and kept in the Shōjō Ge-in temple, and the
Rakuchū rakugaizu (Paintings of Kyoto and Its Environs), painted
at the end of the Warring States period, show rows of townhouses
lined up on the main streets. In such paintings, the backyards, which
served as a collective living space, with wells, gardens, and latrines,
attract our attention most. Workers in the scene are women perform-
ing such activities as washing and hanging clothes. The ward com-
munities, which served as ward-level self-government organizations
in the cities, were composed of the male householders living on both
sides of the main streets.[22] It is not clear whether there was also a
women's community centering on these rear gardens.[23] In any case,
the rear gardens depicted in the sixteenth-century paintings of Kyoto
and its environs are imaginary and somewhat misleading for that
time. In fact, urban rents in the central areas of Kamigyō and
Shimogyō, which were four or five times those in nearby villages,
caused what might have been the women's living space to be quickly
obliterated through the construction of new houses for rent.[24] Thus,
while the wealthy had living spaces that included back gardens with
private wells and toilets, most city dwellers used collective wells and
toilets built along the roadsides.[25] Ward houses with frontage of one
or two jo (about three to six meters), measuring five or six tsubo
(about seventeen to twenty square meters) were ordinarily packed
tightly together. It would have been impossible for members of two
generations, or families of wives and mistresses, to share such cramped
quarters. We can assume, then, that urban homes usually housed
nuclear families.

Archaeological excavations, along with literary and artistic evidence, indicate that iron cauldrons, pots, jars, and jugs were the most important household goods and tools used in these townhouses.[26] The excavations found no built-in stoves in the dwellings of Kyoto and the Kinai region, only three-legged earthen cauldrons dating from the twelfth and thirteenth centuries. In the fifteenth and sixteenth centuries, braziers produced in Nara came into use throughout Kyoto; these were suitable for heating the home and barbecuing simple food. In any case, cooking facilities and tools were rudimentary, and in the cities, where fuel was expensive, cooking was not an important part of life. Using three-legged cauldrons and small jugs, people probably prepared such dishes as boiled hodgepodge, taking their daily meals from ceramic or unlacquered wooden bowls. With work of their own to do, women had limited time to devote to preparing food and caring for clothing.

In this context, female peddlers (*hisagime*) became important. They are mentioned in the late-Heian *Konjaku monogatarishū* (Tales of Times Now Past) and became a widespread phenomenon during medieval times.[27] Occupational specialization in all aspects of urban life was built upon these peddlers' commercial activities. Of course, there were also many male peddlers; the *Shokunin uta-awase e* (The Poetry Contest Depicting Merchants and Artisans) depicts both male and female merchants and artisans.[28] These visual sources may not accurately depict the contemporary division of labor, but they largely correspond to the representation found in documentary sources, thus providing us with some basis for an inquiry into male and female roles.[29]

The goods most in demand among commoners were foodstuffs, including, surprisingly, many prepared and semiprepared foods. Given the inadequacy of cooking utensils and the inconvenience of purchasing firewood and fuel from women peddlers who came from the agricultural village of Ōhara on the outskirts of Kyoto (*oharame*), it seems that commoners consumed a lot of coarse or purchased food. Noodles such as *sōmen* or *udon*, for example, whose production required small-eyed stone mortars for grinding the flour, were a form of semiprepared food that was becoming popular. Often these were produced at nunneries and monasteries.[30] In Kyoto and elsewhere, bean paste (miso) shops appeared, along with saké breweries, on such a scale as to fall subject to bakufu taxation. Miso was another prepared food that, along with saké, was homemade in the villages from purchased malt. But in the cities people purchased the finished products. Aside from these

foodstuffs, peddlers also sold goods such as sulfur (which aided fire lighting), brooms, sandals, and clogs. These were easy to produce and thus became widely circulated commodities.

As for the household division of labor, Noh and *kyōgen* plays satirize some men as idlers who make their wives repair even "the leaks in the roof." It was a fixed rule that the man took care of the dwelling, while the woman handled food and clothing matters.[31] The play *Hōshi ga haha* (The Kid's Mother) represents the peasant household as largely self-sufficient by depicting women's work that includes farming and grass cutting, weaving and sewing. In contrast, the urban lifestyle involved a greater specialization of labor. Women not only wove textiles for household use but also marketed their woven cloth. Thus, a "bad wife" in one *kyōgen* play is insulted for "failing to sell even a foot of cloth at the market."[32] The time spent by the farm women in both farming and household work was spent by the city women in commercial and handicraft activities.

Drawings illustrating various artisans in a poetry contest (*shokunin uta awase*) show most textile workers to be women. In Kyoto, silk textile workshops flourished even before the Nishijin operations were founded in the late fifteenth century, and Kyoto textiles were a major commodity in both foreign and domestic trade. Workshops bought domestic or raw thread from China, produced high-quality silk textiles, and sold them to foreign countries such as Korea and the Ryukyu Islands as well as on the domestic market.[33] The depiction of women in the majority of tasks in textile production—from producing silk thread, peddling cotton or white cloth, and dyeing blue cloth, to embroidering, dyeing, and selling kimono sashes (obi)—suggest the extent to which they were engaged in these activities. Paintings of Kyoto and its environs also depict female fan makers and sellers. Fans were an important Kyoto product for foreign trade and domestic consumption.

The production and selling of textiles and fans relied heavily on female labor. It is no wonder that certain women held positions in the otherwise male-dominant monopolistic trade associations of the time, the *za*, or guilds. The guild headed by Kameyagoijo, or "Turtle Shop Fifth Rank Woman," had rights to sell obi throughout Kyoto, while Hoteiya Genryōni, or "Cloth Bag Shop God of Luck Nun," acquired half of the monopoly rights to sell fans in Kyoto.[34] All in all, however, there are few female names on trade association lists. This is because the feudal lords of the medieval period came to use the household

unit, represented by the householder, as the basis for control. Though women managed some productive operations, the male householder was held responsible for all such enterprises. Pottery, saké, textiles, and other goods produced by women were registered under a male householder's name. Kameyagoijo and Hoteiya Genryōni are listed despite their sex probably because one had rank and the other was a widow representing her household in her husband's stead. In any case, it is important to investigate the actual conditions of female labor concealed within the household rather than to assume that operations attributed to male householders were in fact carried out by men.

Beginning in the late Kamakura period, many small-scale operations were controlled by wholesalers (*tonya*).[35] The majority of cotton peddlers associated with the Gion shrine were women who sold cotton received from a wholesaler. Some wholesalers were also women. One of the four wholesalers dealing in "dye ash" (*kōnohai*), with a monopoly on its sale, was a woman called Kagajo, who later passed on her rights to another woman.[36] The "dye ash" transported to Kyoto from Tanba was used as a catalyst in indigo dyeing; there was great demand for it among Kyoto's flourishing textile enterprises. The above-mentioned Kameyagoijo was also a wholesaler who managed many women obi dealers.

In the fourteenth through sixteenth centuries, merchants and small handicraft producers represented by male householders were controlled in some fashion by wholesalers. In the domestic handicraft ("putting out") system controlled by these wholesalers, husbands and wives often worked side by side. In this case, the distinction between the wholesaler and the worker was more important than was the division of labor between the man and wife. However, wholesale operations managed by women, such as the Kameyagoijo and Kagajo organizations, passed into the hands of male wholesalers during the sixteenth century. Chartered by the feudal authorities, such men acquired monopoly rights extending across large domains. Commercial operations run by women disappeared, and it became difficult for small-scale wholesalers, men or women, to survive.

FEMALE ENTERTAINERS: *MIKO* (SHRINE MAIDENS AND FEMALE SHAMANS),
SHIRABYŌSHI (FEMALE DANCER-SINGERS), AND
KANJIN BIKUNI (ALMS-SOLICITING NUNS)

Even after the patrilocal household had become widely established, certain groups of prostitutes and entertainers—such as female dancers

and singers (*kugutsu, shirabyōshi,* and *asobime*)—formed matrilineal groups centered around female household heads. These were families, not necessarily related by blood, brought together as members in a collective by a leader known as the "eldest in the establishment" (*shuku no chōja*). In the early medieval period, the leader was usually a person with the highest seniority in the association.[37] One group of expert poetesses whose popular poetic style (*imayō*) appeared in the *Ryōjin hishō kudenshū* (Songs to Make the Dust Dance on the Beams; ca. 1169) were singer-dancers (*kugutsu*) from Aohaka in Mino Province. They were bound by mother-daughter or foster daughter relations.[38]

The foster daughter relationships involved many instances of the sale and purchase of girls. In a contract dated 1256, a certain Tokuishijo pledged a lump sum of fourteen *kanmon* for the entertainer girl Tamaō, who was to serve her for a five-year period.[39] The sale of a girl called Terutehime for thirteen *kanmon* as an *asobime* in the didactic religious work *Oguri hangan* (Magistrate Oguri) is another, though fictional, example. Thus, the going price for such women seems to have been thirteen to fourteen *kanmon*.[40] The practice of adopting daughters, found among the shamanesses[41] and prostitutes (*yūjo*)[42] of the early modern period and among the geishas of the modern period, can already be seen at this time.

Singer-dancers were known by different names in different eras. In the late Heian period, the dancer-singers called *shirabyōshi* replaced the earlier types known as *kugutsu* and *asobime*. In the late Kamakura and early Muromachi periods, women called *kusemai* chanted legends and sang at temples and shrines. It is well known that Kan'ami (1333–84), a famous dramatist with shogunal patronage, perfected his Noh plays (*sarugaku noh*) after studying under a *kusemai* named Otozuru, who in turn carried on the tradition of another famous female chanter, Hyakuman.[43] The originator of the kabuki dance, Okuni from Izumo, was known as an *aruki miko* or "wandering shamaness."

Various types of entertainers of both sexes were historically associated with districts that suffered from social discrimination. The four Yamato guilds of *sarugaku noh*, for example, were located in such a district (*sanjo shōmonji*) but were able to escape it after winning shogunal protection. During the fourteenth century, discrimination increased against various artists, including female chanters of legends (*kusemaijo*), blind female drummer-reciters (*goze*), jugglers,

puppeteers, yin-yang diviners, and shamanesses, who lived in towns and villages famed for their artist-entertainers.[44]

The art forms associated with these entertainers have lived on. Scripts for Noh theater often present artists from performing villages as the stories' protagonists and thus help to promote their art. Okuni, the kabuki dancer-shamaness, and other women such as wandering female dancers hailed from performing villages. One must note that Japan's traditional arts, including Noh, *kyōgen*, kabuki, and the puppet drama, were all born in these villages.

The various entertainers were commercial performers, but their talents had a strongly religious cast. It was very common to have shamanesses dance sacred dances (*kagura*) as prayers to the gods. Female dancers and chanter-reciters were called upon to perform offertory dances or recite prayers for recovery from sickness, safe childbirth, or reunion with a child.[45] The various Noh forms, such as the monkey dance (*sarugaku*) and rice paddy dance (*dengaku*), also possessed a religious character. As the theater's commercial aspects became more prominent, and as the status of a newer Noh form called *nōgaku* rose, the religious quality was deemphasized and discriminatory attitudes toward the performing villages hardened. The proverb "Perform to save your life—but live a life of unhappiness" illustrates the low status of these performers, both men and women.

Prostitutes, like the Otomae of the Fifth Avenue, lived at the center of Kyoto during the Heian period. In the fourteenth through fifteenth centuries, however, the newly organized urban communities gradually expelled them. They were forced to regroup on the peripheries of urban districts (*machi*), such as in Nijō Yanagimachi (Second Avenue Willow District) and Rokujō Misujimachi (Sixth Avenue Third Street), both inside the Shimogyō ward and marked by walls. These were "brothel districts" in the making, and the pattern of their transfer can serve to indicate the growth pattern of associated urban communities.

This trend toward the articulation of prostitution as a categorizable occupation was accompanied by a process that split the ideal womanhood of medieval times—mother, household manager, and sexual partner—into two distinct components: the woman as mother and household manager who personified "beautiful customs" (*junpū bizoku*) and maintained the household, and the prostitute who, while violating moral norms, gave pleasure. Later, the early-modern love-suicide plays of Chikamatsu Monzaemon graphically portrayed this

bifurcation. In either role, as the woman's individuality came to serve the male, women came to view one another antagonistically and treat one another with hostility.

We turn finally to the medieval "Kumano nuns" (*Kumano bikuni*), who by the early modern period would resemble prostitutes. Barbara Ruch has written about their role in transmitting proselytizing texts, so here I will only describe their functions as "fund-raising priestesses" (*kanjin hijiri*).[46] Starting in the late fifteenth century, generations of nuns supported various forms of public works such as the rebuilding of bridges and shrines. It was the Kumano nuns who solicited votive offerings for the rebuilding of the Ise shrine's inner and outer shrines in 1585. This was the first reconstruction of the Ise shrines in 129 years because the court and the shogunate—the earlier sponsors of this national event—had lost the necessary economic clout by the sixteenth century. As a result of these services, a Kumano nun became the head priestess of the Keikōin temple and received the title "Ise saint" (*shōnin*) from the emperor.

Groups of Kumano nuns solicited small offerings from commoners, but they also received much assistance from regional daimyos and the three unifying warlords—Oda Nobunaga, Toyotomi Hideyoshi, and Tokugawa Ieyasu. Shūyō, the fourth-generation saint, also performed exorcisms for Tokugawa Senhime, who was worried about the vengeful ghost of her late husband Toyotomi Hideyori. She received a hundred *koku* of rice as special grant from the Edo shogunate and acquired aristocratic status by becoming the heir of the noble Senhime.[47]

In the first and second generations, Kumano nuns lived in Kumano and commuted to Ise. The third generation emerged from Iruka village, but the location of their private temple-hermitage, affiliated with Keikō-in of Ise, was Uji-Uradasaka, on the border of Uji-Yamada, the home of many famous performing troupes. Thus, Kumano nuns included such groups as the Ise saints, who raised funds for temples patronized by the nobility, and others who hailed from performing villages and doubled as prostitutes. In the early modern period, as religion generally declined and central control over it increased, the Kumano nuns eventually disappeared.

Conclusion

In this essay, I have described the establishment of the medieval household, which centered around the husband-wife pair; the duties of the

wife within this household; and the lives of people—such as prostitutes and entertainers—whom the household system excluded. In the medieval household, the patriarch was of course the most important figure, but, while he was mostly active outside the household itself, the wife was in charge of its management and was responsible for bearing and raising its successors. Women managed merchant, artisanal, and entertainer households. Harmonious relations between husband and wife, sexual love, and the birth of children all served the purpose of continuing the family line; the husband led and the wife served, but the wife also exercised some leadership.

Aside from the formal religious principles reflecting aspirations commonly held by women, the idea that "the gods protect the mutual vows of husband and wife, male and female" became popular, and deities assumed the form of family-protecting gods.[48] Within the medieval household, the fundamental social unit, wives were expected to serve as mothers, household managers, and sexual partners. In medieval Japan, the family was based on husband and wife. While the wife was subordinate to the husband, males were also subordinate to their masters, who might be either male or female.

With the expansion of society, bureaucratic administration, capitalistic social structures, and masculine structures such as the military overwhelmed the household, gradually reducing its functions. The power of the patriarch was proportionately expanded. In this diminished household, the wife came to be bound by maternal and housekeeping responsibilities based on consumption rather than production. Just as the wife sustained the household, women of the brothel quarters, segregated in distinct districts, became the objects of sexual love. The dichotomy of chaste wives and brothel sweethearts, so evident in Chikamatsu's plays, was to become a striking feature of the early modern period.

NOTES

1. This chapter is based on a number of my published works. See, especially, "Chūsei josei no yakuwari buntan," *Rekishigaku kenkyū* 542 (June 1985): 16–30; and *Nihon chūsei joseishi no kenkyū: seibetsu yakuwari buntan to bosei, kasei, seiai* (Tōkyō Daigaku Shuppankai, 1992).
2. Space limitations prevent me from discussing nunnery life here. On this important topic, see my "Chūsei kōki, machi ni okeru 'Onna no isshō,'" in *Chūsei*, vol. 2 of *Nihon josei seikatsushi*, edited by Joseishi Sōgō Kenkyūkai (Tōkyō Daigaku Shuppankai, 1990), 147–86.
3. Takamure Itsue, *Shōseikon no kenkyū* (Rironsha, 1966).

4. One among many studies is Nagahara Keiji's *Nihon hōkensei seiritsu katei no kenkyū* (Iwanami Shoten, 1961).

5. The period of the establishment of the patriarchal system differs among classes and groups. See Wakita Haruko, "Kodai chūsei Nihon joseishi oboegaki," *Rekishi hyōron* 335 (1978): 54–64; "Rekishigaku to josei," *Rekishigaku kenkyū* 517 (1983): 17–68; and "Marriage and Property in Premodern Japan from the Perspective of Women's History," *Journal of Japanese Studies* 10.1 (1984): 73–99.

6. Inoue Kiyoshi, in *Nihon joseishi* (San'ichi Shobō, 1948), was the only scholar to focus on the women at the bottom of the social scale. He related the improvement in their position to the transition from slavery to serfdom.

7. Wakita Haruko, "Chūsei ni okeru 'ie' no seiritsu to josei no ichi," in Wakita, *Nihon chūsei joseishi no kenkyū*, 1–43; and "Women and the Creation of the *Ie* in Japan: An Overview from the Medieval Period to the Present," *Nichibei josei jaanaru* 4 (April 1993): 83–105.

8. Suzuki Kunihiro, "Kamakura jidai ryōshusei no kōzō to ichizoku ketsugō," *Nihon rekishi* 264 (1970): 20–36.

9. Wakita Haruko, "Bosei sonchō shisō to zaigōkan: chūsei no bungei o chūshin ni," in *Bosei o tou: rekishiteki hensen*, edited by Wakita Haruko (Kyoto: Jinbun Shoin, 1985), 1:172–203. Also see Wakita Haruko, "The Significance of Motherhood: A Historical Survey from the Eleventh to Sixteenth Centuries," paper presented at the International Congress of Historians, Madrid, 1990.

10. This was written by Fujiwara Akihira. See Ōsone Shōsuke, ed., "Shin sarugōki," in *Kodai seiji shakai shisō*, edited by Yamagishi Tokuhei et al., vol. 8 of *Nihon shisō taikei* (Iwanami Shoten, 1970), 133–52.

11. Wakita, "Chūsei ni okeru 'ie,'" 31–35.

12. Hanawa Hokiichi, ed., *Zoku Gunsho ruijū, bui 3* (Zoku Gunsho Ruijū Kanseikai, 1930).

13. Wakita, "Chūsei josei no yakuwari buntan," 15–16.

14. One might also consider the influence of Tang China and discuss this problem in a global perspective. See Wakita, "Kyūtei nyōbō to tennō: 'Oyudono no ue no nikki' o megutte," in Wakita, *Nihon chūsei joseishi no kenkyū*, 231–32.

15. *Kanmon nikki*, Ōei 32 (1425).7.25, in *Zoku Gunsho ruijū, bui 2* (Zoku Gunsho Ruijū Kanseikai, 1930); Wakita Haruko, "Chūsei kōki, machi ni okeru 'Onna no isshō,'" in Wakita, *Nihon chūsei joseishi no kenkyū*, 201–3.

16. Entries for Tenbun 14 (1545).2.7 and 2.10, in Takahashi Ryūzō et al., eds., *Tokitsugu kyōki* (Zoku Gunsho Ruijū Kanseikai, 1972); see also Wakita, *Nihon chūsei joseishi no kenkyū*, 201–3.

17. No. 1–296, Bunmei 18 (1486).6.26, "Ashikaga Yoshimasa Gechi Horikawa no Tsubone seibun," in Kokugakuin Daigaku Kogake Monjo Hensan Iinkai, comp., *Kogake monjo* (Zoku Gunsho Ruijū Kanseikai, 1982).

18. Wakita Haruko, "Hino Tomiko no jinbutsu zō," in *Rekishi e no shōtai*, edited by Nihon Hōsō Shuppankai (Nihon Hōsō Shuppankai, 1984), 31:58–60.

19. *Kōgō* was the title established for the empress when Japan adopted the Chinese bureaucratic system in the seventh and eighth centuries. From the tenth century on, an emperor often had two "primary" wives, who held the titles of *kōgō* and *chūgū*. They were both "empresses" and held equal privilege and status. After the time of Emperor Godaigo (r. 1318–39), however, neither title was used. During the reign of Emperor Gomizuno'o (r. 1611–29) under the newly established Tokugawa system, *chūgū* was the title used for the "empress." In 1868, the Meiji emperor's wife was designated *chūgū* initially, but in the following year she received the designation *kōgō*. This is the current title for the reigning emperor's wife.

20. Not only the emperor's primary wife but even ladies-in-waiting above the third rank established household business offices (*ie no mandokoro*) and became the heads of households. The emperor's wife was the head of her own palace household, and imperial marriages were arrangements involving the heads of both the emperor's and the empress's households.

21. Entry for Bunmei 16 (1484).3.3, in Takahashi Ryūzō, ed., *Sanetaka kōki* (Zoku Gunsho Ruijū Kanseikai, 1962–67); see also Wakita, *Nihon chūsei joseishi no kenkyū*, 204–6.

22. Wakita Haruko, *Nihon chūsei toshiron* (Tokyo Daigaku Shuppankai, 1981), 249–301; Wakita Haruko with Susan B. Hanley, "Dimensions of Development: Cities in Fifteenth- and Sixteenth-Century Japan," in *Japan before Tokugawa: Political Consolidation and Economic Growth, 1500–1650*, edited by John Whitney Hall, Nagahara Keiji, and Kozo Yamamura (Princeton: Princeton University Press, 1981), 295–326.

23. In Ōyamazaki, a medieval city with no trading restrictions (*rakuichi*), there was a *miko-za* whose members were drawn from the daughters of specified households. See "Doroshi shussen no nikki" and "Yorozu kiroku," in Shimamoto-chō Shi Hensan Iinkai, comp., *Shimamoto-chō shi: shiryōhen* (Shimamoto-chō Shi, 1976), 451–61; and Wakita, *Nihon chūsei joseishi no kenkyū*, 223.

24. Information on rents is unavailable for the outlying wards. See Wakita, *Nihon chūsei toshiron*, 139–45.

25. Wakita, "Chūsei kōki, machi ni okeru 'Onna no isshō,'" 214.

26. Chūkinsei Doki Kenkyūkai, ed., *Chūkinsei doki no kiso kenkyū*, 4 vols. (Chūkinsei Doki Kenkyūkai, 1987–89).

27. Yamada Yoshio, ed., *Konjaku monogatarishū*, vol. 26 of *Nihon koten bungaku taikei* (Iwanami Shoten, 1963), 5:299–301.

28. "Shichijūichi ban uta-awase," in Hanawa Hokiichi, ed., *Gunsho Ruijū* (Zoku Gunsho Ruijū Kanseikai, 1933), 28:503.

29. Wakita, "Chūsei josei no yakuwari buntan."

30. Nunneries produced and sold dried melons and dried rice and served as nursing homes for the aged. See Wakita, "Chūsei kōki, machi ni okeru 'Onna no isshō,'" 212–13.

31. See the play *Ishigami* (The stone god), in Koyama Hiroshi, ed., *Kyōgenshū*, vol. 43 of *Nihon koten bungaku taikei* (Iwanami Shoten, 1961), 2:37–43.

32. "Kyōgen kayō," in Shima Shin'ichi, ed., *Chūsei kinsei kayōshū*, vol. 44 of *Nihon koten bungaku taikei* (Iwanami Shoten, 1957–67), 203–39, esp. 231, 236.

33. Wakita Haruko, *Muromachi jidai* (Chūō Kōronsha, 1985), 53–72; Wakita Haruko, *Sengoku daimyō* (Shōgakakkan, 1988), 269–74.

34. Wakita Haruko, *Nihon chūsei shōgyō hattenshi no kenkyū* (Ochanomizu Shobō, 1969), 385–94; "Towards a Wider Perspective on Medieval Commerce," *Journal of Japanese Studies* 1.2 (spring 1975): 321–34; "Chūsei josei no yakuwari buntan," 115.

35. Wakita, *Nihon chūsei shōgyō*, 269–74.

36. Wakita, "Chūsei josei no yakuwari buntan," 113.

37. Wakita Haruko, "Seibetsu yakuwari buntan to joseikan," in Wakita, *Nihon chūsei joseishi no kenkyū*, 121.

38. Fujiwara Kinto, comp., *Wakan rōeishū, Ryōjin hishō*, vol. 72 of *Nihon koten bungaku taikei* (Iwanami Shoten, 1965), 440–70. In English, see Yung-Hee Kim, *Songs to Make the Dust Dance: The Ryōjin Hishō of Twelfth-Century Japan* (Berkeley: University of California Press, 1994).

39. Takeuchi Rizō, ed., *Kamakura ibun*, vol. 11 (Tōkyōdō Shuppan, 1975), doc. 7,992.

40. Araki Shigeru and Yamamoto Kichizō, eds., *Sekkyō bushi* (Heibonsha, 1973), 149–271.

41. Nagaoka Katsue, "'Nonō' miko no kenkyū," *Shinano* 10–12 (1958): 13–23.

42. *Gion machi monjo* (a collection of Gion manuscripts), original documents at Kyoto University Faculty of Letters, Kokushi Kenkyūshitsu.

43. Tanaka Yutaka, "Zeshi rokujū igo sarugaku dangi," in *Shinchō Nihon koten shūsei: Zeami geijutsu ronshū* (Shinchōsha, 1976), 198, 202.

44. Wakita Haruko, "Chūsei hisabetsumin no seikatsu to shakai," in *Buraku no rekishi to kaihō undō: zenkindaihen*, edited by Buraku Mondai Kenkyūjo (Kyoto: Buraku Mondai Kenkyūjo Shuppanbu, 1985), 67–182; "Sanjoron," in *Burakushi no kenkyū: zenkindaihen*, edited by Buraku Mondai Kenkyūjo (Kyoto: Buraku Mondai Kenkyūjo, 1978), 51–88.

45. Wakita, "Chūsei kōki, machi ni okeru 'Onna no isshō,'" 222–29.

46. Barbara Ruch, "Chūsei no yūgyō geinōsha to kokumin bungaku no keisei," in *Muromachi jidai: sono shakai to bunka*, edited by John Whitney Hall and Toyoda Takeshi (Yoshikawa Kōbunkan, 1976), 325–54. The same article in English is "Medieval Jongleurs and the Making of a National Literature," in *Japan in the Muromachi Age*, edited by John Whitney Hall and Toyoda Takeshi (Berkeley: University of California Press, 1977), 279–310. See also Barbara Ruch, *Mō hitotsu no chūseizō: bikuni, otogi sōshi, raisei* (Shibunkaku Shuppan, 1991), 143–84.

47. *Keikōin monjo*, manuscript copy at the Historiographical Institute of the University of Tokyo; Wakita, "Chūsei josei no yakuwari buntan," 182–84.

48. Wakita, *Nihon chūsei joseishi no kenkyū*, 67.

Women's Work and Status in the Changing Medieval Economy

TABATA Yasuko

Translated by Hitomi TONOMURA

Medieval documents say little about women at work, and documentation on female commoners is even more scarce than that on aristocratic women who worked in palaces. Despite these difficulties, this paper seeks to explore the position and activities of female commoners and property holders in medieval Japan (ca. the twelfth through sixteenth centuries). Because medieval society imposed no legal classification for status, the "commoner" is necessarily a historian's referent for people of certain characteristics defined by occupation and residential location. Merchants, artisans, and beggars were urban commoners who lived in towns (*machi*), post towns (*shukuba*), and market towns (*ichi*). Itinerant entertainers and artists, who had no stable domiciles, made up another group of commoners. The rural population of agriculturists, or peasants, many of whom were also part-time merchants, formed the largest group of commoners. Rural residents were differentiated in documents by their descriptive "titles"—upper peasants (*myōshu*), peasants (*hyakushō*), and servants (*genin*). These constituted the village's stable population. In contrast, seasonal laborers (*mōdo* or *mōto*), who were nonetheless a constituent element of the village, belonged incompletely, so to speak, to the village's formal social and religious organization. Local officials of the estate (*shōen*) also lived in the village. They were not commoners but belonged to the ruling class. Among them were samurai with their own property. I will discuss women in this group as well in the section on female rural residents.

I begin with a brief survey of the economic changes that occurred during this period and their effects on different segments of the Japanese population. While this essay is primarily a descriptive introduction to the work and status of medieval women, I wish to argue that

women's positions were inextricably linked to rapidly changing economic conditions. The effects of these changes varied, however, depending on a woman's position in society and whether she lived in town or country. Women did not equally share in or benefit from opportunities to expand their economic activities.

In order to survey the varied experiences of women, I first explore their activities in towns, where the growth of markets and an expanding monetary economy provided them with an increasingly wider variety of work. I then examine the case of village women, who bore increasingly severe legal restrictions on their activities outside the family, a phenomenon that can be seen with particular clarity in the case of rural women with proprietary status.

Transformations in the Medieval Economy

Rapidly changing economic and political conditions in medieval Japan greatly influenced the breadth and character of commoners' activities. Throughout this period, aristocrats, religious institutions, and warriors extracted taxes and labor, both of which were fixed, from the majority of commoners, who were on the land.[1] This hierarchical structure of extraction remained the defining element in the overall social and economic structure. But within this stable framework changes of far-reaching significance were taking place. Stimulated by the greater use of fertilizers and improved tools and seed varieties, agricultural productivity increased, yielding a surplus beyond what was demanded as fixed tax payments; this, in turn, promoted circulation of cash crops at markets, which also multiplied. This trend began in the twelfth and thirteenth centuries and became marked in the fourteenth through sixteenth centuries. Expanded circulation of cash facilitated the conversion of annual taxes and labor dues to fixed cash amounts. As output kept growing, such fixed amounts meant lower payment rates for taxpayers.

Markets were few and far between in the twelfth and thirteenth centuries. Only Kyoto and Kamakura (the imperial and warrior capitals) and towns with provincial headquarters (*kokufu*) held markets regularly. Agricultural, fishing, or mountain villages had no regular markets. In the fourteenth century, however, markets developed on the premises of estates, at harbors, and at temples. At markets, goods were sold for cash. In the late fourteenth century, markets developed into regional cities; in the subsequent century, the protective policies

of the daimyos (samurai lords) further promoted the growth of castle towns and post towns in order to monopolize this cash nexus. Better transportation routes—for example, the Tōkaidō, which connected Kyoto and Kamakura, and the Inland Sea route—promoted efficient movement of goods and people. The nodes of transportation—cities, towns, and markets—attracted people of all sorts in large numbers. These economic changes brought about tremendous growth in that portion of the female work force that participated in commodity circulation.

Major advances in the economy forced transformations not only in the lives of commoners but in the internal composition of the ruling class. Among elite institutions, it was the warrior houses that gained the most power. The other elite institutions—the imperial family, aristocrats, temples, and shrines—began to lose power and authority, a trend that gradually intensified and then was exacerbated during the Warring States period (mid-fifteenth century to ca. 1600). There was a change in the balance of power within the warrior class as well, tipping increasingly away from the center toward the provinces, favoring the provincial notables who were actually on the land at the expense of central bureaucrats. In particular, local warrior agents who lived on the estate, along with urban dealers in cash loans, were in a position to appropriate local surplus from the peasants, calling it their "added share" (*kajishi tokubun*), a form of extra income. They commodified the added share through sale and purchase. The amount of added share generally exceeded the amount of annual taxes. Annual taxes were also paid in cash in the fifteenth century and helped to promote greater circulation of cash.[2]

WOMEN IN TOWNS

Documents tell us little about medieval commoners. Pictorial sources provide more information about the activities of people outside the ruling class. Drawings, accompanying poems, and "personal comments" in the *Shokunin uta awase* (The Poetry Contest Depicting Merchants and Artisans), suggest the kinds of work in which female and male commoners were engaged. Poems in the *Poetry Contest* were composed by a number of aristocrats in the voice of merchants, supposedly reflecting the merchants' personal circumstances and sentiments. The poems were attached to sample caricatures of commoners engaged in particular trades. The different types of trades serve as

the organizing structure for the contest. In addition, a short "personal comment," written by the contest judge but in the voice of a merchant or artisan, is attached to each drawing. In my analysis, I focus on the drawings and personal comments. I believe that these are appropriate sources for observing medieval women at work; unlike most picture scrolls, which situate commoners in the background, *Poetry Contest* makes them its main subject.

From the Kamakura and Muromachi periods, four different sets of *Poetry Contest* books have survived. I will rely mostly on the *Shichijūichi ban shokunin uta awase* (Poetry Contest on Seventy-One Pairs of Merchants and Artisans), believed to have been compiled around 1500 by several aristocrats. This collection features a total of 142 professions and twice as many poems, written by poets who were divided into two competing camps. The word *shichijūichi* (seventy-one) in the title describes the way the 142 trades are paired into seventy-one sets: for example, a saké brewer and a cooking pot seller, or a rice seller and a bean seller. An earlier *Poetry Contest* (*Tōhokuin uta awase*), compiled in 1214, depicted 24 professions. The difference in the number of professions in the two sets suggests that women and men were engaged in an increasingly wider variety of work, doubtless reflecting a trend that accompanied the general expansion of the economy.[3]

In a *Poetry Contest* from 1500, female and male merchants are identified by their commodities. Women, close to forty in number, are engaged in selling a wide range of items, many of which are things to eat, things to wear, and daily necessities such as paper products and cosmetics. Food sold by women includes the basics—fish, beans, rice, and malt—as well as food that requires more processing, like bean curd (tofu), gelidium jelly (*tokoroten*), and pounded sweet rice (*mochi*). Saké, which is made from rice, is also sold by a woman. Other items include obi, floss, white cloth, folding paper cases (*tatōgami*), lamp wicks, ceramics, powdered rouge (*beniko*), and charred firewood (*kuroki*).[4]

Figure 1 depicts a female wearing a piece of cloth on her head and selling squares of tofu. The "personal comment" uttered by the woman reveals her origin: "Have some tofu! It comes from Nara." Tofu carried into medieval cities had to be solid enough to withstand the trip from nearby villages. It was so firm as to be nicknamed "the plaster wall" (*kabe*). Women quartered each piece at the time of sale.

Fig. 1. Tofu seller.

Like the tofu seller, a floss seller, shown in figure 2, also has her head covered. With a weighing rod at her side, she displays her square floss sheet on the ground. She calls out: "Buy my floss! It's from Shinobu" (in Mutsu Province), suggesting pride in a product whose quality was associated with its place of origin. Floss sellers probably possessed a certain amount of business acumen because, unlike tofu sellers, who brought their commodity from home, they bought floss from wholesalers, who traveled long distances, and then retailed it. Gotō Norihiko has observed that headdresses like those of tofu and cotton sellers were common among working women in the Muromachi period.[5] More than just a decoration, headdresses were worn for practical reasons. It was customary for women to cover their heads when they traveled or to keep dust out of their hair. Floss sellers might cover their heads, for example, to travel to the market from their home areas. The prevalence of covered heads in drawings suggests that in medieval Japan women were engaged in the task of transporting goods, often over dusty roads, in addition to manufacturing and selling them.

Figure 3 depicts a woman selling obi. She sits sideways and lifts an obi in order to check its quality. Her hair falls straight down and her brows are painted. She wears a small-sleeved kimono under an outer garment that is draped behind her. "I will see your face powder after I've cut this obi. I'm so busy," says the comment. This seems to be her response to a "face powder seller" who has spoken to her. The way she wears her kimono and the comment that accompanies the drawing suggest that this woman both tailored and sold obi, most likely sitting on a shop floor. The large box beside her probably contains cloth to be cut. She would have sewn together two different kinds of cloth—front and back—to make an obi. The obi seller, then, performed three tasks: cutting, sewing, and selling. In other words, she was simultaneously engaged in both the production and sale of her goods on the shop floor. She probably did not commute from a nearby village but lived in the city. She is without headgear, and the draped outer clothes and the way she is sitting do not suggest that commuting would be part of her routine.

In figure 4, another woman with a covered head reaches over a large tub containing saké. Two jugs, presumably full of saké, stand behind her. "First taste my [unclear] saké! I also have the now popular half-clear saké," she solicits passersby. While this notation suggests that she sold saké, the caption identifies her as a "saké brewer."

Fig. 2. Floss seller.

Fig. 3. Obi seller.

Like the obi seller, who sewed and sold her goods, the saké brewer must have both brewed and sold saké. It is of particular importance to note that the saké-brewing profession is gendered female in this historical source. Other medieval sources, such as the scripts of *kyōgen* (a farce performed between Noh acts)—*Obagasake* (Aunt's Saké) and *Kawara Tarō* (Riverbed Tarō), for example—also portray saké brewers as women.[6] Wakita Haruko has convincingly argued that saké brewing was a job done by women in ancient and medieval times.[7] Descriptions of saké-brewing scenes in a pre-eighth-century regional gazetteer (*Harima fudoki*) and an ancient collection of Buddhist tales (*Nihon ryōiki*) support this position.[8] The home-based mode of production in medieval times tended to facilitate the female gendering of saké brewing. Late medieval changes in production that stressed quantity both lowered the prestige of home-brewed saké and devalued women's position as saké brewers.[9] In the Edo period, women would be entirely excluded from saké brewing. The growing intensity of beliefs regarding female pollution accompanied this transformation.

Cloth dyeing was also women's work in medieval times as can be seen in figure 5. A woman with her head covered soaks cloth in a large vase, her sleeves strapped up and her kimono's hemline lifted. The comment has her saying: "[This customer] asked me to dye it repeatedly until it is dark." She is apparently an artisan with the skill to execute subtle variations in shades of color. Many of the other female artisans are engaged in work involving cloth. See, for example, the weaver and the motif dyer (a person who creates illustrations on cloth with dye) in figures 6 and 7. Their appearance suggests that they dress for simplicity and ease of movement. Their hair is covered or tied, and their kimono sleeves are either short or tucked out of the way.

The "women of Ōhara" (*oharame*) were well-known peddlers who circulated round the fifteen to twenty kilometers between Ōhara and Kyoto. Figure 8 shows a pair of them—probably because they usually traveled in groups—and a man resting beside them. His carrying rod, now off his shoulder, has heavy-looking bundles of charred firewood (*kuroki*) attached to each end. One *oharame* stands with two bundles of *kuroki* on her head; the other crouches on the ground, resting her hand on her bundle. They wear clothes suitable for long journeys: straw sandals, hand covers and leggings, and narrow loose obi. The illustration suggests that the sale of firewood was a female occupation, while making it may have been a man's job. Perhaps

Fig. 4. Saké brewer.

Fig. 5. Cloth dyer.

Fig. 6. Weaver.

Fig. 7. Motif dyer.

Fig. 8. "Women of Ōhara" and companion.

men hefted charred firewood on carrying rods to one of the gateways to Kyoto, where women took over to stand at doorsteps selling it. At any rate, carrying charred firewood from Ōhara to Kyoto and selling it in the city must have been physically demanding.

We can see that female merchants were engaged in many jobs related to distribution and sales. Some were based in villages and peddled their goods in the town. Others were based in the towns and produced and sold their goods there. Other women—such as floss sellers—may also have negotiated with long-distance wholesale merchants. Some artisans—like embroiderers and braided rope makers, stressed production over sales.

It seems that all female merchants shared a vociferous style of selling. According to the notations, they shouted loudly at customers and neighboring merchants as they worked. Their cries advertised their goods and appealed to the potential buyers by demonstrating their pride and confidence in their goods. Male merchants also raised their voices, but the impact of the high-pitched, clear female voices on customers can be readily imagined.

Past scholarship has too often identified men with heavy nondomestic work and women with domestic and light extradomestic work. The depictions of women merchants in these drawings suggest a different picture. The expanding commercial sector and the interconnections between the processes of production, transportation, and sale involved women in much physically demanding work. Apart from the activities already mentioned, women merchants carried weighty items such as rice, pounded sweet rice cakes, and beans. Men, in contrast, dealt in farm implements and armor. We can see, then, that these women were active, loud, physically strong, and mobile. Their portraits suggest an aspect of gender parity in medieval commercial activities, despite the gender distinction that marked different types of merchandise.[10]

WOMEN IN VILLAGES

Women's positions in medieval Japanese villages varied according to the types of villages and the individual woman's class background. Based on the nature of local power relations between regional lords and peasants, villages can be classified into three types: (1) villages controlled by powerful regional samurai (*kokujin*), (2) villages under the direct authority of a locally powerful peasant-cum-samurai

(*jizamurai*), and (3) villages run by the villagers.[11] In the first, the regional samurai's direct authority overpowered villagers, leaving them no opportunity for local self-governance. The lords established markets and charged fees to merchants for their use. They held criminal jurisdiction as well as authority over commodity circulation among and between villages and cities. Villages of the second type were commonly found on estates (*shōen*) whose proprietors were not warriors but aristocrats or near major temples or shrines located in and around Kyoto. Here increasingly powerful local peasants-cum-samurai held the authority to manage and profit from village economies. In the third type, local authority rested in the hands of the peasants, especially upper-level peasants. These three village types shaped the particular kinds of privileges, rights, and responsibilities that resident women could exercise.

Wives of the regional samurai lords obviously did not belong to the commoner class, but for comparative purposes it is valuable to discuss them here. They managed property alongside their husbands and had supervisory authority in all domestic matters. Under the Kamakura bakufu, regional samurai were often away from home, as they were under the obligation to serve as guards in Kamakura or Kyoto. The authority to administer property during the husband's absence rested in the hands of the wife. We should reconsider the established notion that wives took over their husbands' authority to manage property only after they were widowed; in fact, they exercised such authority before the husband's death. Military service was levied on a household basis in accordance with the sum total of property held by all household members. Because the husband and wife jointly constituted a household, either of them was capable of bearing the burden. In one notable case, a wife prepared and supplied clothing in order to fulfill the household's military duties in the husband's absence.[12] Similarly, daughters' portions of property bore the same burden of taxes and military duties as did sons'. Although a woman's husband, father, or brothers sometimes served as her proxy in fulfilling the military service requirements attached to her property, it is noteworthy that taxation knew no gender distinction.

A man's authority deriving from his position as the household head was transferred to his widow upon his death. The widow-nun of the Ōtomo house redistributed her deceased husband's legacy among their children seventeen years after his death. In place of the deceased husband, the widow held strong parental and jurisdictional

authority over the rest of the family members. The female heirs, such as Ōtomo's daughters, would hold property in their own names, independently of their husbands, though sometimes husbands would become involved in its management.[13]

Besides property management, women of the elite warrior class in early medieval times were often engaged in other aspects of the local economy and governance. One document, for instance, mentions a widow-nun remitting an obligation by money order. Another woman is recorded as having exercised jurisdiction over a criminal act that had occurred on her land.[14]

It was in late medieval times, after the mid–fourteenth century, that the notion of a gendered division of labor—men outside, women inside—came to be firmly held. Mōri Motonari (1497–1571), a daimyo, called it "a golden rule."[15] In actuality, it often remained abstract. Women continued to receive rights (*shiki*) to property, joined in battles alongside men, and actively managed their property. It seems that late medieval society gave this established dictum a flexible interpretation. Even when the gendered division of labor was more closely observed, it was still the case that the husband and wife "managed" (*osameru*) two separate spheres. In each sphere, the husband or the wife held the ultimate authority. The relationship between the two was more gender complementary than hierarchical.

Villages that fit the second type had a few dominant peasants-cum-samurai, who, like samurai, sported surnames. Though divisible into a range of economic strata, the majority of the village population were peasants who appear to have acted in unison as one collective body. Needless to say, surname-bearing peasants held higher economic positions and more status than the rest, and normally their signatures on villagewide collective petitions were separate from the signatures of the other peasants.

In contrast to sources regarding women in villages of the first type, sources for women living in villages of the second type are extremely scarce. Only a few documents provide enough information for us to hazard a guess as to the roles performed by women living on an estate. The "Tamagaki Statement," estimated to date from 1463, illustrates the activities of one such woman. Tamagaki was a sister of one Fukumoto, an official on the Niimi estate in Bitchū Province.[16] She oversaw the daily operations of Yūsei, Fukumoto's on-site agent, who had been dispatched by the estate proprietor, Tōji (a temple). Yūsei was murdered by the estate's residents while on an inspection

tour. Tamagaki made a list of his belongings and submitted it to the estate office along with a statement. The statement discloses that she gave some of his clothes to the priest who handled Yūsei's funeral and she had "happily received a portion of his legacy herself" as a token of remembrance. She doubtless held the primary responsibility for handling Yūsei's legacy. Tamagaki presumably had been Yūsei's most trusted secretarial administrator. Her ability to manage an estate agent's secretarial duties and the superb handwriting that graces the statement clearly demonstrate the impressive degree of education that a village woman of this class was able to obtain.[17]

The third village type was characterized by a collective social organization, the *sō*, which was composed of all the male village residents with the self-claimed status of peasant (*hyakushō*). In principle, this association upheld the basic ideal of parity among all residents. But in practice class differences among village residents were easily translated into status distinctions, which came to be articulated, for example, as the difference between villagers (*muranto*) and small peasants (*jigenin*). In the Kamakura and Muromachi periods, villagers were considered to be legitimate members of the village's formal social organization, whereas small peasants were not. But when small peasants gained economic power and a few villagers lost leadership positions in the fifteenth and sixteenth centuries, the village was forced to admit small peasants as full-fledged members of its association. In this way, the scope of the village association gradually expanded. Wives of villagers formed a wives' association, which functioned as an auxiliary unit to the all-male association. Some villages even witnessed the founding of wives' associations by small peasants.[18]

The village association was housed in the local shrine, and its various functions largely overlapped those of the shrine.[19] Because women were barred from most of the shrine's formal functions, they have left few documentary traces. A list of women's monetary contributions to shrines provides one perspective on their involvement. In 1474, a village shrine solicited donations for the purchase of a bell and the building of a bell tower. Thirty-six donations were made. Of these, four were by women—most likely wives of "villagers." Another list from thirty years later, the "List of Donations for Jūrasetsu" (the ten female *rasetsu*; *rasetsu*: Sanskrit *rākṣasa*, guardian gods associated with the *Lotus Sutra*), shows 86 donations by women, or 40 percent of the total of 214. Most of the donations were small, in

amounts somewhere between 2 and 30 *mon* in cash. Only eleven women gave more than 100 mon. This suggests that the contributors were not all of the villager class. Some must have been women of the small peasant class. This pattern of contribution may indicate an accumulation of wealth even at the lower end of the village class structure.

Women's public role in these villages was restricted in some significant ways. Women's names, for example, do not appear on shrine land payment rosters. Shrine land was the community's collective land. Even if women contributed economically to the accumulation of shrine land, their donations were not formally recognized on paper. Initially, only men (husbands and fathers) of the villager class, and later of the small peasant class, had the privilege of maintaining shrine land and appearing on the roster. On occasion, a widow might be recognized as an association member because she was the interim household head between the husband's death and the heir's maturity.[20]

If women held rights to property and participation in certain ceremonies, why were their activities restricted in the ways just described? Exclusion of women from "public obligations"—a term that also meant "taxation responsibilities"—helps to explain this. When the taxation authority listed a landholder's name on its register, it was invariably the name of the husband. In turn, these men were designated by the authority as taxpayers. In the vertical structure of authority and subject, then, it was the male household head who bore the formal burden of taxes and services. In the cities as well, only men could be guarantors of sales transactions involving land and houses by the late medieval period.[21] The ability to guarantee such transactions was synonymous with the possession of publicly legitimated authority. Society gradually delegitimized women's capacities by excluding them from publicly significant activities such as paying taxes and guaranteeing economic transactions. The devaluation of women in this "public" sphere had an effect on the structure of relationships within the household as well, where males clearly evolved to be the dominant members.

CONCLUSION

Medieval Japan saw a marked expansion in commodity circulation and the cash economy. People who collected or purchased surplus yields, which had been made possible by the increase in agricultural productivity, developed into a class of new landowners. Increasing numbers of people were also engaged in the distribution of goods

between towns and villages. Among them were the many women who came to be portrayed in the drawings that illustrated *Poetry Contest* books. The drawings described and reproduced in this chapter inform us that these women lived in either towns or nearby villages and were identified by the goods they sold, just as male merchants were. These women were engaged in the production, transportation, and sale of their commodities. The gendering of work in medieval Japan was far more flexible than it would be in the early modern period.

In the Kamakura period, a gendered division of labor for upper-level peasants had not yet fully developed. Late medieval Japan, however, developed the dictum "men outside, women inside." This was not as rigidly practiced as the saying suggests, nor did it necessarily mean a hierarchically defined division of labor. Both wives and husbands held final decision-making authority within their spheres of influence.

Women of the local peasant-cum-samurai class might have some education, such as the woman who worked as an administrator for an estate official. Wives and daughters of small peasants and villagers possessed the right to hold and cultivate paddies and fields in their own names. They were, however, excluded from holding lands that bore the obligation to pay taxes to a public authority. They were unable to hold the public position of taxpayer. In this regard, they were subject to the patriarch of the house. This distinction between publicly recognized rights and responsibilities and the private right to hold land, for example, still did not necessarily imply inequality between the sexes. In medieval Japan, unlike early modern times, the distinctions between in and out, or public and private, were still incomplete and flexible.

NOTES

1. These estate holders and managers held titles such as *honjo*, *ryōke*, *azukaridokoro*, and *jitō*. Taxes and labor dues were called *nengu*, *kuji*, and *buyaku*.
2. While land stewards (*jitō*), appointed by the bakufu, wielded the most influence in the early medieval period, military governors (*shugo*) and "men of the province" (*kokujin*) were more prominent thereafter.
3. *Tōhokuin shokunin uta awase* and *Shichijūichi ban shokunin uta awase*, in Hanawa Hokiichi, ed., *Gunsho ruijū* (Zoku Gunshoruijū Kanseikai, 1933), 28:441–47, 464–606. See also Iwasaki Kae et al., eds., *Shichijūichiban shokunin uta awase*, *Shinsen kyōkashū*, *Kokon ikyokushū*, vol. 61 of *Shin Nihon koten bungaku taikei* (Iwanami Shoten, 1993), 1–146, 485–590. Increased participation by women in a wider variety of work has been noted by Nagahara Keiji and Wakita Haruko, respectively. See Nagahara Keiji, "Joseishi ni okeru Nanbokuchō, Muromachiki,"

in *Nihon joseishi*, edited by Joseishi Sōgō Kenkyūkai (Tōkyō Daigaku Shuppankai, 1982), 2:160–67; and Wakita Haruko, "Chūsei josei no yakuwari buntan: Kōtō no naishi, hanjo, kanjin bikuni," *Rekishigaku kenkyū* 542 (1985): 16–30.

4. Different types of entertainers and prostitutes are also mentioned in this source. This essay does not discuss them because the complex meaning and history of medieval prostitution demands a full treatment not possible here.

5. Gotō Norihiko, "'Shichijūichi ban shokunin uta awase' no joseitachi," in *Yūjo, kugutsu, shirabyōshi*, vol. 3 of *Shūkan Asahi hyakka, Nihon no rekishi*, edited by Gotō Norihiko and Amino Yoshihiko (Asahi Shinbunsha, 1986), 4–84.

6. The script for *Obagasake* is in Koyama Hiroshi, ed., *Kyōgenshū*, vol. 43 of *Nihon koten bungaku taikei* (Iwanami Shoten 1961), 2:107–14.

7. Wakita Haruko, "Chūsei ni okeru seibetsu yakuwari buntan to joseikan," in *Nihon joseishi*, edited by Joseishi Sōgō Kenkyūkai, 2:86–87.

8. The *Harima fudoki* is a collection of folklore and regional customs. It mentions a female deity brewing saké. See Akomoto Kichirō, ed., *Fudoki*, vol. 2 of *Nihon koten bungaku taikei* (Iwanami Shoten, 1958), 333. The *Nihon ryōiki* was compiled by a monk named Keikai around 822. See especially a story in which Hiromushime appears, in Endō Yoshimoto and Kasuga Kazuo, eds., *Nihon ryōiki*, vol. 70 of *Nihon koten bungaku taikei* (Iwanami Shoten, 1967), 2:393–97. An excellent English-language translation is Kyōko Motomochi Nakamura, trans., *Miraculous Stories from the Japanese Buddhist Tradition: The Nihon Ryōiki of the Monk Kyōkai* (Cambridge: Harvard University Press, 1973).

9. For example, a shop called Yanagi Sakaya began producing high-grade saké in large quantities. See Toyoda Takeshi, *Nihon no shōgyō*, vol. 2 of *Toyoda Takeshi chosakushū* (Yoshikawa Kōbunkan, 1982), 14, 54.

10. Although I assume that the female traders illustrated in the *Poetry Contest* are representatives of those centered around the city of Kyoto, those working in regional cities and markets must have had a similar appearance. I wish to emphasize that in medieval times the domestic and extradomestic spheres were not clearly demarcated. I assume, however, that women were engaged in work related to the house and in child care to a greater extent than men were.

11. More discussion of this typology based on power relationships in village governance can be found in Hitomi Tonomura, *Community and Commerce in Late Medieval Japan: The Corporate Villages of Tokuchin-ho* (Stanford: Stanford University Press, 1992), 90–91.

12. Wakita Haruko, Hayashi Reiko, and Nagahara Kazuko, eds., *Nihon joseishi* (Yoshikawa Kōbunkan, 1987), 77.

13. See Tabata Yasuko, *Nihon chūsei no josei* (Yoshikawa Kōbunkan, 1987), 22–30, for more information regarding this case. Property was given to sons, daughters, and the wives of dead sons; the type of property divided included *jitōshiki* and *myōshushiki*, status-defining property with important responsibilities. In English, the Ōtomo case is discussed extensively in Hitomi Tonomura, "Women and Inheritance in Japan's Early Warrior Society," *Comparative Studies in Society and History* 32.3 (July 1990): 592–623.

14. Tabata, *Nihon chūsei no josei*, 61–62 and 39.

15. Tōkyō Teikoku Daigaku, comp., *Mōrike monjo*, vol. 8 of *Dai Nihon komonjo, iewake* (Tōkyō Teikoku Daigaku Bungakubu, 1922), 543.

16. It is not clear whether she was his younger or older sister.

17. "Tōji hyakugō monjo," box no. *yu*, unpublished document in the archival collection at Tōji.

18. On women, see, in English, Tonomura, *Community and Commerce*, esp. 57–62.

19. See Katō Mieko, "Women's Associations and Religious Expression in the Medieval Japanese Village," in this volume, for a description of shrine associations.

20. See Tabata, *Nihon chūsei no josei*, 103–15; and "Daimyō ryōgoku kihan to sonraku nyōbōza," in *Nihon joseishi*, edited by Joseishi Sōgō Kenkyūkai, 2:209–50. Other relevant works are Katō Mieko, "'Onna' no za kara nyōbōza e," in *Bosei o tou*, edited by Wakita Haruko (Kyoto: Jinbun Shoin, 1985), 1:204–27; and Kuroda Hiroko, "Chūsei kōki no mura no onnatachi," in *Nihon josei seikatsushi*, edited by Joseishi Sōgō Kenkyūkai (Tōkyō Daigaku Shuppankai, 1990), 2:187–222.

21. Tabata, "Daimyō ryōgoku," 248–49.

Women's Associations and Religious Expression in the Medieval Japanese Village

KATŌ Mieko

Translated by Suzanne GAY

Despite the great progress women have made in advancing their social status, they still encounter places and occasions that are off limits to them. For example, women may not participate in Kyoto's Gion Festival, one of the three largest festivals in Japan and widely known as a "man's festival." The same is true of many village festivals throughout Japan. It is often assumed that such restrictions are "traditional," having existed since time immemorial. The historical reality is far more complicated.

Scholars of folklore explain that women are barred because they are considered by nature to be defiled, while the shrine association (*miyaza*, whose members are all male) and its festivals are regarded as sacred and pure.[1] A closer look at specific festivals in contemporary Japan suggests that this explanation is simplistic. Representations of women are present, for example, in the shrine association ceremony held on the seventh day of the first month in the village of Nishiichinobechō, where men appear in the guise of women—the supposedly defiled gender—playing the roles of bride and wife.[2] There are many other examples of either men garbed as women or women and girls themselves (wives or daughters) participating in local shrine association observances. The wives of the association members participate through their own association, which sponsors a performance of Shinto sacred dance (*kagura*) in the village of Minami Hirao.[3] The unmarried daughters of the presiding official make offerings at Juka shrine in Yamanaka village.[4] At both Takagi shrine in Yabu village[5] and Kagami shrine in Kagami village,[6] girls adorned with the finest sashes owned by the presiding official's wife participate by making offerings.

I argue that the current phenomenon of women, or men in women's garb, participating in these annual observances is a vestige of widespread participation in religious affairs by women in earlier times. Witness that in the medieval period women performed recitative dances (*kusemai*) in the now all-male Gion Festival.[7] These examples, therefore, are at odds with the folklorists' contention that women's defiled state has prohibited them from participating in shrine association observances. This essay examines to what extent and in what capacity women in the medieval period participated in the activities of the shrine associations, including village ceremonies and festivals, by using materials drawn chiefly from the area around Kyoto and Lake Biwa. I will also explore women's religious expressions in the context of shrine associations and compare them to those of men. My aim is not to present exhaustive evidence for the extent of women's participation in village rites and ceremonies but to demonstrate the existence of this participation and suggest some ways in which women exploited it.

Daughters' and Women's Associations

In villages, festivals and ceremonies are organized and carried out by the shrine association. In the latter half of the medieval period, beginning in the fourteenth century, this association was also the administrative organ for the self-governing, or corporate, village (*sōson*) common in central Japan. With few exceptions, the shrine association's membership was male and hierarchical, deferring to age and generally excluding cultivators and other poor peasants. Many associations refused to admit nonrelatives or newcomers as members. Younger villagers participated in shrine ceremonies in a subordinate capacity and in some cases formed auxiliary associations.[8]

One of the most important annual ceremonies performed by the shrine association is the New Year's observance, variously called *kechi*, *shinji*, *okonai*, and so on, depending on locale.[9] The first festival of the year, its main purpose is to pray for a bountiful harvest. A lengthy annual record of this ceremony from the village of Namazue, dating back to 1575 and continuing to this day, has been handed down with the headmanship itself through the line of the leading family.[10] In the introductory segment of the document, women's names such as Ofuchi and Tora are written in small print on the right shoulder of the names of men playing various leading roles. This suggests that women participated in the festival at least in 1575. Likewise, in nearby Imabori

village, a list of items used in the New Year's Festival of 1384 in-
cludes entries such as "women's association—three *to* [of wine]" (one
to = 4.8 U.S. gallons) alongside "shrine association wine—one *to*."[11]
This notation makes it clear that a women's association, called a
nyōbō-za, existed in Imabori and that wine was used in the New Year's
entertainment by this association. The term *nyōbō* referred variously
to a lady-in-waiting in aristocratic households; a wife, mistress, or
married woman; or just an "adult woman." There was an increasing
emphasis on the meaning "wife" from late medieval times on.

For the Okushima Estate, located in the same district as Imabori,
we can confirm that women were involved in some capacity in New
Year's observances that took place on the fifteenth day of the first
month. Records of New Year's ceremonies dating from 1324 to 1326
show that rice cakes were offered at Ōshima shrine, the spiritual fo-
cus of the village. Among those making the offering appear names of
women: Kesame and Saeki no Uji no Musume (Daughter of the Saeki
lineage).[12] A chronicle of ceremonies performed at Tenjin Hachiōji
shrine in Ōyamazaki near Kyoto also records the admission of certain
daughters of shrine association members into an existing association
of female shrine attendants (*miko za*). This is additional evidence
that women participated in village shrine ceremonies; in this case,
the term *miko* suggests that they served as intermediaries between
the humans and the deities.[13]

The four examples given above are evidence of women's partici-
pation in the shrine association's religious activities dating from the
fourteenth century and later. The sources also reveal that women who
participated in such observances were immediate relatives—daugh-
ters or wives—of the shrine association's male members. Was female
participation originally as daughters or wives? Did women's ties to
the community's socioreligious center derive from their familial posi-
tions in their natal communities or from their acquired positions in
their husbands' households? Whether a woman obtains her privilege
to participate in the sacred observances as a daughter or a wife is a
question with important ramifications for understanding the status
of women in the community.

It would appear that changes in marriage practices had an effect
on women's participation in shrine associations. A document with
multiple signatures, dated 1365.10.14, preserved at Ōji shrine in the
village of Higashimura on Kokawa Estate records a decision that
among the daughters of the villagers those living outside the village

would be prohibited from serving as the presiding official in shrine association observances.[14] This statement suggests that until 1365 daughters of the village regularly presided over shrine association observances. Initially it was the daughters' birthright that qualified them to become chief officiators at shrine association observances, but this statement imposes a new residential requirement. A closer look at the document, moreover, reveals further changes. On the outer edge of the document there is an undated inscription that was clearly added later—"women are forbidden to be chief"—a turn of phrase indicating that at some point all women of Higashimura, not just daughters who moved to other villages, were barred from their earlier role in village religious ceremonies. It would appear that in 1365 daughters who married out of Higashimura were denied the right to preside over village ceremonies and gradually this prohibition was extended to all village women.

Did this kind of prohibition mean that in general women were being excluded from shrine observances? We saw that in the late fourteenth century members of a women's association in Imabori village participated in the New Year's observance. The document that lists a large amount of wine being used for entertaining, however, suggests that the women's association was auxiliary to the all-male shrine association. At roughly the same time, then, the native daughters of Higashimura who married out of it were losing their presiding role in shrine observances, and the married women of Imabori were occupying a regular position in the corporate village as members of a women's association. In considering the relationship of village women to the shrine association, it would appear that during this period the qualification to participate in shrine association observances was shifting from daughters to wives. This change was closely linked to a transformation in the social structure of the corporate village on which the shrine association was based.

The transformation of the corporate village social structure can be detected through the types of names appearing in documents, evidence of which is summarized here. In Higashimura on Kokawa Estate, names likely to be those of cultivators, like Yagorō and Umatarō, begin to appear in documents from the 1330s on and increase in number from about the middle of the fourteenth century. At the same time, the surnames of prominent village families like Saeki begin to disappear and are nearly nonexistent by the latter half of the fourteenth century. As if in concert with this trend, the rise of the small

peasant and the accumulation of communally held village (sō) land intensified.[15]

In Imabori village records as well, names associated with wealthy peasants like Moritsugu and Tōnai can still be found in the first half of the fourteenth century, but in the latter half they disappear. Instead, names of peasants from the cultivator class proliferate. Concurrently, village acquisition of communal land reaches a peak. Such trends indicate a basic change in the membership of the corporate village social structure from an entity dominated by an alliance of wealthy peasants to a more broad-based organization that included cultivators. Simultaneous with this change was the reorganization of the structure of the shrine association.[16]

In both Higashimura and Imabori, then, during the latter half of the fourteenth century the membership of the corporate village broadened considerably, accompanied by the increasing prominence of small peasants and an increase in communally held village lands. In accordance with this, shrine association membership was reconfigured from an alliance of wealthy peasants to a group inclusive of most peasants. It is against this background of change in village and shrine association membership that participation by daughters in shrine association observances ceased in Higashimura, while in Imabori wives began to assert their presence in such observances.

But there are counterexamples. The daughters' association in Ōyamazaki did not disappear in the late fifteenth and early sixteenth centuries as it had in Higashimura. Instead, as we have seen, it took the form of a shrine attendants' association. We can explain this difference by examining Ōyamazaki's late medieval period social structure. The communal governing body of Ōyamazaki had three components whose membership overlapped: an economic unit composed of tradespeople (jinninchū); a political unit composed of members of the corporate, administrative organ (sōchū); and the shrine association, the religious and ceremonial organization for Tenjin Hachiōji shrine. Membership in these units was exclusive. Only descendants of shrine association members and their collateral families going back to the early medieval period could participate.[17] On the one hand, Ōyamazaki is known for its spectacular development as a medieval self-governing and economically flourishing city; on the other hand, it was a tradition-bound, exclusive community, preserving the old structure of shrine association and maintaining the same status hierarchy among families. Unlike Higashimura, Ōyamazaki's shrine association

retained its outline and organizational structure from early medieval times in static form. It was in this context that the shrine attendants' association made up of daughters also lived on.

The shift from daughters to wives in the shrine association's female membership occurred against the background of a changing society and its views toward outsiders. In a list of Imabori regulations dated 1489.11.4 there is an item stating that outsiders who lack an Imabori resident sponsor will not be allowed to live in the village.[18] There are many similar regulations with which the corporate village sought to normalize the exclusion of outsiders by clearly marking them as just that. A regulation of 1460 disallows shrine association membership to outsiders and adopted sons by "forbidding those born outside the village to participate in the coming of age and other village initiation ceremonies."[19] Another item in the regulations of 1489 states that if a family without an heir adopts a son, he will be ineligible for shrine association membership unless the adoption occurs before the age of seven.

The trend toward communal exclusiveness was related to an increase in communally held village land in the mid to late fourteenth century. As the economic basis of the corporate village, such land had to be maintained and inherited—not by outsiders but by children born in the village and tied to its social structure. The continuity of the corporate village was predicated upon the existence of natives with a strong sense of themselves as the collective heirs to the communally held village lands and the associated social structure. It was here that women—specifically mothers, who bore the village's children/heirs—had a special role to play. Wives of members of the corporate village were of course valued for their productive labor, but their central significance came from their role as the procreators and nurturers of the village children.[20] Among the documents of Sugaura village is an early-sixteenth-century record of items used in the coming of age ceremony.[21] "Rokurō's mother" and "Yasaburō's mother" are the designations for women who provided "widow's offerings" in this ceremony. "Widow's offerings" was a special offering category for boys whose fathers had died. These women were standing in for their deceased husbands. It is noteworthy that the document does not name these women in relationship to their husbands but to their sons. Though this may be a special instance of a ceremony whose focus was on sons, the documentary emphasis on the women's maternity suggests that motherhood was what qualified a

woman for full participation in village observances. I argue that the preeminence of the women's association was related to the women's essential role as mothers of village children, especially boys, who ensured the continuity of the village's corporate structure.[22] We can assume also that by the fourteenth century patrilineal descent and patrilocal marriage had become the social norm in villages, and married daughters were considered to belong to their husbands' and children's villages rather than to their natal communities.

WOMEN AND RELIGIOUS EXPRESSION

The foregoing section demonstrated that women as well as men participated in shrine association observances in medieval times. What, then, was the nature of women's religious beliefs, and how were these beliefs related to the practices of shrine associations? Records of donations of land to shrines in Ōmi Province offer insights into these issues.[23] It must be remembered that at this time Buddhism and Shintoism coexisted, or were joined together, through the theory of *honchi suijaku*. Buddhist prayers might be offered at a shrine, or *jinja*, and some shrine buildings were named after bodhisattvas.

The donated lands considered here constituted a portion of the pool of communally held village lands accumulated over the years and managed by the shrine association. These lands had a close relationship with the economic interests of the village itself. Donors designated their parcels for specific purposes, either shrine operations or architectural embellishments. The purpose of the donation reflected the donor's wish to use his or her economic resources to promote particular religious and spiritual interests. Do our documents allow us to determine whether there were gendered differences in how people donated their lands to the community?[24]

The Sugaura village collection contains seventeen medieval documents that record donations of land. Thirteen concern men and four concern women. Of the men's donations, six are addressed to the "Group of Twenty Village Elders," the village's decision-making body. Women, however, tended to make donations for the refurbishing of religious buildings or to mundane, if essential, village organizations like the "bath group." There is not a single donation from a woman to the Village Council or elders. Keeping this in mind, let us turn to similar documents for several other villages in Ōmi Province.[25]

Among the documents of Sou shrine, which served the villages of Hashimoto and Takehisa, there are twenty-three records of donations

of land, four of which involve women donors. Male donors listed as their donees the Sou shrine itself or "the villages of Hashimoto and Takehisa," a phrase that denotes the shrine association and the governing council of the two communities. Such central village organizations have no place in the donations of women. Women's donations were for smaller, local, religious purposes: for expenses pertaining to the Sou shrine's Circle of Eight (a consociation for group prayer), for shrine lands set aside for the sutra-copying cult, and for praying to Amida Buddha.

Female donors number seven among Imabori's records. In this village, the gender distinction represented in the records of donation is less clear-cut. Two of the seven, for example, are addressed to the shrine association in the name of Jūzenji shrine. This seems an exceptional instance of land donations from women to the shrine association. But here women are not the sole donors; their signatures are accompanied by the signature of a man. On one document, a mother and her son sign jointly, and on another an unidentified male has left his signature alongside the woman's. Imabori's other records show land donations by men designated for Jūzenji shrine but also for the meeting place of the sutra-copying cult and the hall of Yakushi Buddha. Several also include the phrase "to the Village Council of Imabori," which refers to the executive body of the Imabori corporate entity, organized around the shrine's physical and administrative structures. No woman donated land directly to the shrine association on her own.[26]

Finally, we find a divergent pattern in the collection of donation records for Ōshima and Okutsushima shrines. Of fifty-six documents, nine were written by women. In contrast to the cases given above, four women independently directed their donations to two shrines, Ōmiya (another name for Okutsushima shrine) and Wakamiya, a newer shrine in the area that emerged along with the independent corporate village of Okushima in the fourteenth century.[27] What accounts for this difference? The answer seems to lie in the status of the shrine association when the donations were made. Compared to Imabori, Sugaura, and Hashimoto, whose corporate assets had steadily increased,[28] Wakamiya was a new center of worship that demanded more concerted commitment from and far stronger participation by the area's residents as it sought to form a united front against outsiders, including the local warrior manager dispatched by the estate proprietor. The urgency of the shrine's need to quickly build a stable

economic and political base led some women to contribute land directly to it.

In addition to the residents' commitment to the shrine's well-being, documents of land donations in the four villages of Sugaura, Hashimoto, Imabori, and Okushima show differences in men's and women's personal desire to assure spiritual stability in this world or smooth passage into the next by economic means. In this endeavor, men generally sought to actively enhance their positions of influence in the corporate village structure by augmenting communally held land, a key to the village's economic well-being. Men saw the shrine association as providing an opportunity to assume leadership; by supporting the association with donations of land, they attempted to tie it to their personal wishes regarding both this world and the next. Women, who were potentially separated from their natal villages upon marriage, had less commitment to the community's core organization—the shrine association. Even in their new homes, women were recognized mainly for giving birth to the village's collective heirs. Their participation in the shrine association was in an indirect and subordinate capacity through the women's association. Women held little of the formal political authority that full membership in the shrine association imparted. It follows, then, that women's religious expression represented by the donation of land to religious organizations primarily took the form of personal appeals—such as participation in the sutra-copying cult or worship of a particular bodhisattva—for happiness in the afterlife. We need to note, finally, that women had enough property to make donations of land to shrines in the first place. Their potential as contributors was significant enough that shrines could not ignore it. The community of Ōshima and Okutsushima even solicited donations from women. At the same time, however, women generally eschewed contributing directly to the shrine association, choosing instead paths that were more immediately satisfying to their spiritual needs.

FEMALE-SPECIFIC DEFILEMENT

Closely tied to women's religious expression in the medieval period was an internalized sense of guilt and defilement. The document collection at the Kōyasan monastery holds records of some two hundred donations of land to a memorial chapel dating from the thirteenth or the fourteenth century. Among those written by women, several contain phrases that do not appear in men's donations: "a supplication

for attainment of Buddhahood by transformation from the feminine state and achieving the afterlife in a felicitous place" or "women, who are subject to the five obstructions and the three obediences, are steeped in sin, and therefore the time at which they escape from samsara is distant."[29]

The phrases "attainment of Buddhahood by transformation from the feminine state" and "the five obstructions and the three obediences" derive from an older form of Buddhism. The five obstacles that prevented women from achieving nirvana consisted of their inability to attain the five high existences of Mahābrahman, Indra, Māra, world-ruling king, and Buddha, subject as they were to a heavy karmic burden. Women were barred from attaining salvation, or Buddhahood, so long as they remained "women." But through prayer women could transform themselves into men and attain salvation. The three obediences imposed on women an obligation to obey the father in childhood, the husband during marriage, and the son during widowhood. These notions took root in the late ninth and tenth centuries in Japan's aristocratic society, which already embraced a broadly encompassing purity fetish. Buddhist ideas concerning women fused with the notion of purity and pollution. The result was a Japanese notion that women were inherently defiled and impure. In medieval aristocratic society, this idea evolved through a focus on motherhood that was then gaining much esteem.[30] Thus, mothers came to be viewed as so inherently sinful that they caused the various forms of suffering that accompany human birth and growth.[31] The phrases found in the Kōyasan monastery documents clearly reflect aristocratic women's internalized sense of maternal guilt and the desire for liberation in the afterlife from the female-specific spiritual constraints that dogged them in this life.

These desires were not limited to aristocratic women. Similar inscriptions can be found among documents preserved in the four villages cited above, though not in the part of the text explaining the religious donations but scribbled on the back. It may also be significant that the estate proprietor of these villages was Enryakuji, the great Tendai monastery on Mount Hiei and a bastion of the older Buddhism. A recent archaeological excavation has unearthed evidence that in the early fifteenth century in northern Japan ascetics of the Tendai sect performed a ritual based on the *Blood Bowl Sutra*. This is a spurious work created not in India but in China and found in various versions. It establishes an understanding that a special hell

awaits women, initially because their blood is polluted through men-
struation and/or childbirth and increasingly simply because they are
women. At the same time, the sutra offers women liberation from the
prospect of descending to this special hell.[32] Although this example
comes from an area far from the four villages under study, it suggests
that even village women had direct exposure to the medieval belief
that defilement was basic to the female nature.

In medieval times, women often linked their religious practices
to the *Lotus Sutra*. This is understandable given that the "Devadatta"
chapter of the *Lotus Sutra* contains the story of a six-year-old dragon
girl becoming a Buddha.[33] In the "Darani" chapter, also, ten female
spirits (*jūrasetsunyo*) along with the female deity of safe childbirth
and protection of children, Kishimo, pledge to protect anyone who is
a practitioner of the *Lotus Sutra*.[34] Many popular Buddhist tales in-
clude plots in which the guilt of a woman who dies in childbirth is
eradicated through the act of copying the *Lotus Sutra*. The *Nihon
ryōiki* (Miraculous Stories from the Japanese Buddhist Tradition) from
the ninth century contains a story of a woman saved by her husband's
act of copying the *Lotus Sutra* after she dies while delivering their
child.[35] A tale in the *Konjaku monogatarishū* (Tales of Times Now
Past) from the early twelfth century also tells of three sons who save
their mother, dead in hell, by copying the *Lotus Sutra* a thousand
times in a single day.[36]

The *Lotus Sutra* was commonly chanted in medieval times to
facilitate recovery from illness and to resolve various other problems.
This sutra was profoundly linked to women, a connection most obvi-
ous in the cult of sutra copying, which had mostly, though not en-
tirely, female adherents. In the villages examined here, a woman of
Sugaura named Keigan Myōchū Daishi was the main patroness for
the meeting place of the sutra-copying cult; she had it built in the
temple compound to honor the tutelary deity of the village in the
mid–fifteenth century.[37] In the early fifteenth century, in another ex-
ample, two nuns (*bikuni*) held authority over the Inoue meeting place
of the sutra-copying cult on the Okushima Estate.[38] A pervasive sense
of feminized pollution among the common people most probably served
as one component of these women's enthusiastic devotional practices.

CONCLUSION

This essay has described the development of the women's nexus in
village shrine associations and women's religious expressions in the

medieval corporate village. While women were not necessarily inactive in village religious organizations, the latter half of the fourteenth century saw a shift from daughters to mothers and wives in the status of women who participated in shrine association observances. This shift occurred concurrently with changes in marriage practices and changes in village social structure, reshaped by the consolidation of shrine association membership to include a broad segment of male peasants in the village. These changes emphasized the women's worth to the community in their role as the wives and mothers who bore and raised the village's collective heirs.

An examination of land donation documents has revealed gendered differences in religious motives that underlay the act of donation. Men tended to donate in such a way as to promote the organizational center of village solidarity. Women directed their donations to deities with whom they held a much more personal relationship. One reason for this is that women had no involvement in the village's public issues, which were monopolized by the all-male shrine association. But there were other, more spiritual reasons as well.

Medieval women lived their lives carrying the burden of two conflicting social attitudes toward their biological and social roles. On the one hand, women who were either barren or died in childbirth went to hell and were disqualified from achieving enlightenment, while childbirth and menstruation were by nature defiling. On the other hand, the external social reality granted women recognition in the village with the birth of a son. In this way, medieval women suffered under the pressures of conflicting customs and beliefs from which the village's formal social structure offered no refuge. It is understandable, then, that women expressed their religious feelings in economic forms by channeling their offerings toward personally gratifying activities and objects like the sutra-copying cult.

It is often believed that it was the *fact* of female defilement that gradually closed women out of shrine association activities. It goes without saying that female pollution is a socially constructed concept that changed with historical conditions; women were not always nor consistently held to be polluted. Imabori's association for married women and Ōyamazaki's association for shrine attendants prove this point. From medieval through early modern times, there were countervailing trends that emphasized feminine defilement on the one hand and maternity on the other. The women's associations given Buddhist names—like the Kannon association, the Jizō association,

and the Nineteenth Night association—flourished to resolve spiritu-
ally the contradiction inherent in these conflicting views of women.
The practices of nearly all of them focused on devotions for safe child-
birth, and some are still thriving.[39] In Imabori, the women's associa-
tion has been replaced by the so-called nuns' consociation (*ama kō*),
whose primary function is chanting the name of Amida Buddha for a
recently deceased woman and chanting the *Blood Bowl Sutra* during
the fall and spring Buddhist memorials to the dead.[40] As the daugh-
ters' and women's associations of the medieval period disappeared,
they gave way to new women's organizations that aimed to pray for
salvation after death and safe childbirth in this life. This fundamen-
tal transformation of women's organizations from medieval to early
modern times was a fateful stage in the history of Japanese women.

NOTES

1. Higo Kazuo, *Ōmi ni okeru miyaza no kenkyū* (Tōkyō Bunri Daigaku, 1938), 78.
2. Ibid., 309. This village is located in Yōkaichi City, Shiga Prefecture.
3. Ōfuji Yuki, "Igomorisai to josei," *Josei to keiken* 1 (1956): 23–24. Minami Hirao is
 located in Yamashiro-chō, Sōraku County, Kyoto Prefecture.
4. Higo, *Ōmi ni okeru*, 266. Yamanaka village is in Ōtsu City, Shiga Prefecture.
5. Ibid., 289. Yabu village is in Chūzu-chō, Yasu County, Shiga Prefecture.
6. Ibid., 292. Kagami village is located in Ryūō-chō, Gamō County, Shiga Prefecture.
 Girls who participate in observances at the Takagi and Kagami shrines are thought
 to do so under their mothers' names. For a more detailed discussion of this, see
 Katō Mieko, "Musume no za kara nyōbō-za e," in *Bosei o tou*, edited by Wakita
 Haruko (Kyoto: Jinbun Shoin, 1985), 1:204–27. The presiding official (*tōnin*)
 or family prepares the shrine association ceremonies and appoints a person or
 family responsible for carrying them out.
7. Buraku Mondai Kenkyūjo, ed., *Burakushi shiryō senshū* (Kyoto: Buraku Mondai
 Kenkyūjo, 1988), 1:211. See especially the section "Kusemai guruma."
8. For more on shrine associations, see, in English, Hitomi Tonomura, *Community
 and Commerce in Late Medieval Japan: The Corporate Village of Tokuchin-ho*
 (Stanford: Stanford University Press, 1992), esp. chap. 2; Kristina Kade Troost,
 "Common Property and Community Formation: Self-Governing Villages in Late
 Medieval Japan, 1300–1600," (Ph.D diss., Harvard University, 1990), esp. chap. 3.
9. In Buddhist parlance, this is known as the *shujōe* or *shunie*. *Kechi* is also written
 ketchin, which is probably the older form.
10. Namazue is located in Aitō-chō, Echi County, Shiga Prefecture. The document is
 called the *Namazue no shō Morimura kechinyaku nikki* (Chronicle of the role of
 kechin of Morimura, Namazue estate) and is in the collection of Namazue-ku,
 Aitō-chō, Echi County, Shiga Prefecture. Photographs of this collection are at
 Tokyo University's Historiographical Institute.
11. Document 331, in Nakamura Ken, ed., *Imabori Hie jinja monjo shūsei* (Yūzankaku,
 1981), 205. Imabori village was in Tokuchin-ho, Gamō County (today's Imazaki-
 chō, Yōkaichi City, Shiga Prefecture).
12. *Ōshima Okutsushima Jinja monjo*, docs. 22, 24. For a detailed analysis, see Katō,
 "Musume no za."

13. *Dōshi nenjū gyōji oboe*, one of the seven-volume *Dōshi shuseni nikki*, a chronicle of the Tenjin Hachiōji shrine dedicated to the tutelary deity Oyamazaki, Otokuni County, Yamashiro Province (present-day Oyamazaki-chō, Otokuni County, Kyoto Prefecture). See Shimamoto-chō Yakuba, comp., *Shimamoto-chō shi* (Shimamoto-chō Yakuba, 1976), 505–7.

14. *Oji jinja monjo*, doc. 81, in Wakayama-ken, comp., *Wakayama-ken shi: chūsei shiryō* (Wakayama-ken, 1975), 1:442. The original is preserved in Oji shrine in Kokawa Higashino, Naka County, Wakayama Prefecture.

15. Kuroda Hiroko, *Chūsei sōsonshi no kōzō* (Yoshikawa Kōbunkan, 1985), 138.

16. Maruyama Yukihiko, "Shōen sonraku ni okeru sōyūden ni tsuite," in *Chūsei no kenryoku to minshū*, edited by Nihonshi Kenkyūkai Shiryō Kenkyūbukai (Sōgensha, 1970), 309.

17. Wakita Haruko, *Nihon chūsei toshiron* (Tōkyō Daigaku Shuppankai, 1981), esp. chap. 3, sec. 1.

18. Nakamura, *Imabori Hie*, 218, doc. 363.

19. Ibid., 221, doc. 371.

20. Women were vital workers in villages. See, for example, depictions of crowds of women gathering grasses and women with tousled hair caring for silkworms in the early Kamakura period chronicle "Kaidōki," in Hanawa Hokiichi, ed., *Gunsho ruijū*, vol. 18, no. 30 (Zoku Gunsho Ruijū Kanseikai, 1928), 437.

21. Doc. 467, in Shiga Daigaku Keizaigakubu Shiryōkan, ed., *Sugaura monjo* (Yūhikaku, 1967), 1:204. Sugaura was in Nishiazai-chō, Ika County, Shiga Prefecture.

22. It is clear from the example of Higashimura of Kokawa Estate that daughters, who might marry out of the village, were risky heirs to the communal land. Even today, there are many examples of women first being allowed to take the role of chief officiator upon the birth of a son (see Higo, *Ōmi ni okeru*). Those interested in reading more on women's associations are referred to Tabata Yasuko, "Daimyō ryōgoku kihan to sonraku nyōbōza," in *Nihon joseishi*, edited by Joseishi Sōgō Kenkyūkai (Tokyo Daigaku Shuppankai, 1982), 2:209–50; Tabata Yasuko, *Nihon chūsei no josei* (Yoshikawa Kōbunkan, 1987); Katō, "Musume no za"; and Kuroda Hiroko, "Chūsei kōki no mura no onnatachi," in *Nihon josei seikatsushi* edited by Joseishi Sōgō Kenkyūkai (Tokyo Daigaku Shuppankai, 1990), 2:187–222.

23. Here we are analyzing a type of document called a *kishinjō*, drawn up for the purpose of commending land or other property to a temple or shrine. In the corporate village, many donations were in the form of land addressed to the village deities, usually given in order to aid the repose of the donor or parents or siblings after death.

24. In English, see Tonomura, *Community and Commerce*, 62–68, for a greater explication of how shrine land functioned.

25. For a close analysis of the records of donations from Sugaura, Hashimoto, Imabori, and Okushima, see Katō Mieko, "Chūsei no josei to shinkō—miko, bikuni, kirishitan," in *Nihon josei seikatsushi*, edited by Joseishi Sōgō Kenkyūkai, 2:259–87.

26. Nakamura, *Imabori Hie*, docs. 425 (1456.10.17), 435 (1418.4.29).

27. Tabata Yasuko, *Chūsei sonraku no kōzō to ryōshusei* (Hōsei Daigaku Shuppankyoku, 1986), esp. chap. 7, sec. 2.

28. Maruyama Yoshihiko, "Chūsei kōki shōen sonraku no kōzō: Imabori-gō ni okeru sonraku kyōyūden no keisei o chūshin ni," *Nihonshi kenkyū* 116 (January 1971): 1–33; Sekiguchi Tsuneo, "Sō ketsugō no kōzō to rekishiteki ichi," *Keizai shirin*

33.2 (1964): 136–37; Hatai Hiromu, *Shugo ryōgoku taisei no kenkyū: Rokkaku-shi ryōgoku ni miru Kinai kingokuteki hatten no tokushitsu* (Yoshikawa Kōbunkan, 1975), esp. chap. 6, sec. 2.

29. All of these examples are drawn from *Kōyasan monjo, Dainihon komonjo, iewake*, vol. 2 (Tōkyō Teikoku Daigaku, 1904), docs. 45, 125, pp. 165, 229.
30. Taira Masayuki, "Kyūbukkyō to josei," in *Hōken shakai to kindai: Tsuda Hideo sensei koki kinen* (Kyoto: Dōhōsha, 1989), 21–22.
31. Wakita Haruko, "Bosei sonchō shisō to zaigōkan," in *Bosei o tou*, 1:172–203.
32. Tokieda Tsutomu, "Chūsei Tōgoku ni okeru ketsubonkyō shinkō no yōsō: Kusatsu Shiraneyama o chūshin to shite," *Shinano* 36.8 (July 1984): 587–603.
33. Sakamoto Yoshio and Iwamoto Hiroshi, eds., *Hokkekyō* (Iwanami Shoten, 1964), 2:218–25.
34. Ibid.
35. Endō Yoshimoto and Kasuga Kazuo, eds., *Nihon ryōiki*, vol. 70 of *Nihon koten bungaku taikei* (Iwanami Shoten, 1967), story 9, 339–43. See, in English, Kyoko Motomochi Nakamura, trans., *Miraculous Stories from the Japanese Buddhist Tradition: the Nihon Ryōiki of the Monk Kyōkai* (Cambridge: Harvard University Press, 1973). The collection was compiled about 822.
36. Author unknown. See Yamada Takao et al., eds., *Konjaku monogatarishū*, vol. 24 of *Nihon koten bungaku taikei* (Iwanami Shoten, 1961), 3: tale 14–8, 289–92.
37. *Sugaura monjo*, vol. 2, doc. 811 (1425.11). The *Heart Sutra* was also popular with women in medieval times.
38. *Ōshima Okutsushima jinja monjo*, doc. 102 (1405.4.25?).
39. Miyata Noboru, "Hayarigami to onnatachi: kigansuru onnatachi," in *Teikō ni mezameru onna*, edited by Kasahara Kazuo (Hyōronsha, 1975), 137–55.
40. Yōkaichi-shi Shi Hensan Iinkai, ed., *Yōkaichi-shi shi* (Yōkaichi City: Yōkaichi City Yakusho, 1986), 4:763.

Sexual Violence Against Women: Legal and Extralegal Treatment in Premodern Warrior Societies

Hitomi TONOMURA

The subject of sexual violence was largely ignored in Japanese scholarship until recently. This is not because topics related to sex and sexual practices were marginalized. Scholars in folklore studies (*minzokugaku*) have paid much attention to sexual symbols and sexual relations in Japan's premodern society. In 1959, for example, a three-volume compilation of "sexual customs" (*sei fūzoku*) was published, with topics ranging from courtship and marriage to prostitution, contraception, festivals, bathing, theaters, makeup, and sexual orientation.[1] Serious folklore studies may provide much valuable information about Japan's folk traditions and their strong sexual components.[2] It is difficult, however, to link their findings firmly to a diachronic framework.

Other literature merely perpetuates impressionistic myths and fantasies that reflect each author's contemporary perspective more than a critically examined historical situation. The author of *Kodaijin no sei seikatsu* (The Sexual Life of Ancient People) attributes supposed "coldness" on the part of an ancient female emperor, for example, to her lack of experience in "rapelike sex" with older men in her youth.[3]

While some past writing on sexuality may have done injustice to its topic, the Marxist historians who dominated postwar historical studies paid scant attention to sexuality and even less to sexual violence. We can explain this by looking at the structural dichotomy that has pervaded our own intellectual world. On the one hand, we have the institutions and practices that were considered public, rational, male, political-economic, and productive. On the other hand, there is the domain of the private, biological, emotional, psychological, and reproductive, deemed unworthy of serious inquiry.[4] Sex and

sexuality, along with Freud, were relegated to the latter domain. Marxists, whose work is associated with the former, tended to exclude the private domain from their sphere of investigation.

Among Marxist scholars, however, the pioneering women's historian Takamure Itsue is an outstanding exception. Takamure's work, rooted in the theoretical traditions of J. J. Bachofen and Frederick Engels, delineates the transformation of marital customs from matrilocal to patrilocal systems and the accompanying changes in such sexual practices as "adulterous behavior" and prostitution. In her view, increasing strictures on female sexual autonomy and progressive commodification of the female body accompanied these changes.[5]

Takamure's theoretical premises and concrete findings laid the groundwork for the subsequent development of women's studies in Japan, a field that has flourished remarkably in the last three decades.[6] Even in the new literature, however, issues related to sexual violence are only occasionally problematized. This inattention in Japanese scholarship probably reflects the historian's perception of the contemporary situation in which cases of rape[7] are infrequent by international standards and are not articulated in Japan's social, political, and intellectual discourse.[8] A similar neglect of the topic in the past scholarship of other countries, however, demands that we consider additional explanations. First, there is a widely held view that sexual violence lacks historicity; it is part of a constant and universal structure with unchanging implications and significance. Some anthropologists simply declare rape to be a cultural universal,[9] and to Catharine MacKinnon all heterosexual copulations are rape.[10] According to Susan Brownmiller, author of a best-seller, *Against Our Will: Men, Women, and Rape*, "From prehistoric times to the present [rape has been] nothing more or less than a conscious process of intimidation by which all men keep all women in a state of fear."[11] These views establish rape as a historical given set in an immutable structure of the male-female oppositional hierarchy—hardly a promising subject for historical analysis. The topic of sexual violence may also be considered an isolated and individualized activity committed by perverts: "a marginal event, a private catastrophe doubtless, but one of little historical significance, for aren't rapists just a tiny, crazed fringe of sex maniacs?"[12]

Finally, we may attribute omission in Japanese scholarship to the way that, according to Ogino Miho, much of the new literature has uncritically integrated the Western analytical strategy, which is built

upon a Victorian outlook that dichotomizes female sexuality into two mutually exclusive categories: the domains of sex and prostitution and motherhood and reproduction.[13] Sexual violence is a form of nonreproductive sex that fits neither category, a topic that can easily fall through the cracks. As the following pages demonstrate, more-over, premodern Japanese legal sources have tended to deny the full significance of sexual violence; they have subsumed rape under the general category of "violation" (*kan*), which is defined in terms of the male-centered sexual relationship that upholds the patrilocal and patrilineal marriage structure. These sources have obfuscated the meaning of sexual violence and discursively prevented it from be-coming an independent subject for historical inquiry.[14]

Needless to say, sexual violence, like sexuality itself, should be relativized and historicized. The observation that West Sumatra is rape free compared to the rape-prone United States, for instance, enriches our understanding of issues related to rape as we consider the differences in the social structure of the two societies.[15] Abundant incidences of rape in the "amatory pursuits" of the Greek gods and the postbattle seizure of females by victorious soldiers in different wars provide a comparative perspective.[16] Gerda Lerner's contention that rape among fighting tribes marks the very origin of world patri-archy stimulates us to reconsider the historical meaning of rape.[17] In Japan, sexual violence surely accompanied wars—premodern and modern—and men "seduced," abducted, and violated women in their pursuit of what they may have called love.[18] Our task, however, is not to catalog instances of sexual violence but to investigate the transfor-mation in the meaning that came to be assigned to sexual violence in the centuries before the modern era. I begin by examining codes, of-ficial chronicles, and judicial records issued by the governments and warrior houses from the eighth through the sixteenth centuries.

THE RISE OF THE WARRIOR SOCIETY

The chronological framework within which my analysis takes place falls within Japan's so-called medieval period, which was dominated politically by the warrior class. The warriors, or samurai, began to rise in political importance around the eleventh century. By the end of the twelfth, Japan's first warrior government (the Kamakura bakufu) was established without destroying the imperial institution, which had been in existence since the seventh century. The bakufu's political authority was by no means hegemonic, extending mostly to

its vassal warriors and only lightly touching on commoners and aristocrats. The bakufu laws (*Goseibai shikimoku*), issued first in 1232 but with continuing revisions and addenda, were intended to uphold the bakufu's peacekeeping role for the country and were mostly directed toward the bakufu's vassals. The imperial government had its own set of laws applicable to the aristocrats. Commoners, all in all, lived under little burden of direct legal administration from above.

The collapse of the Kamakura bakufu in 1333 was followed by the inauguration of the second, Muromachi bakufu, which continued the basic legal tradition of the first, maintaining many of the principles underlying the *Goseibai shikimoku* in compiling its laws. As the effectiveness of the bakufu wore increasingly thin from the mid-fifteenth century on, however, local warrior lords consolidated their territorial and human resources, eventually developing into independent regional powers, each with its own set of house codes.

In the period of approximately four centuries that saw the rise of the warrior government and the subsequent trend toward increasing decentralization, the organization of warrior houses underwent a monumental shift. At the inauguration of bakufu rule around 1232, warrior houses were organized around the principle of divided inheritance for daughters and sons. The descent system was not always patrilineal, as marriage was not always patrilocal. Property was held separately by wife and husband, with full rights to alienate as each wished. Although children belonged to the husband's line in most cases, women, married or not, had the legally sanctioned right to adopt their own heirs. Women's property rights, unquestioned at first, gradually diminished along with secondary sons' rights. The increasingly competitive atmosphere of the country compelled the military houses to consolidate their land and lineage under one chief, replacing the divided inheritance system with a unigeniture system and firmly establishing patrilineal descent and patrilocal marriage practices. For women, this process meant a historical abrogation of their earlier rights to hold property and adopt children independently. Women, now with little economic power, became appendages to the house structure dominated by male-centered principles.[19]

On the plane of sexual violence, how did women's position change? Was there a correlative process to the gradual but definitive economic reorganization just outlined?

The Kamakura authorities regarded rape and abduction as volatile sources of prospective violence and therefore as offenses in need

of control. During the Middle Ages in the West, secular and ecclesias-
tical authorities were equally concerned with rape, as is evident, for
instance, in Hincmar's *De la repression du rapt* (Of the Suppression
of Rape).[20] The intention of the samurai officials, needless to say, was
not to create a society in which women might be safely autonomous.

The fledgling Kamakura bakufu doubtless wanted to eliminate
the kind of situation recorded in its official chronicle (*Azuma kagami*)
in the year 1200. According to this entry, a low-ranking retainer (*rōjū*)
murdered in broad daylight a high-ranking official who had violated
(*okasu*) his wife. After killing the rapist, the murderer fled but was
captured by the bakufu authorities and subsequently punished. The
focus of this record is on the public nature of a murder committed at
midday, not on the rape, which it mentions only in passing.[21]

Thirty-two years after this incident, the Kamakura bakufu is-
sued the *Goseibai shikimoku*, whose thirty-fourth article dealt with
secret embracing (*mikkai*), forced sexual violation (*gōkan*), consen-
sual sexual violation (*wakan*), and abduction (*tsujitori*).[22]

Concerning the crime of secret embracing (*mikkai*): Whether
it is forced (*gōkan*) or consensual (*wakan*), a retainer
(*gokenin*) who embraces another's wife shall have half of his
fief (*gokenin* land) confiscated [by the bakufu] and shall cease
to serve the bakufu. In case the offender holds no fief, he
shall be sentenced to banishment. The woman's [adulteress
or victim's] fief shall be subject to the same term. If she holds
no fief, she too will be banished.[23]

The article subsumes "forced" and "consensual" violation under the
discussion of "secret embracing" as its variant form. For the bakufu,
there was no functional distinction between rape and adultery. Both
were a potential source of disorder, inasmuch as the wronged hus-
band might seek revenge against the perpetrator, as we saw in the
case from 1200. Both offended the husband's exclusive proprietary
claim to the wife's sexual being.

The term *tsujitori* in and of itself does not denote gaining sexual
access to a woman's body, but the consequence of abduction for the
woman may have differed little from that of *gōkan* (though, of course,
there is a possibility that a woman might willingly connive at her
abduction). Abduction has the connotation of a crime committed out-
doors (*tsuji* means "streets"), involving capture (*tori*) of, presumably,

married or unmarried women.[24] According to Amino Yoshihiko, who cites Luis Frois, a European who resided in Japan in 1563–97, women traveled quite freely on their own "without getting permission from their parents" and were "free to go wherever they like without informing their husbands."[25] If *tsujitori* was a prevalent practice, we might speculate that women's freedom of independent action certainly had its cost.

Abduction was punished less severely than rape; for the crime of abduction, the bakufu's vassal was to stop serving the bakufu for a hundred days. If the violator's rank was that of *rōjū* or lower, he was to have one side of his head shaved. As for priests—notorious in medieval sources for their sexual escapades—each case was to be judged separately.[26]

Regarding abduction, the bakufu entirely ignored the welfare of the injured party—the captured woman. In the eyes of the law, the crime of abduction was an offense committed against the bakufu's authority to maintain order. The woman's body was merely a vehicle through which officials could reinforce governmental authority. With adultery, the bakufu did make provisions for the woman. It punished her for being penetrated by a man other than her husband, whether or not it took place against her will.

By establishing a penalty measured in terms of governmental confiscation of land, the bakufu essentially abrogated the right of the husband to take revenge for another's transgression of his wife's body. This was an innovation that went against the customary mode of resolution among warriors, which, according to Katsumata Shizuo, was for the husband to kill the interloper when the man visited his wife in his home. The husband did not kill the man outside his home. The passage of the code probably had little impact in changing this practice.[27] It also should be noted that in the case from 1200 cited in the *Azuma kagami*, the bakufu's attitude was highly influenced by the factor of status. The chronicle makes a point of the difference in rank; the rapist was an elite warrior who was highly cultured and "a beautiful man," while the husband was only a *rōjū*. It was regarded as outrageous that a mere *rōjū* should cut down a warrior of high rank— especially at midday.[28]

Confiscation of property by the bakufu was a punitive measure widely applied to a broad spectrum of crimes. Murder, name calling (such as calling someone a non-*gokenin*), kicking, and forgery called for either confiscation of all the vassal's land or banishment.[29] If

we judge by the amount of land confiscated, then rape and adultery, which led to the loss of half one's land, were crimes of lesser significance.

The Kamakura period was a time when women could both *have* and *be* property. Women of the warrior class typically held land in their own names, independently of their husbands. Of course, this is why the law could stipulate confiscation of the land of the rape victim or adulteress. At the same time, the law codes often listed women (and children) with other types of property belonging to the husband. For instance, after arresting a criminal, a military governor (*shugo*) was forbidden to confiscate, without a good reason, property such as "paddies and fields, homestead, wife and children, and miscellaneous goods."[30] The woman's body being property claimed by the husband, aggression upon it was damage done to the husband. But being landholders themselves, these women might have their own land confiscated for having their sexual domain accessed—willingly or unwillingly—by a male other than the husband. The warrior government drew a sexual map for the warrior class as it sought to stabilize the country's relations of power, which were invested in political authority and property rights. In so doing, it created a practice and discourse that bifurcated the woman into property (of the husband) and propertied. The law alienated the sexual side of the woman from the rest of herself, and it held the propertied woman responsible for protecting the human property in herself that belonged to her husband.

The Kamakura bakufu was a warrior government with a mission: to establish order among warriors based on the grant of fief and the recipient's obligation attached to it. For the imperial government, without a similar purpose or the practice of enfeoffment, the situation was quite different. The eighth-century imperial codes (*Yōrō ritsuryō*), set forth at the time of Japan's earliest state making, incorporated the legal language and terms used in China's Tang codes—sometimes regardless of their applicability to prevailing Japanese customs.[31] For example, the code stipulated punishment for all sexual unions made outside the proper marriage ritual (*li*) in the Chinese sense.[32] Both premarital and adulterous sex fell under the category of violation, or *kan*, of the proper ways. For premarital sex, the punishment was a one-year prison term; for adultery (involving a woman with a husband), the punishment was a two-year term. In the case of forced violation, the woman did not incur joint responsibility.[33]

The code distinguished forcible rape from consensual adultery and women with a husband from those without. Most significantly, rape was recognized as rape and its victim was free from the guilt of being raped.[34] A later imperial code on "violating another's wife," issued in 1263 during the Kamakura period, upholds these crucial distinctions: for rape, the man would pay two *kanmon* in cash and the woman would not pay. In the case of mutually consensual adultery, there was a penalty of two *kanmon* for the couple, to be paid by the man and the woman in equal proportion. The code is also explicit in declaring that there would be no judgment if the incident was not brought to court. Finally, if the woman had invited the act, the woman would pay two *kanmon* and the man would not pay.[35] Considering our modern legal situation and the complex interpretations of sexual harassment, this last item gives us much food for thought.

The codes issued by the imperial government positioned rape as a subcategory of *kan*—that is, "violation"—and maintained the philosophical and functional distinction between rape, or *gōkan* (illicit and coercive violation), and adultery, or *wakan* (illicit and consensual violation). But the warrior government paid less and less attention to this distinction, so crucial for the women involved. The record of a fascinating legal suit over a deceased father's estate, dated 1272, clearly demonstrates this lack of concern. The case involves two brothers, vassals of the Kamakura bakufu, who compete to defend or expand their claims to their father's land. In the process, each accuses the other of having had sex with their father's women: their mother (a nun), their stepmother, and their father's concubine. The trial record gives no indication as to whether these sexual acts were rape or adultery. The acts are expressed as *kaihō* (to embrace), *totsugu* (to have sex), and *kan* (to violate). The body of the women remained irrelevant to the judicial process, whose primary concern was the mediation of property transmission and the maintenance of social order.[36]

The law codes of the Muromachi bakufu (ca. 1336–1573) were issued against the background of greater political decentralization and the growing strength of regionally independent military lords. By this time, patrilineal and patrilocal marriages had firmly taken hold, and women were largely excluded from property transmission. Though the initial set of codes (*Kenmu shikimoku*), issued by the bakufu on 1336.11.7, included no provision regarding rape or adultery, an incident that occurred in the aftermath of the Ōnin War (1467–77) forced the bakufu to come up with an effective code. In 1479, a

samurai had sex (*mikkai*) with the wife of a saké seller in Kyoto. Her husband avenged himself by cutting down the intruder on the street. As it happened, the dead man had served the Akamatsu, a major warrior house. The husband's son had served the Itakura, another major house, and was a relative of the Yamana, who were the archenemies of the Akamatsu. The cast of characters, the timing of the incident, and its emotional quality promised to explode into a confrontation and possibly a replay of the Ōnin War. In fact, the two camps immediately began to assemble fighters for further revenge. The Muromachi bakufu came up with this: if the wronged husband kills the violator outside his own home, he must also kill his wife; if the revenge takes place within his own home, the wife may be spared.[37]

This differed from the earlier Kamakura code in two significant ways. First, the conceptual distinction between rape and adultery, which at least had been acknowledged, was now gone. Laws only spoke of *mittsū* (the same as *mikkai*)—an inclusive category describing illicit sexual intercourse. Second, the bakufu no longer had the responsibility to punish adultery or rape. Instead, the law expected the wronged husband to kill the violator, probably upholding a widely recognized custom under which the husband, in his own home, would kill a perpetrator on the spot, letting the wife live. If revenge took place outside the husband's home, however, the law required him to kill the wife as well.

Why should the wife die? The reason was that killing the man alone might be misunderstood as a common form of murder, a crime in and of itself. Killing the wife provided concrete evidence that the husband was committing an act of revenge, fully supported by customary practices, in retaliation for invasion of the man's space and his property, which included his wife's body. Thus, the consequence of illicit intercourse for a married and propertied woman moved from the loss of her land in the thirteenth century to the possible loss of her life in the fifteenth. (By that time, she seldom held property of her own.) The extramarital sexual intercourse of the wife of the saké seller—regardless of whether it had been adultery or rape—prompted the issuance of a new bakufu code, and, in accordance with its prescription, she was indeed cut down by her husband.[38]

Laws issued by various warrior houses in the sixteenth century essentially upheld the same punitive principles, with some variations, embracing the notion that the husband (*honpu*, the "true" or "original" husband) should kill the violator (*kanpu*, the "violating" husband)

and the wife. If the violator was caught in the bedroom, the wife might be spared. The Daté family codes (*Jinkaishū*), issued in 1536, and the house codes of the Rokkaku (*Rokkakushi shikimoku*), issued in 1567, for example, state that "both man and woman must be killed by the husband." The *Jinkaishū* also treats the abduction of a daughter who is already engaged in the same manner as adultery (*mittsū*), requiring the same penalty as the one specified for the married couple.[39] These house laws represented the collective voice of warrior-class males as they struggled to bring social stability to their territories in years of extreme decentralization. The provision reflected, according to Katsumata Shizuo, the general understanding that a man held, practically speaking, autonomous and full rights within his own residence but little claim to revenge in the home of a third party.[40] A part of this effort to bring stability was played out on the female body, whose sexual boundaries were defined and guarded by the husband and his space. Public discourse promoting domainal welfare invested command and power over women—more specifically women's sexuality—with the legitimacy of law. As was suggested by Carole Pateman for the European tradition of social contract thought, the warrior codes "establish[ed] men's political right over women—[especially] sexual in the sense of establishing orderly access by men to women's bodies."[41]

LITERARY EVIDENCE OF ADULTERY AND RAPE

The attitude toward adultery (and rape) expressed in the sixteenth-century military house laws illuminates the great distance traveled from the depiction of rape and adultery found in the literature of earlier centuries and other classes. Takamure Itsue has noted that in the *Tale of Genji* (Japan's first "novel," written by Lady Murasaki in the early eleventh century against the backdrop of visiting marriage) a husband may pretend to know nothing about his wife's extramarital liaisons or may continue to show his fondness for her anyway.[42] She notes that in the Tokugawa period (1603–1868) some warriors regarded the *Tale of Genji* to be harmful to women's morality, and during the Meiji period (1868–1912) and the Pacific War sections depicting certain adulterous relationships involving emperors were censured.[43]

Popular tales such as those in the *Konjaku monogatarishū* (Tales of Times Now Past), compiled in the twelfth century, also depict many instances of rape among people of different classes.[44] In these, women

were not punished by anybody for having been raped, though they might be admonished for independent actions that led to the rape, a typical instance of blaming the victim. In one case, a wife is raped at swordpoint by a priest while her husband is away from home. In another, an aristocratic woman on a pilgrimage to an isolated temple is raped by a ruffian.[45] The tale's compiler declares that, in the first case, the wife should not have decided on her own to allow the priest to perform ceremonies while her husband was away; in the second, he cautions that travel by women of naive heart (*kokoro osanaki onna*) must cease.

Whether or not these stories accurately represent the contemporary perception of rape, we can assume that the ambiguity and flexibility in descent, inheritance, and marriage patterns; the strength of female property rights; and a great tolerance of polyandry (to a lesser extent than polygamy) doubtless influenced how the woman's body was then viewed. As the patrilineal descent and inheritance pattern came to be firmly consolidated among the warriors of the late medieval era, women's sexuality also came to be possessed by the male line. The male order appropriated women's sexuality to itself, as each house sought stability and power in an increasingly militaristic society. In this competition, the warrior class fraternally shared collective control of female sexuality.[46] The changing political structure and military needs of the ruling warrior families demanded increasingly stringent mediation in the female sexual realm as they also subverted women's economic independence by taking away their property rights.

AFTERTHOUGHTS

This essay has discussed rape, a form of sexual violence that occurs at the vagina. This way of structuring the discussion in and of itself may reflect my late-twentieth-century American bias. It is not meant to foreclose the consideration of other aspects of the confusing field of sexual violence. Some forms of violent male appropriation did not involve the flesh. Heian literature suggests that women's handwriting, their floor-length hair, their silk garments, and their perfumes were all potent symbolic loci of sexual appeal for aristocrats. If so, what, for instance, did the theft of clothing signify? Was the action of a priest who seized a female worshipper's outer robes near Daigo temple in the mid-thirteenth century, for example, simple property damage or a grave sexual offense?[47]

We may also consider the meaning of hair. In a society in which hair was the shining black flag of a woman's secular status, as Katsuura Noriko has suggested, we may assume that haircutting could signal condemnation or denial of female sexuality. Take the incident on the Ategawa Estate in 1275 in which the estate manager (*jitō*) rounded up the wives, "cut off their ears, noses, and hair, and made them into *nuns*" after their husbands had absconded in protest of onerous taxation.[48] Likewise, an adulteress was sometimes punished by haircutting.[49] Here short hair was an inscription of shame, a visual representation of a desexualized, castrated female—perhaps a subjectively more humiliating experience than uninvited vaginal penetration, which at least was hidden from continuous public view. But the story of the woman's subjective experience and feelings remains largely unarticulated, as uncovering it is a task made formidable by the scarcity of relevant sources.

We may inquire into the subjective experiences of rape by contextualizing them within the culturally specific meanings and practices related to sex and sexuality. According to Japan's native religious system, sexual union was a cause for celebration, not for guilt or grief. In contrast to what the expulsion of Adam and Eve from the Garden of Eden may say about sex,[50] the *Kojiki*,[51] Japan's creation myth and the textual foundation of its native belief system (later called Shinto), abounds in sexual symbols related to the birth of the Japanese archipelago and the activities of deities and mortals. Historically, the stories in the *Kojiki* have perpetuated sexual images in ceremonies and people's daily lives through, for instance, vagina- and phallus-shaped offerings and stone statues on roadsides. In ancient Japan, sexual intercourse seems to have lacked the restrictive moral imperatives—sex for reproduction only—idealized in Judeo-Christian societies.[52] Ancient society had few restrictions on the number of lovers one could take (though women had fewer than men). It seems that copulation of unmarried youths was encouraged, especially during such festivals as the *kagai*, or songfest, in which an exchange of poems preceded sexual union. *Yobai*, or "night crawling," in which men visited women at night at the latter's homes, was also a custom in some areas.[53] There is no evidence that there was a semantic distinction between rape and willing sexual union.

The same was true of Japan's ancient marriage custom in which the term *totsugu*, which today means "for a woman to marry into a man's house," meant "to have sex" whether or not it was forced on

the woman. Ancient and medieval literature, whether written by women or men, typically positions all sexual unions—good or bad—as the preordained effects of karma or consequences of one's previous life; lovemaking and what we might call "rape" seem to have been born from the same cyclical dynamic.[54]

Perhaps the most significant factor in considering Japan's place in cross-cultural, comparative discussions of rape and sexuality is the absence of concern for virginity—a primal organizing principle in the construction of sexuality in most societies.[55] In Japan, we find no terminology for virginity as such until the nineteenth century, and the only possible analogue is a reference to the "purity" of young girls "who had had no men," a quality required for marriage to gods and their descendants (emperors).[56] Premodern Japanese society seemingly made no connection between a woman's reshaped hymen and her loss of honor or social value assessed in terms of marriageability.[57] Was the social and psychological impact of rape different in this society compared with those that monitored virginity and assessed it against social and economic power relations? These customary sexual practices, while providing no direct and conclusive link, may nonetheless have influenced the way the female victim, her assailant, her family, society, and even the political authorities viewed and treated the experience of sexual violence.

NOTES

1. Nagasaka Kazuo, *Sei fūzoku*, 3 vols. (Yūzankaku, 1989–90; first published in 1959).

2. See, for instance, Ichirō Hori, "Rites of Purification and Orgy in Japanese Folk Religion," *Philosophical Studies of Japan* 9 (1969): 61–78; and Ishida Eiichirō, *Momotarō no haha: aru bunkashiteki kenkyū* (Kōdansha, 1991; first published in 1984).

3. Negishi Kennosuke, *Kodaijin no sei seikatsu* (Kindai Bungeisha, 1983), 144.

4. This dichotomous thinking has made studies of sexuality illegitimate, according to Robert A. Padgug. See his now classic article "Sexual Matters: On Conceptualizing Sexuality in History," *Radical History Review* 20 (spring-summer 1979): 3–23, later published in Martin Duberman, Martha Vicinus, and George Chauncey, Jr., eds., *Hidden from History: Reclaiming the Gay and Lesbian Past* (New York: Meridian, 1990), 54–64. R. Howard Bloch, in his *Medieval Misogyny and the Invention of Western Romantic Love* (Chicago: University of Chicago Press, 1991), provides Western literary evidence for how "the feminine is . . . synonymous with the realm of the senses," quoting, for instance, Philo, who "states that 'the most proper and exact name for sense-perception *is* "woman,"' who is allied with the sensitive (i.e., sensual) part of the soul as opposed to man who remains on the side of intellection" (105).

5. See her *Shōseikon no kenkyū*, 2 vols. (Rironsha, 1977; first published by Kōdansha in 1959); and *Josei no rekishi*, 2 vols. (Kōdansha, 1977). From 1938 on, she spent no less than ten hours daily and altogether thirteen years and nine months

to complete these projects (*Shōseikon no kenkyū*, 1:3). For an elaboration of Takamure's ideas, see my "Re-envisioning Women in the Post-Kamakura Age," in *The Origins of Japan's Medieval World: Courtiers, Clerics, Warriors, and Peasants in the Fourteenth Century*, edited by Jeffrey P. Mass (Stanford: Stanford University Press, 1997), esp. 146–55.

6. See the appendix to this volume for a discussion of relevant authors. In addition, the following are important: Zenkindai Joseishi Kenkyūkai, ed., *Kazoku to josei no rekishi: Kodai-chūsei* (Yoshikawa Kōbunkan, 1989); Joseishi Sōgō Kenkyūkai, ed., *Nihon josei no rekishi*, 3 vols., with subtitles *Sei, ai, kazoku, Bunka to shisō*, and *Onna no hataraki* (Kadokawa Sensho, 1992–93); and Sekiguchi Hiroko, *Nihon kodai kon'inshi no kenkyū*, 2 vols. (Haniwa Shobō, 1993). More recently, scholars have focused on sexuality per se in, for example, Kurachi Katsunao and Sawayama Mikako, eds., *"Sei o kangeru": watashitachi no kōgi* ("Thinking about sex": our lectures) (Kyoto: Sekai Shisōsha, 1997).

7. Sylvana Tomaselli has an excellent discussion of the definitional problems surrounding the term *rape* in her introduction to Sylvana Tomaselli and Roy Porter, eds., *Rape: An Historical and Social Inquiry* (Oxford: Blackwell, 1986), esp. 9–11.

8. As of 1995, of the approximately 2.4 million reported cases of crime, about 1,600 were called rape (*gōkan*). Between 82 and 92 percent of the criminals have been arrested annually since 1984. See Hōmushō Hōmu Sōkai Kenkyūjo, ed., *Hanzai hakusho* (Hōmushō, 1995), 408–9. I thank Mieko Yoshihama for providing this information.

9. Craig Palmer examined societies in which rape was seen to be either absent or inconceivable by other ethnographers and reached the conclusion that rape is universal. Palmer advocates its elimination not through abandonment of social practices that encourage rape but through identification of "the ways in which certain cultures are inefficient in discouraging males from raping" ("Is Rape a Cultural Universal? A Re-examination of the Ethnographic Data," *Ethnology* 28.1 [January 1989]: 12).

10. See Catherine MacKinnon, "Does Sexuality Have a History?" *Michigan Quarterly Review* 30.1 (winter 1991): 1–11.

11. Susan Brownmiller, *Against Our Will: Men, Women, and Rape* (New York: Simon and Schuster, 1975), 5.

12. This rhetorical question is posed by Roy Porter in "Rape—Does It Have A Historical Meaning?" in Tomaselli and Porter, *Rape*, 216.

13. Ogino finds this dichotomous thinking in *Nihon joseishi* and *Bosei o tou*, edited by Joseishi Sōgō Kenkyūkai and Wakita Haruko, respectively (Tōkyō Daigaku Shuppankai, 1982 and 1990, respectively). She contends that this binary thinking reflects the authors' unconscious absorption of Victorian-style pruderies that entered Japan at the turn of the century. See Ogino Miho, "Seisa no rekishigaku: joseishi no saisei no tame ni," *Shisō* 768 (June 1988): 82–83.

14. See, for example, Sekiguchi Hiroko's magnum opus, *Nihon kodai kon'inshi no kenkyū* (see note 6). As the book's title (*The Study of Marriage History in Ancient Japan*) suggests, the discussion of rape is included in her meticulous examination of the various meanings of *kan* (see esp. 123–288).

15. Peggy Reeves Sanday, "Rape and the Silencing of the Feminine," in Tomaselli and Porter, *Rape*, 85.

16. For an excellent literary analysis of rape in Greek myth, see Froma Zeitlin, "Configurations of Rape in Greek Myth," in Tomaselli and Porter, *Rape*, 122–51. Susan Brownmiller provides a large sampling of cases of wartime rape in various countries in her *Against Our Will*, esp. 23–118.

17. Gerda Lerner, in her *The Creation of Patriarchy* (Oxford: Oxford University Press, 1986), argues that sexual subordination of women preceded the formation of private property and class society.

18. For the ancient period, see, for example, the following entry in *Nihon shoki*, which describes Japan's defeat by Silla in A.D. 562: a Silla general asks a Japanese general, Kawahe no omi, "which is dearer, your life or your woman?" Responding, "Why, for the love of one woman, should I choose misfortune? Nothing surpasses life," he gives up his woman. The Silla general then violates her in the presence of all (Sakamoto Tarō et al., eds., *Nihon shoki*, vol. 2 of *Nihon koten bungaku taikei* [Iwanami Shoten, 1994], chap. 19, 124). Rape of foreign women by Japanese men during the Pacific War was extensive and is well known. Stories of amatory pursuits that may or may not have been "rape" can be found in abundance, for instance, in such Heian literature as the *Tale of Genji*.

19. Hitomi Tonomura, "Women and Inheritance in Japan's Early Warrior Society," *Comparative Studies in Society and History* 32.3 (July 1990): 592–623.

20. Hincmar (ca. 806–82) was the archbishop of Rheims. George Duby, in his *Le chevalier, la femme et le pretre: Le marriage dans la France feodale* (Paris: Hachette Littérature Générale, 1981), also comments that "rape is ubiquitous in the small number of ninth century texts that have come down to us" (quoted in Sylvana Tomaselli's introduction to Tomaselli and Porter, *Rape*, 3n.6).

21. Entries for 1200.4.8, 4.10, and 4.11, in Nagahara Keiji and Kishi Shōzō, eds., *Zenyaku Azuma kagami* (Shinjinbutsu Ōraisha, 1976–77), 3:385–86.

22. "Goseibai shikimoku," no. 34 in Ishii Susumu et al., eds., *Chūsei seiji shakai shisō*, vol. 21 of *Nihon shisō taikei* (Iwanami Shoten, 1972), 1:27.

23. Ibid.

24. One story, "Monokusa Tarō," in a late medieval collection of narrative tales, the *Otogi zōshi*, has the lazy hero, with no money to hire even a cheap prostitute, ask a worldly man: "What is *tsujitori*?" The answer is: "It is a universally permitted practice of abducting a beautiful woman who is traveling unaccompanied by a man or in a carriage." The hero then stands in front of a popular temple with his arms wide and waits for an appropriate catch. Many young women pass, but he is insufficiently moved to capture any until he sees one seventeen or eighteen years of age with beautiful black hair and eyebrows like cherry blossoms on the distant mountain, clothed in a many-layered kimono, a bright red underskirt, sandals with no backing and a hair ornament scented with plum . . . she is the Boddhisatva herself. He grabs her. Physically overwhelmed, the woman resists by challenging him with a series of poems full of classical allusions. Passersby look on sympathetically, but no one does anything. In the poetic contest, she is essentially defeated, as he responds with quick wit, fully in command of all the appropriate metaphors. She finds him appalling but considers this incident another manifestation of karma. She gives him a cryptic description of her house and finds an opportunity to get away as he loosens his grip. When the man finds her house, she allows him to stay one night to protect him from the house guard. After she has him bathe for seven consecutive days, he becomes a different person, not only in appearance but in rank and wealth. He is found to be a lost son of an emperor, becomes the lord of a certain district, governs the people benevolently, lives 120 years, and in the end turns into a deity along with his wife (Ichiko Teiji, ed., *Otogi sōshi* [Iwanami Shoten, 1957], 187–207). See also the English-language translation by Virginia Skord in her *Tales of Tears and Laughter: Short Fiction of Medieval Japan* (Honolulu: University of Hawaii Press, 1991), esp. 185–204, under the title, "Lazy Tarō." Her rendering of *tsujidori* is

"cruising," literally "street-corner picking," or soliciting a prostitute (191, 203, n. 6). The bakufu law suggests that the term applies to the capturing of women in general.

25. Amino Yoshihiko, *Ikei no ōken* (Heibonsha, 1986), 73.
26. "Goseibai shikimoku," no. 34, in Ishii et al., *Chūsei seiji*, 1:27.
27. Katsumata's interpretation is based mostly on narrative tales and assumes that the instances of violation are cases of adultery, not rape, although the term *kanpu*, used in these tales, can mean either an adulterer or a rapist. See Katsumata Shizuo, "Chūsei buke mikkai hō no tenkai," *Shigaku zasshi* 81.6 (June 1972): 4–7. This article was later included in his *Sengoku hō seiritsu shiron* (Tōkyō Daigaku Shuppankai, 1979).
28. *Azuma kagami*, 3:385–86.
29. "Goseibai shikimoku," nos. 12, 13, 15, in Ishii et al., *Chūsei seiji*, 1:14–16.
30. "Goseibai shikimoku," no. 4, in Ishii et al., *Chūsei seiji*, 1:10.
31. See the editor's comment in Inoue Mitsusada et al., eds., *Ritsuryō*, vol. 2 of *Nihon shisō taikei* (Iwanami Shoten, 1994; first published in 1976), 563–64: "In ancient Japan, premarital sex was relatively free, and we can assume that most marriages began first with sexual relationships. Therefore, these articles had no actual function. The Japanese codes [usually] demonstrate much revision from the Tang codes, but for these provisions, the codifiers adopted the Tang codes as they stand. Is this perhaps because the codifiers sought to educate the people in the ways of Chinese family morality and propriety in order to establish order?"
32. The code presupposed Chinese–style marriage based on the formal recognition and approval of each family's household head, to be followed by the fulfillment of a set of six rituals. Japan lacked the equivalent concept or custom of "marriage" (Sekiguchi, *Nihon kodai*, 125).
33. The term *violation* appears in a number of contexts in ancient sources. Sekiguchi Hiroko classifies them into the following categories: (1) incest, sex between siblings with the same mother; (2) pollution, men's sexual contact with women in ritual occupations, including shrine maidens and nuns; (3) mourning period, a widow's sexual relationship during the period of mourning for her deceased husband; (4) premarital sex, an engaged woman's sexual relationship with men other than the future husband; (5) adultery, a man's sexual relationship with other men's wives; (6) status exogamy, a sexual relationship that crosses the status boundary between ordinary people (*ryō*) and inferior people (*sen*); (7) rape, the coercive sex that we call rape today; and (8) unclear situations (*Nihon kodai*, 136).
34. See Sakagami Akikane, ed., *Hōsō Shiyōsho*, no. 41, in vol. 1 of *Nihon keizai taiten*, edited by Takimoto Seiichi (Yoshikawa Kōbunkan, 1928), 98; and Katsumata, "Chūsei buke mikkai hō no tenkai," 23.
35. From "Jingikan kudashibumi," dated 1263.4.30, in Kasamatsu Hiroshi et al., eds., *Chūsei seiji shakai shisō*, vol. 22 of *Nihon shisō taikei* (Iwanami Shoten, 1981), 2:29–30.
36. Entry dated 1272.12.26 in Seno Seiichirō, ed., *Kamakura bakufu saikyojōshū*, vol. 1 (Yoshikawa Kōbunkan, 1970), doc. 132, 176–79.
37. Entry dated 1479.5.23, in "Nagaoki Sukune nikki," cited in Satō Shin'ichi and Ikeuchi Yoshisuke, eds., *Chūsei hōsei shiryōshū* (Iwanami Shoten, 1957), 2:237–38. Described in Joseishi Sōgō Kenkyūkai, *Nihon josei no rekishi: sei, ai, kazoku*, 107.
38. "Nagaoki Sukune nikki," entry dated 1479.5.23 (see note 37).
39. "Rokkakushi shikimoku," no. 49, in Ishii et al., *Chūsei seiji*, 1:295; "Jinkaishū," nos. 163, 164, 165, in Ishii et al., *Chūsei seiji*, 1:237–38.

40. Katsumata, "Chūsei buke mikkai hō no tenkai," 15–16. He also states that there were many cases of such executions (Ishii et al., *Chūsei seiji*, 1:460–61).

41. Carole Pateman, *The Sexual Contract* (Stanford: Stanford University Press, 1988), 2.

42. Takamure, *Shōseikon*, 2:880. Here Takamure may be too optimistic about the absence of negative sentiments directed at adultery. Illicit relationships are not always received with open arms by husbands or society in the *Tale of Genji*. What needs to be said, however, is that adultery in and of itself is not depicted as a crime, and a woman sharing her body with a man other than her husband is not punished directly. What seems immoral is not the woman but the relationship that involves a particular set of people—such as a woman and her stepson. We might also note, again to modify Takamure's idealistic view, that some instances of sexual advances in Heian literature could be called rape under our modern American definition of the term. I thank an anonymous reviewer for urging me to clarify these points.

43. Ibid., 1:611–12.

44. The translation of the title is from Marian Ury, *Tales of Times Now Past: Sixty-Two Stories from a Medieval Japanese Collection* (Berkeley: University of California Press, 1979). For analyses of gender relations and sexuality found in the *Konjaku monogatarishū*, see my "Long Black Hair and Red Trousers: Gendering the Flesh in Medieval Japan," *American Historical Review* 99.1 (February 1994): 129–54, esp. 149–52 (on the representation of sexual assault in these tales).

45. Tales 26–21 and 29–22. The tales' numerical designations follow those in Yamada Takao et al., eds., *Konjaku monogatarishū*, vols. 22–26 of *Nihon koten bungaku taikei* (Iwanami Shoten, 1979–80).

46. We may link this development to the development of the notion of motherhood valued solely for the benefit of the male line. On the changing concepts of motherhood, see Wakita Haruko, "Bosei shōchō shisō to zaigōkan—chūsei no bungei o chūshin ni," in *Bosei o tou*, edited by Wakita Haruko (Kyoto: Jinbun Shoin, 1985), 1:172–203.

47. This incident, recorded in a document from around 1241, is cited in Tsuchiya Megumi, "Ganshu to ama: Daigoji no josei," in *Ama to Amadera*, vol. 1 of *Josei to bukkyō*, edited by Ōsumi Kazuo and Nishiguchi Junko (Heibonsha, 1989), 206.

48. Katsuura Noriko, "Amasogikō: kamigata kara mita ama no sonzai keitai," in *Ama to Amadera*, 33–34. The governmental codes of the Kamakura bakufu prohibited local warriors (such as the *jitō*) from seizing property left by absconding peasants. Property included wives and children as well as movables. See "Goseibai shikimoku," no. 42 in Ishii et al., *Chūsei seiji*, 1:31.

49. Katsuura, "Amasogikō," 36.

50. Elaine Pagels, *Adam, Eve, and the Serpent* (New York: Vintage, 1988).

51. The best translation is Donald L. Philippi, *Kojiki* (Tokyo University Press, 1968).

52. Genesis and the *Kojiki* have strikingly different outlooks on sexual matters. See Elaine Pagels's explanation of the evolution of sexually restrictive attitudes in the West in *Adam, Eve, and the Serpent*.

53. A discussion of polyandrous practice and the songfest can be found in Michiko Y. Aoki, *Ancient Myths and Early History of Japan* (New York: Exposition Press, 1974), 143–55. Novels and diaries written by aristocratic women reveal patterns of sexual practice in the Heian period. See, for example, Sei Shonagon, *The Pillow Book of Sei Shōnagon*, edited and translated by Ivan Morris (Baltimore: Penguin, 1967).

54. According to Daigan and Alicia Matsunaga, karma justified the illusory nature of life, induced resignation, and promoted hedonism. See their *Foundation of Japanese Buddhism* (Buddhist Books International, 1974), 1:213–14.

55. Little has been written about the historical significance of the concept and prac-
tice of virginity. Christen Hastrup provides a comparative discussion of virginity
as a biological category that is integrated into the social and cultural construc-
tion of the position of women. See her "The Semantics of Biology: Virginity," in
Shirley Ardener, ed., *Defining Females: The Nature of Women in Society* (Lon-
don: Croom Helm, 1978), 49–65.
56. Karen A. Smyers states that at the beginning of Japan's state-making period "vir-
ginity" signified a woman's spiritual state. Even a pregnant woman could be
virgin. The requirement of virginity for women to be possessed by deities did not
emerge until a few centuries after the compilation of the *Kojiki* in the eighth
century. See her "Women and Shinto: The Relation between Purity and Pollu-
tion," *Japanese Religions* 12.4 (July 1983): 11.
57. Evidence of this is abundant for premodern Japan. Luis Frois, a European in
Japan at the end of the sixteenth century, was struck by this lack of concern, in
contrast to that of his home society, and noted it in his writing (cited in Amino,
Ikei no ōken, 73n.25).

Imagining Working Women in Early Modern Japan

YOKOTA Fuyuhiko

Translated by Mariko Asano TAMANOI

It is generally assumed that the status of women was low in early modern Japanese society, owing to the formation of status and feudal systems that maintained patriarchy. Commonly held views of women's history argue that Japanese women's status had been higher in the ancient period owing to the matrilineal system then in effect. The establishment of private property, the class system, and the house (*ie*) system gradually brought it down. During the Tokugawa period, it reached its nadir, but the emergence of modern women's movements restored women to a higher status, a trend that continues today.[1]

RETHINKING THE *GREATER LEARNING FOR WOMEN*

The most visible culprit that has helped to promote this negative assessment of the Tokugawa period is *Onna daigaku* (Greater Learning for Women), a widely circulated moralistic text attributed to Kaibara Ekken. Dating from the early eighteenth century, it encapsulates the discourse that subordinates women to their husbands (and/or their houses) and entraps them within the home, based on a gendered division of labor for housework, reproduction, and child rearing. According to the text, a woman should think of "her husband's house as her own" and "obey her husband as her master." A woman should be mindful of the seven reasons for which a man might divorce her, including disobedience, infertility, and talkativeness. The text advises a woman "not to go out needlessly, but to stay at home to sew clothes for her parents-in-law, fix meals, serve her husband, wash and fold clothes, sweep the floor, and rear children."[2] This clearly worded text has often tempted modern writers to characterize women's status as low for the entire two and a half centuries of the Tokugawa period.

In contrast to this conventional assessment of the status of women in early modern Japan, more recent studies have revealed that women participated not only in housework and child rearing but in various forms of socially productive labor. As a result, they have argued that an important gap existed between discourse and practice.[3]

What, then, is the relationship between these recent images of women as producers and the supposedly dominant discourse seen in *Greater Learning for Women*? One way of explaining it has been to assume that women as producers and women represented in the dominant discourse come from distinctly different social, chronological, and discursive origins. First, in terms of class, the images found in this text might be considered representations of women from either the warrior or the urban upper classes; commoner women who actually worked at various kinds of occupations led very different lives. The second explanation points to issues of historical periodization. During the seventeenth century, women may have existed in the state depicted in *Greater Learning for Women*, but by the last half of the early modern period it appears that this situation may have broken down as women came to participate in the work force. It has been confirmed, however, that even ordinary farm women in peasant villages read *Greater Learning for Women*, and by the time it was disseminated in the middle of the early modern period various kinds of work that precluded women being shut up inside the house had already become widespread.[4] The third explanation makes a distinction between the legal system and ideology, on the one hand, and actual practice on the other.

The two need not, however, be seen as contradictory. Drawing on the findings in the field of Japanese ethnology, we can reevaluate women's labor in terms of its contribution to the cooperative management of the household by both wife and husband and use this reappraisal to read what in *Greater Learning for Women* is termed "instructions given to domestic servants" as, in modern parlance, the authority of the housewife. What we find in addition is that women were engaged in a wide variety of work even in the formative stages of the early modern period and that these experiences never confined them solely to the house. At the same time, *Greater Learning for Women* was relevant to the lives of commoner women. Women's work developed basically in tandem with it, and the issue lies in understanding how they were articulated together.

It must be pointed out that the text we know as *Greater Learning for Women* is one that has been taken out of context. Up to the present day, no one has paid any attention to the fact that it was first published as one section of *Onna daigaku takara bako* (A Treasure Chest of Greater Learning for Women), first published in 1716, by Kashiwabara Seiemon in Osaka and Ogawa Hikokurō in Edo. In addition to the text of *Greater Learning for Women*, this volume includes items related to training in literature and the arts such as poems taken from the fifty-four chapters of the *Tale of Genji*, a collection of one hundred selected poems by one hundred poets (the *Hyakunin isshu*), both from the Heian period, plus biographies of twenty-four filial children in China and essays promoting practical knowledge related to the proper care of clothing, how to train children, and what to do in medical emergencies. This text is but one example of a large number of books for educating women that came to be printed in the flourishing mass publishing culture centered in the three major cities during the late seventeenth through early eighteenth centuries.

A Treasure House of Greater Learning for Women also provides precisely detailed illustrations of practices in agricultural work done by women as well as a variety of occupations performed by female artisans and merchants—including prostitutes—under the heading "A Complete Illustration of Lower-Class Women's Manual Skills" (fig. 1). In this way, far from negating the value of female labor, the discourse of *Greater Learning for Women* itself stood on a philosophical foundation that recognized the great variety of work performed by women. To restate this position, the text known as *Greater Learning for Women* should not be read in isolation but in terms of its place within the entirety of *A Treasure Chest of Greater Learning for Women* and as one segment of a larger discourse that sustained the publishing culture of its time.

Lists of women's occupations that came to be produced and circulated in print were not confined to such books as *A Treasure Chest of Greater Learning for Women*, which emphasized women's training and education. I shall examine these lists and analyze the location of *Greater Learning for Women* within them in order to advance our understanding of the discourse concerning early modern women's work and the perspectives that were brought to bear on it in this society.

Fig. 1. "A Complete Illustration of Lower-Class Women's Manual Skills."

HISTORICAL RECORDS THAT LIST WOMEN'S OCCUPATIONS

The oldest of the books devoted to cataloging occupations is the dictionary-style *Jinrin kimmō zui* (Miscellaneous Instructions for Enlightening Humanity), completed in 1690.[5] The publication of this kind of compendium had begun with *Kimmō zui* (Miscellaneous Instructions for Enlightenment), by the Confucian scholar Nakamura Tekisai (1629–1702), published in 1666, and the 1690 publication that extracted from it the section on the four social classes. Describing about five hundred kinds of work performed by men and women, it is really an encyclopedia of occupations.

Another encyclopedia of occupations, from 1732, *Hyakunin jorō shinasadame* (Evaluation of One Hundred Women), was devoted to women.[6] The first volume describes the wives of the court nobility, the military aristocracy, Shinto priests, Buddhist priests, warriors, townsmen, artisans, and peasants in terms of the kind of work they did (fig. 2). The second volume focuses on other female occupations, including prostitution in the licensed quarters of Shimabara in Kyoto, Yoshiwara in Edo, and Shinmachi in Osaka; various types of concubines; bathhouse attendants (*furo onna*); tea house waitresses (*chaya onna*); female servants; female entertainers who solicited contributions for religious purposes (*kanjin*); and nonlicensed prostitutes. The 1695 *Wakoku hyakujo* (One Hundred Women of Japan) had similar contents. As Sone Hiromi makes clear in her essay in this volume, the service sector of the economy, including prostitution, constituted a major source of employment for women during this period, and no list of female occupations could claim comprehensiveness without including it.

In addition to these occupational encyclopedias, lists of women's occupations also appear in books belonging to two genres: educational books for women and erotic literature. The educational books for women list an amazing variety of statuses and occupations. *Onna chōhōki* (Important Treasures for Women) from 1692 mainly provides practical knowledge for women, yet in the first part there are drawings of aristocrats, warriors, townswomen, peasants, concubines, harlots (*keisei* or *yūjo*), the wives of brothel owners, and widows.[7] It also explains the different terms used for wives in each class, from the emperor's consort to the basest of outcasts. *A Treasure Chest of Greater Learning for Women* is an educational book that includes pictures showing upper-class women's child-rearing practices and writing styles plus pictures of women sewing, picking cotton, working

Fig. 2. *Hyakunin jorō shinasadame.*

a cotton gin, hand-loom weaving, doing laundry, and working at twenty or so other occupations defined as "jobs done by lower-class women." Although its selection of poems taken from the fifty-four chapters of the *Tale of Genji* is the main focus of another text from 1736, *Onna Genji kyōkun takarakagami* (A Treasured Reflection of Precepts for Women from *Genji*), the latter also illustrates its instructions in women's customary practices by including pictures of aristocrats, warriors, townspeople, widows, nuns (*bikuni*), and concubines plus the different kinds of prostitutes (*tayū*, *tenshoku*, *kakoi*, *hashijorō*), tea house waitresses, and bathhouse attendants.[8] The late seventeenth century saw a number of books of this type.

Another place to look for information on women's occupations is in erotic literature. The original purpose of the *Shikidō ōkagami* (The Great Mirror of the Erotic Way) of 1678 was to serve as a guidebook to the licensed prostitution quarters.[9] Naturally enough, its first chapter describes many types of prostitutes, but it also presents twenty-six occupations for women, ranging from those performed by the wives of townsmen to unlicensed prostitutes. *Miyako fūzoku kagami* (A Mirror of Customs in the Capital), published in 1681, includes discussions of the wives of merchants, various female servants, bathhouse attendants, tea house waitresses, and proselytizing nuns in the section on the manners and fashions of urban women. In its literary style, this book reflects the process of transformation from the storybooks using the Japanese syllabary (*kana zōshi*) of the early seventeenth century to the erotic literature found in realistic novels (*ukiyo zōshi*) at its end.[10] *Kōshoku ichidai onna* (The Life of an Amorous Woman), published by Ihara Saikaku in 1686, stands as one of the masterpieces of the realistic novel.[11] While tracing the protagonist's life, the novel depicts thirty to forty occupations for women, from companion to a daimyo and wife of a townsman to various types of domestic work, then female entertainer, prostitute, and unlicensed prostitute. Other books from the same period take a similar sweeping approach to the range of occupations open to women. By excluding occupations related to agricultural, mountain, and fishing villages, these novels demonstrate the urban orientation of this particular form of erotic literature. In this fashion, it can be seen that from the late seventeenth to the early eighteenth century, all sorts of publications, from encyclopedias to educational treatises for women to erotic literature, came to include lists of women's occupations and statuses. It

would appear that in this period defining women's work had become a social concern that accompanied a certain degree of social acceptance.

Occupations for Women

In this section, I explore what was regarded as "women's work" in early modern Japan. The records show approximately one hundred types of occupation for women compared with more than four hundred types for men. The women's occupations reveal several noteworthy characteristics.[12]

In the agricultural, forestry, and fishing industries, women and men worked almost cooperatively. This can be seen in "A Picture of Farming" in *A Treasure Chest of Greater Learning for Women* and in the descriptions of female divers in sayings such as "the husband controls the boat and the woman dives to the bottom of the sea."[13] Compared to the mercantile and handicraft industries, in which men performed a wide variety of specialized tasks, women's specializations were concentrated only in those related to textiles: spinning, weaving, dyeing, cleaning, and sewing. In the category of service industries, jobs for women employed inside the house—attendants, maids, hostesses, seamstresses, wet nurses, and cooks—were all listed as "occupations." These domestic workers were employed widely by aristocrats, samurai, and even middle-class townspeople. They were not regarded simply as "domestics" but were proper wage earners. Finally, in the category of art, entertainment, and religion, men's "high-level artistic" jobs, such as scholarship, poetry (*waka*) writing, and medicine, as well as "low-level artistic" jobs, such as theatrical performance and ballad drama (*jōruri*) singing, were recognized as occupations. In contrast, most artistic work performed by women was simply consigned to the licensed prostitution quarters; the professions to be found there were not delineated.

The central issue here revolves around what was defined as an occupation. Apart from the agricultural, fishing, and forestry industries, "women's occupations" were restricted to the domestic sphere plus the textile and entertainment industries. A closer examination of explanatory notes attached to occupational lists in encyclopedias, educational materials, and books like *The Life of an Amorous Woman* can help us to analyze these occupations in greater detail by sorting them into six groups.

1. Small businesses in which the husband and wife work cooperatively
2. Piece-rate wage work done part-time at home within the putting-out system
3. Independent businesses run by women
4. Service (mainly domestic work)
5. Service (mainly work done in cottage industries)
6. Prostitution

Categories 1, 2, and 3 apply to married couples and families. More specifically, category 1 refers to the helpmate type of cooperative work done by a couple. Categories 2 and 3 must be considered within the context of the household economy in which both men and women worked for a living, although they might also apply to women living alone. Categories 4, 5, and 6 can be defined as live-in contractual labor. In fact, the distinctions between them are often ambiguous. Servants in cottage industries (category 5) might perform elements of the domestic labor done by the women of category 4, whereas the domestic servants defined in category 4 might also be expected to provide sexual services like those in category 6. In such cases, they served as a type of concubine.

It is assumed that the prevalence of these categories varied according to the social setting and historical period. In agricultural villages, the most common was category 1, the helpmate variety involving cooperative work done by a couple, although among wealthier peasants the work force might include servants from category 4. This pattern is also recognizable in fishing and mountain villages. In the cities as well, category 1 is usually considered to be basic, category 4 being found chiefly in the enterprises managed by upper-class townspeople and merchants. Categories 2, 3, and 5 are said to have made their appearance late in the early modern period.

This way of interpreting the history of the household economy corresponds to the discourse found in *Greater Learning for Women*, which presumes the practice of women's work to be subsumed under the control of their husbands and/or the male head of their households. This interpretation also corresponds to the current assumption among academics that the reality of women's lives began to diverge from their representation in such writings as *Greater Learning for Women* only under the economic conditions that developed late in the early modern period.[14]

In challenging this assumption, I argue that as early as the be-ginning of the seventeenth century, and certainly by the late seven-teenth and early eighteenth centuries, women were working part-time at home (category 2) and serving as wage-earning servants in cottage industries (category 5) on a wide scale in the textile-related indus-tries developing in Edo, Osaka, and Kyoto. Although the numbers were small, there also were female-operated, independent businesses (category 3) as well as women living alone and supporting them-selves in the cities. A literary expression of this phenomenon can be seen in *The Life of an Amorous Woman*, in which the protagonist manages to earn a living alone in the city by pursuing a variety of occupations.

It is difficult to determine to what extent the last three occupa-tional categories existed in contemporary society. According to fam-ily registration documents (*shūshi ninbetsuchō*) of this period, be-tween one-quarter and one-half of the female population in various sections of Kyoto and Osaka were servants.[15] We can conclude that this percentage represents women who worked as domestic servants or in cottage industries (categories 4 and 5). Other working women were engaged in cooperative businesses, wage work, or independent businesses, some of which were probably run by widows who are listed in the registers as living alone.

Particularly significant are examples of wage work for an em-ployer and independent businesses run by women (categories 2 and 3). In these situations, even women with husbands did not work un-der their husbands' supervision but dealt directly with customers and putting-out dealers (*toiya*) who were not members of their house-holds and paid wages directly to the women. Neither can we subsume female servants' work within the context of the patriarchal house-hold economy. Female servants usually renewed their contracts every six months, which means that they were highly mobile. The existence of specialized employment agencies for female servants (*kuchiire ya*) also points to the establishment of a labor market aimed solely at them in both domestic and cottage industry work.

It is clear that women's work had taken a variety of forms as early as the seventeenth century. For an understanding of the eco-nomic changes that made this kind of differentiation possible, let us consider the argument first made by Nagahara Keiji. He suggested that Japan's manufacturing structure shifted significantly when the materials for people's clothing changed from hemp to cotton during

the transition from the medieval to the early modern period.[16] In the medieval period, hemp was produced mainly for family and local use in agrarian villages, a cottage industry chiefly monopolized by farm housewives.[17] The introduction of cotton in the sixteenth century, in contrast, led to a variety of specializations in spinning and weaving, the development of subcontracting, and the establishment of large textile industries in the cities. In seventeenth century cities, the various specializations caused an increase in the demand for women's work in the form of publicly recognized occupations that were relatively simple forms of subcontracted wage labor or factory work. It is true that textile-related labor was considered women's work even in the most primitive stages of the division of labor. What I want to emphasize here, however, is that, on the one hand, this "women's work," instead of being done by wives to maintain their families' self-sufficiency, now integrated women into the work force, into a social system of production and marketing. On the other hand, it was denigrated because subcontracted labor was considered inferior to work done by men; it was so-called second-class labor. According to *Saikaku oritome* (Saikaku's Notes on Weaving), published in 1694, and *Seken musume katagi* (The Spirit of Worldly Women), published in 1717, men were criticized and made to feel shame for doing women's work and were castigated for not being mature adults if they ginned cotton.[18]

To sum up, wage labor and factory work in the textile industry, domestic labor, and even prostitution eventually came to be seen as publicly recognized occupations. It is for this reason that in the late seventeenth century we begin to see the appearance of published lists of occupations performed solely by women.

SOCIAL VALUATION OF WORKING WOMEN

How were these working women depicted in the descriptions of publicly recognized occupations? Let us examine this question by comparing educational books directed at women and erotic literature. Educational books for women offered instruction in various areas of knowledge that women might need in the course of their daily lives. Moral instruction, represented by works such as *Greater Learning for Women*, was included as part of an overall education. The ideal type of woman in this text was one who engaged in housework and child rearing and generally provided support services for her husband's work, an image that fits category 1. In reality, however, in the first

half of the early modern period women were already engaged in the work force in various occupations, including prostitution. Responding to this reality, these educational texts listed all occupations, including prostitution, as items of practical knowledge, but they defined them as the labor performed by base women and labeled them a necessary evil produced by women's low status or poverty.

Erotic literature, such as *A Mirror of Customs in the Capital* and *The Life of an Amorous Woman*, depicts merchants' wives and women shopkeepers who increase the number of regular customers with the strategic deployment of their beauty. Also described are female peddlers and hawkers for whom the final price of the merchandise includes the original price of the goods plus the woman's fee as a prostitute.[19] The section on miscellaneous women in *The Great Mirror of the Erotic Way* provides instructions on how to seduce various women who are classified according to their occupations: prostitutes, waitresses, maids, factory workers, and the wives of townsmen. This suggests that all the women on the list—whether or not they were explicitly engaged in sexual labor as prostitutes—were regarded as sexually loose (prostitutelike) as long as they had contact with the wider society through their work. In this literature, all female labor has a sexual dimension; every woman is in some sense for sale. This is the reason erotic literature includes lists of occupations.

There is no reason to assume that working women in the late seventeenth and early eighteenth centuries were as sexually loose as they were portrayed in erotic literature. One of the stories in *Saikaku's Notes on Weaving* is a case in point. In this story, a female servant, who envies the good-looking women of her day while painfully fulfilling her duties, devotes herself to applying cosmetics and dressing up the moment her contract expires. Her actions, seen as "prostitutelike," reflect the dominant society's interpretation of self-realization and self-expression on the part of women who sought to partake of the advantages brought about by late-seventeenth-century economic development and the concomitant improvement in lifestyles.

Greater Learning for Women denied the sexual and prostitutelike dimension of women's work, though it did not deny the existence of prostitution per se. It thus made a sharp distinction between prostitutes and ordinary women, locating all sexuality in the bodies of the prostitutes and demanding labor from ordinary women to maintain the household and reproduce heirs. Ordinary women were required

to remain chaste; women's morality was represented in the statement that "women should always consciously maintain strict standards of modesty." This text made a clear distinction between sex and reproduction by delineating the difference between prostitutes and sexual professionals on the one hand and wives and childbearers on the other. The spatial and classificatory institutionalization of licensed prostitution quarters in the early modern era systematized this division between prostitutes and ordinary women.

It might appear at first glance that women's educational books and erotic literature contradicted each other when it came to the relationship between women's work and sex (prostitution). This seems especially true because the readership of these two types of writing was divided between women and men. If we consider how society perceived and positioned the women who participated in the work force as a whole, however, it would seem that women's educational books and erotic literature coexisted interdependently within a single discourse.

While erotic literature assumed that all working women had the latent potential to become sexually loose, the discourse found in *Greater Learning for Women* implied this in rationalizing surveillance and ethical control over working women. This is a point that must be emphasized. The essential meaning of this discourse was not to suggest that those women who were working and supporting the economy should return to their homes. It intended rather to construct internal norms of self-restraint so intensive and excessive that working women would be able to protect themselves from the accusation of being sexually corruptible. Other evidence for interdependence between these two literary forms comes from an examination of the origin of texts like *Greater Learning for Women*. These educational books were not translated directly from Chinese Confucian texts but, like the erotic literature of the floating world, were born out of the seventeenth-century storybooks written in the Japanese syllabary. In other words, the relationship between these two types of books was fundamentally Janus faced. This claim has already been made in several studies of Japanese literary history.[20]

During Japan's medieval period, prostitutes had not yet been segregated from society nor had ordinary women developed a strong sense of chastity. A division between sex and labor as well as between sex and reproduction seems to have been a product of the early modern period. Early modern discourse gave the label "second-class labor"

to women who engaged directly in society by joining the work force without the intervening layer of a husband, and it simultaneously dictated the internalized norm that chastity and latent sexual looseness coexisted as two sides of the same coin. This historically specific discourse emerged with the establishment of an early modern society that was undergoing an early stage of industrialization.[21] The structure of this early modern ideology, therefore, was fundamentally different from the structure of ideology in the medieval period and before, which had discriminated against women because they were seen as polluted. Until now, *Greater Learning for Women* has been seen unproblematically as a reflection of Confucian morality and feudal ideology. Might it not be possible, however, to see it as the first step in the establishment of a structural relationship between the "good wife, wise mother" ideology and the pervasive presence of the "professional housewife" in modern Japan? This is not to deny the connection between women's advances in the work force and women's liberation. I mean simply to call into question the point at which this advance creates the structure of an ideology that casts it under a new spell.

NOTES

1. The works of Takamure Itsue, one of the most influential scholars in the development of women's history in Japan, illustrate some of the notions described here. See, for example, *Shōseikon no kenkyū* (Kōdansha, 1953); and *Josei no rekishi*, vols. 1, 2 (Kōdansha, 1954–55).
2. An English-language translation of *Onna daigaku* can be found in Sakai Atsuharu, "Kaibara Ekken and 'Onna Daigaku,'" *Cultural Nippon* 7.4 (1939): 43–56. The quotations are on pp. 45, 49, and 53. In fact, Kaibara Ekken did not write *Onna daigaku*. See Ishikawa Shōtarō, ed., *Onna daigaku shū* (Heibonsha, 1977). For the way these ideas came to be disseminated, see Michiko Y. Aoki and Margarett Dardess, "The Popularization of Samurai Values," *Monumenta Nipponica* 31.4 (1976): 393–413.
3. See for example, articles in *Kinsei*, vol. 3 of *Nihon joseishi*, edited by Joseishi Sōgō Kenkyūkai (Tōkyō Daigaku Shuppankai, 1982); Kinsei Joseishi Kenkyūkai, ed., *Ronshū kinsei joseishi* (Yoshikawa Kōbunkan, 1986); Kinsei Joseishi Kenkyūkai, ed., *Edo jidai no joseitachi* (Yoshikawa Kōbunkan, 1990); and *Kinsei*, vol. 3 of *Nihon josei seikatsushi*, edited by Joseishi Sōgō Kenkyūkai (Tōkyō Daigaku Shuppankai, 1990).
4. Yokota Fuyuhito, "Ekken hon no dokusha," in *Kaibara Ekken*, edited by Yokoyama Toshio (Heibonsha, 1995).
5. I consulted the original edition of *Jinrin kimmō zui*, published in 1690, in the Kobayashi Collection of Kobe University. The work was republished by Heibonsha in 3 volumes in 1990.
6. "Shoshoku fūzoku zue," in Miyamoto Tsuneichi, Haraguchi Torao, and Higa Shunchō, eds., *Nihon shomin seikatsu shiryō shūsei*, vol. 30 (San'ichi Shobō, 1982).

7. Ogawa Takehiko, ed., *Onna chōhōki, kanai chōhōki*, vol. 18 of *Kinsei bungaku shiryō ruijū sankō bunkenhen* (Benseisha, 1981), 1–220.

8. I used the original print of this work (first edition of 1736) in the Kobayashi Collection at Kobe University. The text includes depictions of women in emotional states such as jealousy. "Onnayō kimmō zui" (Drawings of instruction for enlightening women) was also compiled in 1687, but I omit it from the discussion here.

9. Noma Kōshin, ed., *Kanpon shikidō ōkagami* (Yūzankaku, 1961).

10. In Watanabe Morikuni and Watanabe Kenji, eds., *Kana zōshishū*, vol. 74 of *Shin Nihon koten bungaku taikei* (Iwanami Shoten, 1991), 429–78.

11. Ihara Saikaku, *Kōshoku ichidai onna* (Iwanami Shoten, 1960). There is an English translation by Ivan Morris, *The Life of an Amorous Woman, and Other Writings* (London: Chapman and Hall, 1963).

12. Wakita Haruko has performed a similar analysis of women's occupations in medieval Japan in *Nihon chūsei joseishi no kenkyū* (Tōkyō Daigaku Shuppankai, 1992), 178–88.

13. *Jinrin kimmō zui*, vol. 3.

14. See, for example, Seki Tamiko, *Edo kōki no josei* (Aki Shobō, 1980).

15. Tsuruoka Mieko, "Kan'ei-ki no 'Kirishitan kishōmon' kara mita Rokkaku-chō no jūmin kōsei," *Shiryōkan hō* 28 (1978): 1–4; Hayami Akira, "Kyoto machikata no shūmon aratamechō," *Tokugawa rinseishi kenkyūjo kenkyū kiyō* (1981): 502–41; Hayami Akira, *Osaka kikuya-chō shūshi ninbetsuchō*, vol. 1 (Yoshikawa Kōbunkan, 1971). This percentage is based on the entire female population, which included a number of infants as well as very old women who were unable to work. Thus, if only the female working age population is considered, the percentage would be much higher.

16. Nagahara Keiji, *Shin momen izen no koto* (Chūō Kōron, 1990).

17. According to an illustrated text from the sixteenth century showing various crafts (*shokunin uta awase-e*), the production of hemp involved some degree of specialization in terms of production and distribution, but it had not reached the point where it allowed for the formation of an industrial society within the context of Nagahara's economic periodization. See Tabata Yasuko, "Women's Work and Status in the Changing Medieval Economy," and Wakita Haruko, "The Medieval Household and Gender Roles within the Imperial Family, Nobility, Merchants, and Commoners," both in this volume, for further information on this scroll.

18. Noma Kōshin, ed., *Saikaku shū*, vol. 48 of *Nihon koten bungaku taikei* (Iwanami Shoten, 1980), 2:453; Hasegawa Tsuyoshi, ed., *Keisei irojamisen, keisei denjugamiko, seken musume katagi*, vol. 78 of *Shin Nihon koten bungaku taikei* (Iwanami Shoten, 1989), 456.

19. Yasukuni Ryōichi first pointed out the sexual implications of this line of work in "Kinsei Kyoto no shomin josei," in *Kinsei*, vol. 3 of *Nihon josei seikatsushi*, 73–109.

20. One example is Aoyama Tadakazu's *Kana sōshi jokun bungei no kenkyū* (Ōfūsha, 1982).

21. During the question and answer period that followed the presentation of this paper, Anne Walthall asked me whether this division between sex and reproduction existed in rural villages. I responded that this division was disseminated through the expansion of licensed prostitution quarters, which had institutionalized the division between sex and reproduction from the largest urban cities to castle towns and post stations. In addition, it is important to realize that the diffusion of the monetary economy into villages changed folk customs.

Prostitution and Public Authority in Early Modern Japan

SONE Hiromi

Translated by Akiko TERASHIMA and Anne WALTHALL

Literary works such as novels, essays, and verses tell us that a great number of women in early modern Japanese society had a variety of ways to sell their bodies. For too long, however, research in this area of early modern history has tended to focus on public prostitution—the courtesans (*yūjo*) of the pleasure districts—with most of the emphasis placed on the artistic or cultural accomplishments of these women. Little attempt has been made to adopt a more comprehensive approach to prostitution by situating courtesans within the category of prostitutes as a whole.

The development of research into women's history over the last ten years has shed some light on the various forms of private prostitution that existed outside the licensed pleasure districts. Police records, for example, give glimpses of how prostitutes led their lives and the conditions that informed their existence. Even so, the evidence is scanty. These were not women who figured greatly in official literature, and the conclusions to be drawn from the documentation that exists must of necessity be tentative. The purpose of this essay is to provide a concrete introduction to the various ways in which prostitution was carried out by contrasting public and private practice, to investigate the special character of the social and economic background that gave rise to prostitution in early modern times, and to examine the attitude and response of public authority to prostitution in its various forms.

THE ESTABLISHMENT AND DEVELOPMENT OF A SYSTEM OF PUBLIC PROSTITUTION

This section provides an overview of how and why pleasure districts were established in the three major cities: Yoshiwara in Edo, Shinmachi in Osaka, and Shimabara in Kyoto.[1] Kyoto contained the

oldest officially recognized prostitution district. There Toyotomi Hideyoshi (1536–98) had authorized the consolidation of brothels into a pleasure district at Nijō Yanagimachi in 1589. It was moved to Rokujō Yanagimachi in 1602 and again to the place known as Shimabara. A moat 2.7 meters wide surrounded the area. Research shows that by the latter half of the seventeenth century it contained six wards in which there lived 282 courtesans.

The pleasure district in Osaka's Shinmachi received public approval around 1610. It had been created at the beginning of the seventeenth century at the behest of Yasui Kyūbei and other concerned residents, who brought together the brothels that had been scattered throughout Osaka.[2] Its entrance was marked by an elaborate gate, and its wall was surrounded by a moat. It was said that in the first half of the seventeenth century 1,752 courtesans lived in the Shinmachi pleasure district, including girls and young women aged seven or eight to fourteen or fifteen who would become courtesans upon maturity.

The brothel owner Shōji Jinnai appealed to the shogunate to establish a new brothel district in Edo in 1612. At that time, more than twenty publicly authorized brothel districts had been created in Kyoto, Osaka, Suruga, and the ports of the various provinces. In Edo, however, the brothels were scattered all over the city. Jinnai proposed that they be consolidated in one place. The shogunate avoided giving a specific reply immediately. Five years later, in 1617, it finally approved the establishment of a brothel district based on the following five conditions.

1. Prostitution would not be allowed outside the brothel district and no courtesans were to be dispatched outside the district.
2. Guests would be forbidden to stay longer than one day and one night.
3. The clothing worn by the courtesans would be dyed indigo, with no gold or silver foil allowed (i.e., luxurious clothing was forbidden).
4. The brothels in the district would not be luxurious. The district as a whole would be charged the same taxes and have the same obligations as any ordinary ward.
5. Suspicious-looking people would be interrogated and reported to the city magistrate's office.

Based on these regulations, Edo's first publicly authorized brothel district—the pleasure quarter of Yoshiwara—was established. In this

confined district, the sole entrance was the big gate on the north side; the rest was surrounded by a moat 5.4 meters wide. At first, the district included the first and second blocks of Edomachi plus the first and second blocks of Kyōmachi. In 1626, Sumimachi was added, for a total of five blocks. Here, until the end of the Tokugawa period (1603–1868), on average two to three thousand courtesans found themselves confined. Thus, by the middle of the seventeenth century large-scale pleasure districts had been established one after the other in the three metropolitan cities of Edo, Osaka, and Kyoto under the authorization and protection of the shogunate.

What was the purpose of consolidating pleasure districts? The second character in the term "pleasure district" (yūkaku) can also be read as "enclosure" (kuruwa). It originally referred to the earthen or stone enclosure built around a military encampment such as a fort or a castle. The pleasure districts were also called enclosures because they were designed to be special spaces isolated from ordinary citizens and their circumferences were bounded by a moat or a ditch. This is one of their most distinctive features. In the case of Yoshiwara, the big gate that provided the sole passage in and out was locked at midnight. For the rest of the night, traffic was possible only through the two small side gates to its left and right, a restriction that severely limited entry and egress. Next to the side gates stood gatehouses, called "places to watch faces" (menbansho), where day and night not only watchmen and detectives but two members of the secret police sent from the city magistrate's office were posted in rotation for surveillance of pedestrians. Inside the district and close to the main gate was an office (kaisho) positioned to keep watch over courtesans who went out and ordinary women who went back and forth between the district and the outside world. Under this system, courtesans were forbidden to leave the district after 5 P.M. even upon the death of a parent. Ordinary women coming into the district had to have a letter of permission (tori kitte). These restrictions gradually loosened over time, but even in the late Tokugawa period some courtesans, wanting to see their parents, siblings, or lovers, committed arson in order to escape from the pleasure districts.[3]

Most courtesans were sold into prostitution by their parents when poverty left them no other choice. Usually girls had reached the ages of ten to fifteen before they were sold, but some were as young as seven or eight. Within the pleasure district, these young girls were called kamuro. They performed various tasks at the beck and call of

their seniors among the courtesans. Once the brothel owner decided that a girl had the qualifications to become a high-class whore, he would have her educated, trained in various performing arts, and taught proper deportment and manners. At the age of fifteen to eighteen, the girl would be expected to receive customers as a full-fledged courtesan.

The courtesans were ranked and graded depending upon their attainments, artistic skills, and appearance, from the top class (called *tayū*), whose members excelled in their personal appearance and artistic accomplishments, to the women sold cheaply for ten minutes at a time, called "slice at a time whores" (*kiri mise jorō*). The fact that the charge for buying a courtesan differed according to rank shows how truly the courtesans had taken on the character of merchandise.

Customers who bought courtesans in order to take their pleasure with them were chiefly warriors and upper-class townsmen. In the case of Yoshiwara, warriors constituted the chief clientele in the first half of the early modern period, whereas townsmen predominated in the second half. It is also well known that throughout the early modern period the pleasure district of Yoshiwara served as a background for the showy diplomacy conducted by domainal officials stationed in Edo.[4]

The character of the pleasure district underwent a transformation when private prostitution developed outside its walls. The officially authorized brothels gradually lost the character of salons where customers came to enjoy the various cultural accomplishments of the courtesans. Instead, it became a place where prostitution was the chief object. This shift in focus paralleled a change in the social profile of the clientele. Not a few customers at the end of the early modern period were ordinary commoners such as artisans and small shopkeepers.

In this fashion, the development of private prostitution meant that the pleasure districts, which had once functioned as cultured spaces with samurai as customers, gradually took on the coloration of whorehouses serving a vast range of commoners. At the same time, the terms used to refer to the women who worked there changed. The word *yūjo* had been used from ancient times to designate not just a courtesan but an artist. By the end of the early modern period, it could be found only in literature, having disappeared from people's speech. In its place, the most common appellation was "whore" (*baika*).[5]

As we have seen, the shogunate tried to protect the privileges of the pleasure districts by forbidding prostitution outside publicly authorized enclosures. Despite its efforts, various types of prostitutes continued to operate outside. In some cases, they came to lead a sort of semiofficial existence, authorized and regulated by the shogunate, though never to the same extent as the women sold into places such as Yoshiwara.

Serving girls (*meshimori onna*) who provided tea, food, and their bodies at tea shops and inns along the highways constituted the most numerous of the semiofficial prostitutes.[6] Until the middle of the seventeenth century, the shogunate prohibited the employment of prostitutes at tea shops and travelers' inns in the post stations along the chief highways, and it severely punished innkeepers who violated these regulations. The regulations had no effect at all, however, and in the last half of the seventeenth century the shogunate was forced to change its policies. In 1678, it permitted each tea shop to employ two waitresses. Though the tea shops were places where highway travelers would stop to rest and eat during the lunch hour, some were permitted to allow travelers to spend the night and some secretly hired prostitutes. The shogunate authorized the tea shops to operate from dawn to dusk, and it permitted them to hire two prostitutes as long as they were called waitresses (*kyūji onna*). In 1718, it allowed the inns hosting overnight travelers to hire two women per inn as waitresses.

It must be emphasized that the shogunate gave the tea shops and inns permission to employ not prostitutes but "waitresses." Nonetheless, it was a public secret that these women did not just help with meals but also engaged in the selling of sex. In 1772, the shogunate issued a new regulation applicable only to the four entrances to Edo at Shinagawa, Naitō Shinjuku, Itabashi, and Senjū. Instead of two women per establishment, the shogunate fixed the number of women at so many per post station, thus publicly authorizing the hire of 500 serving girls at Shinagawa, 150 at Naitō Shinjuku, 150 at Itabashi, and 150 at Senjū.

The shogunate did not strictly enforce the restrictions on the number of serving girls. While official documents recorded two women per establishment, in reality most places employed considerably more. It must be said that the magistrate in charge of roads and other shogunal officials intentionally overlooked what was going on because the presence of the serving girls had a major impact on the prosperity of the towns and post stations and hence on their financial

well-being. The fee paid for serving girls was called the "balling fee" (*gyoku dai*) or "frying fee" (*age dai*), and the market price ranged from three to seven hundred *mon*. Since the price for a night's lodging alone was two hundred *mon*, depending on who the customer was, buying a serving girl could easily triple or quadruple his bill. At the end of each month, the serving girls had to pay the post station a fixed amount out of the fees they had collected. Every night they also had to turn over a fixed amount per customer, depending on the number of customers they had had. In this fashion, a percentage of the fees collected by the serving girls found its way into the post station's coffers. From there, it was applied to the post station's operating expenses, including the purchase of horses used for government business.

In general, serving girls were cheaper than the courtesans in the pleasure districts. Their customers consisted of ordinary travelers on the road as well as local farmers. The courtesans were permitted to wear silk kimonos, but the serving girls were forbidden to wear anything but cotton. They had to wear an apron as proof that they were not prostitutes but maids, and they were not allowed to wear fancy ornamental hairpins. In this fashion, the shogunate tried to maintain a clear distinction between serving girls and courtesans. For this reason, serving girls cannot be called public prostitutes in the officially recognized sense of the term. In formally regulating the "waitresses" by fixing their numbers, however, the shogunate created a gray area between public and private prostitution and allowed it to be filled with serving girls.

THE CONFIGURATION OF PRIVATE PROSTITUTION

Aside from serving girls in the post stations and courtesans in the pleasure districts, vast numbers of nonofficially recognized prostitutes thronged early modern Japanese society. These women sold their bodies without the permission of the authorities. From its inception, the shogunate tried to extend its control over private prostitutes, but their numbers steadily increased. In the city of Edo, in popular parlance the places where these private prostitutes congregated were known as "the hills" (*oka basho*). It was said that by the 1860s some thirty such enclaves had sprung up in places like Nezu and Fukagawa.

The population of "the hills" included everyone from professional private prostitutes employed by entrepreneurs to the lowest of the private prostitutes, who were referred to in derogatory terms as "cotton

pickers" (wata-tsumi), "curbside peddlers" (sagejū), and "night hawks" (yotaka).[7] But what most distinguished "the hills" was that the women who worked there were not necessarily full-time, professional prostitutes. Many were performing artists and dancers who gathered at the tea houses and restaurants. Others were waitresses and tea servers. At "the hills," women with legitimate occupations as dancers, samisen performers, waitresses, or tea preparers would sometimes sell their bodies in accordance with the customer's wishes.

The shogunate was never able to exercise complete control over acts of prostitution performed on the spur of the moment by women who at least on the surface had a different occupation. In the end, it was forced to relax its penalties for private prostitution, announcing that "if women summoned to the tea shops as dancers or waitresses practice prostitution through an agreement with the customer, that is different from ordinary private prostitution."[8] Furthermore, each "hill" hired a watchman to signal when official inspectors appeared. This made it extremely unlikely that the inspectors would find evidence of prostitution because the locals had plenty of time to conceal it before they arrived.

In contrast to the women who worked at "the hills," there were "secret," "underground," or "hidden" prostitutes (kakushi baita) who worked clandestinely. For this reason, they tended to be the objects of suppression and punishment by the public authorities and townspeople of Yoshiwara. While considerable research has been done regarding the conditions under which courtesans in the pleasure districts and serving girls at the post stations worked, the study of underground prostitution has fallen decisively behind. Official announcements that ordered its elimination and records of court cases showing the punishments that these women received remain only in fragmentary form. In the absence of other records, it is nonetheless worthwhile to use court cases to inquire a little more closely into the lives of those underground prostitutes and their employers who were exposed, punished, and hence documented by the public authorities.[9]

In the ninth month of 1684, a woman called Ichi was arrested as she was leaving a guardhouse at the entrance to a samurai residence.[10] Ichi was the daughter of a man named Koemon from Takaita village, in the province of Musashi, bordering Edo. Having lost her father while still a child, she was sent to the nearby village of Kashiwazaki at age five for adoption by Saburōbei. Once she reached puberty, she became intimate with a seller of knickknacks called Matabei. She

promised to marry him and move to his house without telling her
adoptive father about her plans. Saburōbei became extremely angry
when he discovered her secret and beat her time and time again. She
finally ran away to Edo. There she asked Jirōbei, a man she had met
on the road, to be her guarantor while she indentured herself for four
years in Edo as a clandestine prostitute. When she became ill, she
was released from her contract a year early and sent back to her
guarantor, Jirōbei. As it turned out, she was suffering from syphilis,
and in the end Jirōbei also drove her away. For the next three months,
Ichi maintained her existence by wandering from residence to resi-
dence, selling her body as she went and sleeping where she could.
This was her situation when she was arrested.

Ichi's life story suggests that clandestine prostitutes can be clas-
sified into two types. The first engaged in prostitution under contract
with an employer or pimp who served as her guarantor. The second
found her customers on her own, as Ichi did for her last three months.
Let us call the first type "the prostitution business" and the second
"individual prostitution." Throughout the early modern period, the
former predominated. The authorities punished pimps, who as busi-
nessmen and entrepreneurs employed the prostitutes, far more se-
verely than they did the prostitutes themselves.

We can assume that instances of individual prostitution, in which
a woman made a living without an employer or anyone watching over
(or living off) her, were extremely rare. These women seldom came to
the attention of the authorities and hence left little trace in written
records or the lives of the people around them. Even Ichi became
independent only because she had been abandoned by her employer
and guarantor after she contracted syphilis. It is still important to
recognize, however, that at one extreme of underground prostitution
in early modern society there existed women who lived not by enter-
ing into a contract with someone else but by selling their bodies them-
selves. As was characteristic of the early modern stage of prostitu-
tion, this woman from the countryside was able to earn a living only
by selling her body in a big city like Edo, where she had no connec-
tions. It was a society that made cheap and naked sex a commodity,
even among the lowest class of commoners.

The actual practices informing the "prostitution business" are
not well known. Despite the draconian punishments threatened by
the authorities, few cases were ever brought to court. Documents gen-
erally disclose little more than the fact that most operators were not

established landlords but tenants. It also seems that in many cases the operators were themselves, or had long-standing connections with, men of no permanent address (*mushukunin*) and gangsters (*yakuza*). For example, in 1682 a man called Yabei was arrested in Edo for the crime of keeping two clandestine prostitutes named Hatsu and Hana on a boat.[11] In 1684, a vagrant called Iemon was arrested at dusk while he was chaperoning Shichi, a clandestine prostitute employed by another man called Gorōzaemon of Asakusa.[12] This case demonstrates that vagrants like Iemon might work as agents for underground prostitution enterprises. In 1778, one Gorōbei, a tenant in Edo, was punished for the crime of having plotted with some vagrants to kidnap the daughter of another vagrant in order to force her into underground prostitution.[13] This is further evidence that underground prostitution was connected with people with no official address and that it might be initiated in an extremely violent manner. In the prostitution business, many women were forced to work under the supervision of gangsters or vagrants who kept them either through a contract or by force.

The prostitution business was not limited to vagrants and gangsters. In one case, a sumo wrestler who had fallen on hard times began an enterprise by hiring a prostitute to support his parents, or at least he so claimed.[14] Sometimes poverty might prompt a husband to send his wife out as a prostitute.[15] In all cases, however, the vast majority of enterprises were extremely small in scale, employing only one or two women. It is noteworthy that in early modern society these enterprises could be set up with just enough capital to hire one prostitute. Operators did not need even this small investment if they could manage to seduce or rape a woman, or if, as a husband, they could coerce their wives. Because the prostitution business promised economic returns with almost no capital investment, it could be widely practiced by poverty-stricken city folk as well as gangsters and vagrants who lived by avoiding legitimate work.

THE TRIALS AND TRIBULATIONS OF BEING A PROSTITUTE

Confinement characterized the lives of official and clandestine prostitutes alike. We have seen how the courtesans of the pleasure districts lived within a circumscribed area enclosed by a moat with only one large gate. This sort of imprisonment applied equally well to the clandestine prostitutes outside the pleasure districts. They, too, were constantly watched by enforcers (*giu*) who deprived them of their

freedom.[16] One enforcer might have several prostitutes for whom he performed such services as supervising their relations with customers, touting, and preventing quarrels among the guests.

Sometimes the methods used to restrain clandestine prostitutes turned extremely violent, and occasionally they even resulted in death. In 1800, for example, a prostitute named Naka, who worked for an entrepreneur in Fukugawa, ran away because she was suffering from syphilis. The entrepreneur had her brought back, stripped naked, bound, and beaten with a stick. Despite having caused her severe internal injuries, he forced her to continue prostituting herself. This caused Naka's death.[17] Such beatings were also administered to serving girls. The *Seji kenbun roku* (Record of Things Seen and Heard) describes the punishment for a serving girl who failed to attract customers or a runaway who was brought back: "They strip her completely naked, bind her tightly with rope, and then pour water over . her. As the rope gets wet, it shrinks, causing the girl to groan and cry out in pain. Sometimes she is tortured to death."[18]

In general, it can be said that the prostitute's lifestyle was unhealthy. Courtesans suffered from chronic malnourishment and lack of sleep. They never got to enjoy the sunlight, they had only two meals a day, never breakfast, and their usual fare was rice gruel.[19] Serving girls were forced to perform heavy labor such as farm work or weaving during the day and were obliged to entertain customers at night.[20]

In addition to the trials of ordinary life, syphilis took a significant toll on the prostitutes' bodies. Syphilis attacks every organ in the body. It causes repeated skin eruptions and ulcers, it brings about hair and nose loss, and finally it attacks the brain and turns the sufferer into a cripple. According to the records kept at Jōkanji, the well-known dumping ground for the corpses of the Yoshiwara courtesans, syphilis and its complications were the most common cause of death for courtesans.[21] The year of death carved on the gravestones of serving girls at the post stations shows that they died on average at the age of twenty-one. We can assume that syphilis shortened their lives.[22] Many of the "night hawks," the lowest class of prostitutes, suffered from the final stages of syphilis. Among the night hawks of Edo was a woman whose spine was so bent from the disease that she could disguise herself as a young girl; another fashioned a nose from wax to replace the one she had lost. They both continued to sell their bodies.[23]

Mistreatment and disease destroyed the prostitutes' fertility, caus-
ing repeated miscarriages and finally making pregnancy impossible.
Abortion doctors and medicines did exist at that time, but they often
caused the death of the woman. According to a document called
Oshioki saikyochō (Record of Punishments), in the ten years between
1679 and 1689 at least one doctor who failed in an abortion and four
men who caused women's deaths by giving them abortion-inducing
medicines were sentenced to death or exile.[24] There must have been
many more cases that never found their way into the record books.

Naturally enough, it was not just prostitutes whose maternity was
denied in early modern society. Many servants who were forbidden to
have sex became pregnant during their terms of service and sought
abortions when the need arose. However, it is said that the most fa-
mous of the Yoshiwara courtesans, Takao, would promenade with a
wet nurse carrying her baby. This does not mean that all courtesans
were able to bear and raise children. Takao got away with this only
because she was at the zenith of her career and unrivaled among the
courtesans of her day. For the vast majority of early modern prosti-
tutes, who were forced to sell sex as merchandise to every man who
came along, it was an absolute and heteronomous contradiction for
them to have and raise a child created through a relationship with
just one man. In that sense, we can say that prostitution as an insti-
tution fundamentally denied maternity.

The emotional life of prostitutes was as constrained as their ma-
ternity. If a prostitute fell in love with a man, except within a busi-
ness relationship, she would be set free only if the man repaid any
money she had borrowed or paid an enormous ransom. If sufficient
money were not available, the two might plan to run away, fully real-
izing the danger involved. Elopement with the courtesans or serving
girls, who were publicly authorized by the shogunate, prompted rig-
orous searches and severe punishments. It was rarely successful. One
warrior who hid a runaway courtesan in his own house was even pun-
ished with exile.[25] If a prostitute who had run away escaped punish-
ment by the authorities, she was still likely to receive a severe beat-
ing at the hands of her employer.

Given these circumstances, there was no end to the number of
couples who chose to commit suicide (*aitaijini*).[26] From the middle of
the early modern period on, records of court cases include significant
numbers of double suicides. Most involve men who, after killing the
woman, remained alive and were brought to trial. For that reason,

they say little about the emotional state of the woman on the verge of death. We can be certain, however, that men and women who chose to die together were strongly attached to the idea of "becoming husband and wife" (*meoto ni naru*). In 1775, for example, a young warrior of a high-ranking house agreed to a plan to die with a courtesan from Yoshiwara. But the courtesan alone died and the warrior was exiled. In discussing the particulars of the case, the man said that he had taken pity on her because she had said: "If I can't become your wife, I'll die."[27] In 1854, a serving girl and a customer in northeastern Japan committed suicide, leaving behind a pledge written in blood. Addressed by the man to the woman, it opened with the sentence: "This certifies that you and I have pledged to become husband and wife."[28]

These two examples suggest that a courtesan or serving girl committed suicide with her lover in order to become husband and wife before the gods, an option denied them in this world. For these women, a promise to become a wife apparently had a deeper and more keenly felt meaning than we can imagine today. In discussing early modern couples, Takao Kazuhiro suggests that "as long as men and women loved each other, they believed that they were husband and wife whether or not they had gone through a formal marriage ceremony. Accordingly the word 'husband and wife' (*fūfu*) signified the single unit of a man and a woman who loved each other based on the ethic of monogamy."[29] It was this sense of "husband and wife" for which the courtesans and serving girls longed. They wanted a relationship in which the man and the woman had an exclusive, intimate, and devoted partnership. For these women, the "marriage contract" meant having a commitment to just one man.

It was extremely difficult for prostitutes, who were forced to have sex on a daily basis with many men, to prove their fidelity and devotion to the man they truly loved. This is why they sent such men pledges written in blood and clippings of hair and fingernails, or even the fingers themselves, as proof of their devotion.[30] A prostitute's double suicide signified not just despair at unrealizable love but proof of her devotion to one man.

The public authorities in the early modern period called the love between unmarried men and woman "adultery" and punished it severely. Many cases from the early part of this period demonstrate how love outside of marriage was punished. One woman was executed for having had intercourse with a man not her husband, and a warrior

was exiled just for having written a love letter to a married woman.[31] Authorities thus sought to rigidify marriage relationships by coercive means, inflicting severe punishment on men and women who broke the rules. It is well known, however, that the marriage pattern that came to be established was in fact polygamous; any man could get a woman unilaterally as long as he had the money. Given these circumstances, is it not the case that both the prostitute, who was forced to have sex with many men, and ordinary women, who were forced to endure polygamy, must have desired an exclusive relationship based on mutual devotion with just one lover?

PUBLIC AUTHORITY AND PROSTITUTION

As we have seen, at the beginning of the early modern period, the authorities officially authorized pleasure districts in the major cities. What kind of logic lay behind this process of official authorization? What kind of attitude did the public authorities have toward the issue of prostitution? I emphasize first that it was not the initiative of the authorities but petitions from the townsmen that led to the establishment of the pleasure districts. The shogunate authorized the pleasure districts for two reasons: (1) consolidation of the brothels in one place would facilitate governmental control over public morals and help maintain public security, and (2) the government could realize income in the form of a fixed fee (*myōgakin*) paid by all the operators in the districts. The authorities tried to protect those who paid them money by forbidding prostitution to women who were not publicly authorized, that is, the courtesans of the pleasure districts. In many ways, prostitution was a business like any other. Like the trade in other commodities, it was regulated, confined to designated individuals or areas, and taxed.

The result of the shogunate's efforts to control and tax public prostitution was that underground prostitution, rather than declining, continued to increase. Confronted with this reality, the two city magistrates for Edo proposed to the shogunate in 1731 that it authorize six new locations, including Fukagawa, Honjo, and Nezu, which were already known for clandestine prostitution. "If this unofficial prostitution is given public authorization in a newly fixed number of places, the effect will be that the number of businesses and opportunities for employment will increase and society as a whole will benefit [literally 'be moistened']."[32] Though in the end their proposal was rejected, it is significant that the city magistrates, whose job it

was to suppress underground prostitution, would have presented a plan so apparently contradictory as to consolidate the clandestine prostitutes and grant them official approval. Their proposal clearly demonstrates that prostitution had become an enterprise that brought profit not only to many commoners but to the authorities as well. For that reason, the public authorities tried to both authorize it and regulate it.

How did the authorities control private prostitution? In the first half of the early modern period, employers of unauthorized prostitutes received the death penalty. Throughout the seventeenth century, we find many instances in which men who had employed clandestine prostitutes or husbands who had forced their wives into underground prostitution were executed.[33] By the 1730s, however, the shogunate's policy of control took on the following characteristics: (1) a general relaxing of punishments visited on men who had employed illegal prostitutes, and (2) codification of punitive regulations applicable to a broader group of people than had been implicated before. This meant that, except in particularly heinous circumstances, the death penalty was no longer enforced. Instead, the emphasis shifted to penalties assessed against property: the confiscation of land, houses, or moveable property plus fines.[34] Moreover, the shogunate no longer considered it criminal when impoverished couples sent the wife into clandestine prostitution with her consent. While penalties as a whole were relaxed, they came to be visited not just on the prostitution entrepreneur. The headman of the ward where he lived and residents of the ward, that is, people who could be deemed collectively responsible over a fairly wide area, all became liable for punishment.

The following list shows the chief punishments deemed applicable for the underground prostitution business in the first half of the eighteenth century. At that time, a wide range of people—the prostitute, her employer, her guarantor, and the provider of the site— were all liable for punishment. The fact that the customer received no punishment should be emphasized, for it is an issue still relevant today.

Employer: (1) fine based on social rank; (2) one hundred days of
 imprisonment with the hands bound in chains
Prostitute: relocation to Shin-Yoshiwara for three years
Guarantor: confiscation of two-thirds of his property or a fine equivalent to its value, the rate adjusted according to his social rank
Owner of site: (1) fine based on social rank; (2) one hundred days of imprisonment with the hands bound in chains

Employer's five-household group: fine
Employer's ward headman: heavy fine
Employer's landlord: confiscation of house and lease for five years

This list is based on Article 47, "Kakushi baita oshioki no koto" (Punishments for Secret Prostitution), in *Osadamegaki* (Rules and Regulations).[35]

CONCLUSION

It has been said that premodern societies do not make a clear distinction between law and morality. At least with regard to acts of prostitution, public authority in Japan neither judged them morally nor prohibited them in its laws. As far as the authorities were concerned, prostitution had to be regulated for the sake of public security, but they saw no reason to ban it. When parents brought suits to terminate the prostitution practiced by their daughters by offering to buy them out of their contracts, the authorities would reject the appeal because the girl was bound by a contractual relationship. They would only advise the parties involved to resolve the matter among themselves. This attitude on the part of the authorities was consistent with their attitude toward lawsuits involving contracts and transactions for any business. In their eyes, prostitution was nothing more than one type of commercial transaction based on a contract.

The advent of the swarms of prostitution entrepreneurs and clandestine prostitutes in early modern Japan coincided with the development of a commercial and monetary economy. The development of a monetary economy accelerated class stratification in both town and country by producing both a huge urban lower class that was dependent on daily wages and multitudes of impoverished farmers who, having lost their lands, could not live without a cash income. Despite their needs, they had relatively few opportunities to earn money since a large-scale labor market had not yet developed. Nor did there exist a public welfare system to help the poor. For the lower classes in the large cities, weak ties to the soil and a lack of familial networks meant that the inability to acquire money could lead to a life-threatening situation. Given these economic conditions, the public authorities may have given tacit approval to prostitution because it allowed the poorest people a means of making a living. For that reason, they accepted the argument that even unauthorized prostitution "benefited society." Thus, prostitution in early modern Japan took a particularly raw and

ugly form without the benefit of modern medicine or modern conceptions of human rights. It should force us to confront the reality of prostitution.

NOTES

1. This section on the relationship between the pleasure districts and courtesans is based chiefly on Takigawa Seijirō, *Yūjo no rekishi* (Shibundō, 1965); Ishii Ryōsuke, *Yoshiwara* (Chūō Kōronsha, 1967); Nakano Eizō, *Yūjo no seikatsu* (Yūzankaku, 1981); and Nishiyama Matsunosuke, *Nihonshi shōhyakka: yūjo* (Kondō Shuppansha, 1979).

2. Information on Shinmachi in Osaka and Shimabara in Kyoto is based on Kobayashi Masako, "Kōshō-sei no seiritsu to tenkai," in *Kinsei*, vol. 3 of *Nihon joseishi*, edited by Joseishi Sōgō Kenkyūkai (Tōkyō Daigaku Shuppankai, 1982).

3. References to these can be found in the sections dealing with arson (*kazai*) in *Tokugawa keiji saiban reishū* (Tachibana Shoin, 1986), 1:263–80.

4. These officials, called *rusu-i*, were in charge of the domainal office in Edo when the daimyo was back in his home province. They handled diplomatic relations with the other domains and the shogunate.

5. See the section on prostitutes in Kitagawa Morisada, *Ruijū: Kinsei fūzokushi*, vol. 19 (original title *Morisada mankō*) (Bunchōsha Shoin, 1927).

6. The chief reference on maidservants at inns is Igarashi Tomio, *Meshimori onna: shukuba no shōfutachi* (Shinjinbushu Ōraisha, 1981).

7. Suzuki Katsutada, *Senryū zappai kara mita Edo shomin fūzoku* (Yūzankaku, 1978).

8. Minami Kazuo, ed., *Kyōhō sen'yō ruishū*, vol. 1 of *Kyūbakufu hikitsugi eiin sōkan* (Nogami Shuppan, 1985), vol. 1.

9. Except where noted, the following section is based on Sone Hiromi, "'Baita' kō: kinsei no baishun," in *Kinsei*, vol. 3 of *Nihon josei seikatsushi*, edited by Joseishi Sōgō Kenkyūkai (Tōkyō Daigaku Shuppankai, 1990), 111–41.

10. *Oshioki saikyochō*, vol. 1 of *Kinsei hōsei shiryō sōsho*, edited by Ishii Ryōsuke (Sōbunsha, 1959), 523.

11. Ibid., 518.

12. Ibid., 521.

13. *Tokugawa keiji saiban reishū*, 1:36.

14. Minami, *Kyōhō sen'yō ruishū*, vol. 2, sec. 2.

15. Ibid., sec. 1.

16. Kitagawa, *Ruijū*, sec. 20.

17. *Tokugawa keiji saiban reishū*, 722.

18. Honjō Eijirō, ed., *Kinsei shakai keizai sōsho*, vol. 1 (Kaizōsha, 1926).

19. Nakano, *Yūjo no seikatsu*.

20. Igarashi, *Meshimori onna*.

21. References to Jōkanji can be found in Nishiyama, *Nihonshi shōhyakka yūjo*, 42–43; and Nakano, *Yūjo no seikatsu*, 51–52.

22. Igarashi, *Meshimori onna*.

23. Kitagawa, *Ruijū*, sec. 20.

24. *Oshioki saikyochō*, 217–18, 415.

25. *Tokugawa keiji saiban reishū*, 633, 672.

26. This term refers to people who love each other and die together (usually by mutual consent). Among commoners, this was called love suicide (*shinjū*), but the shogunate's public records avoid this term in favor of one meaning "dying together" (*aitaijini*).

27. *Tokugawa keiji saiban reishū*, 686–87.
28. Igarashi, *Meshimori onna*, 178–79.
29. Takao Kazuhiko, *Kinsei no shomin bunka* (Iwanami Shoten, 1968), 42–47.
30. Nakano, *Yūjo no seikatsu*.
31. See the section on "adultery" (*mittsū*) in *Oshioki saikyochō*, 90–104.
32. Minami, *Kyōhō sen'yō ruishū*, 22.
33. See, for example, *Oshioki saikyochō*.
34. Minami, *Kyōhō sen'yō ruishū*, 22.
35. Okuno Hikoroku, *Teihon osadamegaki no kenkyū* (Sakai Shoten, 1968).

The Reproductive Revolution at the End of the Tokugawa Period

OCHIAI Emiko

Scholars of reproductive history generally agree that modern Japan underwent two main waves of change. In the first, which took place at the beginning of the twentieth century, traditional birth attendants—"old midwives" (*kyū-sanba* [the official expression] or *toriagebaa-san*)—were replaced by "new midwives" (*shin-sanba*) who had received a modern medical education. In the second wave, which followed World War II, home births attended by new midwives grew fewer due to a rise in the number of births in hospitals under the care of doctors and nurses. Fujita Shin'ichi, a journalist, called these changes "the first reproductive and second reproductive revolutions," respectively.[1] The first revolution was based on the midwife regulations (1899) and the second on the Occupation policies of the United States. Based exclusively on external phenomena, this divisional scheme suggests that reproductive changes in the course of Japan's modernization depended on the medicalization of childbirth led by the government under the influence of modern Western medicine. I wish to argue that this approach is too narrow and its interpretation too stereotyped.

In an earlier paper, I examined the social background of these two "revolutions," or waves, through the oral life history of a new midwife who lived all her life in a small village in the Tohoku (northeastern) region.[2] This midwife experienced the two waves personally as two turning points in her own identity. The new midwives shifted childbirth from the world of impurity to the realm of hygiene and nutrition. Police controlled the education and registration of midwives, just as they did in Europe. My informant was herself a symbol of the new age, riding a bicycle and carrying a bag full of glittering instruments. But in the realm of social relations the new midwives

were not so different from the old. Communities and local districts—
the village (*mura*), county (*gun*), and prefecture (*ken*)—to which
midwives had strong ties, played an important role in the reshaping
of midwives and thus the definition of the first wave. A feature of the
second wave was the collapse of such communities. The midwife I
studied was upset when governmental policy on midwives changed
from simple regulation to the mobilization of midwives accompany-
ing the centralization of power prior to and during World War II. In
my earlier paper, I proposed that the second wave should be viewed
as beginning as early as the 1930s, not after the World War II.

Changes in childbirth practices occurred as part of the whole
transformation of society in which social relations and systems of
meaning were reconstructed. As in Europe, changes in reproduction
during the process of modernization went beyond the medicalization
of childbirth; they coincided with an increase in state control over
childbirth and the occurrence of childbirth within the confines of the
modern family. The concept of what it meant to be "human" also
underwent reconstruction at that time.[3] This essay reexamines repro-
ductive history in Japan, first as an aspect of broad social transfor-
mation and, second, by going back as far as the Tokugawa period.
Some evidence seems to suggest the existence of an earlier reproduc-
tive revolution at the end of the eighteenth century.[4] If this actually
happened, it would have taken place before the founding of the Meiji
government, which introduced "modernization from the top down."
It also would have preceded the extensive Westernization of Japa-
nese society. Did such a revolution in reproduction in Tokugawa
Japan actually occur? And, if so, what was the mechanism of this
transformation?

DISCOURSE AGAINST INFANTICIDE AND ABORTION

The central evidence that leads us to the hypothesis of a reproductive
revolution in Tokugawa Japan is the definitive appearance of a new
discourse opposed to infanticide and abortion.[5] Evidence for the fre-
quency and context of these practices is less reliable. Did they occur
only during crises such as famine or in normal daily life as well?
Studies in historical demography suggest that such practices were
not as common as was previously believed.[6] The motives for infanti-
cide and abortion are also under discussion. One possible motive was
to escape from the extreme poverty caused by land taxes and famine.
Another was to obtain a higher standard of living for the future, a

hypothesis that positions infanticide and abortion as rational behavior in neo-Malthusian terms.[7]

In the midst of such confusion, one reliable fact is the eighteenth-century rise of a discourse opposed to infanticide and abortion. "More than sixty or seventy thousand babies have been stealthily murdered in just the two domains of Mutsu and Dewa. What is more curious is that there is apparently no one who deplores or criticizes this fact."[8] This statement by the famous social philosopher Satō Shin'en, which appeared in 1827 in his well-known book of political economy (the *Keizai yōroku*), is typical. At this time, many domains established rules prohibiting infanticide and abortion.

Discourse of this kind was produced simultaneously by various types of intellectuals, including Buddhists, Confucianists, nativists, agriculturists, and medical doctors. In Europe, Christianity was the theoretical and ethical backbone for the criticism of infanticide and abortion in the early modern and modern periods. But Christianity is not alone among belief systems in serving as a resource capable of generating this kind of discourse. In Japan, every type of belief system invited its adherents to develop an anti-infanticide theory from its stock of doctrine and knowledge.

The nativist scholars, who interpreted life as a good and death as an evil, called abortion a sin against the gods who had given the divine gift of life.[9] They took advantage of the antiabortion campaign to attack the Buddhists, who, they claimed, were relatively permissive toward abortion and infanticide because of the doctrine of transmigration of souls. But in reality it was Buddhist monks who, applying the doctrine of compassion for all living beings, worked most effectively against these practices at the village level.[10]

The fairly flexible theoretical structures of religious and other schools of thought facilitated their adherents' ability to emphasize certain ideas to suit the moral purpose embedded in the new trend. New religions founded in the latter part of the Tokugawa era also joined the then prominent discourse against infanticide and abortion—at least after a fashion. Konkōkyō, which preached "native enlightenment" and "belief compatible with reason," can serve as one example.[11] Konkōkyō's sacred book, *Konkō daijin oboe* (Records of Master Konkō), pronounces: "Aborting children causes disasters."[12] Instead of censuring infanticide outright, however, Konkōkyō encouraged reasoned consideration because Master Konkō, the founder of Konkōkyō, had been a peasant. It is said that when his wife was

pregnant, sick, and considering abortion, Master Konkō was told by an oracle that this would be their last child. Relieved to hear this, his wife decided to have it.[13] Some years later, she became pregnant again and gave birth. This time the oracle said: "Do not raise this child. It won't grow up, no matter what you do."[14] It seems this meant that infanticide could be overlooked. The case of Konkōkyō suggests how the peasantry managed to rationalize their changing attitudes—in a roundabout way.

Figure 1 provides a macroscopic view that helps us to consider the spatial distribution of attitudes. The shaded areas are the prefectures where, according to folklorists' reports, the custom of infanticide was said to exist at the beginning of the Meiji period. The map indicates that while the custom was widespread there was no reported reference to infanticide in the region around Kyoto and Osaka (Kinki District), economically the most advanced area at the time. We cannot interpret the lack of reports to mean the absence of the practice, however. Tacit pressure against even discussing it could have caused the same result. Still, we can conclude that attitudes toward infanticide were obviously different among residents in Kinki than they were among people in other areas.[15]

A woman committing infanticide is depicted as a demon in figure 2.[16] This design on a woodblock print demonstrates the cruelty of infanticide. At the beginning of the nineteenth century, temples and the shogunate's magistrates distributed woodblock prints as propaganda against the custom. Women's associations (*nyonin-kō*) and local leaders frequently dedicated votive tablets (*ema*) with similar designs to temples and shrines in the latter half of the nineteenth century. Figure 3 shows the geographical distribution of these votive tablets (with *x*) and prints (with *o*).[17] Note the zone of concentration across the northern part of the Kanto region and the southern part of the Tohoku region. This belt represents, according to the chart's compiler, Chiba Tokuji, a zone of confrontation between two sets of divergent values and customs: that of the peasant society of the Tohoku region and that of the city of Edo.[18] The issue of abortion and infanticide perhaps became the locus of confrontation whereby urbanites were motivated to "enlighten" the peasants; vivid images that warned against the practice may have represented a concrete expression of the urbanites' moralistic concern.

Available evidence supports my argument that an early "reproductive revolution" took place at the end of Japan's early modern era.

?: No information

Fig. 1. Areas where infanticide was reported.

Fig. 2. Woodblock print denouncing infanticide.

Fig. 3. Geographic distribution of woodblock prints and votive tablets denouncing infanticide.

At the cusp of the late Tokugawa period and the early Meiji, a pair of opposed *mentalités*, one urban, one rural, held different attitudes toward infanticide. Believers in the new attitude, which developed in the cities, tried passionately to enlighten the peasantry and erode the old attitude maintained by rural society. Intellectuals of various types worked as ideologues promoting the new attitude, and the temples and local leaders functioned as a medium for this transformation. Let us analyze more closely what these attitudes represented.

<div align="center">UNDERSTANDING PREGNANCY</div>

Folklorists typically associate a lack of guilt over infanticide with the Buddhist doctrine of transmigration of souls. There is an old saying that infants under the age of seven belong to the gods. In this way of thinking, infanticide is not homicide but simply an act that returns the child to the other world. In addition to the religious doctrines, what Japanese people knew about pregnancy and the interior of the abdomen most likely had an intimate connection with how they viewed infanticide. Let me examine this question in the way Barbara Duden and Angus McLaren, respectively, have done for Germany and England.[19]

Shitai hirōsho (Announcement of a Dead Fetus), a valuable document from the Sendai domain, reveals a great deal about how peasant men and women understood the process of conception and pregnancy.[20] This document originated in the Sendai domain's policy against infanticide and abortion. It is a collection of testimonies by family members in cases of miscarriage, stillbirth, or the death of a newborn transcribed by a "superintendent in charge of policy on babies" (*akago seido yaku*). The style of transcription reflects the actual expressions used by the people to some extent, as the superintendent was himself a native villager.

The document reveals that people did not necessarily view the cessation of menstruation as a sign of pregnancy. People often treated women in this condition as ill. Such women would take medicine to recover from this illness and begin menstruating again. Similar cases are reported by McLaren.[21] Can we call this treatment induced abortion? Caution forces us to wonder whether "illness" was a metaphor knowingly used to establish innocence.

The term *dead fetus* was never applied in cases of miscarriage within four months of conception.[22] The most common expression was: "She gave birth to something that lacked human shape." This

finding by Sawayama Mikako raises the question of how people perceived the first four months of pregnancy.[23] At what point did people consider the fetus to have a life? "Tainai totsuki no zu" (Pictures of the Interior of the Womb in Each of the Ten Months) provides some insight (see fig. 4).[24] These types of pictures were popular among the people; they were used by itinerant Buddhist priestesses (Kumano *bikuni*) as an illustrated text for preaching, and they appeared in popular dictionaries and handbooks of common knowledge (such as *Setsuyōshū*) and in general educational textbooks for women in the Tokugawa period. These prints depict the first four months of pregnancy as Buddhist altar fittings inside the womb. A human shape appears only from the fifth month on. It is possible to assume some interrelationship between these pictures and popular perceptions about pregnancy; development inside the womb during the first four months of pregnancy belonged to the abstract realm of the Buddhas with no concrete association with the human world.

Fetuses less than five months old were not called fetuses. What, then, was meant by *fetus* in the expression "dead fetus"? Sawayama reports that most incidences of "dead fetus" occurred at seven or eight months of pregnancy.[25] The causes of what we would call premature births were usually reported as accidental falls. For example: "This woman fell down by chance. After that she felt pain in the waist and had lochia."[26] Some or even most of these "accidental" falls might have been intentional. The usual method of induced abortion for villagers in early modern Japan was to cause premature births after six months (unlike today's induced abortion, which is usually performed in the first two or three months of pregnancy), most of which resulted in stillbirth or the newborn's death.

This pattern contrasted with the common pattern found in urban centers. In the close-knit village environment, the fact of pregnancy—and premature birth—was less a personal matter than a social, communal act that would have been nearly impossible to hide from others. This meant that terminations of pregnancy most likely occurred within a marriage and with the consent, or at least the tacit permission, of family members and neighbors. By contrast, in the cities, where most abortions were said to be the outcome of illicit affairs, people often took medicine in the early stage of pregnancy in order to hide the fact of pregnancy itself.[27]

The peasantry's particular way of understanding the process of pregnancy helped to shape its attitude of tolerance toward infanticide

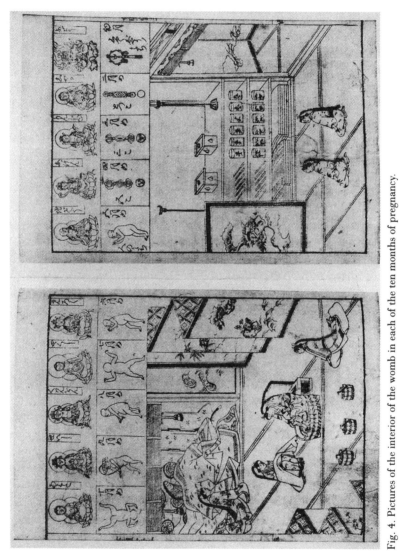

Fig. 4. Pictures of the interior of the womb in each of the ten months of pregnancy.

and abortion. Because the first four months were not clearly included
in the concept of pregnancy, abortions in the early months were not
perceived as abortions and abortions in later months were permitted.
We can look further into the peasant's perception of the process of
abortion and infanticide, as well as life and death, by examining the
Japanese terms that they used. Present-day Japanese usage distin-
guishes the terms *mabiki* (literally, thinning out) and *datai* (literally,
aborting a fetus). *Mabiki* is customarily translated into English as
"infanticide" and *datai* as "abortion."[28] Our document provides no
such division or clarification. Instead, we find that the Chinese char-
acters for *datai* are accompanied by a note, in the Japanese alphabet,
advising the reader to read (pronounce) them as *mabiki*.[29] The con-
cepts of abortion (*datai*) and infanticide (*mabiki*) collapsed, making
the fetus and human being analytically indistinguishable.

 This raises a further question. At the time of delivery, what did
the peasant call that which was delivered—whether dead or alive?
The crucial period for recognizing the existence of a fetus was in the
middle months of pregnancy, not at the moment of conception. The
starting point for human life proper was probably not the moment of
delivery but sometime after it. The term *mabiki* in the peasant's us-
age pertained to what was considered to be the prehuman, fetus form.
It probably embodied the overlapping concepts of what we would
call induced premature deliveries resulting in stillbirths or in the
deaths of newborns and the intentional killing of newborns after
delivery.

THE POPULARIZATION OF THE OBSTETRICAL "GAZE"

The rise of the Kagawa school of obstetrics, founded by Kagawa
Gen'etsu (1700–77) in the eighteenth century, had an important im-
pact on the appearance and spread of the new view of pregnancy that
went against traditional rural knowledge. In eighteenth-century Eu-
rope, "obstetricians" were not physicians with medical degrees but
low-ranking surgeons with hands-on experience. Similarly, Gen'etsu
began his career practicing the techniques of acupuncture and mas-
sage, and he established an empirical method of study based on his
experience.[30] Gen'etsu criticized such established practices as the use
of belly bands (*haraobi*) and maternity chairs, in which mothers sat
upright for several days after childbirth. He also censured midwives
for their erroneous practices and sought to enlighten them in new ratio-
nal knowledge. This was an early appearance of professional strictures

justified by a form of empirical science—a pattern that would inten-
sify during the reproductive revolution of the Meiji period.

A history of the development of the "technique of reviving" (*kaisei
jutsu*), developed by Gen'etsu, illustrates the shift to new attitudes.
Kaisei jutsu was a technique of intervention in a difficult labor in-
volving extraction of the fetus with a hook to save the mother. While
this technique gave the Kagawa school its reputation, Gen'etsu was
ashamed of its cruelty. So he turned it into an esoteric art and com-
manded his successors to develop a technique that could save both
mother and baby.[31] The Kagawa school clearly belonged with those
who viewed abortion and infanticide as crimes, unlike the proabortion
Chūjō school that flourished in the late seventeenth century.[32]

The development of obstetrics led by the Kagawa school also
helped to change people's image (or, to use Foucault's term, their
"gaze") regarding the womb. Before the eighteenth century, it was
believed that the baby reversed itself within the womb, placing its
head downward just before birth. But Gen'etsu discovered that the
baby faced downward from the beginning of pregnancy. Gen'etsu's
discovery is thought to have been made independently, without the
influence of Western medicine, because it took place prior to the in-
troduction of William Smellie's book, *A Set of Anatomical Tables with
Explanations and an Abridgment of the Practice of Midwifery* (pub-
lished in 1754), into Japan in 1770.[33] Smellie's book was the first
European medical volume to describe the correct position of the fe-
tus. It is possible that Gen'etsu arrived at his discovery due to his
experiences of palpation and of having viewed many dead fetuses
injured during abortions. An anatomical image backed up by empiri-
cal observation thus began to supplant the vague and mysterious image
of a fetus symbolized by Buddhist altar fittings.

While no picture was included in Gen'etsu's *Sanron* (Treatises on
Obstetrics), published in 1765, many illustrations of the interior of
the womb appeared ten years later in the second volume of the *Sanron
yoku* (Appendix to the Treatises on Obstetrics), authored by Gen'etsu's
successor, Genteki (see fig. 5).[34] They showed the baby leaving the
mother's body from a variety of fetal positions in a manner that de-
parted remarkably from the illustrations· found in Japan's classic
medical textbook, the *Ishinpō* (Essentials of Medicine; see fig. 6).[35]
Based on medical books from China and edited in the tenth century,
the *Essentials of Medicine* depicted fetuses as hovering within the
abdomen of the mother. The illustrations in *Appendix to the Treatises*

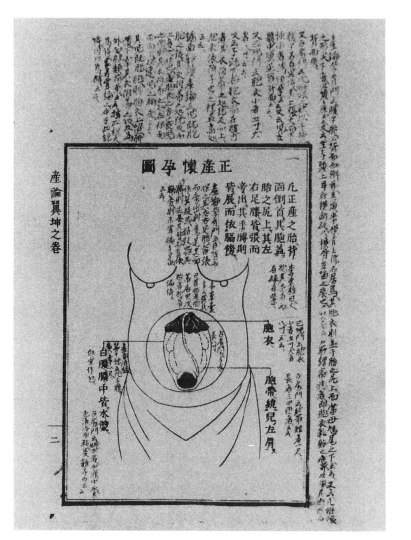

Fig. 5. Illustration from *Appendix to the Treatises on Obstetrics*.

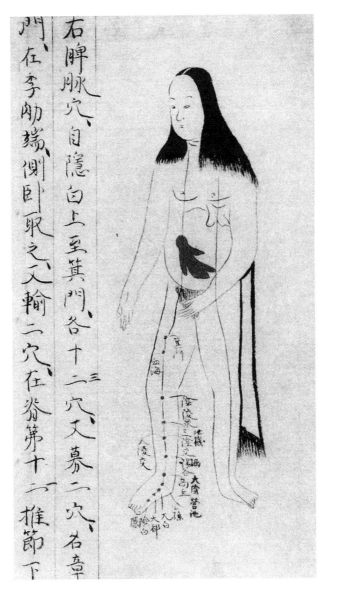

Fig. 6. Illustration from *Essentials of Medicine*.

on Obstetrics were also very different from those in the *Fujin kotobuki-gusa* (Ladies' Well-Being Pamphlet) of 1692, authored by Kazuki Gozan half a century before (fig. 7).[36] The figures in the *Ladies'* depicted several scenes from the everyday life of a pregnant woman, including the setting of the room, the ornaments for rituals, and the movements of servants. This type of drawing had been common in medieval scrolls such as the *Kitano tenjin engi emaki* (Scroll of the History of Kitano Tenjin God), which included delivery scenes. In contrast, the illustrations in *Appendix to the Treatises on Obstetrics* contain undressed pregnant bodies lined up, without heads and hands, and show fetuses, umbilical cords, and placentas through visual angles into the vagina and an opening in the abdomen. These drawings embodied the principles of modern anatomical illustration in their realism and impersonalization.

Although it is almost certain that Gen'etsu discovered the correct fetal position on his own, he and his successors probably were not ignorant of Western anatomical science. In 1754, a decade before the publication of *Treatises on Obstetrics*, Yamawaki Tōyō had executed the first recorded dissection of a human cadaver in Japan by employing Western methods. Tōyō published his *Zōshi* (Record of the Organs) in 1759. Gen'etsu and Genteki most likely were exposed to Western anatomical science through these events. There is much evidence to show the close relationship between the Kagawa and the Yamawaki families. Tōyō's second son even wrote the preface for Gen'etsu's *Treatises*, and his son, for Genteki's *Appendix*.[37]

The influence of Western necrotomy is clearer in obstetrics books published in the nineteenth century. Illustrations from 1838 by Kagawa Juntoku, reproduced in figure 8, display even greater anatomical realism than do those found in *Appendix to the Treatises on Obstetrics*, in which the womb seems to lack shape, for example.[38] Kuriyama Shigehisa, a medical historian, points to the significant change in vision regarding the human anatomy that the transformation in the technique of illustration suggests. The difference between Tōyō's *Record of the Organs* (1759) and Sugita Genpaku's *Kaitai shinsho* (New Book on Anatomy), published in 1774, which was a translation of the Dutch version of a German book, *Anatomische Tabellen* (1722), bespeaks this transformation.[39] Assessed in light of these two works, the style of *Appendix to the Treatises on Obstetrics* seems transitional.

Fig. 7. Illustration from *Ladies' Well-Being Pamphlet*.

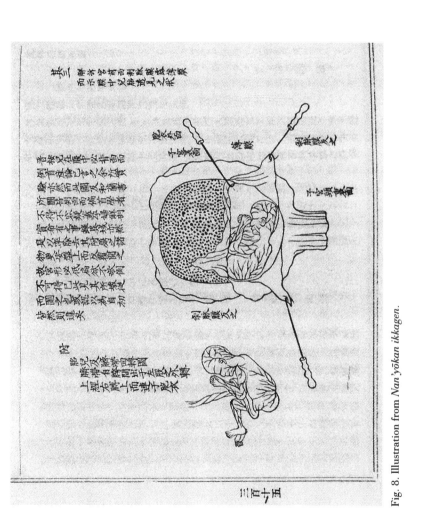

Fig. 8. Illustration from *Nan'yōkan ikkagen*.

Obstetrics books by Gen'etsu and Genteki achieved national stat-
ure and became requisite texts in every doctor's office in Japan. Many
books with different styles followed them. Subsequently, illustrations
of the interior of the womb found their way into textbooks for mid-
wives written by doctors and into general educational books for girls
and women. Some drawings aimed for anatomical realism; others
imitated the ukiyoe style, even in its reflection of the taste for the
erotic and grotesque that characterized the early nineteenth century
(fig. 9).[40] Some drawings of the interior of the womb went beyond
the limited audience of medical texts and educational books and spread
into popular culture, setting trends of their own. Keisai Eisen's *Makura
bunko* provides a most remarkable example. A set of "Drawings for
Understanding the Gratitude Due Parents," for example, depicts a
woman in the ten stages of pregnancy, moving from right to left and
showing an increasingly large abdomen with a cutout in the middle
for the growing fetus (fig. 10).[41] Pictures of beautiful pregnant women
with the interior of their wombs exposed appeared even on *sugoroku*
(a kind of backgammon game; see fig. 11)[42] and fans (fig. 12).[43] In
show tents, people enjoyed watching the so-called living dolls (*iki
ningyō*), a set of ten female dolls with the interior of their wombs
exposed, reflecting monthly changes in the stages of pregnancy.[44] This
could be called "the period of womb watching" or "womb peeping,"
as well as "the age of visual rape."[45]

DOMAINS AND VILLAGES AS PROMOTERS OF CHANGE

In addition to specialists such as those in the Kagawa school, who
were the primary agents in promoting the new attitude toward child-
birth? It was not the bakufu that took open countermeasures against
abortion. Although it punished adultery (a reason for abortion) and
abortions that ended in the mother's death, it established no stric-
tures against abortion per se until 1842. In addition, the law of the
bakufu was enforced mainly in Edo, while in rural areas there was
only a 1767 recommendation that villagers keep an eye on each other
and watch out for infanticide.[46] It was the domains, not the bakufu,
that put energy into devising countermeasures—for economic rea-
sons. Some domains, suffering from a drop in population, devasta-
tion of farmland, and the consequent decrease in tax revenue, needed
new measures to revive their economies. They devised measures
against abortion and infanticide as part of their larger policy of in-
creasing the population, along with such measures as promoting the

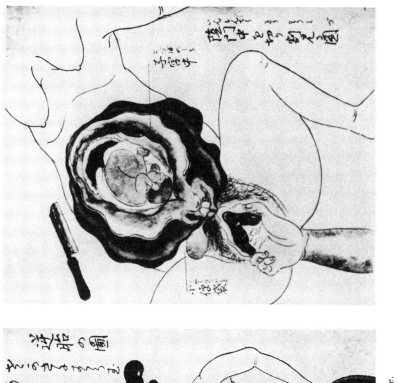

Fig. 9. Illustrations from *Yōka hatsumō zuge*.

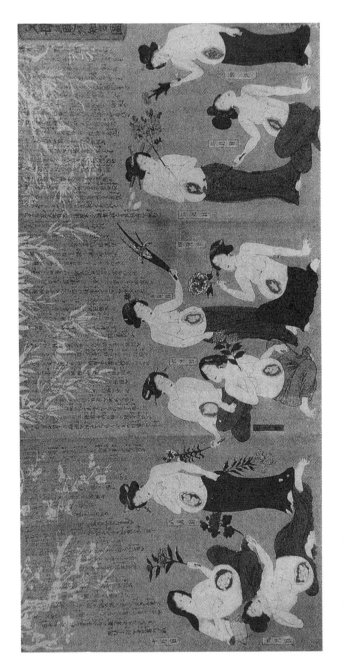

Fig. 10. "Drawings for Understanding the Gratitude Due Parents."

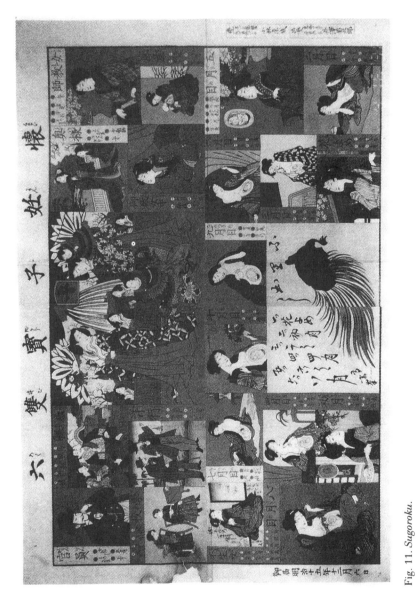

Fig. 11. *Sugoroku.*

Fig. 12. Fan.

migration of peasants from other areas, encouraging peasants to establish branch families, and simplifying marriage procedures.

The effort made by the Kasama domain can serve as an example.[47] Following the famine of the 1780s, the domainal lord, Makino Sadayoshi,

> ordered his Confucianist vassals to go and teach the peasants that abortion is wrong and immoral. When this had little effect, he thought that the Buddhist priests, experienced in teaching people not to kill, might bring better results if they introduced obligations to the country and the Buddha's way to the peasants along with the teachings against killing. So he gathered all the chief priests of the temples in his domain . . . asking them to teach people at every Buddhist ceremony to raise the children they bore and to thoroughly rectify public morals through their own virtue as priests.[48]

This was an effective way to reach the people given the parishioner system in which everyone was registered at a temple and temples had a tight hold on people's affairs. Makino "also held an official tour of the villages, made pregnant women register themselves, and provided each woman with three *to* of rice for each childbirth."[49] Looking at the examples of other domains as well, we can see that it was the priests, the Confucianists, and the stratum of village officials—namely, the high-ranking and prosperous householders—who were active agents of domainal policies.[50]

The "new attitude" did not come solely from above, however. It was village officials, for example, who established the system for infant care in the Sendai domain that was related to the policy of eliminating infanticide and abortion mentioned earlier. Long before the institutionalization of infant care in 1796, several villages had developed a system of mutual help, putting aside rice and money for troubled families with infants as a kind of child care allowance. Even after 1796, visits by domainal officials in charge of the infant care program numbered only about three a year. It was, therefore, the village official who performed the job of implementation under regular guidance and supervision from above, supported by the family and community network as the basis of his operation.[51]

Why did these village officials take seriously the issue of abortion and infanticide? To begin with, villages were the units of taxation in the Edo period and village officials were responsible for collection of the land tax from each household. Abortion and infanticide, which would change the village's taxation profile, had direct

relevance to the official's work. In addition, childbirth—or death—was not a private family matter that took place behind closed doors, as it does today. It was an event that broadly concerned villagers and was supported through a variety of social networks. One "announcement of a dead fetus" from the Sendai domain is informative on this point: "[The expectant mother] was laid up with a cold, and her temperature was increasing daily. . . . Her family panicked, and not only the relatives but also the neighbors gathered to nurse her."[52] As the following passage from the Tosa domain demonstrates, it was a matter of course for villagers to interfere in the number of children a couple had: "People laugh at families who have many children in spite of being poor, saying that they are too stupid to take into account their own position or consider the difficulties the future will bring."[53]

CONCLUSION

This essay began with two questions: whether or not the late Tokugawa period saw a reproductive revolution and, if so, how the transformation took place. I have sought to demonstrate that a revolution did indeed occur by tracing the rise of a new attitude toward reproduction, developing first in cities and spreading later to the villages through an educational movement on the part of intellectuals. A change in attitude toward infanticide and abortion, moreover, did not occur in isolation but was accompanied by a restructuring of knowledge about pregnancy, childbirth, and the body—surely a sign of a great societal transformation. In engendering new attitudes, the impact of medicine was significant, and the background for the rise of the Kagawa school deserves a closer look; it certainly would be a mistake to conclude that modern Western medicine alone led to these changes.

Studies in historical demography typically divide the Tokugawa period into three phases: a time of population growth in the seventeenth century, a plateau or a time of stability in the eighteenth century, and a second phase of population growth in the nineteenth century (fig. 13).[54] The early modern revolution in reproductive practices took place precisely at the beginning of the third phase, a time of growth at the end of the eighteenth century. The detailed study of childbirth practices enriches our reading of demographic shifts beyond the understanding of a possible correlation between the frequency of infanticide and population growth. The growth in the third

million

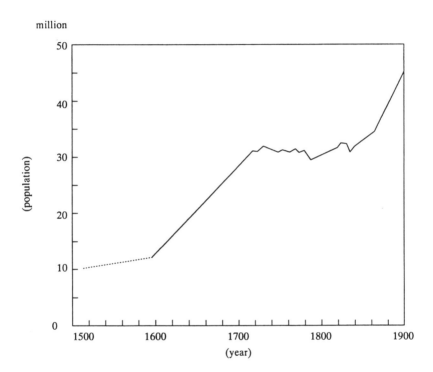

Fig. 13. Total population of Japan.

phase coincided with the initial stage of centralized control over in-
dividual lives, which Michel Foucault would call the rise of bio-
power.[55] A program to induce population growth itself was an aspect
of this major reconstruction of society.

Observations about the agents of change have also illuminated
some crucial aspects of the transformation. The reproductive revolu-
tion at the end of the Tokugawa period was carried out by two kinds
of social units: the village and the domain—the prototypes of the
modern state. The dualistic structure (village and domain) that sur-
rounded birth continued into the Meiji era, when the newly central-
ized nation-state took over the functions of the domains. After the
establishment of the Meiji government, the situation changed slowly,
though the regulation of midwives began as early as 1868 in a Cabi-
net decree.[56] Thereafter, the revolution proceeded basically along the
structural lines outlined at the beginning of this essay.

It could be said that the reader has "attended the birth of mod-
ern Japan" in the course of reading this essay. In the late nineteenth
century, the first wave of the modern reproductive revolution began
as an extension of its early modern predecessor, focusing on the vil-
lages as before and sharing more similarities with earlier patterns of
change than with the second wave that followed World War II. Today,
as we approach the end of the twentieth century, involvement in child-
birth by villagers and prefectures is almost nil. The communal struc-
ture of villages has broken down, and neighbors do not interfere.
Midwives have lost the autonomy to practice. Only the family and
the state take a serious interest—for different reasons—in childbirth
now. The shift to today's structure began before World War I and
accelerated prior to and during World War II, but the process of trans-
formation was completed only with the second wave of the reproduc-
tive revolution during the period of high economic growth in the post-
war period.

NOTES

Initial editorial assistance was provided by Margaret Lock.

1. Fujita Shin'ichi, *Osan kakumei* (Asahi Shinbunsha, 1979), 103, 142.
2. Ochiai Emiko, "Aru sanba no Nihon kindai," in *Seido to shite no onna*, edited by
 Ogino Miho et al. (Heibonsha, 1990), 257–322. An English version of this paper
 is to be published as "Modern Japan through the Eyes of an Old Midwife: From
 an Oral Life History to Social History," in Wakita Haruko et al., eds., *Gender in
 Japanese History* (Osaka: The University of Osaka Press, forthcoming). I have

adopted some of Peter Berger's sociological concepts (such as "alternation" and "turning point") for my analysis. See Peter Berger, *Invitation to Sociology: A Humanistic Perspective* (Garden City, N.Y.: Doubleday, 1963), chap. 3.

3. Ochiai Emiko, "Shussan no shakaishi ni okeru futatsu no kindai," *Sociologos* 8 (June 1984): 78–94; reprinted in Ochiai Emiko, *Kindai kazoku to feminizumu* (Keisō Shobō, 1989), 25–55. For the role of the state and the history of childbirth in Europe, see, for example, J. Gelis, M. Laget, and M. E. Morel, eds., *Entrer dans la vie* (Paris: Gallimard, 1978).

4. Ochiai Emiko, "Edo jidai no shussan kakumei—Nihon ban 'sei no rekishi' no tameni," *Gendai shisō* 15.3 (March 1987): 131–41; reprinted in Ochiai, *Kindai kazoku*, 56–78.

5. See, for example, Takahashi Bonsen, *Datai mabiki no kenkyū* (Daiichi Shobō, 1981; originally published in 1936).

6. For an overview of this discussion, see Saitō Osamu, "Infanticide, Fertility, and 'Population Stagnation': The State of Tokugawa Historical Demography," *Japan Forum* 4.2 (October 1992): 369–82. The most recent studies tend to emphasize regional differences: infanticide and abortion were more frequent in the northeast than in the central and western regions. See Tomobe Ken'ichi, *Natural Fertility Patterns in Early Modern Japan*, Tokuyama University Economic Research Institute Working Papers 22 (1993):6–8; paper originally presented at the eighteenth annual meeting of the Association for Social Science History, Baltimore, November 1993. See also Kurosu Satomi, "Sex Ratios and the Year of the Fire Horse: Cultural and Regional Experiences in Japan," paper presented at the eleventh International Economic History Congress, Milan, September 1994.

7. See Hayami Akira, *Kinsei nōson no rekishi jinkōgakuteki kenkyū* (Tōyō Keizai Shinpōsha, 1973), esp. 228. In English, this view can be found in Thomas Smith, *Nakahara* (Stanford: Stanford University Press, 1977); and Susan Hanley and Kozo Yamamura, *Economic and Demographic Change in Preindustrial Japan, 1600–1868* (Princeton: Princeton University Press, 1977).

8. Takahashi, *Datai mabiki*, 18.

9. For example, see Miyahiro Sadao, "Kokueki honron," and Suzuki Shigetane, "Yotsugi gusa," both in *Kokugaku undō no shisō*, edited by Haga Noboru and Matsumoto Sannosuke, vol. 51 of *Nihon shisō taikei* (Iwanami Shoten, 1971), 291–309, 231–43, respectively.

10. On Buddhist activities, see the example from Kasama domain, discussed later.

11. Murakami Shigeyoshi, "Kaisetsu," in *Konkō daijin oboe*, edited by Murakami Shigeyoshi (Heibonsha, 1987), 272.

12. Murakami, *Konkō*, 60.

13. Ibid., 17.

14. Ibid., 51.

15. Chiba Tokuji and Ōtsu Tadao, *Mabiki to mizuko* (Nōson Gyoson Bunka Kyōkai, 1983), 112–34. Figure 1 is taken from page 122. The map is based on data in Onshi Zaidan Boshi Aiikukai, ed., *Nihon san'iku shūzoku shiryō shūsei* (Daiichihōki, 1975), 159–72.

16. "Kogaeshi no ezu," in "Shison hanjō tebikigusa," a pamphlet distributed by the Kikusui temple in Chichibu. It is reprinted in Nihon Ishi Gakkai, ed., *Zuroku Nihon iji bunka shiryō shūsei* (San'ichi Shobō, 1978), 4:204.

17. Chiba and Ōtsu, *Mabiki*, 65–80. Figure 3 appears on page 69.

18. Ibid., 134.

19. Barbara Duden, *The Woman beneath the Skin: A Doctor's Patients in Eighteenth-Century Germany*, translated by Thomas Dunlap (Cambridge: Harvard University

Press, 1991); Angus McLaren, *Reproductive Rituals* (London: Methuen, 1984). A Japanese translation of the latter by Ogino Miho was published as *Sei no girei* (Kyoto: Jinbun Shoin, 1989).

20. My analysis of *Shitai hirōsho* is based on Sawayama Mikako, "Kinsei nōmin kazoku no san no fūkei," *Bulletin of Junsei Junior College* 19 (1990): 141–54. This article includes a list of summaries of documents. The documents were later published as a chapter in Ota Motoko, ed., *Kinsei mabiki kankō shiryō shūsei* (Tōsui Shobō, 1997). In English, see Ota Motoko aand Sawayama Mikako, "From Infanticide to Abortion," in *Abortion, Infanticide and Reproductive Culture in Asia*, edited by Saitō Osamu and James Lee (London: Oxford University Press, forthcoming). See also Sawayama Mikako, "Kinsei nōmin kazoku ni okeru 'ko-umi' to 'umu' shintai," *Nihonshi kenkyū* 383 (July 1994): 59–76; "Sanka yōjōron to kinsei minshū no 'san' no shinsei," *Joseishigaku* 4 (July 1994): 18–30; and *Shussan to shintai no kinsei* (Keisō Shobō, 1998).

21. McLaren, *Reproductive Rituals*, chap. 4.

22. Sawayama, "Kinsei nōmin kazoku," 146.

23. Ibid., 148.

24. The illustration is from *Onna chōhōki taisei 3*, originally published in 1692. It is reproduced in Namura Jōhaku, *Onna chōhōki, kanai chōhōki*, vol. 18 of *Kinsei bungaku shiryō ruijū sankō bunkenhen*, edited by Kinsei Bungaku Shoshi Kenkyūkai (Benseisha, 1981), 94–95.

25. Sawayama, "Kinsei nōmin kazoku," 146.

26. Ibid., case 5, 151.

27. Takahashi, *Datai mabiki*, 20–25.

28. The historian's understanding of what *mabiki* meant in Tokugawa society has undergone several changes. Kitajima Masamoto, in *Nihon rekishi daijiten* (Kawade Shobō, 1959), defines *mabiki* as a "popular expression for abortion and infanticide common in the late Tokugawa period" (vol. 17, 135–36). Chiba and Ōtsu, writing in the 1980s, however, assert that "demographers who distinguish abortion from infanticide understand *mabiki* in the Tokugawa period to be in fact infanticide taking place after live-birth" (*Mabiki*, 49).

29. Miyahiro, "Kokueki honron," 293.

30. Ogata Masakiyo, *Nihon sankagakushi* (Kagaku Shoin, 1980; originally published in 1918). Ishihara Tsutomu notes similarities in the backgrounds of Kagawa Gen'etsu and Ambrois Pare, the first French obstetrician. See Ishihara Tsutomu, "Development of Obstetrics and Gynecology in Japan and Resemblances to Western Counterparts," in *History of Obstetrics: Proceedings of the Seventh International Symposium on the Comparative History of Medicine—East and West*, edited by Ogawa Teizō (Taniguchi Foundation, 1983), 237–51. For an overview of the Kagawa school, see Sugitatsu Giichi, "Kaidai: Kagawa Gen'etsu to Kagawaryū sanka no hatten," in *Sanron, sanron-yoku, zoku-sanron*, edited by Kagawa Gen'etsu Kenshō Kinen Shuppankai (Shuppan Kagaku Sōgō Kenkyūjo, 1987), 9–72.

31. Ogata, *Nihon sankagakushi*, 126–31; Sudō Mieko, "Umu shintai no kindai," *Gendai shisō* 19.3 (March 1991): 220–29.

32. The Chūjō school was widely known as a strong advocate of abortion. On the school, see Ogata, *Nihon sankagakushi*, 69–77.

33. See Kyotofu Ishikai, ed., *Kyoto no igakushi* (Shibunkaku, 1980), 1106–7.

34. The figure is taken from Nihon Ishi Gakkai, *Zuroku*, 1:245. The text of *Sanron* and *Sanron-yoku* is in Masuda Tomomasa, Kure Shūzō, and Fujikawa Yū, eds., *Nihon sanka sōsho* (Shibunkaku, 1971), 114–33, 143–63, respectively.

35. Tanba Yasunori, ed., *Ishinpō*, vol. 22, published in 984. The figure is in Nihon Ishi Gakkai, *Zuroku*, 1:243.

36. Kazuki Gozan, *Fujin kotobuki-gusa* (published in 1692), in Masuda et al., *Nihon sanka sōsho*, 63–113. The figure appears on page 100. At the 1993 meeting of the Berkshire Conference of Women Historians, Terazawa Yuki compared *Fujin kotobuki-gusa* and *Appendix to the Treatises on Obstetrics* and concluded that the style of drawings in the latter reflected indigenous development in Japanese obstetrics. In my view, this assertion seems naive in light of the influence that Yamawaki Tōyō's *Record of Organs* had on the obstetrics field, as is discussed below.

37. See Sugitatsu, "Kaidai," 36–37.

38. Kagawa Juntoku, *Nan'yōkan ikkagen* (published in 1838), in Masuda et al., *Nihon sanka sōsho*, 308–16. The figure appears on page 315.

39. Kuriyama Shigehisa, "Between Mind and Eye: Japanese Anatomy in the Eighteenth Century," in *Paths to Asian Medical Knowledge*, edited by Leslie Carles and Allan Young (Berkeley: University of California Press, 1992), 21–43.

40. Yamada Hisao, *Yōka hatsumō zuge*, published in 1851. The figure is in Nihon Ishi Gakkai, *Zuroku*, 1:262.

41. Hasegawa Sonokichi, "Fubo no on o shiru zu" (drawn in 1883), in Nihon Ishi Gakkai, *Zuroku*, 1:210.

42. Kobayashi Eisei, "Kainin kodakara sugoroku" (drawn in 1882), in Nakano Misao, *Nishikie igaku minzokushi* (Kanehara Shuppan, 1980), 199.

43. Harold Speert, *Obstetrics and Gynecology: A History and Iconography*, 2nd ed., rev. (San Francisco: Norman, 1994). Figure 12 is from a Japanese translation by Ishihara Tsutomu, trans., *Zusetsu sanfujinkagaku no rekishi* (Enterprise, 1982), 181.

44. I am grateful to Noriko Yokota for her information on the source and the idea of "living dolls." For the example of living dolls on display in 1864, see Kaneko Mitsuharu, ed., *Zōtei bukō nenpyō* (Heibonsha, 1968), 2:198.

45. Sudō Mikako has called this period "the opening of modernity in childbirth" (*shussan ni okeru kindai*) and "the age of violence by visual rape" (*shikan no bōryoku no jidai*) in her "Shussan ni okeru kindai: kaisei jutsu no hen'yō," *Maimai* 11 (September 1989): 39.

46. Takahashi, *Datai mabiki*, 44–45.

47. Ibid., 65–93.

48. Ibid., 81–82.

49. Ibid., 83.

50. Ibid., 55–282.

51. Sawayama, "Kinsei nōmin kazoku," 142.

52. Ibid., case 22, 154.

53. Takahashi, *Datai mabiki*, 195.

54. Kitō Hiroshi, *Nihon nisen nen no jinkōshi* (PHP Shuppansha, 1983), 68.

55. This point was made by Margaret Lock in her discussion of my paper.

56. Ogata, *Nihon sankagakushi*, 1042.

Matsuo Taseko and the Meiji Restoration: Texts of Self and Gender

Anne WALTHALL

Matsuo Taseko (1811–94), a peasant woman from the Ina Valley in the mountains of central Japan, took herself to Kyoto in 1862. She went to study poetry, she said, and while she was there she managed to hobnob with the court nobility, tour the imperial palace, and even view the emperor.[1] At the other end of the social scale, she made friends with a number of young imperial loyalists, most of them of commoner status, joined their xenophobic plots, acted as a liaison for them with the court nobility, and spied for them on the shogun's supporters. In 1868, she went back to the city, this time determined to witness the restoration of rule by the emperor. She sent her sons to serve the imperial armies while she moved into the compound of the court noble Iwakura Tomomi. Her connections with the architects of the new government made it possible for her to act as an employment broker for men seeking bureaucratic positions. To the end of her life, she remained interested in politics and famous for the services she had rendered on behalf of the state.

Born in the Ina Valley high in the mountains northwest of Nagoya, Taseko spent most of her life in a rural backwater. Yet her male kin were village headmen, as their forefathers had been before them. She learned how to raise silkworms, and her marital family brewed saké. In the status system of the time, Taseko was by definition a peasant, no matter how wealthy her family happened to be, and by virtue of this status she was subjected to various formal restrictions on her behavior, no matter that she ignored them by finding her way to Kyoto and participating in a political movement. By the 1860s, domestic unrest and the fear that foreigners were preparing to grab Japan made politically aware people all over the country increasingly critical of the shogun and his government, called the bakufu. Not everyone assumed

that Japan's problems could be solved by expelling the barbarians and revering the emperor, but Taseko could be found among those who did. Despite the disabilities imposed on her by her class and gender, she ended up in Kyoto at that brief moment when it had again become the political center of Japan.

Taseko's decision to go to Kyoto and her commitment to reverence for the emperor and expulsion of the barbarians (*sonnō jōi*) have brought her a certain measure of renown, even though she rejected the conventional role of women. She has never been portrayed with the same complexity or depth as men who acted self-righteously, but in 1903 she was posthumously awarded the fifth court rank by the Meiji emperor and officially recognized as one of the three outstanding female poets of the Restoration.[2] As a consequence, her family erected a new gravestone for her, making it larger than her husband's. Today her descendants proudly display the souvenirs she received from the emperor's household along with her portraits, diaries, poetry collections, and letters. A number of biographical sketches have appeared in women's magazines and volumes on women's history. In all cases, she has been viewed solely as a model mother who became a patriot, for only within the narrow confines of action taken on behalf of the state did she become famous. When I began my research on her in the Ina Valley, my interest in someone praised in the dark days of the Pacific War for being an ultranationalistic supporter of the emperor system aroused unpleasant memories in the people I met. This representation of her is significant, for it provides one clue as to why and how she has been marginalized in books written about both women's history and the Meiji Restoration.

Taseko's trip to Kyoto offers a new perspective on a female experience heretofore largely overlooked in studies of Japanese women. Whereas women in the aggregate had an impact on the French Revolution and individual women aided husbands or lovers who brought about the Meiji Restoration, Taseko fits neither of these images. Like Vera Brittain, whose record of what happened to her in World War I was either ignored or deemed insignificant, and other women who participated on their own in "reverberating public events,"[3] Taseko's contribution to the turmoil of the 1860s has been slighted by historians when it was not simply forgotten. It has been all too easy to assume that no woman working apart from other women could take any action with historical consequences, and, besides, women are not supposed to be concerned with the violent world of men and power.

Yet Taseko refused to remain confined to the woman's lot of marriage and child rearing, of circulation between men. Like other extraordinary women, she had to write her own narrative. Not for her was the quest plot that provides the life narrative for famous men. This lack of what a sociologist would call role models means that it was much more difficult for Taseko to act as she did than it was for the men she met in Kyoto, and, again like other extraordinary women, she has been largely relegated to obscurity.

Biography can provide a powerful means of opening up an opportunity for heretofore silenced voices to be heard. Here I want to discuss three issues: how writing a feminist biography can help explain why Taseko found herself in a position to act, what she did in Kyoto that made her famous, and what her writings suggest about her uneasy relationship with the system of domination under which she lived. Along the way, I reflect on some of the methodological issues involved in writing a woman's life, especially one from a culture and historical period radically different from my own.

Growing Up in the Ina Valley

Writing Taseko's biography engages several issues raised by feminists who have turned to life histories to challenge androcentric scholarship. Dissatisfied with research projects that lead to large-scale models of social life, they argue the need to see the individual variety in women's lives, to reconstitute "the meaning of women's social experience as women lived through it."[4] Much has been written about the life cycle of Tokugawa peasant women and the constraints seemingly imposed by norms expressed in such texts as *Onna daigaku* (Greater Learning for Women); we know less about how individual women maneuvered within these constraints and the leeway they had to make for themselves. Even within the rural entrepreneurial class to which Taseko belonged, women's experiences varied depending on their distance from the shogun's capital at Edo and the particular traditions of their families' households.[5] Without the added dimension of individuality and the opportunity to explore how specific women responded to their own situations, however, new knowledge about the life patterns of women risks reducing their experiences to new stereotypes.

Taseko's life unfolded within the framework of an apparent acceptance of social norms and expectations, and it is only the advantage of hindsight that allows us to see that at least some of her activities

had the potential to challenge these conventions. Her class background, for example, gave her several advantages in terms of education, wealth, and experience.[6] She came from a rural entrepreneurial (gōnō) family. She never had to worry about subsistence; in fact, she learned to manage a household of servants, run a business, and interact with people from a variety of classes. Like all other women of her status, she acquired much more than the rudiments of literacy, and literacy can negate some of the most debilitating effects of political powerlessness by enhancing a woman's self-respect and sense of autonomy.[7] In particular, she learned classical poetry. It took considerable time and effort to acquire a mastery of the arcane and elaborate rules that governed its use, but the rewards were great. This skill, it can be argued, provided her with the cultural competency to negotiate the gulf between her life as a village woman and the rarefied world of the court aristocracy.

Poetry gave Taseko an entrée into the society of men. She began to write poems before she was married, and she studied with a number of teachers who passed through the Ina Valley. As a married woman, she participated in poetry meetings at her cousin's house and hosted gatherings at her own. On these occasions, men and women exchanged poetic sallies and celebrated the beauties of nature. This confusion of social boundaries forces us to reconceptualize the limitations imposed on women in Tokugawa society. These poetry meetings provided one of the few occasions when women and men and people of different statuses met on the same footing in an environment in which the social construction of normative roles mattered less than the ability to write an appropriate poem.[8]

Taseko's presence at poetry meetings reminds us that she spent her days enmeshed in a web of human relationships and that the process of becoming a political activist did not depend solely on her individual efforts. There is, after all, political danger in writing biography. By privileging the individual over the collective, the extraordinary woman over communities sustained by classes and groups, the biographer risks giving "intellectual sustenance to the political celebration of individualism now reigning in the atmosphere of neoconservatism."[9] Tracing Taseko's life course places her alone under the spotlight. Her relatives, friends, and enemies remain in the shadows. As Liz Stanley has pointed out, "this is quite unlike life where the lives of even the famous and infamous are densely populated by peers." Better to reject the "spotlight" approach to a single

individual and replace it with a focus on informal networks.[10] Taseko's network, however, did not go to Kyoto. It nurtured her skills as a poet, but she acted alone.

Poetry gave Taseko a way to express herself outside the confines of household and family. Poetry makes a performative break with everyday speech. In so doing, it makes room for voices otherwise marginalized, yet in certain instances it can be summoned to evoke "memories of the ethos of the community and thereby provoke hearers to act ethically."[11] Even Japanese men who habitually wrote prose treatises in Chinese (*kanbun*) switched to poetry when it came time to express their central thoughts and most deeply held beliefs. The value of poetry as a vehicle with which to express emotion made it a favorite medium of native poets, who valued the exercise of feelings for concrete things over the acquisition of abstract learning.[12] Roger Thomas has pointed out that among the changes taking place in the classical poetry circles of the late Tokugawa period can be detected a new interest in using poetry less as an "exercise" in spiritual or moral development and more as an expression of the personal, if not political, voice.[13]

Through the medium of poetry, Taseko expressed herself on a wide variety of topics and acquired a network of correspondents. But, while men supplemented their poetry collections with treatises on government, the family, and the practice of agriculture, even an exceptional woman like Taseko remained confined to this single mode of expression. Poetry writing also provided the opportunity for public performance. What Taseko wrote she read and discussed with her friends. It was through poetry that she alluded to her views on politics as well, forcing the reader interested in tracing the contours of her thought to contend with a most elusive medium. Ultimately, poetry provided both her and some of her friends with access to nativist discourse, and poetry circles provided the seedbed in which the Hirata school of nativism could sprout.

The path from poetry-writing circles to the Hirata school of nativist study was not an obvious one. Taseko's training in the *Shinkokinshū* (New Collection of Ancient and Modern Times), compiled in 1206, taught her how to write poems that combined a delicacy of feeling with depictions of the natural setting. Peter Nosco has argued that "for the more ideologically inclined nativists of the nineteenth century, ancient prose works became the favored sources."[14] Hirata Atsutane despised poetry writing as an effeminate waste of

time. If one were to write poetry, only the masculine models found in Japan's most ancient poetry collection, the *Man'yōshū* (Ten Thousand Leaves), offered the appropriate model. In place of poetry, he preached the study of ancient history, which came the closest to illuminating the age of the gods. Created by the gods, Japan's position in the universe was unique. Gods inhabited an invisible world where people went when they died; the mediator between their world and his own was the emperor. His iconoclastic view of Chinese studies and his verbal battles with other scholars made him many enemies. Most practitioners of classical poetry never joined the Hirata school, including Taseko's husband and many of the men with whom she exchanged poems.

Taseko the classical poet was not the same as Taseko the nativist. She cannot be said to have lived her life "in a continuous, unilinear, well-ordered and coherent manner."[15] The different phases of her life, in fact, challenge the notion of the unified self that has traditionally served as the basic structuring principle of male (auto)biography. Postmodern criticism has reduced the concept of the unified self to "a cultural and linguistic fiction, constituted through historical ideologies of selfhood and the processes of our storytelling."[16] Feminist theory has replaced it with an emphasis on the multiplicity of selves that constitute any single individual. Taseko's identity as a nativist, and later as an activist, required her to become a different kind of poet, and it ultimately contradicted her vision of herself as a woman.

When Taseko formally became a disciple of the Hirata school in 1861, she signed the pledge "wife of Matsuo Sajiemon, Takemura Taseko," a common way for married women to identify themselves before the modern state insisted that they take their husbands' names. At the same time, she may have wished to indicate that her interest in nativism was hers alone, unshared with her husband, and that she was acting not as his representative but for herself. By asserting her individual identity, she rejected the negation of the female autonomous self found all too often in premodern marriages where women were known referentially as men's wives or mothers. This phrase also points to a tension between the cultural expectation that she maintain the silence of the ideal woman and her later deeds, which suggest a desire to earn recognition through significant public acts. In any case, her decision to join this school provided the justification for her to speak to issues ordinarily beyond the ken of women. Dorinne Kondo's work on crafting selves emphasizes the importance of agency,

the idea that even the most oppressed people have the power to fashion their identity: "Human beings create, construct, work on and enact their identities, sometimes creatively challenging the limits of the cultural constraints which constitute both what we call selves and the ways those selves can be crafted."[17] Taseko both constructed her own identity as a nativist and through that identity challenged the cultural constraints on permissible speech by women.

H. D. Harootunian has argued that in rural nativism "the poet was displaced by the peasant sage, and a discourse on origins became a discourse on practice and politics."[18] For a woman like Taseko, however, poetry continued to be the preferred medium of expression, and the discourse on origins became tied to the discourse on politics. During the last ten years of Tokugawa rule, Japanese poetry became more politicized than it had been in centuries, and the long poems used for eulogies in ancient Japan became a vehicle for expressing political frustration. The fullest statement by Taseko that demonstrates the politicization of this form comes in a long poem that she wrote upon hearing of the assassination of the chief architect of the bakufu revival, Ii Naosuke. It was entitled "Upon Hearing About the Sakurada Incident on the Third Day of the Third Month ˌf 1860."

> In the eastern provinces where the birds sing, in place of the emperor who once had taken charge of the great affairs of government for the realm in his palace far away above the clouds, the shameless charlatans who run the administration have abandoned the way of the foundation for the sun and learned even from superficial Chinese teachings.

> Having groped their way by the light of the moon and hidden themselves all too well in the shade of trees, under the fruit of the Tsukubane tree, the ancient military servants of the emperor now shout and shout, inflaming the true Japanese spirit of these myriad islands. For the sake of the country they forget their families and consider their lives less than nothing, and the deep snow fallen from a leaden sky they stain with crimson.

> I am reciting this here because when reflecting on recent events I realized that we must not forget anything that has happened even in our sleep, whether long or short. While grieving we must affirm their deeds.

> Envoy: So many flowers blown away by the storm at the peak of their glory. How keenly they bring to mind thoughts of ancient days.[19]

The multiple layers of meaning contained in this poem would have been readily intelligible to the members of Taseko's nativist cell, who shared her knowledge of the form and the news of the day. A typical long poem, or *chōka*, told a story in strings of beautiful images followed by a short envoy, which contained a more direct statement of emotion expressed almost always in a description of nature. For the loyalists who had performed the assassination, she used *mononofu*, the term used to refer to the ancient military men responsible for pacifying Japan in the name of the emperor, and depicted them in images drawn from classical Japanese verse, the incantation of which resonates with magic. She included *tamakatsura*, meaning both "vines" and "the light of the moon," and *tsukubane*, the name of a woodland flower, both for the beauty of their sound and to heighten the contrast between the virtuous servants of the emperor and the despicable military men of Edo who followed the Chinese Confucian way damned by the ugly sound *utsusegai* (literally, the empty shell of a clam). Among its many messages, the poem drew on an idealized past of direct imperial rule to criticize a degenerate present and made an implicit comparison between the way the shogun's ministers had been taken in by Confucianism and the way they were currently being taken in by Western technology. Given the context alluded to in its title, at the most concrete level Taseko's friends would have read this poem as a criticism of Ii Naosuke's signing of a commercial treaty with the United States instead of taking the right way and obeying the emperor.

The cultural activities and political stance that came to inform them exemplify the tendency of the peasant elite in Japan to aspire beyond its formal social status, which had remained frozen at an inferior level. Sidonie Smith has proposed that we "imagine writing as a female equivalent to male warfare, a heroic arena in which women might gain access to distinction through merit." For the nativists of the Ina Valley, almost all of whom were peasants and thus officially excluded from the political arena of their time, this statement holds true not only for women but for men who were denied access to the politically informed deeds of the warrior. Nativism provided a vision of human possibility that gave its peasant practitioners, both men and women, "a place of power, language, and expansive rather than constricted selfhood."[20] Nativism not only subjected Taseko to a given apprehension of reality; it also began to qualify her for conscious social action. Thus, it both constrained her vision of the future and

started the process of transforming her into an activist determined to demonstrate her loyalty to the emperor.

In the process of transforming herself into an actor in the Restoration, Taseko's experience as a participant in the silk trade played a crucial role. In her long poem about the assassination of Ii Naosuke, she had expressed her frustration at the inadequate response to the foreign threat and the lack of respect for the emperor, but she had lauded the deeds of others. It was only after the foreigners made themselves felt in her valley by buying up silk for export that she began to phrase Japan's problems in more personal terms. In a poem "to be read lamenting the export of thread to other countries," she brought together national issues and herself as subject, a connection historically denied to women.

> It is disgusting, the agitation over thread in today's world. Ever since the ships from foreign countries came for the jeweled silkworm cocoons to the country of the gods and the emperor, people's hearts, awesome though they are, have been pulled apart and gnawed by rage. The soulless foreign barbarians pile up mountains of silver, and even though I am not a brave warrior from the land of the rising sun I cannot bear it in my poverty.[21]

Empowered to know by her prior encounter with nativism, Taseko used its language to express her resentment at the intrusion of foreign capital into her livelihood and the livelihoods of those around her. Her understanding of this threat forced her to translate her nativist beliefs into action.

In emphasizing Taseko's intellectual credentials, I am defining achievement according to the male public world, but it is in this world that Taseko herself sought recognition.[22] All too often the definition of the exceptional woman is one capable of a type of political behavior most often practiced by men. Taseko's intent was of a rationality men can understand, unlike the founders of new religions or women who gained the power to speak publicly only when possessed by a god. As Carolyn Heilbrun has pointed out: "Women's selfhood, the right to her own story, depends upon her ability to act in the public domain." Women who do not are "deprived of the narratives by which they might assume power over—take control of—their own lives."[23] They remain anonymous, denied the chance to have a voice of their own. Nevertheless, it is important not to end up with a derivative history built from male modeling, which obfuscates what Taseko as a

woman actually did or the obstacles that women, not men, have to overcome. Sidonie Smith has argued that if a woman "presumes to claim a fully human identity by seeking a place in the public arena, she transgresses patriarchal definitions of female nature by enacting the scenario of male selfhood."[24] It is because Taseko went to Kyoto in that autumn of 1862 that she has a story inscribed in texts, but what she did and what she said did not simply replicate what men did and said. By creating a public self, she, not they, risked a loss of reputation, risked the stigma of becoming unfeminine.

Out of the materials given her by the chaotic events leading up to the Meiji Restoration, Taseko remade her life, with its ordinary lack of plot, into an eccentric story. She insinuated the lines of her story through the lines of male models, and she crafted an identity other than the one she left submerged in marriage. In some ways, simply by going to Kyoto she became more heroic than a man like Sakamoto Ryōma, for she had to overcome the constraints not only of class but of gender as well. Her unconventional usurpation of the male prerogative is not to be denied. And, as Nancy K. Miller has said, "to justify an unorthodox life by writing about it is to reinscribe the original violation, to reviolate masculine turf."[25] In the sense both of who has been written about and who has done the writing, the events leading up to the Meiji Restoration have constituted masculine turf. Let us now proceed to violate it.

Kyoto, 1862–63

Most nineteenth-century Japanese women lived their lives oblivious to the reverberating public events taking place around them, or at least so it would appear from the written record. Even Taseko, for all the recognition she has achieved, actually did very little. By going to Kyoto in 1862, she found herself in the right place at the right time. As a student of classical poetry, she struck up an acquaintance with the aristocratic keepers of the courtly tradition, and her political beliefs concerning the sanctity of Japan and the divinity of the emperor brought her an introduction to the young radicals who promoted reverence for the emperor and expulsion of the barbarians. A search for contributions to the vast enterprise of the Meiji Restoration that can be identified as hers, however, turns up more fantasy than fact. My discussion of Taseko and the Meiji Restoration must thus focus less on what effect she had on the course of events than on what effect the course of events had on her. This amounts to turning inside out the

standard justification and impulse for biography. Regardless of how much she personally affected her times, it is clear that the opportunities afforded her in her encounter with the circumstances in Kyoto made it possible for her to act in ways that in comparison with the conventional female behavior of her times can only be defined as extraordinary.

Taseko took an extraordinary step in going to Kyoto alone. Heilbrun has written that women who throw off the yoke of being female impersonators in their old age need courage to overcome the obstacles of misery, anxiety, and ridicule that society can vent on those who deny the enforced destiny of women. Virginia Woolf, for example, "found a new and remarkable kind of courage when she was fifty . . . an achievement uniquely female."[26] In Taseko's case, the confluence of the freedom bestowed by old age and the revolutionary crisis made it possible for her to have an adventure, one conventionally denied to women, whose travel was more often done in groups on pilgrimage. The official reason for her trip was to study poetry, a conventional reason for visiting the city and one sometimes used by imperial loyalists to evade bakufu spies. In a letter to her cousin written after she was well on her way, she said only that "I have made up my mind to go to Kyoto, something I have wanted to do for a long time. . . . When I have successfully returned home, I look forward to telling you everything I have done."[27] Taseko may have kept her decision secret until it was too late for her to be stopped out of a desire to protect her friends from bakufu reprisals should she be deemed a traitor, but she may also have wished not to argue with them over the propriety of her actions.

Taseko's decision to go to Kyoto and go alone marks her as truly radical. Unlike the wives and mistresses of the male loyalists, who participated in the Restoration only insofar as it helped their menfolk, Taseko acted on her own. Not for her was the role usually assigned to women in revolution, that of "giving moral support to the men" or as one of "Carlile's womenfolk who underwent trial and imprisonment more out of loyalty than conviction."[28] Taseko acted not as a surrogate for a man or out of loyalty to a man, but for herself. At this point, we can identify the two necessary components in her creation of a loyalist identity. One is given in her age and her class background as a *gōnō* woman. The other demonstrates agency in the path she chose, which led from poetry circles to nativism to direct action.

One striking difference between the men and women who gathered in Kyoto to demonstrate their loyalty to the emperor was age.

The major males in the Restoration were young, an appropriate time at which to launch quests, to sow wild oats. Taseko was fifty-one. Trapped in an ordinary marriage and tied down with childbirth from the age of twenty to forty, her only chance for adventure came in old age. As Nagashima Atsuko has pointed out, for the Japanese women of her time and status, freedom and authority were incompatible.[29] Life crises occur later for women than for men; for women, the moratorium before action can last for decades until they are old enough to have done with the business of being women (female impersonators) expected of them by society.[30] Nevertheless, not every old woman freed from the responsibilities of family and household ran off to Kyoto to plot rebellion with young men. Despite the cultural context that provided Taseko with the ingredients she used to craft her identity, she transformed herself into a loyalist; no one did it for her.

Taseko's letters and diary suggest that she pursued two lives in Kyoto. The first consisted of the role she played in public. She wangled meetings with court nobles to whom she presented her poems. She paid visits to the famous sites of Kyoto, especially the hills of Arashiyama, covered in a brocade of autumn color. Together with a samurai from the Chōshū domain, she sought and found the reputed grave of Wake no Kiyomaro, the architect for the planning of Kyoto in 794, whose guardian spirit is still said to hover over the city. By the end of the year, she was spending many days in attendance on Hirata Kanetane, the adopted son of Atsutane and the leader of his school, who had come to Kyoto to collect information for the domain lord of Akita. She also met ladies-in-waiting at the imperial palace. Dressed in borrowed finery, she witnessed the banquet and dances held shortly after the beginning of the new year in the presence of the emperor. She was even allowed to catch sight of him. As she wrote to her cousin, "I am enjoying a most unusual spring." Following the dance, she was allowed to tour the palace. "I felt like I was truly in a dream, and I have been able to think of nothing but the emperor. . . . I have also visited the highborn ladies-in-waiting, and soon there will be nothing I have not seen. All of these pleasures are truly awe-inspiring for someone like myself." And she included a poem for her cousin to pass on to the other Ina Valley nativists: "More exalted than anything ever talked about while in my hometown was the scenery that spread before me at the imperial palace."[31]

The list of Taseko's acquaintances in Kyoto points to a substratum of activists—commoners and low-ranking samurai from many

different parts of Japan—who came together in the new political space created by restorationist politics. Membership in the Hirata school brought them together to discuss national affairs—the shogun's vacillations in the face of the latest exorbitant demands made by the barbarians and the emperor's desire for their immediate expulsion. Neither Taseko nor her friends had access to the high-ranking shogunal bureaucrats who made the decisions on how to handle the foreigners. The only thing they could do was try to figure out how to influence public opinion. Her family's wealth made it possible for her to entertain these men at saké shops. As a woman she could also act as an informant on internal conditions at the imperial palace and as a liaison between the court nobility and the loyalists, for whom she passed letters and information back and forth. She also appears to have spied on bakufu supporters, though this work was so secret that it appears in her diary only as "an investigation of weeds [suspicious types] in the royal flower beds." Less likely to attract the attention of bakufu police than her male associates, Taseko had the freedom of movement to establish contacts with men as exalted as the emperor's ministers and as base as a fertilizer merchant.

Did Taseko actually do anything besides spy on bakufu supporters at the palace, carry letters for her friends, and write poetry castigating the government? According to Inoue Yorikuni, who met Taseko years later and maneuvered to obtain for her posthumous court rank, she saved the life of Iwakura Tomomi, one of the engineers of the Meiji Restoration and a central figure in the new government that followed. In 1862 he had been forced into exile to a village north of Kyoto for having promoted the marriage of the emperor's sister to the shogun in an effort to shore up the alliance between court and bakufu (*kōbu gattai*). Many young loyalists, including the Hirata disciples, believed him to have been a traitor to the throne. They set Taseko to watch Tomomi because she could move through the streets of Kyoto unremarked by bakufu police. Somehow she wangled an introduction. In the course of a long conversation, she ascertained that he was sincerely devoted to the emperor. She told the loyalists everything he had said to her and thereby saved his life. "This was Taseko's greatest achievement."[32]

There is not the slightest shred of evidence that Taseko ever met Tomomi during her first trip to Kyoto in 1862. A number of historians have tried to come up with plausible scenarios for when and how she managed to make contact with him but without adducing any

support for their narratives. Her diary mentions him not at all, though admittedly it leaves out much of what she did, partly because had it fallen into the hands of the suspicious bakufu police it might have caused trouble for her and her friends. Nor does his diary mention her. "Those who tried to serve the emperor did not do so in order to make themselves famous in the future, so they didn't write anything down," one of her friends later told her cousin. "Even if I once had some documents, everything connected with your query [regarding what Taseko did] has long since been lost."[33] Most of the letters she exchanged with imperial loyalists and her friends were burned if they made any mention of national affairs. Taseko later became friends with Tomomi and spent some months living in the Iwakura compound at the end of 1868. By asserting that Taseko had earlier saved his life, Yorikuni neatly explained how this old peasant woman had come to the attention of a powerful court noble and justified her receipt of imperial honors.

Writing Taseko's biography, or indeed any biography, raises issues of evidence and choice. Frustrated at the paucity of sources available for the study of Tokugawa women, I first decided to study Taseko because at least some of her writings had been preserved. Many more, especially her letters, have not. Despite what I have been able to find, I am all too aware of the irreducible gaps in what I know about her life and her response to the circumstances within which she maneuvered. How does the biographer acknowledge the role that chance has played in preserving documents or the self-interest of the sources? Carolyn Heilbrun has argued that all biographies "are fictions necessary to the biographer" because the results of our scholarship are never as conclusive as we might make them appear.[34] Furthermore, my action in narrating here, in the present, the events of the past, in Japan, must become intensely self-conscious because, just as previous biographers have done, I choose what of a person's life is relevant and what is not based on whatever evidence happens to survive. Any biography is thus both historical and contemporary. The distance between the two cannot be mediated by a dialectic resolution or recuperation because the biographer has the power to decide how the text will be presented and the text has no power to answer back except insofar as the reader bestows her own reading on it. The postmodern biography tries to present a portrait of an individual and yet, in the words of Linda Hutcheon, it "subverts any stability in or certainty of ever knowing—or representing—that subject,"[35]

refusing to create a harmonious narrative out of the dissonant experience of history.

The incident that finally endangered Taseko's safety was the decapitation of the statues of the first three Ashikaga shoguns on 1863.2.22. Perpetrated by Hirata disciples, most of them commoners, who exposed the heads of these statues on the Kamo riverbed as if they had been criminals, the deed was done to castigate men deemed traitors to the throne back in the fourteenth century and to warn men in the present, especially the shogun, not to follow their example. Decapitating statues was a symbolic deed par excellence. Taken to exemplify loyalty to the emperor, it served as its own justification. The shogun was not amused. Assassinating low-ranking servants to intimidate their masters was regrettable, and none of the assassins was ever brought to justice. Attacking the shogun, however, even if by implication, was a crime deserving of death.[36] As a consequence, the Hirata disciples were arrested or driven from the city, and the incident ended in a grave setback for their school. With a number of others, Taseko sought safety in the Chōshū compound, where she was to remain for six weeks until she made her escape from the city. Yorikuni said that while she was in hiding she uncovered a bakufu spy and forced him to commit suicide. Other men disagree.[37]

How much Taseko knew about the Ashikaga incident and the meaning of her involvement with its perpetrators has been questioned even by men who knew her. Her chief biographer, Ichimura Minato, collected a number of statements from those held responsible for it, ranging from Tsunoda Tadayuki's "she had nothing to do with it" to a recollection by Morooka Masatane, reported in a letter from the son of Watanabe Shinzaburō, that she had instigated the incident. She never mentioned having gone to see the statues in her diary, and when a meeting was called to discuss "wooden heads" she did not attend. On the night the deed was done, she was home alone when after midnight a number of men appeared with mud on their clothes. "Have you been up to more mischief" (*Mata itazura o nasarebe senu ka*)?[38] she asked, suggesting a certain degree of disapproval.

Whatever meaning Taseko attached to her role in this incident, it is clear that Tsunoda tried to silence it by attributing gender to her deeds in a way that precluded her knowledge of what happened. Morooka perhaps subverted the meaning that she attached to the incident by giving her an overly active role. The distance between these two positions is unbridgeable. Kathleen Barry has argued that because

"meaning is attributed in interaction" it acquires gendered attributes that subvert, silence, or interpret the meaning women attach to action to be something else, thus creating an unsolvable problem of verification.[39] Whatever Taseko did, she did as a gendered subject, and her deeds have always already been interpreted in this light.

Harootunian has argued that for the loyalists who flocked to Kyoto in the early 1860s the restorationism that they espoused functioned less as a blueprint for the future than as a "system of meaning sanctioning forms of action."[40] In her poems, Taseko expressed similar sentiments. Poetry is of course more suited to calls for great deeds than to defining institutional configurations, but even her diary notes only anger at the shogun or disgust at the barbarians, never the practical measures needed to reform the state. It could be said that, being a woman and confined to the medium of poetry, she had no choice but to ignore practice. But that would be to expect more of her than what was actually offered by her male companions. The year 1862 was not yet a time for goal-oriented action; it was a time for committed idealism, and this approach to problem solving Taseko shared with the men around her.

Through her engagement with the men she met in Kyoto during a brief six months in 1862 and 1863, Taseko became an imperial loyalist. She had started out a poet, and by writing poetry filled with indignation at the barbarian's threats and the shogun's weakness she joined in the political process that led to the overthrow of the bakufu and defined a public identity for herself. As Dorinne Kondo has pointed out, "Identity is not a static object, but a creative process, hence crafting selves is an ongoing, indeed life-long occupation."[41] Nevertheless, in Taseko's case it is possible to identify major turning points in this process, from poet to nativist to loyalist, moments in time when she as her own agent enacted an identity that she then consciously maintained. After 1868, her political identity apparently remained constituted in terms of the lessons she learned as a loyalist—to revere the emperor and expel the barbarian.

Taseko's concern with national affairs continued after her brief stint in Kyoto. A number of imperial loyalists hid at her house in the Ina Valley. She provided them with food and shelter, then sent them on their way with money and letters of introduction. As soon as she received word that the shogun had returned his powers to the throne, she made preparations to return to Kyoto. There she renewed her contacts with men she had met in the Chōshū compound and had

herself introduced to various members of the court aristocracy, in-
cluding Iwakura Tomomi. Through her good offices, a number of
men from the Ina Valley were able to find preferment in the new
Meiji bureaucracy, so much so that she became known as the "Iwakura
employment office." She went to Tokyo in 1869 to use what political
influence she had in helping two bakufu bannermen try to get the
status in the new government that they felt they deserved. In 1881,
Tomomi invited her to bring her grandson to Tokyo to give him a
chance to serve the emperor as a bureaucrat. For a woman from the
countryside, devoted to the ideals of expelling the barbarian, the West-
ernized "enlightenment" (bunmei kaika) atmosphere of the capital
was a shock. Like Aoyama Hanzō, the protagonist of Before the Dawn,
Shimazaki Tōson's great historical novel about the Meiji Restoration,
she was unable to adjust to the reality of the new age. Instead, she
remained highly critical of the direction urban change had taken, as
the following poem shows: "These strangers who have come in—weed
them out. When will the imperial reign be purified?"[42] She remained
unreconciled to modern Japan for as long as she lived.

Harootunian believes that within ten years after the Restoration
the nativist ideals of a pure, unsullied Japan where people lived simple
lives in the imperial presence had all but vanished.[43] This may have
been true at the political center of the country but not in rural areas.
For Taseko, expulsion of the barbarians was tied irrevocably to rev-
erence for the emperor. Having once committed herself to an identity
as a loyalist, she refused to move with the times. Her stance reminds
us that not all Japanese greeted change with equal delight; for some,
the old discourse continued to have significance.

Biographers of an eminent man often argue that their subject is
worthy of study not only because of what he did but what he repre-
sented, yet Taseko was by any definition an extraordinary woman,
one with no counterpart. If she represented anything, it was the xe-
nophobic wing of the Hirata school. Feminist scholars have pointed
out that claiming representation submerges individual differences in
cultural generalization.[44] A feminist biography that acknowledges its
subject to be unrepresentative also recognizes itself to be a subjective
document; it does not claim an "ungendered point of viewlessness."
In the words of Susan Geiger, "notions of objectivity themselves are
androcentric, and higher levels of abstraction assumed to present a
true picture of reality often represent neither truth nor reality for
women."[45] Accounts of the Meiji Restoration that emphasize the role

of samurai from the southwestern domains present a version of reality that contests the truth of Taseko's experience and indeed the experiences of many of her associates. For these people, who desperately wanted to act on behalf of the emperor but lacked the connections that came so easily to the ruling class, the political maneuvering between court and bakufu appeared to be nothing more than empty posturing that allowed each side to save face. In their eyes, and as we can read in Taseko's poems, the Meiji Restoration ended not in the triumph of a newly unified state but in frustration at the Western influences it brought in its train.

SELF AND DOMINATION

Lest this narrative appear too harmonious in its portrayal of a woman committed to political action, let us now examine the contradiction between what Taseko did and her vision of herself as a woman. She acted at an extraordinary time, a time of national crisis, when the public space expanded beyond the ability of the ruling authorities to control it and normative standards of behavior were temporarily in abeyance. Young men defied the political hierarchy that defined their place, and Taseko became androgynous, a *onna masurao*, as one of her fellow disciples called her.[46] Mary Ryan and Carroll Smith-Rosenberg have argued that in periods of social confusion and/or class formation women are granted larger public roles than usual for a brief period while the line between public and private dims.[47] At such times, they fill a position in what Victor Turner has identified as one of the four major forms of antistructure, that of marginality. "Marginality refers to people who are simultaneously members of two or more groups whose social definitions and cultural norms are distinct from and often opposed to one another, for example, a woman in a changed, nontraditional role."[48] It must be remembered that Taseko never characterized herself as marginal. She might be defined as such from the perspective of her society's dominant norms and established power relations, but this deviation from the norm empowered her instead because, while it maintained her distance from the center of power, it also distanced her from the conventions of female selfhood. This condition did not last long, however, for as soon as the confusion abated the lines of gender rigidified, and Taseko was expected to fall back into a more limited, structurally acceptable role.

Ultimately Taseko could neither maintain her distance from the conventions of female selfhood nor deny her desire to go to Kyoto,

which effectively negated them. Caught up, if only briefly, in the greatest story of her time, she had an experience that set her off from everyday life, making her conscious of both its frame and its content. In such instances, the self may "reflect on itself as well as on the underlying cultural system that creates it."[49] One of her poems that rails against the social constraints imposed on her reminds us of the conflicts between the various contexts of her life, the limits placed on her ability to craft a loyalist identity, and the difficulty of sustaining an autonomous identity. Entitled "On Regretting Being a Woman," it reads: "Morning is celebrated on the plains of heaven in the sky, but in the hateful lower depths, you cannot even see the sunshine."[50] As Roland Barthes has pointed out, to represent the self is to constitute the self,[51] and here the female self becomes innately inferior to men. This poem demonstrates how people inevitably participate in their own oppressions; they comply with the hegemonic representations of their selfhood even as they struggle against them. As long as Taseko saw her world in nativist terms, she supported the system of gendered relations that, in separating her from other, less politically conscious women, maintained sexist power.

Taseko's inability to subsume her understanding of what constituted the female self into her identity as a loyalist can be read in a number of ways. Carolyn Heilbrun has written that "above all other prohibitions, what has been forbidden to women is anger, together with the open admission of the desire for power and control over one's life."[52] Even though Taseko was an unconventional person who defied the appropriate gender assignments imposed on women by the society of her times, her rage at the frustrations of being a woman could only be expressed if it were tied to her devotion to the imperial cause. In other words, it was defined in nativist rather than feminist terms, and she blamed not society but the fragility of her own body for preventing her from acting, as we read in the following poem:

> Born in the country of Japan, blessed by the myriad deities, weak woman that I am, I am useless. Had I been born a manly man, even were I not numbered among the warriors, I would gird a great sword at my hips, in my left hand I would grasp a straight bow from Shinano where the fine bamboo is cut, and my right hand would hold feathered arrows. The despicable rascals who know not the way, the lunatics who betray the emperor, they would all be driven out, every last one of them would be expelled. From the bottom of my heart I am filled with ardor, but like a leech I cannot stand on my own. Here I am, regretting the useless body of a weak woman.

How awful to have the ardent heart of a brave man and the useless body of a weak woman.[53]

Of all the long poems Taseko wrote on political subjects, this one challenges the reader most. Let us first examine the phrase "weak woman that I am, I am useless" (*tahayame no ware wa kai naki*). It was unusual for anyone, male or female, to use the term *ware* in a long poem. The preferred term was *waga*, a word she had employed in her poem lamenting the silk trade and used often in a form akin to a possessive—"my" or "our" beloved lord, for example.[54] For the subject of action to stand out as the self (*ware*) instead of remaining implicit is thus anachronistic given the conventions of the form. This effect is heightened by Taseko's use of a Chinese character, which casts a masculine shadow, instead of the Japanese syllabary always considered more appropriate for females. Furthermore, although the phrase itself had been used by men to refer to themselves from the middle ages on, it was used seldom by women. Among the whole series of self-referential words used by Tokugawa period women, including *watakushi*, are several of two syllables (such as *washi*) that would have fit the meter.[55] Why, then, did Taseko pick precisely the term that jars most sharply the culturally defined character of women presented in the poem?

First, we must decide whether this use of *ware* really points to a contradiction lying at the heart of the poem. Perhaps it can simply be explained away by attributing it to Taseko's lack of education. Never having received the training that properly brought up young ladies might acquire in the mansions of the daimyo, had she learned only how men referred to themselves in writing? Given her broad range of connections in Kyoto, this seems unlikely. The rest of the poem could also be read as ironic self-deprecation or rhetorical posturing for public consumption, but I would argue that Taseko took herself far too seriously to be consciously ironic and valued too highly the sincerity of the true loyalist to lapse into hypocrisy. Perhaps a better explanation might be found in the behavior of the female founders of new religions like Nakayama Miki (1798–1887) and others like her, who continue to take on the accoutrements of male identity to give themselves the authority to speak in public space.[56] The use of this term also links Taseko to Kishida Toshiko (1863–1901), who, like Taseko, took advantage of an accidental encounter with a significant political event to speak in public, and Higuchi Ichiyō (1872–96), the Meiji period

essayist and short story writer, who used the term *ware* in a statement regretting not being woman enough to have children. As Nishikawa Yūko points out, women of the nineteenth century—Miki, Taseko, Toshiko, and Ichiyō—lived betwixt and between the certainties of the Tokugawa period and the completion of the Meiji state, a time when language, like so much else, was up for grabs.

This poem can also be read as a direct statement about the process of constructing a life story, revealing as it does Taseko's profound ambivalence about her position as an interloper in androcentric space and suggesting that, like all women who have led unconventional lives, she teetered uncertainly between two destinies, masculine and feminine, "clearly the rightful possessor of neither."[57] Her vulnerability to the cultural fictions about appropriate female behavior appears in the writing of other Tokugawa period women as well, notably the poet-painter Ema Saikō (1787–1861), who despite her fame as an artist felt that she had failed as a woman because she never married.[58] Both of these women became the subjects of their own lives, but in so doing they had to go so far beyond the conventional female plot of their day that they could not always deal with the consequences. Perhaps for that reason they retreated into a denial of their achievements. Taseko's poem is dominated by a yearning for male-identified selfhood, and the language is martial in the extreme. Yet, by rejecting any possibility that she can join the troops raised by the god of war, she also subverts the authorized and public version of herself as a manly woman, an unnatural hybrid who as a loyalist had defied the ideology of sexual difference. This poem accepted cultural expectations about appropriate feminine behavior and offered reassurance that Taseko fundamentally accepted her identity as the silent and passive woman expected by patriarchal culture.

Reading this poem in another way would emphasize that to the extent Taseko defined worthwhile action in male terms and acknowledged the male-centered ideology of selfhood she gained "the cultural recognition that flowed to her as a person who embodied male-identified ideals, but she also perpetuated the political, social, and textual disempowerment of mother and daughter."[59] In the end, it was simply not possible for her to assert her multiple identities as a woman and an activist. Her adventure in Kyoto failed to lead her to the self-illumination that might have rendered it truly subversive according to contemporary standards, but it is hardly fair to judge a woman of the past by the advanced feminist standards of the present.

As Dea Birkett and Julie Wheelwright remind us, "rather than raid-
ing the past to find satisfactory models for today, we should look to
the difficulties, contradictions, and triumphs of women within the
larger context of their own times."[60] In regretting the weak body of a
useless woman, Taseko speaks directly to the contradictions that re-
sulted from her crafting of a loyalist identity. Even in reflecting on
this critical moment in her life, she was unable to maintain the fic-
tion of a unified self.

NOTES

1. I first came across Matsuo Taseko in Shimazaki Tōson, *Before the Dawn*, trans-
lated by William E. Naff (Honolulu: University of Hawaii Press, 1987), 780. For
making available to me their insights and suggestions, I would like to thank
Peter Nosco and Herman Ooms.
2. The other two were nun-poets who gave aid and assistance to male activists: Ōtagaki
Rengetsu (1791–1875), born the daughter of a domainal lord; and Nomura Bōtō
(1806–67), the daughter of a samurai from Chikuzen in Kyushu.
3. Carolyn G. Heilbrun, *Hamlet's Mother and Other Women* (New York: Ballantine,
1990), 123. The reference to Vera Brittain is on page 44.
4. Susan N. G. Geiger, "Women's Life Histories: Method and Content," *Signs: Journal
of Women in Culture and Society* 11.2 (1986): 335.
5. For an extended discussion of this issue, see my "The Family Ideology of the Rural
Entrepreneurs in Nineteenth Century Japan," *Journal of Social History* 32.3
(spring 1990): 463–83.
6. The most exhaustive biography is Ichimura Minato, *Matsuo Taseko* (Iida: Yamamura
Shoin, 1940). For her collected works, see Shimoina-gun Gunyakusho, ed.,
Shimoina gunshi shiryō, vol. 2 (Rekishi Toshosha, 1977). I have also relied on
Takaki Shunsuke, "Sōmō joseishi," in *Kinsei*, vol. 3 of *Nihon joseishi*, edited by
Joseishi Sōgō Kenkyūkai (Tōkyō Daigaku Shuppankai, 1982).
7. This is a close paraphrase of a line found in Nellie Y. McKay, "Nineteenth-Century
Black Women's Spiritual Autobiographies: Religious Faith and Self-Empower-
ment," in *Interpreting Women's Lives: Feminist Theory and Personal Narratives*,
edited by Personal Narratives Group (Bloomington: Indiana University Press,
1989), 146.
8. For another example of the artistic circles open to women, see Patricia Fister,
"Female *Bunjin*: The Life of Poet-Painter Ema Saikō," in *Recreating Japanese
Women, 1600–1945*, edited by Gail Lee Bernstein (Berkeley: University of Cali-
fornia Press, 1991), 120, 124–25.
9. Tinne Vammen, "Forum: Modern English Auto-Biography and Gender," *Gender
and History* 2.1 (spring 1990): 17.
10. Liz Stanley, "Moments of Writing: Is There a Feminist Auto-Biography?" *Gender
and History* 2.1 (spring 1990): 61–62.
11. Stephen A. Tyler, "Post-modern Ethnography: From Document of the Occult to
Occult Document," in *Writing Culture: The Poetics and Politics of Ethnography*,
edited by James Clifford and George E. Marcus (Berkeley: University of Califor-
nia Press, 1986), 125–26.
12. H. D. Harootunian, *Things Seen and Unseen: Discourse and Ideology in Tokugawa
Nativism* (Chicago: University of Chicago Press, 1988), 98.

13. Roger K. Thomas, "Plebeian Travelers on the Way of Shikishima: Waka Theory and Practice during the Late Tokugawa Period," Ph.D. diss., Indiana University, 1991.
14. Peter Nosco, "*Man'yōshū* Studies in Tokugawa Japan," *Transactions of the Asiatic Society of Japan*, 4th ser. 1 (1986): 142.
15. Vammen, "Forum," 20.
16. Sidonie Smith, *A Poetics of Women's Autobiography: Marginality and the Fictions of Self-Representation* (Bloomington: Indiana University Press, 1987), 45.
17. Dorinne K. Kondo, *Crafting Selves: Power, Gender, and Discourses of Identity in a Japanese Workplace* (Chicago: University of Chicago Press, 1990), 48. Let it be noted that poststructuralism deconstructs such notions as agency and free will, pointing to the danger of speaking in terms of choice, but that is not a debate I want to enter here. See Diana Fuss, *Essentially Speaking: Feminism, Nature, and Difference* (London and New York: Routledge, 1989), 34.
18. Harootunian, *Things Seen*, 98.
19. Ichimura, *Matsuo Taseko*, 25–26.
20. Smith, *Poetics*, 97, 134.
21. Ichimura, *Matsuo Taseko*, 57; see also Shimoina-gun Gunyakusho, *Shimoina gunshi shiryō*, documents sec., 149.
22. Gayle Greene and Coppélia Kahn have pointed out that "describing exceptional women defines achievement according to the male, public world, and appending women to history as it has been defined leaves unchallenged the existing paradigm." See their "Feminist Scholarship and the Social Construction of Women," in *Making a Difference: Feminist Literary Criticism*, edited by Gayle Greene and Coppélia Kahn (New York: Methuen, 1985), 13.
23. Carolyn G. Heilbrun, *Writing a Woman's Life* (New York: Norton, 1988), 17.
24. Smith, *Poetics*, 7–8.
25. Heilbrun, *Writing a Woman's Life*, 11. See also Smith, *Poetics*, 42. Taseko's transgression of cultural expectations may be one reason why she disappears from the texts written by the men she knew and from the written works collected by other men.
26. Heilbrun, *Writing a Woman's Life*, 124–25.
27. Ichimura, *Matsuo Taseko*, 75. Her decision to see for herself can be read as analogous to Mary Wollstonecraft's determination to visit revolutionary Paris in 1792. As Virginia Woolf wrote regarding Wollstonecraft, "The revolution was not merely an event which happened outside of her; it was an active agent in her own blood" (quoted in Sian Reynolds, ed., *Women, State and Revolution: Essays on Power and Gender in Europe since 1789* [New York: Wheatsheaf Books, 1986], ix).
28. Joan Wallach Scott, *Gender and the Politics of History* (New York: Columbia University Press, 1988), 73.
29. Nagashima Atsuko, "Bakumatsu nōson josei no kōdō no jiyū to kaji rōdō," in *Ronshū kinsei joseishi*, edited by Kinsei Joseishi Kenkyūkai (Yoshikawa Kōbunkan, 1986), 168.
30. Heilbrun, *Writing a Woman's Life*, 126–28.
31. Shimoina-gun Gunyakusho, *Shimoina gunshi shiryō*, documents sec., 181–82. The letters from Taseko to her cousin and other members of her family are mentioned repeatedly in *Before the Dawn*, where they became an important source of information for Tōson's father and the other rural nativists (see 213, 307).
32. Inoue Yorikuni, "Shinano no retsufu: Matsuo Taseko," *Yamato shinbun*, 17 November 1911, 1; Ichimura Minato's conversation with Yorikuni is reported in Shimoina-gun Gunyakusho, *Shimoina gunshi shiryō*, narrative sec., 108–10.
33. Shimoina-gun Gunyakusho, *Shimoina gunshi shiryō*, narrative sec., 85.

34. Heilbrun, *Writing a Woman's Life*, 29.
35. Linda Hutcheon, *The Politics of Postmodernism* (London and New York: Routledge, 1989), 116.
36. See Anne Walthall, "Off with Their Heads! The Hirata Disciples and the Ashikaga Shoguns," *Monumenta Nipponica* 50.2 (summer 1995): 137–70.
37. Watanabe Genpo, "Matsuo Taseko den Genpo-kun bengi," *Shidankai sokkiroku*, vol. 93 (Shidankai, 1900), 32.
38. Ichimura, *Matsuo Taseko*, 117–19.
39. Kathleen Barry, "The New Historical Synthesis: Women's Biography," *Journal of Women's History* 1.3 (winter 1990): 77.
40. Harootunian, *Things Seen*, 378.
41. Kondo, *Crafting Selves*, 48.
42. Shimoina-gun Gunyakusho, *Shimoina gunshi shiryō*, documents sec., 212.
43. Harootunian, *Things Seen*, 403.
44. Smith, *Poetics*, 8.
45. Geiger, "Women's Life Histories," 338. See also "Afterward" in *Interpreting Women's Lives*, 261–64.
46. Ichimura, *Matsuo Taseko*, 117.
47. Carroll Smith-Rosenberg, *Disorderly Conduct: Visions of Gender in Victorian America* (New York: Oxford University Press, 1985), 44, 140, 157–58; Mary P. Ryan, *Womanhood in America: From Colonial Times to the Present* (New York: New Viewpoints, 1975), 42, 74.
48. Quoted in David L. Barnell, "Bashō as Bat: Wayfaring and Antistructure in the Journals of Matsuo Bashō," *Journal of Asian Studies* 49.2 (May 1990): 276.
49. Riv-Ellen Prell, "The Double Frame of Life History in the Work of Barbara Myerhoff," in *Interpreting Women's Lives*, 251.
50. Shimoina-gun Gunyakusho, *Shimoina gunshi shiryō*, documents sec., 102.
51. Hutcheon, *Politics*, 41.
52. Heilbrun, *Writing a Woman's Life*, 13.
53. Ichimura, *Matsuo Taseko*, 98.
54. For examples of this usage in *Man'yōshū* poems, see Gary L. Ebersole, *Ritual Poetry and the Politics of Death in Early Japan* (Princeton: Princeton University Press, 1989), 175, 193, 196, 210, 217.
55. See Sugimoto Tsutomu, *Onna no kotoba shirushi* (Yūzankaku, 1985), 191 (for a history of the term), 170, 171, 181, 188 (for examples of women's speech).
56. I am indebted to Helen Hardacre for this insight.
57. Heilbrun, *Hamlet's Mother*, 34.
58. Fister, "Female *Bunjin*," 129.
59. Smith, *Poetics*, 53.
60. Dea Birkett and Julie Wheelwright, "How Could She? Unpalatable Facts and Feminists' Heroines," *Gender and History* 2.1 (spring 1990): 50.

Diaries as Gendered Texts

NISHIKAWA Yūko

Translated by Anne WALTHALL

In modern times, almost all Japanese people keep diaries (*nikki*, from *nichi*, meaning "day," and *ki*, meaning "record") at one time or another during their lives. Diaries, especially those written by women, constitute a major genre in modern Japanese literature, behind which lies a rich and lengthy tradition of more than a thousand years of diary writing in Japanese. Here I first emphasize the differences between men's and women's diaries in the classical tradition and the implications for diary writing that assumes a readership. I then discuss modern Japanese diaries, those written by Higuchi Ichiyō and Kishida Toshiko as well as many unknown housewives. In considering the role played by diaries in the self-education of women, especially in the acquisition of a gendered identity, I focus on how the standardized format launched by publishing firms early in the twentieth century contributed to the training of the professional housewife.

THE DIFFERENCES BETWEEN MEN'S AND WOMEN'S DIARIES

In Japan, men's and women's diaries have differed in content, style, and rules for the use of written characters. The ancient Japanese imported the laws, rituals, and bureaucratic system of Tang dynasty China, which meant that each government office had to record the day's business using Chinese characters. Soon after, men began to keep private records relating the affairs of their houses. Before long, the bureaucracy became the hereditary occupation of the aristocracy, and the relative weight given to government records versus private house diaries reversed itself. The aristocrats at court recorded the business done at their government offices and the rituals of the court as well as their household enterprises and the affairs of their clans in one place—their private house diaries. From the tenth century on,

they began to collect diaries, borrowing and copying not only the diaries kept by their ancestors but famous diaries kept by other people in order to cite them as precedents for customary practices.[1] These diaries were handed down from father to son, giving substance to the conception and prestige of the house.

Women of the same period wrote diaries in Japanese using the syllabary system (*kana*) unique to Japan. Women at court kept official records of official business and private diaries of daily life. "I intend to see whether a woman can produce one of those diaries men are said to write," begins *Tosa nikki* (A Tosa Journal), a travel diary written by a man imitating the style of a woman.[2] *Kagerō nikki* (The Gossamer Diary), *Murasaki Shikibu nikki* (Diary of Murasaki Shikibu), *Izumi Shikibu nikki* (The Izumi Shikibu Diary), and *Sarashina nikki* (The Sarashina Diary) are called *nikki*, but each and every one of these literary diaries is set in the middle years of the author's life when the past is recalled and rewritten from memory. They are carefully constructed literary works written in a polished style.[3] Women's diaries, too, were copied by others, and thus they spread to readers outside the family and to later generations.

There are various reasons why diaries written by women in Japan developed as they did in the Heian period. One that I would like to stress here is how the marriage customs and household system peculiar to ancient Japan shaped the circumstances within which women's diaries were created. The marriage practices prevalent among the aristocracy of the time constituted a form of matrilocal marriage, with the man visiting the woman's house (*kayoi kon*). The children produced by these "commuting marriages" were born and raised in their mother's house, but this did not imply the existence of a matriarchy because male children obtained their social position with their father's backing. In principle, one man might visit plural wives, and in the course of her lifetime one woman might be visited by plural husbands. In reality, the former situation was far more common. Even though a man might set up a house to which he would invite one of his wives to come and live, it was recognized that he might have other wives whom he would continue to visit. Whereas there were various formalities and ceremonies connected with the beginnings of such marriages, it was difficult to know when a marriage had ended. The only way for a woman to know a separation had taken place was when the man's visits stopped altogether. The diaries written by the women often depicted the long history of a commuting marriage by

linking the poems exchanged with a man to notes explaining them. These might include the circumstances under which a poem was written, the author's feelings at the time, thoughts expressed later, or a psychological contemplation of the self left isolated. In addition to depicting a woman's life for her descendants and serving as a model for young members of the same sex in the extended family, these diaries also served as a sort of proof of parentage for the children born of the commuting marriage.

Down through later centuries, the custom of keeping a diary gradually spread to other social classes. Once it became the custom to take in a bride and patrilocal cohabitation became the norm, successive generations of male heads of households kept and preserved the family diary. After the great age of classical literary diaries, many of which were written by women at the Heian court, the number of diaries written by women, at least those we know about, seems to have dwindled, although women officials at court continued to keep journals, as did some wives of warriors. One exception comes in the Edo period, when many women wrote travel diaries. In this period, diary writing may even have become the fashion for women who had the opportunity to extricate themselves from the family by entering a nunnery or traveling.

Once we reach the point in modern times when standardized, printed, and bound diaries, always called *nikki*, were published, we find that both men and women kept diaries in large numbers. Even in this age of modern diaries kept by individuals and for individuals, however, diaries still tend to be divided between those for men and those for women.

Diaries That Assume a Readership

Most traditional diaries, in both their original and copied forms, were polished in style and written in clean copy with elegantly formed characters. This is because they were written for an audience, even though it might be just the family or a small social group. Almost no originals remain of the classical diaries of the Heian court, but when we stop to consider that they were read and handed down in numerous copies, we can see that the diary was conceived as something written with a readership in mind. The diaries written in later periods by warriors, merchants, and peasants also constituted records of events, practices, and observances kept for the author's sake and that of his descendants. Of course, diaries written in Japanese were not limited

to house diaries. There were many varieties, including travel diaries, traditional Japanese poetry diaries, haiku diaries, and picture diaries in addition to records of illness and nursing and ascetic practices. No matter what the subject, in all cases there is a tendency to assume a readership.

Do not diaries written with the assumption that they would be read by someone contradict the notion of the diary as commonly conceived in the West? Were I to apply a Western classification of standard literary genres, the literary *nikki* written by women in the Heian period might better be designated memoirs. The writer of a Heian literary diary might rewrite the whole thing toward the end of her life. For the writer and the readers among her contemporaries, everyone knew when, where, and between which people an exchange of poems had taken place. The date was often ambiguous, and even when the date was given the year often was not. Poems entered in the diary sometimes served the role of marking the date, and it was perfectly all right for the flow of time to be subjective.

In her book on diaries (*Le journal intime*), Béatrice Didier argues that diaries kept in the West are an expression of the self in an age of modern individualism. The diary is to be kept shut up in a locked drawer in one's own room inside the house, and the diary itself is a text meant to be read silently.[4] In the early twentieth century, some men in Japan began to write private individualized diaries in the Western mode, not showing them to others. Ishikawa Takuboku (1886–1912), for example, kept his diary (*Takuboku nikki*) in the Latin alphabet so that his wife could not read it. On the other hand, some fathers at the end of the day would gather their children together and read a summary of the day's events aloud as a way to complete the day. Even today, elementary school teachers will read a record of the day's assignments to their students and add their own reflections. These diaries serve an educative role.

There are probably few examples in the West of the records of illnesses or death (indeed, accounts of approaching death) that were then made public, such as those kept by Masaoka Shiki (1867–1902) and Nakae Chōmin (1847–1901). Shiki's diary was serialized in a newspaper with only the briefest interval between the time of writing and the time when it could be read. Thus author and reader observed the death of the author, that is, his self, as though watching an actor perform on stage. This is probably the most extreme example of the Japanese tradition of diary writing that assumes an audience.

Regardless of the differences between Western diaries written in secret and Japanese diaries that presume an audience, they share one commonality defined by Didier: "If there is one constant to the movement of the diary writer, it is to move from externalities to the internal self."[5] It seems to me that women's diaries served as a means of acquiring a gendered identity on the part of both the diary's author and its reader. By writing a diary, some women might gradually internalize gendered norms and make them their own, whereas others might discover a self to whom the norms of gender did not apply. To make this argument, I plan to take up the splendid *Ichiyō nikki* (Ichiyō Diary), kept by the novelist Higuchi Ichiyō (1872–96), which synthesized the received tradition of all sorts of diaries written in Japanese, and compare it with the diary kept by an early advocate for women's rights, Kishida Toshiko (1863–1901).[6] Then I shall discuss the vast number of diaries written by housewives in books standardized, printed, and bound for that purpose that spread throughout Japanese society following Ichiyō's death.

THE *ICHIYŌ DIARY*

I chose the *Ichiyō Diary* because it can be situated at a special point, at the gulf between tradition and modernity. Higuchi Ichiyō consciously took over the tradition of women's diaries and in her diary depicted the anguish of having selected the modern profession of a writer. It is also possible to compare the *Ichiyō Diary* with the *Shōen nikki* (Smoke from the Xiang River Diary), written by Japan's first women's rights advocate, Kishida Toshiko. Through her own efforts Higuchi Ichiyō cleared the path for the first female professional writers in modern Japan. Upon her death at the young age of twenty-four in 1896, she left more than forty hand-bound notebooks of diaries she had kept day by day for about nine years.[7] The first distinctive feature of her diaries is that they inherited a style from all the various traditional lineages of diary keeping. The second is that Ichiyō recorded the names of about five hundred people, an extremely large number to find in a single example of this genre. The third is that she wrote in a polished yet concise style that has affected generations of readers. Even though she wrote every day, the *Ichiyō Diary* can be divided into three or four parts and read like a structured work or a novel.

Higuchi Ichiyō had a number of reasons for writing her diaries. After she received her elementary education, she did not have the

money to go to a girl's school. Instead she became an apprentice at the Haginoya, the "Bush-Clover Cabin," a private conservatory that taught the daughters of the new Meiji aristocracy and the bourgeoisie the interpretation of classical literature and the art of writing Japanese classical poetry (*waka*). There she did the cleaning and attended lessons whenever she had the chance. Later she was even taken on as an assistant instructor. From the age of fourteen, Ichiyō kept a diary in a classical style that joyfully imitated the style of the literary diaries of the Heian period. In addition to incorporating quotations taken from classical diaries, she tried out pastiches and parodies of the classics.

After Ichiyō turned fifteen, her family suffered a series of misfortunes. Her elder brother died of an illness, and her other brother turned profligate. Her father died in 1889, having completed the formalities for making her his successor and the head of the household with responsibility for taking care of her mother and younger sister. In the diary in which Ichiyō recorded how she had conducted her father's funeral, adhering to the rituals he had described for his son's, she used the pronoun *yo*, commonly reserved for men. Thus, her diary became that of the head of a household.

Following the death of her father, Ichiyō resolved to become a novelist in order to earn money. To further her career, she apprenticed herself to Nakarai Tōsui, who wrote novels serialized in newspapers. At that point, her diary became a means of discipline, a place where she could write depictions of events and people that could serve as materials for her novels and record the teachings and criticisms of her mentor. She wrote that she decided to mark with a black circle in her diary those days when she had neglected to work on the manuscript she had planned for a novel. Ichiyō also loved Tōsui, and for this reason her diary also became the record of her love.

Ichiyō was unable to sell the manuscript of her novel, and she was disappointed in love. At one point, she abandoned her story writing, moved to the impoverished lowland area of Tokyo, and opened a store where she sold trinkets, toys, and cheap sweets. In her diary, she reports: "13 August, clear. Went to Tamachi peddling my goods. Today's sales totaled thirty-three *sen*."[8] The diary had become a ledger recording the laying in of merchandise, accounting for her money, and marking the gradually increasing burden of debt.

The *Ichiyō Diary* is truly multifaceted. As an aid to memory, it recorded the names of all visitors, their business, and the exchange of

presents. In addition to a detailed accounting of debts and repayments, it contained a record of income and expenses for such items as manuscript paper, as well as notations for a complex household budget. Stock phrases for the weather plus descriptions of the regular functions of each month, birthdays of members of the household, and the dates of temple fairs were repeated throughout. Rather than making it monotonous, however, these repetitions served as a refrain, giving the diary rhythm. In this sense, her diary resembles later housewives' diaries, but Ichiyō kept these ledgers as the female head of the household.

Ichiyō's life as a merchant ended in a miserable failure after ten months, and she moved again. While her mother and sister took in sewing to keep the household going, she borrowed money for their immediate expenses and renewed her determination to become a novelist. Taking advantage of favorable attention attracted by a short story she had published in the monthly journal *Bungakkai* (World of Literature), she placed other stories in *Bungei kurabu* (Literature Club) and *Taiyō* (Sun). *Sun* was an omnibus magazine. Its publisher, Hakubunkan, one of the largest publishing firms in Meiji Japan, boasted that it had a current circulation of one hundred thousand. All at once, Ichiyō had become a popular writer. While still struggling to repay her family's debts, she frantically continued to write short stories. Her diary during this period became a record of her internal being, the sufferings she endured, her struggles as a writer, and the scandals and abuse that afflicted her as a woman author.

Ichiyō met many people in the course of her short life, but her survival depended on her own efforts. In her diaries, she drew portraits of numerous literary figures of the time in pitiless and cold strokes of the brush. People frequently spoke of her cold demeanor and how difficult it was to get to know her. Close to the end of the *Ichiyō Diary* she recorded her feelings of isolation as follows: "I have not one person I can call a friend, and when I think that no one has taken the trouble to get to know me, I feel like I am the only person ever born in this world. Because I am a woman, no matter what sort of scheme I think up, I never know whether I will be able to put it into practice."[9] She was also saying that an existence like hers, without husband or child, was lonely. By keeping a diary, she became conscious of the complexity of her own self, which changed with every new circumstance, and aware that she led an isolated existence in which she had gradually deviated from the norms of femininity.

Ichiyō had considered dividing her diaries into four parts while she was alive. The first part covered her idyllic existence as a young girl when she lived under her father's protection. In the second part, entitled *Yomogyu nikki* (The Small Dilapidated Diary), she recorded her troubles, beginning with her father's death and the torments of her love for Tōsui. The third part she called *Chiri no naka nikki* (Diary in the Dust), a record of how she abandoned middle-class life to live as a miserable shopkeeper in the lowlands of Tokyo. The fourth, called *Mizu no ue nikki* (Diary above the Water), recorded the internal solitude of a novelist enveloped in scandals and glory. Ichiyō also dealt with many social problems in her diary, using it as a forum to record denunciations of individuals and criticisms of her times that could not be expressed to others. The changes in the title of her diary reflect the transformations in her life and her sojourns in one place or another. By keeping a diary, Ichiyō observed her conduct objectively, resolutely proceeded to the next stage in her life by her own volition, and grasped the meaning of her existence, its isolation and challenges, which had deviated from gendered norms when she decided to become an author. The way she lived, using her own agency to cut a way through life, gave her diary dramatic intensity and structure.

Ichiyō's father also left a diary, and it was probably he who taught her how to keep one. Ichiyō taught her younger sister the art of diary keeping in turn; she checked her sister's diary and evaluated its writing. It seems that Ichiyō's diary became a model of composition and penmanship for her sister. For Ichiyō, the diary was thus something to be written as a form of education within the household, and people within the household would be expected to read it. Once she began to write a diary about love and her internal suffering, however, there were times when she devised various stratagems so as not to let her sister know what she was writing. She kept what might be thought of as a twofold record, a diary to be read and a hidden diary. After her death, her sister made a clean copy of all of Ichiyō's diaries, including the hidden ones, and she put all her efforts into getting the *Ichiyō Diary* published. The *Ichiyō Diary* is a house diary in the tradition of those written in Japanese. It is a woman's diary, and it constitutes a record of the solitary spirit of an individual who has deviated from the norm.[10] As a writer, Ichiyō consciously pushed the feminine style of writing to its limits, but the kind of diary she wrote using a woman's vocabulary was that traditionally kept by the male head of the household. What does it mean for there to be this sort of gendered inversion

between a text that records the history of a house and the words that make it up?

Like Higuchi Ichiyō, Kishida Toshiko left abundant diaries in various forms. She began with a literary diary interwoven not with Japanese poetry but with poetry written in Chinese. Unlike Ichiyō, Toshiko had a modern middle school education similar to what a man might receive at the beginning of the Meiji period, which enabled her to make a stab at writing in Chinese. Later, in her speeches for women's rights, she would explain the necessity for men and women to receive an equal education. Having been arrested following one of her speeches, Toshiko then kept a prison diary.

Later Toshiko married Nakajima Nobuyuki (1846–99), vice-chair of the Liberal Party, first Speaker of the Lower House in the Imperial Diet, and then ambassador to Italy. Toshiko did competent work as her husband's private secretary, and in her diary she recorded confidential conversations as well as the way business proceeded in the first session of the Diet. She also paid attention to domestic problems, meaning that her diary addressed both public and private matters. Toshiko caught tuberculosis about the same time that Ichiyō did, but she outlived both Ichiyō and her husband. She continued to keep a diary of her illness until five days before she died. Considering that she traveled throughout Japan giving speeches and then journeyed all over the world, she ought to have left travel diaries, but because her diaries contained a lot of information on national affairs and the secrets of political parties, many of her notebooks appear to have been concealed or destroyed. Only one-fifth to one-tenth of her diaries remain.[11]

In addition to a rich and dazzling array of contents, what the *Smoke from the Xiang River Diary* and the *Ichiyō Diary* have in common is that they found passionate readers within the household. The first reader of Ichiyō's diary was her younger sister, who, fearing that the original would be scattered and lost after Ichiyō's death, made a complete copy, omitting not a single character, in order to preserve it. Toshiko's mother had been her most faithful reader, and after Toshiko's death she took steps to preserve Toshiko's diary. While I was working on a biography of Kishida Toshiko, I discovered two more volumes of her diary, one that her mother had given to a young girl among her relatives to be used as a model for grammar and penmanship and another that Toshiko's disciple and comrade Tomii Oto had copied from her prison diaries and kept with her until she died. It is not

surprising that in both cases relatives or young friends of the same sex preserved these diaries, for the authors had written them in accordance with the tradition of diary writing in Japan, which presumed that the diaries would be read by family members. As a result of assuming a readership, both diaries were written in a refined style with well-proportioned handwriting.

The Era of the Standardized Diary Format

Most traditional diaries were written using a brush and black ink on Japanese paper, folded in two, and sewn into a hand-bound ledger. Higuchi Ichiyō wrote her diary using a brush. However, for the "pocket diaries" printed and bound for that purpose and sold beginning in 1895 by Hakubunkan, a lead pencil was attached. Thereafter, writing utensils gradually shifted to pen and ink. Owing to the production of standardized notebooks in a diary format, almost all Japanese at some point in their lives have had the experience of keeping a diary, at least for a few months, whether they wanted to or not.

The publishing company Hakubunkan was deeply intertwined in Ichiyō's life. It published all of her novellas in its magazines. It popularized and standardized the diary form. It had Ichiyō write a collection of models for letters of practical use, and this volume sold better than her short stories well into the second decade of the twentieth century. We can also assume that, like her letter collection, the diaries included in her collected works, published by Hakubunkan shortly after her death, were read as a model for literary diaries.

At the end of 1896, Hakubunkan succeeded in selling ordinary and deluxe editions of its "daily use diary" (tōyō nikki), a full-scale blank diary. It was said that its format was modeled after the English Collins diary. It achieved popularity by virtue of the ingenuity that went into its making. On supplementary pages were inscribed items of information useful in daily life, such as Japan's old calendar, postal rates, and an explanation of the vocabulary used in current events. In the margins were printed Japanese poems for the seasons, haiku, aphorisms, and descriptions of historical events. Thus began a competition with other companies, which soon noticed the demand for blank diaries. Hakubunkan set up a diary section inside the company and poured special resources into manufacturing and sales, making the blank diary into a novel, if representative, commodity. In the days of its greatest popularity, it was said that the company recorded sales of three million copies in some forty different formats distinguished

according to age, sex, and occupation. If we add to this the sales of other diary companies, the number becomes truly vast. We are left with the peculiar impression that once the new year rolled around almost everyone living in Japanese society resolved at the least to keep a diary for the year and thus purchased a notebook.[12]

Not just men but women, too, used these standardized notebooks to keep a diary. One historian was able to consult a year-long diary kept by his mother in her youth, which he organized and published as social history. Edited by Nakano Takashi, *Meiji yonjūsannnen Kyoto: Aru shōka no wakazuma no nikki* (Makiko's Diary: A Merchant Wife in 1910 Kyoto) constitutes the record of one year in the life of a twenty-year-old woman.[13] She kept this journal to preserve the conventions for the ways domestic duties were performed in an old merchant family under the direction of her mother-in-law. In 1910, fourteen years had passed since the death of Higuchi Ichiyō. The original was written first with a brush and later with a pen in a standard blank diary. According to the editor, each day was given one page. On each were printed the day of the month and the day of the week, and in the margins there were categories such as temperature, weather, messages sent, messages received.

The author of *Makiko's Diary* recorded the yearly round of ceremonies in her marital house, beginning with the New Year and including Bon (held in August), the Doll's Festival (3 March), and Buddhist memorial services; monthly customs such as the day of each month when everyone in the extended family paid a visit; food served to guests, the presentation of food to family members, and how to preserve food by pickling and other methods; how to shop; and the proper way to treat the people employed in the family store. She also noted how her mother-in-law performed her domestic duties, her thoughts when she had tried them herself, her husband's opinions, and so forth. She obviously intended this diary to serve as a reminder for the days when she would have to do these domestic chores herself. In the meantime, she vividly recorded the fun of festivals and guests, the sufferings of her natal family, fights with employees, and her own frank impressions.

In comparison to the complex *Ichiyō Diary*, which combined the characteristics of various classical precursors, *Makiko's Diary* is simply a housewife's record. Unlike Ichiyō, the author does not write in a classical style but uses ordinary spoken language. As a wife, she was placed in the environment of a merchant family in the city of Kyoto,

where she participated in her family's vast network of business asso-
ciates, social friends, relatives, and guests. For that reason, even
though in size it does not compare with the *Ichiyō Diary*, the number
of people described in *Makiko's Diary* is still quite large. Naturally
her husband and her husband's mother appear most frequently. In
contrast to Ichiyō, whose sense of solitude deepened as she felt her-
self drawing away from the norms of ordinary women, by keeping a
diary Makiko came to conform even more closely to the norms of a
good wife that would please her husband and mother-in-law. Over
time, she was able to solidify her position in her marital house.
Makiko's Diary is written in the type of blank diary called a "daily
record," which was meant for use by men, but it was the predecessor
of a vast number of diaries later written by housewives.

The manufacturers of blank diaries had to notice their women
customers. One reason for the expansion in sales of these notebooks
is that the publishing companies researched their customers by di-
viding them into social categories. Depending on their needs—indeed,
even before a need was felt—the companies began to compete in sell-
ing blank diaries of every type and description. In 1908, Hakubunkan
began to sell a household diary (*katei nikki*) aimed not at the old-
style family head but at the housewife. It contained many pages of
appendixes, called "the household encyclopedia," that explained
menus and provided guides to the yearly round of events. Tokutomi
Sohō (1863–1957), zealous in his promotion of the modern family
through his progressive *Katei zasshi* (Household Journal), encour-
aged wives to regulate family life by keeping a diary and a ledger
showing household expenses. Around the same time, Hakubunkan
began to sell a pocket diary for salaried workers. Up to then, the
traditional family diary had been kept by the head of the household.
That the writer of the modern household diary was assumed to be a
woman was really epoch making. Once the family of a salaried man
who worked for a large company began to emerge as a social class in
Japan, the professional housewife, who had received her education at
a girls' school, began to manage household affairs. While the posi-
tion of the wife rose within the household, the role of women ended
up being confined to the home.

The battle for sales among the diary companies soon gave birth
to new refinements. In the 1920s, Hakubunkan combined a ledger
for the daily recording of household expenses with its household diary
and sold in addition a woman's diary (*fujo nikki*) for not yet married

women and a diary for beauties (*reijin nikki*) for the "modern girls" of the cities (the latter included guides to movie houses and theaters). Other companies bound and sold a schoolgirl's diary (*jogakusei nikki*) for young girls, the housewife's diary, and even an infant's diary (*ikuji nikki*) for new mothers. By 1935, which saw the peak of the diary boom, a specific type of diary had been created to fit each stage in a woman's life.

Women's journals encouraged women to construct budgets for household expenses, to balance the accounting of income and expenditures every month, to reflect on what they did, and to manage their households on the basis of rational planning by keeping accounts and diaries. Beginning in 1931, *Shufu no tomo* (Housewife's Companion), the largest women's journal in the prewar period, began to include a ledger for keeping household accounts as an appendix to the first issue of the year.[14] Soon all the women's journals either included a ledger for household accounts and a diary in the first issue of each year or sold them separately. The peak of the battle for sales of blank diaries was in the 1930s, but they are still being sold today. Even though the housewife's diary has had to compete with other activities open to women and other modes of expression in the postwar period, the Shufu no Tomo Company still produces and sells diaries and account ledgers at the end of each year.

Once standardized blank diaries were targeted at housewives, menus, domestic suggestions, conventions for practicing the yearly round of events, and many other hints began to be printed in the diaries, as if to guide the writer in how to manage a household. In the case of *Makiko's Diary*, the author had received an education in domestic duties from her mother-in-law, who taught her the customary practices. In the age in which household diaries gradually became popular, the housewives who were to be the writers of these diaries probably learned to manage their households not with the guidance of their mothers-in-law but by reading the household columns in the women's journals and following the advice in the encyclopedias attached to the blank diaries. In fact, instances in which the mother-in-law did not live with the bride gradually increased in the nuclear families that constituted the new urban middle class formed by second and third sons who had escaped from the patrilocal family. We can say that the professional housewife in the domestic household, which constitutes the Japanese modern family system, completed her education using housewife's diaries following her graduation from a women's college and her marriage.

Once blank diaries were mass produced and housewives' diaries began to be kept in large numbers, few with any literary value appeared. For one thing, the standardization of the form took away the writer's freedom of expression. As a result of the education provided in diary writing, structure and content became fixed, as exemplified in the limited amount of space allotted to each day. Most importantly, the world within which the professional housewife lived became confined to the household, with few opportunities to meet outsiders. None of the housewives' diaries include the vast numbers of names found in Ichiyō's and Toshiko's diaries. Few show changes in structure or the tension that invigorates the diaries of these women whose lives fluctuated so violently. Most professional housewives who kept diaries were educated in women's schools, and they did have personalities. In comparison with the personalities expected in an age of modern individualism, however, they were bashful indeed.

CONCLUSION

The writing of a diary, usually seen as a fundamentally individual action, is actually dominated by the culture of the group, both in the West and in Japan. Consciousness of the divisions of the day, week, and month has varied, depending on the culture and the historical period, but in the modern period the tendency has been for citizens to be coerced into a life that conforms to commonly accepted notions of time. Keeping a diary is useful for making appointments, settling accounts, and, upon reflection, maintaining a rhythm in one's life. Through writing, the author of a diary performs an act that creates reality and the self. In this way, the standardized blank diary constitutes a means for educating a country's citizens.

In Japanese society, the standardized blank diaries for women developed into an elaborately structured resource, and they served the purpose of training middle-class professional housewives for the Japanese modern family. It was a momentous occasion when the education that the mother-in-law imparted to the bride within the household was transformed into the ideological education imparted by compulsory schooling assisted by newspapers and magazines. Through writing in the standardized format of household and infant diaries, many women tried their best to approach an idealized image of motherhood and be the housewives they felt they ought to be. This is one of the ways they internalized the "good wife, wise mother" ideology. Through writing her diary, Higuchi Ichiyō became aware of the

constraints of the condition known as womanhood, achieved a consciousness that overcame the divisions implied in gender-based roles, and tasted the pain of isolation inflicted on a person attached to no one. In contrast to her, most of the women who kept standardized household diaries pursued segregated, gender-based roles and became competent, happy housewives. Finally, it seems to me that in the long history of women's diaries written in Japanese, there arose several moments suitable for giving birth to literary masterpieces. I would hypothesize that these correspond to those moments when the structure of the family was undergoing great change. To prove this hypothesis is my next task.

NOTES

1. Matsuzono Hitoshi, "*Chūyūki* to 'nikki no ie': Heian jidai no nikki no rikai no tame ni," *Bungaku* 57 (June 1989): 9–29.
2. Helen Craig McCullough, ed., *Classical Japanese Prose: An Anthology* (Stanford: Stanford University Press, 1990), 73.
3. Edward G. Seidensticker, *The Gossamer Years: The Diary of a Noblewoman of Heian Japan* (Rutland, Vt.: Tuttle, 1964); Sonja Arntzen, *The Kagerō Diary: A Woman's Autobiographical Text from Tenth-Century Japan* (Ann Arbor: Center for Japanese Studies, University of Michigan, 1997); Richard Bowring, *Murasaki Shikibu: Her Diary and Poetic Memoirs* (Princeton: Princeton University Press, 1982); Edwin A. Cranston, *The Izumi Shikibu Diary: A Romance of the Heian Court* (Cambridge: Harvard University Press, 1969); Ivan Morris, *As I Crossed a Bridge of Dreams: Recollections of a Woman in Eleventh-Century Japan* (New York: Dial, 1971).
4. Béatrice Didier, *Le journal intime* (Paris: Presses Universitaires de France, 1976).
5. Ibid., 109.
6. Higuchi Ichiyō, *Higuchi Ichiyō zenshū*, vol. 3, part 1 (Chikuma Shobō, 1976).
7. For a biography of Higuchi Ichiyō, see Robert Lyons Danly, *In the Shade of Spring Leaves: The Life and Writings of Higuchi Ichiyō, A Woman of Letters in Meiji Japan* (New Haven: Yale University Press, 1981).
8. Higuchi, *Higuchi Ichiyō zenshū*, vol. 3, part 1, 322. A *sen* is one-hundredth of a yen.
9. Ibid., 472.
10. Nishikawa Yūko, *Watakushi katari: Higuchi Ichiyō* (Libro Port, 1992).
11. Ōki Motoko and Nishikawa Yūko, eds., *Shōen nikki* (Funi Shuppan, 1986).
12. Tsuboya Zenshirō, ed., *Hakubunkan gojūnenshi* (Hakubunkan, 1937).
13. Nakano Takashi, ed., *Meiji yonjūsannen Kyoto: Aru shōka no wakazuma no nikki* (Shin'yōsha, 1981). In English, see Nakano Makiko, *Makiko's Diary: A Merchant Wife in 1910 Kyoto*, translated by Kazuko Smith (Stanford: Stanford University Press, 1995).
14. Shufu no Tomosha, ed., *Shufu no tomosha no gojūnen* (Shufu no Tomosha, 1967).

Mobilized from Within: Women and Hygiene in Modern Japan

NARITA Ryūichi

Translated by Julie ROUSSEAU

The themes of illness and hygiene offer a crucial key to interpreting the history of nineteenth- and twentieth-century societies, in part because they provide a perspective that radically recasts the traditional historical narrative of political and economic events. Accordingly, a number of recent works on modern Japan have dealt with these themes as well as the history of doctors and medical treatment.[1] Although they have made stimulating contributions to our understanding of modern society, in that they chart the history of illness and hygiene by focusing on the relationship between state and society, they often overlook its relationship to sexual differences between men and women. By centering on the development of public hygiene in terms of "humanity" abstracted from any consideration of maleness or femaleness, they ignore the issues surrounding "hygiene *with* a sexual difference."

This chapter examines the history of hygiene in modern Japan with a focus on sexual difference by dividing it into three phases: the period from 1880 to 1900, which saw the introduction of public hygiene; the second phase, from 1900 to 1935, in which ideas about public hygiene were disseminated (with a climax in the 1920s); and 1935 to 1950, a period associated with the institutionalization of hygiene and its function as one of the core areas around which the Japanese people were mobilized for the Pacific War.

THE BIRTH OF HYGIENE

Women-Specific Hygienic Concerns:
Prostitution and Childbirth/Child Rearing

Modern methods of hygiene in Japan began with the "Medical System" law promulgated in 1874 to establish a system of medical care.

The section of this law dealing with hygiene did not explicitly mention sexual difference. The "protection of health" and the "treatment of disease" were written into the law with the intention to establish, foster, and delineate the new relationship between the "nation" and the "citizenry." We can assume that this new "citizenry" took men as the model, and therefore we can assert that modern Japanese hygiene began from the premise of "hygiene without sexual difference."

Prostitution and childbirth/child rearing, however, were two notable spheres of hygiene that demanded clear sexual differentiation. The Meiji government's prostitution policy continued the Tokugawa practice of restricting public prostitutes to licensed quarters, and it sanctioned and controlled prostitution through a system of licensing. Private prostitution was prohibited, and public prostitutes were sequestered in order to preserve the public order and contain venereal disease, which was perceived as a general threat to the people at large. The government's policy toward venereal disease underlay the concentration of prostitutes in designated areas that could be easily policed. In fact, it was in this period that the government mandated compulsory venereal disease (syphilis) examinations for prostitutes.

Through these measures, venereal disease came to be inseparably linked to prostitutes. Even Hasegawa Tai (1842–1912), who held a doctorate in medical science and worked as the chief of the Home Ministry's Hygiene Bureau, stated: "Transmission of [venereal disease] takes place through intercourse using male and female genitals; in other words, it is professional prostitution that serves as the vector."[2]

The hygienic discourse surrounding childbirth and child rearing also articulated sexual difference. The Ministry of Justice conducted nationwide surveys of customs from 1876 to 1880 in preparation for compiling the Civil Code. These surveys were published as the Collection of Civil Customs (1877) and the Collection of Japanese Civil Customs (1880). "Childbirth" appears as a heading in chapter 1, "Persons: Civil Customary Law." Since these surveys were conducted as preliminary steps for establishing the Civil Code, the data recorded regarding childbirth focused on questions such as: "To whom was the birth reported?" "When was the birth recorded?" "Did the birth occur at the husband's or the wife's home?" "What traditions surrounded childbirth?"

Incidentally and infrequently, information pertaining to hygiene was also recorded in this section on childbirth. These entries show that the gaze of modernity and modern law discovered "birth pollution"

and "blood taboo" and positioned them as obsolete beliefs and practices to be shunned and eliminated. For example, "in Izu Province, Tagata County, birth is regarded as pollution, so an outcast (*hinin*) woman is hired as midwife." Similarly: "In Uzen Province, Oitama County, when a child is born, the family observes the blood taboo for seven days, and on the fourth day the birth is orally reported to the local headman."[3] The report labeled "birth pollution" and "blood taboo" as "harmful traditional practices" and placed them in direct opposition to "modernity" and "law." The modern gaze articulated and analyzed "customs," found their deficiencies to be self-evident, and judged them inferior and best avoided.

Within the framework of hygiene without sexual difference, the outline of hygiene with a sexual difference began to make some inroads, especially in the areas of prostitution and childbearing/child rearing. It was the gaze of modernity, with a will to control and establish explicit sexual difference, that gave shape to this emerging practice.

Obstetrics and Gynecology: Women Confront the Model

From the early Meiji to the 1890s, the medical and hygienic discourse surrounding women's bodies progressed behind closed doors. In Japan, obstetrics and gynecology were taught at the Imperial University based on the German model, and from the first half of the 1880s they were incorporated into the general medical curriculum. The 1890s saw both the publication of many translated works from German into Japanese and the establishment of the Sanka Fujin Kagakukai (Association of Japanese Obstetrics and Gynecology). Consequently, the 1890s have been called the "quickening period," or the period of the first recognizable stirrings, of Japanese obstetrics and gynecology.[4]

As a specialty, obstetrics and gynecology dealt with women's pregnancy and parturition. In so doing, they tended to concentrate on cases involving abnormal conditions or difficulties instead of the normal body and normal processes of pregnancy and delivery. Copious case studies of puerperal fever, morning sickness, problems with menstruation, and pregnancy toxemia, as well as studies of pregnancies of women who were suffering from various illnesses, frequently appeared in the *Sanka fujin kagaku zasshi* (Journal of Obstetrics and Gynecology), edited by the Association of Obstetrics and Gynecology. In this way, the new science of obstetrics came to divide pregnancy into the normal and abnormal. In this division, infertility fit

the abnormal category, and its cause was discussed, for example, in terms of the abnormal growth of the reproductive organs. As obstetrics took as its primary focus the act of childbirth in and of itself, women's bodies that could not give birth and thus did not enter the arena of childbirth were also characterized as "abnormal."

Obstetrics and gynecology were born of a medical science that made the male body the universal human model. They saw women's reproductive organs as a deviation from this model. In the "Obstetrics Lectures" published serially in the *Sankafu zasshi* (Obstetricians' Journal), the opening lines of the first installment state: "It is necessary for us to understand, first of all, the structure of the general human body and a rough outline of physiology and, second, the details regarding the physiology and structure of women's reproductive organs."[5] The progression of studying first the "general human body" and only then "women's reproductive organs" articulates the notion that men's bodies are general or universal and women's bodies are atypical. This discourse also ascribes the special characteristics of women's bodies solely to reproductive organs upon which the disparity between men's and women's bodies rests. This is nothing less than the acceptance of a superior-subordinate relationship between man the universal and woman the marginalized deviant.

Obstetrics and gynecology exposed women's bodies to two interrelated constraints. They evaluated women's bodies in terms of the standard, or universal, model, which was male. They also defined women's bodies in terms of their reproductive organs, which deviated from this model. Through this maneuvering, women came to be viewed solely as the childbearing sex.

THE DISSEMINATION OF HYGIENE

The Structure of Hygiene Networks

Around 1900, the focus of hygienic discourse shifted from acute contagious diseases typified by cholera to chronic contagious diseases such as tuberculosis and trachoma.[6] Newly implemented policies toward chronic contagious diseases advocated careful maintenance of hygiene in daily life. Through these measures, the notion of hygiene infiltrated the household and the individual, transforming people's consciousness and attitudes regarding issues related to daily care and cleanliness. Concerns for hygiene on the national level spread down to the household and individual levels.

The new hygienic awareness and practices had a dramatic impact on women's roles. Women came to be viewed as the agency for this transformation and a target for a network of hygiene instruction aimed explicitly at them. Women-specific instruction in turn served to generate new concepts and practical ideas regarding women's bodies and sexuality. Consequently, around 1900, women and hygiene entered a new stage, with "hygiene with a sexual difference" at the forefront of hygienic discourse.

Three main, overlapping avenues developed for transmitting this new hygiene to women. First, neighborhood hygiene associations and schools offered education in hygiene that never failed to reach women. Second, the media in general and women's magazines in particular came to include hygienic instruction targeting women. Finally, this new hygiene reached women through their personal experiences, most directly through childbearing and child rearing.

The hygiene associations, although originally established in neighborhoods to combat cholera, now undertook to impart knowledge about hygiene to women through their bulletins and lectures. In Tokyo, for example, each ward had an association whose membership ranged from two hundred to two thousand. *The Hygiene Monthly*, published by the Kyōbashi Ward, featured articles attributed to doctors on such topics as "the relationship between contagious diseases and flies" and "the prevention of tuberculosis at home and in elementary schools." Indeed, those with medical degrees and doctorates in medicine were in the forefront of this campaign. They busily issued various warnings concerning the prevention of tuberculosis and advice on childbirth and child rearing. This was a social movement in which these neighborhood associations sponsored "general housecleaning" or large-scale neighborhood cleanups. They also eagerly volunteered to implement the cleaning measures that had been stipulated under the 1897 Law for the Prevention of Contagious Diseases.

In addition to neighborhood associations, schools also played a primary role in the transmission of knowledge about hygiene. Students learned in school, for example, how to prevent the spread of trachoma. Even ethics and calisthenics classes became forums for teaching the virtues of "cleanliness." These ideas were transmitted from the students to the home, to the mother or, in other words, to women. Thus, the network was forged for the transmission of hygienic ideas linking schools to pupil/child and to home/mother.

Augmenting the efforts of local associations, media such as women's magazines played an active role in disseminating knowledge about hygiene and the sanitary ideal to women all over Japan. For example, *Fujin sekai* (Woman's World), the most representative women's magazine of the period, which came on the market in 1906, covered topics such as child rearing, cooking, and the home. It promoted "practical women" (*jissaiteki fujin*) and "home improvement" (*katei no kairyō*) at the same time that it espoused the ideology of the "good wife, wise mother." The magazine called upon medical doctors to contribute to its feature columns, which provided knowledge and information about various aspects of health and hygiene. These professionals advised on preventive measures for illnesses particular to each season; suggested home cures for sicknesses and injuries; explained the mechanisms and process of menstruation, pregnancy, and childbirth; and issued various warnings about "abnormal" pregnancy.[7]

Woman's World also established columns called "Advice on Child Rearing" and "Advice on Hygiene." Significantly, the latter was soon renamed "Advice on Women's Hygiene." Women wrote to the columns about health conditions that they felt were "abnormal"—that is, anything that deviated from what they had come to understand as the medical norm. "My period is delayed by twenty days to a month, and two or three days prior to its onset I get pains in the lower abdomen that are bad enough to put me to bed. . . . What do you think?" asked a Nagoya woman. Another woman, from Mino, worried that "seven years after marriage, no child has been born, despite my having my monthly menses." Questions regarding menstruation, pregnancy, birth, and infertility dominated the space in "Advice on Women's Hygiene." "Advice on Child Rearing" invited questions about the value of breast versus bottle feeding and children's physical development.[8]

The questions asked by women and published in these columns demonstrate that women's concerns were firmly grounded in the new hygienic and medical knowledge. Women expected the answers to be based on authoritative hygienic and medical science. The new medical discourse indeed criticized the use of "methods secretly transmitted" among members of a particular lineage or dependence on prayers to gods and buddhas in seeking cures for illnesses.[9] The advice columns provided a space where women could seek all the reassurance and comfort that the authority of medicine, medical terminology, and logic could offer. It can be said that these columns oriented

women to view their own and their children's bodies through the eyes of medicine.

Women's direct involvement in obstetrics and gynecological science was the third medium through which hygienic awareness and information directly reached women. The articulation of details of pregnancy and childbirth educated women about their bodies—or the ideal body. Against this ideal, women themselves, or with doctors, could check their bodies for "abnormalities." The new hygienic standard urged upon women a bodily self-consciousness and concern based on the norms of medicine and hygiene that included the areas of obstetrics and gynecology. Obstetrics and gynecology simultaneously educated and normalized, defining a "standard" body that, for women, included a meticulously defined schemata of the "normal" pregnancy and menstruation.

As the gaze of medical science and hygiene increasingly managed and controlled the body, the dominant discourse came to discriminate against women with a "weak constitution," women without "average" bodies, and in particular women who could not give birth. The establishment of the "normal" also discriminated against certain occupational groups. Wet nurses, who had a close connection with children's hygiene, now faced a thorough physical examination administered by their potential employers. *Woman's World* admonished wet nurses not to offer milk during menstruation and even called them "machines from which milk flows." A proper consciousness of hygiene was also demanded of male and female servants. Venereal disease (syphilis) examinations administered to prostitutes easily gained general social acceptance in this atmosphere of discrimination justified by a consciousness of hygiene.[10]

The spread of knowledge about hygiene constructed "normal" human archetypes at the expense of diversity. Women internalized the new prescriptive norm and viewed the diversity among their bodies with suspicion. With this new knowledge, then, women became the wardens of their own corporeal confinement.

Sexual Politics

Sexuality soon joined the body at the center of medical and hygienic discourse. Following the 1900s, and especially around the 1920s, discussions about women's sexuality suddenly increased in the popular press. Underground movements continued as before, including the *sōtaikai*, an exclusive discussion group headed by Ogura Scizaburō,

whose members—among whom were such well-known figures as Akutagawa Ryūnosuke and Hiratsuka Raichō—aimed to share and exchange their personal views and experiences regarding sex and sexuality, often in graphic terms.[11] Now statements concerning sex appeared in widely circulated women's magazines such as *Shufu no tomo* (Housewife's Companion) and *Fujin kōron* (Woman's Reader), in literary journals, and in medical books. In the language and logic of medicine and hygiene, sex came to be discussed in relation to a wide range of topics such as love, marriage, birth control, the prevention of venereal disease, sexual desire, widowhood, and sexology. Accordingly, knowledge about sex, and sex considered as knowledge, gained a new importance.[12]

The debates over the relationship between sex and love and marriage serve to illustrate this new trend. Prior to the 1920s, discussions about marriage had carefully avoided the topic of sex. Instead, conflicts and tensions between women and the family system, exemplified by such problems as parental opposition to a daughter's marriage to her lover, occupied the central stage. This old discourse had presented love as the ultimate form of women's self-actualization. The 1920s discourse replaced this with the view that love was the first step toward inevitable sexual relations. A prominent author's remark that "the aim of love is the completion of the *sexual* self" illustrates this new thinking.[13]

Sex displaced spiritual and mental concerns in the debates on love and marriage. This new sexual focus soon promoted sexual education and knowledge about sex, a notable about-face from the accepted convention that sex should not be discussed. In an article, "Marriage Problems Relating to Young Women," published in *Housewife's Companion*, the woman principal of the Tokiwamatsu Girls' School argued that "in preparation for marriage, I think we must provide young girls with knowledge concerning sex."[14] The 1920s became the period in which "sex education" was popularized, and those who wrote on this topic were widely published.[15]

The onslaught of sex education, ironically, reaffirmed the social relations surrounding women. The presupposition that women, in particular young unmarried women, lacked knowledge about sex and must therefore be "enlightened" lay at the foundation of all these discussions of sex education in the 1920s. The roles of conveying sexual knowledge to these girls were assigned as follows: men were to educate women, teachers were to instruct students, and mothers were

to inform daughters. In an age of more knowledge, the authority of men, teachers, and parents expanded to cover the field of sex, and this, if anything, strengthened their dominant social position. People who had always been in a superior social position were now teaching women this "profoundly complex" field of knowledge called sex. There was no discussion of what it meant to "educate"; instead, people were concerned about "how" to educate these young girls.

In women's magazines, the knowledge conveyed to women about sex was drawn from medicine or offered and sanctioned on the basis of medical supervision and counsel. It was doctors and those with doctorates in medical science who discussed sex, and they invariably used medical terminology. The fact that sex was discussed in a medical context in women's magazines indicates the extent of faith in science when it came to sex. This faith extended to all areas concerning sex—not only to sexual acts but to venereal disease, marriage, love, and even jealousy. Anything related to sex was now subject to scientific investigation and analytical explanation. Articles entitled "Sexual Anatomy of Boys and Girls," "Anatomy of the Virgin," and "Anatomy of a Married Couple's Sexual Life," for example, appeared in *Woman's Reader* under the bylines of doctors. Medical expertise added credibility even to such columns as "Readers' Experiences." A 1921 issue of *Housewife's Companion* solicited readers' letters on "experiences in fighting the temptations of men during the summer season," and a 1927 issue invited confessions on the topic "pains and worries of young women in dealing with the crisis over chastity." Readers' letters appeared together with the comments of an authority, who analyzed the situations according to their pedagogical usefulness. Advice and recommendations on sexual matters by medical authorities also occupied space in the magazines' advertisement sections, which promoted, for example, medicines that alleviated sexual dissatisfaction and methods for limiting births.[16]

The linking of hysteria with menstruation or pregnancy fits within a long trajectory of medicine's attempt to find a physical basis for all aspects of human life. "A round table discussion on hysteria," which appeared in *Woman's Reader* in 1931, featured doctors' and novelists' views. Despite the differences among them, these views agreed on two points: hysteria was an illness found more frequently in women than in men, and women's hysteria was generated by illnesses connected with their reproductive organs. The "experts" identified puberty, pregnancy, menstruation, and breast-feeding as the most probable

times when hysteria might surface. Sexual dissatisfaction and jealousy were identified as the fundamental causes of female hysteria.[17]

In other areas, doctors declared women's "sexual frigidity" to be the cause of infertility and explained aging in terms of declining sexual functions. The issues surrounding virginity invited one doctor to invent a scientific method to detect protein from semen in a woman's body; this was to determine whether the hymen's rupture was caused by intercourse.[18] Medical attention was also directed at masturbation. In an article entitled, "In Response to Questions from Women Who Suffer from Evil Sexual Habits," published in a 1926 issue of *Housewife's Companion*, Dr. Yoshioka Yayoi emphasized that masturbation by women would cause "the absence of sexual love" for the husband, disharmony within the home, and sterility. She recommended that these women confess to a doctor as soon as possible and receive proper treatment, as though this were an illness. By the same token, in the eyes of many medical experts, women's same-sex love (*dōseiai*) "went against nature" and was thought to be a condition particular to women who had bodily impediments.[19]

All in all, then, medical experts in the 1920s promoted a trend in which sexual relationships would be limited to intercourse between husband and wife at the expense of the diversity of sexualities and the range of experiences that surround sexual love. The rich complexity of human relations became interpreted reductively in terms of sex, whose "norm" was directed toward reproduction. Despite new discussions on sex and the changing social dynamics surrounding sexuality in the 1900s, the image of sex itself went backward. Knowledge about sexuality often became synonymous with knowledge about the reproductive organs. Only procreative sex was "real sex," and sexuality was confined ultimately to intercourse. Medicine and science exerted their authority in making this patently clear to everyone.[20]

The Home as Stage

Hygiene in the early twentieth century progressed in tandem with an increasing focus on the home. The home was the main stage for the full-scale emergence of a "hygiene with a sexual difference" and a discourse on women's bodies and sex. The home more than anywhere else served as the locus for daily attention to hygiene and for maintaining the family's health. It became the site for nursing the sick and implementing the new sex education.

The increasing attention to the home that accompanied the changing social attitude toward hygiene also articulated the relationship between man/woman and adult/child into clearly defined familial roles: "husband/wife," and "father-mother/child." Descriptive labels such as the "fit" and the "ill" and "employer" and "employee" also were used for assigning roles and titles. For women, role designations clustered largely around the tasks of implementing hygiene. As a wife, women bore the assigned role of ensuring the health of their husbands, and as a mother they were to safeguard the health of their children. *Katei eisei kun* (Home Hygiene Instructions), a general hygiene manual from 1905, reminds its readers, for instance, that "the wife (*shufu*) of the house directly manages the hygiene that constitutes a healthy home."[21] Articles on children's hygiene published in *Woman's World* invariably contained the phrase, "[a condition] that the mother should attend to."[22] Women were also expected to serve as a nurse in times of sickness. "A woman's warm heart and thorough care promote a fast recovery from illness," asserted a writer in *Kaji kyōkasho* (Domestic Science Textbook), edited by Gokan Kikuno and Sakata Shizuo and intended for girls' higher schools.[23] The fulfillment of expected roles solidified relationships within the home.

Against the backdrop of increased concern over chronic contagious diseases, women were assigned the important task of overseeing the family's hygiene. Chronic contagious diseases stood out in marked contrast to acute contagious diseases, which had clearly defined outbreaks and rarely involved protracted illness. The media and other sources supported the view that the daily management of physical health through careful attention to hygiene, cleanliness, and nutrition was the key to avoiding chronic contagious disease. Moreover, if a family member did contract a chronic disease, a long period of nursing became necessary; a woman's self-sacrifice in caring for the sick was considered only proper.

The *Domestic Science Textbook* details the activities in which women's roles were cast. The second chapter of its first volume, devoted solely to hygiene, advocates letting sunshine into the house, frequently circulating the air, and keeping the kitchen immaculate. In the section on nutrition, it states that a balanced diet and digestion should be carefully monitored. These were all women's responsibilities. The second volume explicates another job assigned to women: caring for the sick. It provides instructions on how to administer first aid,

including techniques for sterilization, bandaging, and the dispensing of medicine. These were defined as the responsibilities of the "housewife."[24]

For women, both hygiene and sexuality were confined within the home. Sexual relations meant sex for reproduction. An essay published in *Housewife's Companion* expounded on the "Skills for conjugal harmony," stressing "healthy pleasures." These healthy pleasures were limited to intercourse for the preservation and continuation of the family; sexual acts that diverged from this norm were to be shunned as unhealthy.[25] It was in this context that virginity was discussed repeatedly, and the propensity of men to seduce women was viewed as dangerous.

Mobilizing Hygiene

In the quasi-wartime social structure that followed the 1931 Manchurian Incident, and later during wartime itself, hygiene was given a prominent role.[26] Indeed, against the backdrop of the war with China and the Pacific War, hygiene became a cornerstone of mobilization policies. With this, the relationship between women and hygiene moved into a new, third phase. The wartime system was predicated on "compulsion," and because hygiene became a pillar of this system, women were forced to participate.[27] Four routes were established for the mobilization of hygiene: (1) movements led by the government, semipublic-semiprivate organizations, and regional associations focused on hygiene; (2) government hygiene measures and legislation, including a national health policy, population policy, and mother and child health care policy; (3) presentation of wartime lifestyle models, which incorporated daily hygiene; and (4) reexamination of industrial hygiene, which accompanied the mobilization of women in the workplace. The usefulness of these routes was predicated upon the value of hygiene having become internalized through the dissemination of information and practices earlier in the century. Mobilization hinged upon having an already receptive audience that would support this new, compulsory system.

During the wartime period, the resources necessary for everyday life were generally scarce. Sanitary conditions declined. Working hours were greatly expanded, and the community and workplace environment degenerated. With soldiers being moved to the battlefield and around the country and supplies continually being transferred, the

groundwork was laid for outbreaks of contagious disease. In fact, from around 1935 on, chronic and acute contagious diseases such as typhoid fever and tuberculosis became prevalent.

In order to deal with these sanitation problems, the government called for cooperative and collaborative actions by the citizens. Numerous measures were proposed. These were implemented by means of movements controlled from above. The sponsors of these movements were mainly regional organizations such as neighborhood hygiene associations. As part of its activities, the Yokohama Maita First Hygiene Association, for example, promoted radio exercises for its members and even undertook a campaign to give cash rewards for the killing of rats and flies. Also, "to stress hygienic practices and foster hygienic habits," it designated the tenth day of every month as "Public Morale Day," "The Benefits of Sunshine Day," "Health Promotion Day," and "Housecleaning Day."[28]

The government continued to actively promote hygiene campaigns, for example, the National Movement for the Prevention of Tuberculosis, begun in 1936, and the 1940 hand-washing movement, organized by the Metropolitan Police Department. At the same time that mobilization centered around hygiene was meeting an enthusiastic response, the army and navy were launching an extensive program of air raid drills. The government continually lamented, however, that the people were passive in their participation and exhibited a distinct lack of cooperation. The disparity between activities implemented only through outside coercion and those motivated by internalized values was striking.

Wartime demanded a large-scale military buildup that included manpower. To that end, the government actively promoted fecundity, the protection of health, augmentation of the "national physical strength," and maternal and infant health. The establishment of the Ministry of Health and Welfare in January 1938 was emblematic of these initiatives. Its goal was to "manage the affairs of national health, social services, and labor."[29] It implemented measures such as programs for the prevention of tuberculosis, improvement of nutrition, measurement of physical strength, and extensive maternal and child protection.

The protection of maternal and child health and the campaign against tuberculosis were the central hygienic policies. In 1939, health examinations of infants and children began, and in 1942 maternity

record books were institutionalized. This was an institutionalization of routines that women had previously practiced. But the intervention of the government and the establishment of hygiene norms burdened women with dual constraints. First, programs for hygiene limited women's sense of their own bodies, and, second, its institutionalization made it absolute.

The infant and child medical examinations administered throughout the country in 1940 illustrate the absolute character of this new hygiene policy. The examinations revealed that slightly less than one-fourth of all children (approximately 400,000!) "required medical attention."[30] Through these examinations, comparing and differentiating infants and children were made routine, and those who "required medical attention" were marginalized in the name of the national strength. Starting in 1941, physical strength surveys became a standard criterion for ranking and differentiating infants and children. Thus, "health" became absolutely defined and physical strength went unchallenged as the highest value.

Maternity record books, issued to pregnant women by their doctors, served to construct a "watch system" that identified pregnant women individually and continued to track the mother and child after birth. The record books made not only the pregnant woman but her husband and other family members aware of the "public" significance of pregnancy. Pregnancy and childbirth, no longer private matters, became nationally recognized as public concerns. Maternity record books also functioned as authorizations to receive rationed goods, further reinforcing the public character of pregnancy in each ration district.

From this time on, various medical examinations for expectant mothers were institutionalized, and the results were carefully entered into the maternity record books. Information regarding the pregnancy and parturition of each expectant mother was recorded, examined, and made public. No pregnant woman went without her record book. This meant that all pregnancies and births came to be watched by the state. This system eliminated birth based on free will and instilled in women the notion of obligatory pregnancy and birth.

During the wartime period, the government institutionalized intrusions into a wide range of matters involving mothers and children. It encouraged the issuance of marriage loans under favorable terms to promote marriage. It gave awards to households with "healthy and abundant children," defined as those with more than ten "fit" offspring, to

encourage women to bear more children. In 1940, the National Eugenics Law in one stroke established eugenic ideology as official policy, denying the value of variation in the ways of birth and life.

The government also proposed a new model home appropriate to the wartime order. Again, hygiene was given a central role. *Kōshin katei seikatsu* (A Revised Home Life), published by the Dai Nihon Rengō Fujinkai (Greater Japan Federation of Women's Associations) in 1934, included the Shizuoka Prefecture Housewives Association's "basic conditions for kitchen improvement." Among the hygiene tips, the following was placed at the top of the list: a clean environment free of stagnant water and rats.[31] These points were nothing less than a repetition of the early-twentieth-century hygiene lessons taught to women. In the wartime period, women's associations became an arm of the government, promoting officially endorsed hygienic practices. Through these organizations, women were incorporated into one wing of the wartime order. Here, too, the values that had been internalized by women were utilized for mobilization.

The government carefully investigated this new "hygiene with a sexual difference." In order to mobilize men for the front, it drafted women to replace men in the domestic labor force. As women became visible in the work force, it was argued that labor management for women must be different from that for men. Series like *Joshi kinrō kanri zensho* (Compendium of Labor Management Practices for Women, 11 vols.) were written, and publications on personnel management unfailingly came to include several volumes on women.[32] This was the first time in Japan that sexual difference came to occupy such a prominent position in the discourse on labor. The hygiene measures that they incorporated contributed to the extensive development of hygiene with a sexual difference.

Establishment of the wartime mobilization order resulted not only from the power of compulsion but from the identification of hygiene as a focal point. In utilizing hygiene in this fashion, the government drew upon previously established values and practices. Under mobilization, in fact, women's activities begun in the 1900s became officially recognized and institutionalized. As far as women were concerned, hygiene became the cornerstone of their mobilization. The hygiene of the early twentieth century urged women to be aware of their bodies, and through this it created norms for the body and sexuality. By 1935, wartime hygiene was centered on mobilizing and institutionalizing these norms. This hygiene not only confined women

to their bodies and sexuality but officially sanctioned the regulation and standardization of the body. Activism was demanded based upon this newly articulated hygienic ideal.

The system surrounding sex and the body created during wartime was one "fulfillment" of the work begun at the turn of the century. Nor was it swept away with Japan's defeat in August 1945. As a result of the institutionalization of hygiene, the mentality that supports this system has been continuously reborn. What we have today rests on the foundation of the system constructed during the war. It is not merely a system. In our attitude toward sex and in our view of our bodies, we have yet to be emancipated from these standards and disciplines.

NOTES

1. For example, see Ninomiya Hiroyuki et al., eds., *Anaaru ronbun hen: I to yamai* (Shinhyōron, 1984); Kano Masanao, ed., *Korera sōdō*, vol. 97 of *Shūkan asahi hyakka Nihon no rekishi* (Asahi Shinbunsha, 1988); Tatsukawa Shōji, *Meiji iji ōrai* (Shinchōsha, 1986); Hirota Masaki, "Nihon kindai shakai no sabetsu kōzō," in *Sabetsu no shosō*, edited by Hirota Masaki, vol. 22 of *Nihon kindai shisō taikei* (Iwanami Shoten, 1990). Research in Japan that examines illness and hygiene in the light of sexual difference has been limited to historical works on nursing and female doctors, folklore and anthropological studies, and studies of hygienic history in England. See Kameyama Michiko, *Kindai Nihon kangoshi*, vol. 4 (Domesu Shuppan, 1984–85); Namihira Emiko, *Byōki to chiryō no bunka jinruigaku* (Kaimeisha, 1984); and the following works by Ogino Miho: "Seisa no rekishigaku," *Shisō* 768 (1988): 73–96; "Onna no kaibōgaku," in *Seido to shite no 'onna*,'" edited by Ogino Miho et al. (Heibonsha, 1990), 13–76; "Sei no eiseigaku," in *Eikoku o miru*, edited by Kusamitsu Toshio (Riburopōto, 1991), 237–67.
2. Hasegawa Tai, "Shōfu haisubekarazu aete yo no haishōronsha ni tadasu," *Dai Nihon shiritsu eiseikai zasshi* 81 (1890): 35–40.
3. See *Zenkoku minji kanrei ruishū "Hōritsu,"* vol. 13 of *Meiji bunka zenshū* (Nihon Hyōronsha, 1929). For the English translation, see John Henry Wigmore, ed., *Law and Justice in Tokugawa Japan* (Kokusai Bunka Shinkōkai, 1969), 7:21, 37.
4. Ogata Masakiyo, *Nihon sankagakushi* (Maruzen, 1919).
5. Kusuda Kenzō, "Sankafugaku kōgi," *Sankafu zasshi* 80 (August 1906): 28.
6. This section is based on Narita Ryūichi, "Eisei kankyō no bunka no naka no josei to joseikan," in *Kindai*, vol. 4 of *Nihon josei seikatsushi*, edited by Joseishi Sōgō Kenkyūkai (Tōkyō Daigaku Shuppankai, 1990), 89–124.
7. For example, an article from 1908 advised mothers not to chew food and give it to babies because that is unsanitary and discourages babies from chewing with their own teeth. "A Method to distinguish one illness from another by observing how the child cries" was a topic taken up in 1906. Menstruation was treated in a 1906 article as "a natural function of women" and "nothing to be embarrassed about." For treatment, the article advised the use of cotton or gauze and the avoidance of paper. Ibid., 95–96.
8. Ibid., 100–102.
9. Ibid., 102. Sometimes the new medical knowledge gained by a woman might clash with the traditional knowledge held by the elders of the same house. But the "duty of the mother" was to act in cooperation with the doctor.

10. *Fujin sekai* 1–4 (April 1906), cited in ibid., 105–6.

11. The group had a limited membership and published a newsletter, *Sōtai*, exclusively for internal circulation. The organization was "underground" in this sense.

12. For an expanded discussion of the topic covered in this section, see Narita Ryūichi, "Sei no chōryō: 1920 nendai no sekushuaritei," in *Jendaa no Nihonshi*, edited by Wakita Haruko and S. B. Hanley (Tōkyō Daigaku Shuppankai, 1994), 1:523–64.

13. Kurata Hyakuzō, "Kekkon mae no ren'ai ni tsuite," *Fujin kōron* (August 1925): 149–62 (emphasis added).

14. Mikami Suzuko, "Musume no kekkon mondai ni tsuite," *Shufu no tomo* (April 1920): 88–102.

15. For works on sex education from the perspective of sexology, see Yamamoto Senji, *Sei-kyōiku* (Nagai Shuppan Kabushiki Kaisha, 1923); and Hoshino Tetsuo, *Sei-kyōiku ni tsuite* (Kirisutokyō Kyōiku Fukyūkai, 1927). For more popular works, see Miyake Yasuko, *Wagashi no sei-kyōiku* (Bunka Seikatsu Kenkyūkai, 1924); and Takahashi Hisae, *Joji no sei-kyōiku* (Meiji Tosho, 1925).

16. Narita, "Sei no chōryō," 530–31.

17. Ibid., 546–47.

18. Dr. Nojima Yasutsugu reported this discovery in *Fujin kōron*, June 1932 (ibid., 550).

19. Ibid., 547–48, 563nn.61, 63. Yoshioka also stated that women's "bad habits" had not received sufficient attention despite the widely known fact of "men's bad sexual habits." She asserted that women's cases were surprisingly numerous and in fact had been increasing in number in recent years. The article on same-sex love was published in *Shufu no tomo* in November 1921 under the title "Passionate Same-Sex Love Frequent among Pre-marital Women."

20. Ibid., 540–52.

21. *Katei eisei kun* was written by Chiba Katsukage and Kashima Nobuo and published by Hakubunkan. It is mentioned in Narita, "Eisei," 106–8.

22. Ibid., 107–8.

23. Gokan Kikuno and Sakata Shizuko, eds., *Kaji kyōkasho*, 2 vols. (Seibidō Meguro Shobō, 1898).

24. Ibid.

25. See "Fūfu wagō no hiketsu hyakkajō, number 3," *Shufu no tomo* (July 1928): 30–31.

26. For further discussion of women's activities during the war, see my "Haha no kuni no onnatachi: Oku Mumeo no senji to sengo," in *Sōryokusen to gendaika*, edited by Yamanouchi Yasushi, Victor Koschmann, and Narita Ryūichi (Kashiwa Shobō, 1995), 163–84.

27. On the issue of wartime compulsion, see Yamanouchi Yasushi, "Senjidōin taisei no hikakushiteki kōsatsu," *Sekai* 513 (April 1988): 81–100.

28. *Hoken* (July 1935): 37–58.

29. Kōseishō Imukyoku, ed., *Kōseishō kansei* (Kōseishō, 1938).

30. Kōseishō Imukyoku, ed., *Isei hyakunenshi* (Kōseishō, 1986).

31. Dai Nihon Rengō Fujinkai, ed., *Kōshin katei seikatsu* (Dai Nihon Rengō Fujinkai, 1934).

32. Published by Tōyōshokan in 1943. Each volume has a different theme and author. For example, volume 2, written by Dr. Iwata Masamichi of Nihon Ika Daigaku (Japan Medical University), is titled *Joshi no tairyoku to rōdō* (Women's body-energy and labor). For a list of individual titles and authors, see Akamatsu Yoshiko, ed., *Rōdō*, vol. 3 of *Nihon fujin mondai shiryō shūsei* (Domesu Shuppan, 1977), 35.

Japanese Nationalism and the Female Body:A Critical Reassessment of the Discourse of Social Reformers on Factory Women

Mariko Asano TAMANOI

Nationalist discourse aims to achieve a specific, and if possible stable, perception of a society's proper relationship with the outside world.[1] To that end, it erases the differences within society in terms of gender, class, race, ethnicity, and region and "imagines" a homogeneous space it calls a nation.[2] In this chapter, I try to show that one discourse in Japanese nationalism at the turn of the century made the female body into a privileged signifier precisely in order to imagine such a homogeneous space. But in the process the body itself disappeared along with female subjectivity. This imagination of a homogeneous space entails a number of problems, the most important of which is that Japanese women, who belonged to different classes, had different lifestyles, lived in different regions, and engaged in a variety of work (or none at all), were denied in nationalist discourse the privilege of talking about the multiplicity of their experiences and their own bodies.

I characterize the discourse of Japanese nationalism as a discourse of power. It is also an ideology that gradually gained power after the Meiji Restoration in 1868 and reached its climax during the Fifteen-Year War between the Manchurian Incident (1931) and Japan's defeat in World War II in 1945.[3] I shall be quick in adding here that nationalism did not disappear with the occupation of Japan by the Allied forces in 1945, nor with the more recent triumph of "postmodernism" in information-saturated Japan in the early 1970s.[4] On the contrary, in contemporary Japan, caught in the ever more complex network of multinational capitalism, nationalism continues to be a viable force. In this chapter, however, I focus on a specific nationalist discourse, the discourse of "social reformers," who commented on factory women (*kōjo* or *jokō*) in the textile industry in the

275

late nineteenth and early twentieth centuries. The textile industry was perhaps the most important industry in Japan during the Industrial Revolution, and it relied heavily on cheap labor provided by women of rural origins. In this specific historical context, social reformers saw factory women in terms of their contribution to the construction of the nation and the expansion of Japanese capitalism. I am interested in the way in which "mere factory women" (in the words of one social reformer, Ishihara Osamu) were elevated to "the Japanese woman" (*Nihon no fujin*) in the discourse of social reformers, and what they did to that end.

Due to limited space, I cannot present the narratives of factory women working in textile mills; the songs collected by historians, folklorists, and the social reformers themselves; or the recollections of former factory women of their days in the mills. For these, the reader must look elsewhere.[5] Instead, my goal is to show that social reformers at the turn of the century, despite being characterized as "progressive" by later historians, suppressed these narratives and songs. Instead they spoke *for* the factory women and made their bodies disappear. They made factory women into "the Japanese woman."

NATIONALIST DISCOURSE AND FACTORY WOMEN

But who were the social reformers? Did they constitute a monolithic group in terms of their discourse on factory women? In order to answer this question, I must begin my discussion with those individuals and groups that I do not regard as social reformers.

In 1898, an early advocate of the "good wife, wise mother" ideology, Miwada Masako, commented on factory women.[6] In the following statement, she used the term *jokō*. We must note here that factory women at the beginning of the Meiji period (1868–1912) were called *kōjo*, which was written with the same two Chinese characters as *jokō* but with the order inverted. *Kōjo* were the daughters of ex-samurai or well-to-do commoner families who worked at government-built silk mills in the early 1870s. For various reasons, they were replaced by the daughters and wives of marginally independent cultivators and tenant farmers in and around the 1880s.[7] *Jokō* refers to these factory women of rural and humble origins. Miwada argues:

> Recently, along with the development of manufacturing industries (*shokusan kōgyō*), a group of women called *jokō*, who work at a variety of factories, has emerged. As *jokō* depend upon their own

physical labor to make their living, they are more respectable than those [prostitutes, geishas, barmaids-cum-prostitutes] who waste time sucking the wealth of others. I also view favorably the fact that *jokō* usually engage in work suitable for women. Such [textile] industries constitute a means of enriching the nation (*fukoku no moto*). Thus, *jokō* are not necessarily shameful women.[8]

Miwada seems to have had a hard time endorsing the contribution of the factory women to the construction of the nation-state because of the similarity she saw between them and prostitutes. She did, however, eventually accept them, albeit grudgingly, as subjects of Japan.

While acknowledging the role of factory women as national subjects, Miwada still insisted on identifying a "problem."

Jokō tend to be crude (*inwai*) in their personalities. Working all day long away from their parents, they tend to sing vulgar songs and engage in obscene talk. Unless someone teaches them "women's morality" (*joshi shūshin*), it is natural that they will be confused and tainted with vice.[9]

In her eyes, the problem was factory women's "morality," which could also be interpreted as "sexuality." This may be why Miwada inverted the order of the Chinese characters of the word for factory women, thus conveying her conviction that they were different from the earlier, upper-class, factory women who supposedly did not have such "problems." However, she elevates factory women over prostitutes because factory women "depend upon their own physical labor to make their living" and "usually engage in work suitable for women." For Miwada, their dedication to physical labor, their participation in production, and the "feminine" nature of their work are what make them superior to prostitutes. However, they are of humble origins and away from home, making them vulnerable to "vice." Miwada argues that they need "women's morality," without, however, explaining what that is.

Most employers in the textile industry seem to have agreed with Miwada. I must point out, however, that they were much more interested in the immediate impact of "women's morality" on their productivity than in "morality" per se. For example, two employers in Nagano Prefecture, the center of the silk industry, suggested in 1878 the importance of teaching factory women "women's morality" because "the majority of them were lower than middle class."[10] Otherwise,

they argued, their employees would produce silk thread of poor quality and "endlessly complain about the scantiness and inequality of their wages."[11] Another employer, who claimed that he provided elementary education for his employees at night, argued in 1902 that he "would continue to do so for the sake of not only factory women but his own profits."[12] If "women's morality" would greatly increase factory women's productivity, what was its content? Was its counterpart, "men's morality," inconceivable? What would have happened to factory women without "women's morality"?

The example of the Nagano region shows that local newspapers endlessly published articles about the "problems" of factory women who did not abide by "women's morality": adultery, unwanted pregnancy, abandonment of illegitimate children, suicide attempts, and death. A factory woman named Fusa was reported to have secretly given birth to a girl after "having a clandestine affair with so-and-so Nakamura" in the village where she was working.[13] Another article, published in 1901, reported that allegedly more than thirty young men who failed to pass the physical examination for military conscription had contracted venereal diseases from "factory women in the silk industry."[14] Another hinted that many factory women would eventually fall into the "dirty land" (*fuketsu-chi*), that is, the world of prostitutes.[15] An article published in the *Shinano Daily* in 1914 claimed: "If the majority of these factory women are to become the wives and mothers of the men born in Nagano Prefecture, one wonders whether we can reproduce sound and healthy subjects in our prefecture in the future."[16] As the following headlines from local newspapers suggest, factory women were still represented as promiscuous well into the 1920s.[17]

> "Woman at Silk-Spinning Factory Aborts Fetus:
> Fetus Found in Factory Toilet"[18]
> "Secret Rendezvous of Factory Woman and Local Carpenter Disclosed"[19]

Since these newspapers were well respected and not known for gossip, I argue that very little distinguished factory women from prostitutes. Factory women could be prostitutes and vice versa in the eyes of both middle-class journalists and commentators such as Miwada Masako.

What was "women's morality" then? In short, it was something that could make all the "problems" involving factory women disappear.[20]

Indeed, if the women had "women's morality" (or should I say if they did not have "problems"?), they proudly appeared in nationalist discourse. In Nagano, those factory women who produced more silk thread of better quality than others were publicly acknowledged for their contribution to the construction of the Japanese nation.[21] Their patriotism was also hailed. On 9 October 1894, two months after the outbreak of war between Japan and China, the *Shinano Daily* printed an extra four pages with the names of 2,013 silk factory women in Nagano who had contributed a portion of their wages to the Japanese military. At the time of the Sino-Japanese War, factory women contributed only money. The local media continuously reported the situation at the front but never said anything about the families back home whose men had been conscripted.[22] The Russo-Japanese War dramatically changed the manner in which the media reported the war situation: "fine episodes" (*bidan*) describing the poor women in the Nagano countryside were published in local newspapers as exemplars of national subjects. Among them were the factory women who were helping their families in the absence of their fathers, husbands, and sons.[23] These women were no longer "promiscuous" but respectable national subjects.

Another set of discourses described the factory woman as a "mother" in her relationship with silk and cotton thread and cloth. For example, the physiocrat Inada Masatane argued that the silk-spinning industry demanded motherlike devotion, and it was only "our nation's women" (*waga-kuni no joshi*) who could produce such fine silk thread and cloth, as they had done since the time when Japan was founded.[24] Even when factory women returned to their villages between seasons or after they had quit their jobs at the mills, they were subjected to similar nationalist discourse. Writing in 1906, Nagano teacher Kobayashi Tomojirō argued that a woman should wake up when "silkworm babies" (*sanji*) wake up and go to sleep when they go to sleep.[25] He further declared that "the life of a family depends upon the delicate body of a woman," while "the life of a nation depends upon the slender arms of women."[26] Kobayashi thus argued that a woman should support her family as well as the nation. Another physiocrat, Ishida Magotarō, argued that the soft, delicate, and snowlike white bodies of silkworms demanded the care, affection, patience, and tolerance of a mother.[27]

Here, we must pay close attention to such adjectives as *delicate* and *slender*. The image of a woman with a delicate body and slender

arms sounds like urban upper- or middle-class women. By resorting to such adjectives, Kobayashi and others apparently tried to erase the differences between urban upper- or middle-class women and the working-class women of rural origins in terms of their morality. Thus, whatever her class, a woman was asked to practice endurance, submission, sacrifice, industriousness, and self-reliance, that is, the qualities "equally valuable in industrial development as in the preservation of the household."[28]

This set of nationalist discourses began to appear in the early twentieth century after the Sino-Japanese and Russo-Japanese wars and became ubiquitous after World War I. The relationship between this set of discourses and the ideology of national essence (kokutai), which began to take shape in the 1880s, seems obvious. According to the ideology of national essence, Japan constitutes a unique homogeneous space for a single extended family, with the emperor as its supreme and patriarchal head. The emperor is supposed to offer his unconditional affection to his subjects, as he would to his own children. Such a relationship should not be based on the Western notion of rights and obligations, nor the Eastern (read Chinese) notion of domination and submission, but the truly Japanese notion of harmony. According to the ideology of national essence, then, women are not supposed to be independent subjects but only daughters, wives, and eventually mothers who would "give birth to the descendants of their ancestors and nurture them as Japanese nationals to serve the emperor."[29]

The ideology of national essence deliberately confuses the productive and reproductive work performed by women. Thus, historian Miyake Yoshiko argues: "By examining this interaction [of productive and reproductive work] we can see how women's housework, stemming from their reproductive roles, provided the basis for reproducing the social relations of the capitalist mode of production."[30] Only by examining this interaction can we understand the contents of "women's morality" for factory women. Thus, I argue that "women's morality" is what makes factory women into "good and wise mothers" in and of Japan, now perceived as the "family-nation" (kazoku kokka). Factory women imbued with "women's morality" produce silk and cotton thread and cloth of good quality, but they also reproduce the "social relations of the capitalist mode of production," and, whether working as factory women or not, they give birth to children and raise them for Japan.

Referring to the relationship between women and nationalism in post–French Revolution Europe, Ann McClintock comments:

> Obedient to the inimitable logic that "a man and his wife are one, and he is the one," women in post–French Revolution Britain and Europe were not incorporated into the nation-state as citizens, but only indirectly, through men, as dependent members of the family in private and public law.[31]

Citizenship for a woman in post–French Revolution Europe was mediated by her marriage relationship; it was through her husband that her citizenship and nationality were determined. The marriage relationship, however, did not obliterate her class background. The difference between an aristocrat's wife and a farmer's wife was retained through their husbands. In Japan following the Russo-Japanese War, nationalist discourse discursively obliterated even the class differences that existed among women. The ideology of *kokutai* could incorporate any woman in the space of one extended family, whether she was the wife of an aristocrat or a poor farmer. In other words, the notion of *kokutai* freed every Japanese woman from her own material life.

THE NATIONALIST DISCOURSE OF SOCIAL REFORMERS AND FACTORY WOMEN

There is a contradiction inherent in the ideology of national essence, a contradiction that emerges only if we take into account each factory woman's body. For a factory woman, toiling for the nation undermines her health, making it more difficult for her to play reproductive roles in her own family. Using the discursive power of national essence and "women's morality," many employers in the textile industry refused to acknowledge this contradiction. For another group of individuals, whom I shall call social reformers, this contradiction became a problem that called for solution. Social reformers did not constitute one homogeneous group; rather, they included people from such varied backgrounds as "progressive" bureaucrats and journalists, "paternalistic" employers and factory supervisors, medical doctors, scholars, socialists, Christians, and women activists. I focus here on several individuals but conclude by arguing that all of them had one thing in common: they treated factory women as a category or object to be analyzed. They demonstrated their concern with the bodies of factory women, but they eventually made them disappear under the abstract notion of "the Japanese woman."

One such reformer, an authority on hygiene, Ishihara Osamu, tried to link the bodies of factory women directly to the fate of the nation. In an article and lecture, Ishihara warned that "the degraded condition of health among factory women will decrease their productivity, block industrial development, decrease the birth rate, and jeopardize the health of the newborn. Hence, it will greatly threaten the prosperity of our country (*kokka*)."[32] "Factory women" in his lecture referred to the approximately 190,000 women in the silk-spinning industry, the 80,000 in the cotton-spinning industry, and the 130,000 in the cotton-weaving industry in the early twentieth century. Ishihara attributed the cause of factory women's degraded health to their working conditions, which, he argued, caused them to suffer and die from tuberculosis. Tuberculosis is a disease for which a cure did not then exist. Ishihara predicted that the tubercle bacillus would multiply in the unsanitary conditions of the countryside after the factory women returned home. He was thus concerned not only with the fate of millions of factory women suffering from tuberculosis but with the fate of the nation because these women could not possibly give birth to healthy children. Ishihara concluded his lecture by comparing "soldiers of peace" (i.e., factory women) with the soldiers killed in the Russo-Japanese War.

> I do not know how Japanese citizens (*kokumin*) will be able to reward those who have been killed in the war of peace. Although I am speaking of things that may induce your tears, the fate of factory women is indeed miserable. Even though they are mere factory women (*yahari karera jokō to iedomo*), they are our compatriots.[33]

He thus urged the audience not to look down upon factory women of rural and humble origins but to give them sympathy.

Ishihara was by no means the first person to make public this kind of reformist discourse. More than a decade before he had begun his visits to the countryside as a temporary employee of the Ministry of Agriculture and Commerce, the Home Ministry had established the Factory Survey Office.[34] The (usually temporary) employees of this office investigated working conditions at various textile mills throughout Japan and published *Shokkō jijō* (Factory Workers' Conditions) in 1903. This publication was not widely circulated until the end of World War II. The Home Ministry and the Ministry of Justice worried about its social and political consequences within Japan, and they feared the spread of leftist sentiments, especially among factory

workers. The Ministry of Foreign Affairs also feared the negative impression of Japan it might give to foreigners.[35]

The authors of *Factory Workers' Conditions* revealed the pitiful working conditions at textile mills employing more than ten laborers (we can only imagine the conditions at mills employing fewer than ten). Regarding conditions in the silk-spinning factories, for example, they reported on the prevalence of child labor, unsanitary conditions in the workplace that were detrimental to the factory women's health, long shifts that occasionally extended as long as eighteen hours a day, the widely used system of punishments in the form of wage ex- traction and physical torture of unproductive women, the sty-like dormitories in which the women were confined, the low-quality food served in the dormitories, and the variety of diseases from which the women suffered.[36] These social reformers eventually persuaded the government to promulgate the Factory Law in 1911.

The social reformers also included more or less prominent social- ists and communists. Before discussing their ideas, I must point out that nationalism also found its niche among those who participated in the leftist movements of the late nineteenth and early twentieth centuries. In this respect, as in Europe during the same period, na- tionalism "reached out to liberalism, conservatism, and socialism; it advocated both tolerance and repression, peace and war—whatever served its purpose."[37] Interestingly, this socialist-nationalist discourse was also gendered. For example, writing on the factory women at a cotton textile mill near Tokyo, socialist Hirasawa Keiichi commented:

> Observing the almost magicianlike dexterity of the hands of factory women, I concluded that only women (*onna*) could undertake this kind of work. I also intuitively felt that this was possible only for Japanese women (*Nippon no onna*), not Western women. The Japa- nese woman (*Nippon no fujin*) who identifies sewing with the fe- male vocation is destined to develop the dexterity of her hands from the time she is in her mother's womb.[38]

Note the interesting progression in Hirasawa's definition of fac- tory women. They are first identified as "women," defined by gender alone. "Women" then become "Japanese women," and finally "the Japanese woman," defined by gender and nationality. Hirasawa also makes a distinction between "women" (*onna*) and "woman" (*fujin*). Following his "intuition," Hirasawa presents "the Japanese woman" as a natural category and a cultural superior to the category of "the

Western woman." He elevates factory women to the abstract level of "the Japanese woman," who represents Japan to the outside world. In other words, he defines the culture of factory women not only for them but for the nation-state of Japan.

Hosoi Wakizō was a socialist activist and himself a cotton-spinning factory worker. He thus personally experienced the harsh working conditions of the textile mill together with his wife and her fellow factory women. Hosoi, however, saw factory women as a category of women to be observed and investigated. He writes:

> It is extremely difficult to study the psychology of factory women. But I have lived with them from dawn to sunset. I have observed their entire lives, collected various data, including their songs, studied their physiology from a medical perspective, and tried to clarify the relationship between their physiology and psychology.[39]

His *Jokō aishi* (The Pitiful History of Factory Women), which was published a month before his death at the age of twenty-nine in 1925, is thus the result of his long-term research on factory women.

In this monumental work, Hosoi relies on another term for "women" (*fujin*) in addition to "factory women" (*jokō*). *Fujin* literally translates as "women," and it should include all the people of the female sex. It was apparently Fukuzawa Yukichi, an early Meiji enlightenment scholar, who coined this term. Using *fujin* to emphasize the notion of women as respectable human beings, Fukuzawa tried to reject the Confucian notion of women as legal incompetents and appendages of men. *Fujin*, then, is not simply a term but an ideology, which new patriarchal figures such as Fukuzawa tried to espouse for the women of Japan. Women should be respectable, and to that end educated, so that they will be able to teach their children. Along with another term, *ryōsai kenbo* (good wives, wise mothers), *fujin* gained power as the dominant gender ideology of modern Japan. Hosoi thus describes factory women as a group of women "whose culture is very retarded . . . and who have more or less the psychology of uncivilized savages." His ideal was to elevate the status of "factory women" as close as possible to that of "women."[40]

Hosoi's utopian vision of a socialist Japan would be realized when factory women were included in the category "women." In such a society, he writes:

> The government should make it an obligation for every unmarried woman to work in the production of clothing. If all twenty-five

million young women work, there will be no need to ask sick women or women with children to work, nor will there be any necessity for them to work for ten or twelve hours a day for five or ten years. If every youthful and vibrant woman works only four or five hours a day for one or two years, and only on the days when she feels well, Japan could produce a sufficient amount of clothing.[41]

In this utopian Japan, Hosoi argues, all existing factories must be nationalized and the twenty-five million young single women must work. He also argues that, since these young women constitute the "mother body of Japan" (*Nippon no botai*), with the important obligation of bearing and raising children, they should not work once they are married.[42] In other words, he argues not for improving the working conditions of married working women but that they should not work at all. Referring to Britain after 1945, historian Denise Riley argues that "women were described as either over-feminized mothers, or as under-feminized workers, but the category of the working mother was not acknowledged."[43] I believe I can apply Riley's argument to criticize Hosoi. For Hosoi, mothers should stay home and were thus "overfeminized"; single women should work and were thus "underfeminized"; the category of the working mother did not exist for him either.

In his *Pitiful History of Factory Women*, Hosoi shows his concern for their diseased bodies.

> Factory women work standing on hard concrete floors all year long. They do not work less during menstruation. They live in underheated dormitories. In addition, they masturbate. All these factors lead factory women to suffer from women's diseases. Even so, they do not take care of themselves or they are ignorant of what they do. Consequently, they become barren.[44]

Even if factory women give birth, Hosoi argues, their offspring die, and when they survive they tend to be mentally retarded or physically handicapped.[45]

According to Hosoi, such degraded working conditions do not make factory women conscious of their own exploitation. When factory women go on strike, Hosoi writes, they behave like girls fretting about this and that to their sweethearts.[46] He mentions twenty-four strikes at cotton mills that took place between 1915 and 1923 but refuses to see "cultural significance" (*bunka-teki igi*) in them. I see certain commonalities between Hosoi and the labor organizers of the

early twentieth century, as well as the labor historians of our own time, who have ignored women's roles in the history of Japanese labor movements. Male unionists regarded factory women as "unorganizable." They characterized them as "too attached to the family, too young, too filial, and too impermanent a part of the work force to undertake the historic mission of workers in a labor movement."[47] They also refused to allow women representatives to attend meetings of the International Labor Organization until 1920.[48] The Marxist intellectual Hasegawa Koichi argued that collective actions taken by factory women were merely "accidental," "emotional," and "not modern"; they erupted like fireworks when one least expected it but died out quickly because of the "emotional nature unique to women" (*josei tokuyū no kanshō*).[49] Much later, one labor historian argued that "even deplorable working conditions gave rise to no movements of protest" because of the "ignorant young girls for whom a factory job was only a short interlude in their lives."[50]

Yet Japan's first labor strike, which occurred at the Amamiya Silk Mill in Kōfu in Yamanashi Prefecture in 1886, was organized solely by women. This particular strike produced at least four more strikes in 1886 in the Kōfu area alone. These later spread among both silk and cotton factory women throughout Japan. Sharon Sievers argues that by 1897, when socialists organized the Association for the Promotion of Labor Unions, "Japanese women had been confronting management for more than a decade with demands for better working conditions and higher wages, and had backed those demands up by refusing to return to work until they had won concessions."[51] By the mid-1920s, the frequency of strikes in which women participated, either alone or with men, increased dramatically in both the silk and cotton industries.[52] Hosoi criticized his contemporary male labor unionists for their contempt of factory women and sympathized with women workers who endured deplorable working conditions. However, it is not clear to me whether Hosoi wanted factory women to be awakened as laborers conscious of their class positions. Rather, Hosoi's critique seems to be directed at Japanese capitalism, which forced even sick women and mothers to work outside their homes. He wanted women to return to their homes and be mothers or even "good wives and wise mothers." He was thus critical of the tendency he noted among factory women to "destroy" their family lives by returning to work after marriage.[53]

How did women reformers perceive factory women? Two groups of women activists are worth mentioning here. Reversing the chronological order of their appearance in Japanese history, I first focus on those who were concerned with the lives of working women in the early twentieth century and then explore the activities of late-nineteenth-century Christian reformers. The first is the group of women who participated in the so-called motherhood protection debates (*bosei hogo ronsō*), which began in 1918 and lasted until the early 1930s.[54]

In the history of Western feminism, we can recognize a constant tension between feminists who assert that femininity is the primary vehicle of women's oppression and those who criticize the devaluation of feminine roles and virtues by an overly authoritarian masculine culture. The former try to deny the social construction known as "woman" or "women," while the latter try to define the essential female nature. The motherhood protection debates of early-twentieth-century Japan are characterized by a similar, and perhaps more complicated, tension among several women activists. The debates, which took place largely in print, began in 1918 between Yamada Waka and Yamakawa Kikue on the question "What is woman's true nature?"[55] Even though I run the risk of greatly simplifying the nature of the debates, I focus here on the ideas of only one activist, who exchanged her views on motherhood protection with several of her contemporary feminists.

I characterize Hiratsuka Raichō as a feminist who tried to restore what she thought had been lost under early-twentieth-century Japanese capitalism, namely, feminine virtues. She founded the Bluestockings, originally a literary group of women, which later became much more. In 1911, she launched the first issue of the group's journal, *Seitō* (Bluestocking), with the sentence: "In the beginning, woman was the sun." Influenced greatly by a Swedish feminist, Ellen Key, Raichō discovered feminine virtues in motherhood. To put it another way, Raichō pointed out the negative impact of the Industrial Revolution and the general development of Japanese capitalism on the lives of (working) women. She thus wrote in 1916: "We are not to be liberated from being 'women'; as 'women' we must be liberated."[56] For Raichō, women's liberation entailed, more than anything else, the protection of motherhood, particularly the motherhood of both single and married working women. Unlike Hosoi, for whom the category "working mothers" did not exist, she clearly acknowledged that

mothers worked. She then demanded that state and society, along with male social reformers, protect motherhood, and she devoted most of her life to securing protective legislation—the Factory Law—for mothers and children.

With the exception of reform-minded bureaucrats, state officials and most of the business community strongly opposed the implementation of the Factory Law. Consequently, much of the law was not enforced until 1926. Furthermore, one of its most important articles, which prohibited the labor of women and children between ten o'clock in the evening and four o'clock in the morning, was shelved until 1929. Arguing against the provision in the Factory Law that prohibited more than ten hours of work a day for the laborers younger than fourteen, businessman and commentator Taguchi Ukichi commented:

> In the region of Nagano, more than a fourth of the women working in silk-spinning factories are younger than fourteen. . . . It is therefore not appropriate to order these factories to restrict the number of working hours. . . . We should not restrict production in Japan with such a law.[57]

A supposedly reform-minded and pro–Factory Law journalist put his own twist on the new law. His article, published in a local Nagano newspaper, is entitled: "With the Factory Law, One Set of Bedding for Each Factory Woman: 300,000 Sets of Bedding to be Washed in Okaya Alone, Putting an End to the Practice of Embracing and Sleeping Together." In it, the author mainly discusses the complaints of factory owners, who, now bound by the law, must provide one set of bedding for each woman instead of one for two. For the journalist, this marks more than an improvement in hygienic conditions at the dormitory. It also will lead to the factory women's "moral" improvement. He writes: "It has been rumored that factory women embrace each other while sleeping. I sincerely believe that the Factory Law will improve not only hygienic but moral practices among factory women."[58] He apparently assumed "lesbian" practices existed among factory women who were forced to sleep together under one cover.

For this journalist, a healthy industry would produce a healthy (hygienic) woman and, more importantly, a morally healthy one. This "morality," however, is the one defined by him, a middle-class male. His healthy and morally correct woman, a *fujin*, would produce healthy children, making Japan a healthy nation. Raichō may not have been

interested in healthy industries, but she, too, was caught in this circular rhetoric. She eventually acknowledged motherhood's service to the state and society. She advocated the state's protection of motherhood because she valued feminine virtues, that is, the virtues originating in women's biological contribution (that of bearing and raising children) to the nation-state of Japan. This is why another feminist, Yamakawa Kikue, criticized Raichō's thinking as just another version of "good wife, wise mother."[59] In the end, Raichō upheld the dominant gender ideology of her time.

Another group, the late-nineteenth-century women activists, did not deal directly with the issue of factory women. Instead, they were seriously concerned with prostitution and the lives of prostitutes. These early activists were largely urban middle-class intellectuals influenced by Christian educators. Their superior education made them critical of certain women's roles, namely, those of concubines and prostitutes, and of the men who frequented pleasure quarters and/or kept concubines. In 1886, they established the Tokyo branch of the Women's Christian Temperance Union (WCTU). In 1895, they expanded it into the Japanese WCTU (Nippon Kirisutokyō Fujin Kyōfūkai). In collaboration with male Christian purists, they began a crusade against prostitution, which they understood as a system of slavery and a violation of human rights. In other words, they wanted to "modernize the sexual mores of the populace along the lines of contemporary British and American societies" and confine sexual relations solely to the institution of marriage.[60]

What is important to my argument is the relationship these reformers tried to establish between prostitutes and factory women. Here a comparison of social reformers in Japan and the United States at the turn of the century may be useful. Kathy Peiss has described young, white, working women in New York City between 1880 and 1920 as hard workers who toiled in the city's factories and shops but devoted their evenings to the lively entertainment of the streets, public dance halls, and other popular amusements.[61] Some of these working women were the so-called charity girls, who did not accept money in their sexual encounters with men. Some among these charity girls slipped in and out of prostitution when unemployed or in need of extra income. Many others, however, "defined themselves against the freer sexuality of their pleasure-seeking sisters, associating 'respectability' firmly with premarital chastity and circumspect behavior."[62]

The middle-class reformers in New York City, however, did not see the dynamic in the ways in which working-class women defined their sexuality, and they often ignored the line existing between them and prostitutes.

I see certain commonalities between reformers in New York City and the Tokyo metropolitan area at the turn of the century. I would not deny that their largely philanthropic and humanistic enterprise did save some working women from falling further into the "dirty land." Tokyo reformers held bazaars to spread the idea that concubines and prostitutes were participating in the institution of "vice." They established Jiaikan in 1893, the first of several shelters for young women who could not support themselves except by prostitution.[63] Much later, in 1923, they organized relief for earthquake victims. But these activities also suggest that they, like their counterparts in New York, often did not always perceive the line between working women and prostitutes; most took the "promiscuous" sexuality of working women for granted. In order to bolster my argument, I now look briefly into the antiprostitution struggle, the nature of which changed between the late nineteenth century and 1945.

Judith Walkowitz reports on a social purists' antiprostitution movement in nineteenth-century England in which good feminist intentions yielded only bad results.[64] Protesting the state regulation of prostitution, Walkowitz argues, the feminists acted as "authoritative mothers" vis-à-vis prostitutes, whom they regarded as "innocent daughters."[65] In doing so, "feminists encouraged working men to assume a custodial role toward 'their' women and frequently reminded them of their patriarchal responsibilities as defenders of the family" and the nation.[66] In this process, working women became objects of concern instead of active participants in the antiprostitution struggle. Prostitutes, for their part, were forced to rely on pimps for security and protection, which made prostitution largely a male-dominated trade.

The antiprostitution movement in Japan was largely based upon the British one. However, since the relationship among the state, the brothel owners, the moral reformers, and the prostitutes was different than that in England, the movement had some characteristics unique to Japan. First, the antiprostitution movement in Japan began in Gunma Prefecture, far from the metropolitan centers. This is largely because the state had given local police extensive powers to regulate prostitution by 1900. In other words, the state "could act as

if it were not involved in the dirty business of prostitution" when it faced the international community.[67] Second, the antiprostitution movement in Japan was caught in a dilemma that had been created by the state's management of prostitution. The state classified prostitutes into the licensed and the nonlicensed (the latter therefore being "criminal"). In Gunma Prefecture, for example, state regulation of licensed prostitutes was abolished in 1891 due to the antiprostitution movement. However, the local government continued to levy taxes on brothel owners and strengthened medical surveillance of both licensed and nonlicensed prostitutes.[68] Since a significant number of licensed prostitutes became nonlicensed after the abolition of the state regulation, they were further "criminalized" and subjected to increased state surveillance. Third, in the course of the movement there emerged a discourse that would condone and even legitimize the existence of licensed prostitutes. On this point, Garon comments:

> In the eyes of nineteenth-century European regulationists, women became prostitutes because of "libidinous" temperaments, criminal tendencies, laziness, or because they had fallen outside familial authority as they migrated to the cities. Japanese authorities similarly feared the emergence of a huge class of hedonistic women, as daughters left home to become factory workers or housemaids in the rapidly modernizing society of the late nineteenth and early twentieth centuries. Yet, in the Japanese case, such fears prompted the state to construct the category of the licensed prostitutes, the paradoxically asexual daughter who honored the country's tradition of filial piety.[69]

Garon's argument suggests that one group of prostitutes, namely, licensed prostitutes, could be honored as national subjects. The irony here, of course, is that factory women often became unlicensed prostitutes when they fell into the "dirty land"; then they could no longer honor the "country's tradition of filial piety."

With Japan's entry into the war with China in the 1930s, in collaboration with licensed brothel owners and social purists, the state began suppressing unlicensed prostitutes and those working at dance halls and cafes. In Garon's words, they considered "sexuality in the licensed quarters, symbolized by the Tokugawa district of Yoshiwara, to be traditionally Japanese, aesthetic, and for the sole pleasure of males. Cafes and dance halls, on the other hand, were associated with modernism, individualism, and Western-style romantic relations between the sexes."[70] The sexuality of factory women was thus associated

with the sexuality of cafe girls, dancing girls, and unlicensed prostitutes. By the mid-1930s, the rhetoric of the social purists had produced a curious result: it was thought that a wife's physical desires needed to be restrained in the interests of the family, and so (licensed) pleasure quarters were thus essential for the regulation of public morals and hygiene.[71] Those factory women who fell into the "dirty land" could not even perform the function of regulating public morals and hygiene because when they fell they often became unlicensed, clandestine, and therefore criminal prostitutes.

The antiprostitution movement in Japan eventually became a nationalistic and eugenic one, calling for the purification of Japanese blood and marginalizing perhaps a significant number of women concentrated in the city.[72] This was, then, the ultimate consequence of the antiprostitution movement initiated largely by female Christian reformers. I believe that they, like Raichō, were interested in women's right to participate in political activities, but they were interested in this right for middle-class women only. They did not incorporate millions of working women into their movement, and once working women fell into the "dirty land," all the reformers could do was pity them. Furthermore, these activists denigrated the lives of working women by not acknowledging the line between factory women and prostitutes.

CONCLUSION

I have examined the discourse of various social reformers, beginning with that of Ishihara Osamu and ending with that of the late-nineteenth-century Christian social reformers, who left the legacy of their movements to the eugenics movement of the 1930s and 1940s. Despite the differences in their backgrounds, they all dealt with factory women as a category of women first to investigate and then to reform. They depicted the bodies of factory women as abused, diseased, sexually promiscuous, and barren. Unlike employers in the textile industries, who promoted "women's morality," these reformers called for the improvement of working conditions to make factory women not only physiologically but morally healthy. I argue that they did so in order to make factory women into "the Japanese woman," in their own image, just another "good wife, wise mother." "The Japanese woman" does not control her own body nor her own will, thoughts, and emotions. She is an abstract image. Furthermore, those who did not fit in this image, namely, those who fell into the "dirty land," were further criminalized in the discourses of the turn-of-the-century

social reformers and finally in the eugenics movement of the 1930s and 1940s. Factory women as national subjects were young single women who labored hard (fulfilling their patriarchal fathers' wishes), maintained moral standards, and produced abundant silk or cotton thread and cloth of good quality. Once married, their mission was to stay at home and give birth to healthy children for Japan. Thus, the bodies of factory women had to be prepared for this ultimate goal.

Regarding a similar social reform movement in India, Kumkum Sangari and Sudesh Vaid argue that the "history of reform—whether colonial or indigenous or nationalist—undertaken by men and by women does not seem very inspiring, freighted as it is with many kinds of patriarchal assumptions."[73] They then make a broad distinction between "modernizing" and "democratizing" social movements. The former try to modernize patriarchal modes of regulating women, providing a more "liberal space" for middle-class women only. According to Sangari and Vaid, the nationalist movement in India was such a "modernizing" movement. "Democratizing" movements, however, try to "change, to whatever degree, both the base (the sexual division of labor in production and property relations) and the ideologies of a specific patriarchal formation."[74] If this is so, I argue that the various movements of social reformers in early-twentieth-century Japan were all "modernizing" movements, which changed neither the base nor the ideologies.

To my knowledge, George Mosse was the first to deal with the interrelation between nation and respectability. The relationship between the proliferation of European (particularly German) nationalisms and the formation of the middle-class notion of "respectable" sexuality almost parallels the process in Japan.[75] Mosse argues that middle-class respectability eventually facilitated the rise of fascism in Germany. Fascism sought to strengthen and preserve the division of labor between the sexes and tried to eliminate those who threatened it, including Jews, homosexuals, criminals, and the insane.[76] In Japan, too, the antiprostitution movement became a eugenic one: working women who fell into the "dirty land," those with promiscuous bodies and problematical sexualities, could no longer sustain the purity of Japanese blood. The efforts of social reformers could not save them. Even though such fallen women were Japanese, the social reformers aggravated their fate by contrasting it with their own image of "the Japanese woman."

NOTES

1. James W. White, introduction in *The Ambivalence of Nationalism: Modern Japan between East and West*, edited by J. W. White, M. Umegaki, and T. Havens (Lanham, Md.: University Press of America, 1990), 1.

2. Benedict Anderson, *Imagined Communities: Reflections on the Origins and Spread of Nationalism* (London: Verso, [1983] 1991).

3. I follow here Anthony Giddens's formulation of ideology, that is, the notion of ideology "has to be disconnected from the philosophy of science" and "should be formulated in relation to a theory of *power* and *domination*" ("Four Theses on Ideology," in *Ideology and Power in the Age of Lenin in Ruins*, edited by A. Kroker and M. Kroker [New York: St. Martin, 1991], 21–22). In other words, ideology cannot be defined in reference to truth claims and is "empty of content because what makes belief systems ideological is their incorporation within systems of domination" (22).

4. See Tessa Morris-Suzuki, "Sources of Conflict in the 'Information Society,'" in *Democracy in Contemporary Japan*, edited by G. McCormack and Y. Sugimoto (Armonk, N.Y.: M. E. Sharpe, 1986), 76–89.

5. For narratives by factory women, see the appendix to Ōkouchi Kazuo, ed., *Shokkō jijō* (Kōseikan, 1971). For the songs of factory women, see Hosoi Wakizō, *Jokō aishi* (Iwanami Shoten, 1954); Yamamoto Shigemi, *Ah, nomugi-tōge* (Kadokawa, 1977); Patricia E. Tsurumi, *Factory Girls: Women in the Thread Mills of Meiji Japan* (Princeton: Princeton University Press, 1990); Miriam Silverberg, *Changing Song: The Marxist Manifestos of Nakano Shigeharu* (Princeton: Princeton University Press 1990); and Akamatsu Keisuke, *Onna no rekishi to minzoku* (Akashi Shoten, 1993). For the narratives of former factory women, see Yamamoto, *Ah, nomugi-tōge*; Yamanouchi Mina, *Yamanouchi Mina jiden* (Shinjuku Shobō, 1975); Takai Toshio, *Watashi no "Jokō aishi"* (Sōdō Bunka, 1980); and Mariko Asano Tamanoi, "Under the Shadow of Nationalism: Politics and Poetics of Rural Women in Modern Japan," manuscript.

6. Miwada Masako (1843–1927) was a specialist in women's education. After her husband, Miwada Mototsuna, died in 1879, she founded several schools for women in Matsuyama and Tokyo. She also helped establish the Nippon Joshi Daigaku (Japanese Women's College) and joined its faculty in 1919. She authored numerous books in order to teach Japanese women the ideology of "good wife, wise mother."

7. See Tsurumi, *Factory Girls*, 47. Some of the reasons are the following. First, the glamour and prestige attached to working in the modern plants in the beginning of the Meiji period quickly dissipated. Second, as the size of each factory expanded in accordance with increasing production, the need for factory women ballooned. Third, consequently, "good" families could no longer provide their daughters as "respectable" workers.

8. Miwada Masako, "Jokō kyōiku," *Jokan* 149 (1898): 6.

9. Ibid., 7.

10. Kōzu Zenzaburō, *Kyōiku aishi* (Nagano City: Ginga Shobō, 1974), 362–63.

11. Ibid., 361.

12. Ōkouchi, "appendix," in *Shokkō jijō*, 581.

13. *Shinano mainichi shinbun*, 18 May 1901.

14. Ibid., 1 June 1901.

15. Ibid., 26 January 1893.

16. Ibid., 17 July 1914.

17. This discourse emphasizing the promiscuous nature of factory women was found not only locally but also in the metropolis. For example, *Kokumin shinbun*, specifically commenting on the factory women who came from Nagano to work in Gunma Prefecture, reported: "The behavior of factory women is unmentionable. . . . Those who are only seventeen or eighteen years old earn seven or eight yen in wages every month but send it to their parents only until they are twenty-seven or twenty-eight. After that, they keep moving from one factory to another and eventually become (1) the wives of day laborers, (2) the wives or concubines of gamblers, (3) the concubines of ruffians, or (4) prostitutes" (quoted in *Jogaku zasshi* 355 [14 October 1893]: 406–7).

18. *Shinano nippō*, 30 July 1924, quoted in Hosokawa Osamu, *Kōjo no michi: nomugi tōge* (Nagano City: Ginga Shobō, 1982), 28.

19. *Shinano nippō*, 2 May 1926, quoted in Hosokawa, *Kōjo no michi*, 28.

20. "Women's morality," however, took concrete form at some textile factories. Taking Nagano as an example again, the Rokumonsen Silk Spinning Factory tried to teach its women employees Japanese language (*kokugo*), algebra (*sanjutsu*), sewing (*saihō*), physical exercise (*taisō*), and educational songs (*shōka*) under the rubric of "women's morality." Rokumonsen was one of the few factories in Nagano that offered general education to their employees. However, an article published in a local newspaper disclosed that the classes at Rokumonsen were in session only from November to April (when many women went home) and "no classes were held last year [in 1914] due to the reduction in production" (*Shinano mainichi shinbun*, 8 July 1915).

21. See, for example, articles published in ibid., 8 November 1885, 30 October 1889, and 22 March 1913, which reported the award ceremonies for "excellent factory women" (*yūtō kōjo*). Note that here *jokō* was reversed to *kōjo*.

22. Morosawa Yōko, *Shinano no onna* (Miraisha, 1969), 2:9–10.

23. Ibid., 7–11.

24. Inada Masatane, *Fujin nōgyō mondai* (Maruyamasha, 1917).

25. Kobayashi Tomojirō, "Kōtō shōgakkō san yon gakunen joshi ni yōsan-ka o kuwauru no kibō," *Shinano kyōiku* 241 (1906): 13.

26. Ibid., 14.

27. Quoted in Inada, *Fujin nōgyō mondai*, 104–7.

28. Sharon H. Nolte and Sally Ann Hastings, "The Meiji State's Policy toward Women, 1890–1910," in *Recreating Japanese Women, 1600–1945*, edited by Gail L. Bernstein (Berkeley: University of California Press, 1991), 165.

29. Monbushō, *Shinmin no michi* (Monbushō, 1941), 86. See also Tsunoda Ryūsaku et al., eds., "Foundations of Our National Polity," in *Sources of Japanese Tradition* (New York: Columbia University Press, 1965), 2:278–88.

30. Miyake Yoshiko, "Doubling Expectations: Motherhood and Women's Factory Work under State Management in Japan in the 1930s and 1940s," in *Recreating Japanese Women*, 269.

31. Ann McClintock, "'No Longer in a Future Heaven': Women and Nationalism in South Africa," *Transition* 51 (1991): 112.

32. Ishihara Osamu's article, "Eisei-gaku jō yori mitaru jokō no genkyō," was originally published in *Kokka igaku-kai zasshi*, no. 322, in 1913. In the same year, he gave a lecture entitled "Jokō to kekkaku" at a meeting of the National Association of Medicine. The association published the article and the lecture as a booklet in 1914. I used the version included in Kagoyama Takashi, ed., *Jokō to kekkaku* (Kōseikan, 1970), 81.

33. Ishihara, "Jokō to kekkaku," in Kagoyama, *Jokō to kekkaku*, 196.

34. The Ministry of Agriculture and Commerce became independent from the Home Ministry in 1881.

35. Ōkouchi, "Kaisetsu," in *Shokko jijō*, 17.

36. See also Yokoyama Gennosuke, *Nihon no kasō shakai* (Iwanami Shoten, 1949). Yokoyama was one of the temporary employees in the Factory Survey Office. Prior to the publication of *Shokko jijō*, to which he contributed, Yokoyama published this book, in which he meticulously described working conditions among the lower working class, including spinners and weavers in the silk and cotton industries.

37. George L. Mosse, *Nationalism and Sexuality: Respectability and Abnormal Sexuality in Modern Europe* (New York: Howard Fertig, 1985), 9. For example, Kōtoku Shūsui is "generally known as a socialist and anarchist who participated in the plot against the life of the Meiji emperor in 1910 and was executed for the crime of 'high treason' the following year" (Fred G. Notehelfer, "Kōtoku Shūsui and Nationalism," *Journal of Asian Studies* 31.1 [1971]: 31). But Notehelfer argues that socialism for Kōtoku was "a means of preserving the mission idea of the radical and popular nationalism which he had accepted as the essence of the early Meiji experience" (37). For an excellent analysis of how socialism and Marxism, as offsprings of the universalist ideas of the Enlightenment (of which nationalism is also one), have not sufficiently challenged nationalism, see Shlomo Avineri, "Marxism and Nationalism," *Journal of Contemporary History* 26 (1991): 637–57.

38. Hirasawa's article, "Jokō-san no seikatsu," was originally published in 1916 in *Yūai fujin*. I here quote from Akamatsu Ryoko, ed., *Rōdō*, vol. 3 of *Nihon fujin mondai shiryō shūsei* (Domesu, 1977), 232. Hirasawa was a socialist journalist who became a chief editor for *Rōdō shūhō*. He was one of the ten victims of the so-called Kameido Incident and was brutally murdered by the police for his "dangerous thoughts" in 1923 in the aftermath of the great Kanto earthquake. Biographical information in English on Hirasawa can be found in Andrew Gordon, *Labor and Imperial Democracy in Prewar Japan* (Berkeley: University of California Press, 1991), 177–81, 345.

39. Hosoi, *Jokō aishi*, 324.

40. Ibid., 325.

41. Ibid., 400.

42. Ibid., 399.

43. Denise Riley, *"Am I That Name?" Feminism and the Category of "Women" in History* (Minneapolis: University of Minnesota Press, 1988), 16.

44. Hosoi, *Jokō aishi*, 378.

45. Ibid., 382–83.

46. Ibid., 363.

47. Sharon L. Sievers, *Flowers in Salt: The Beginning of Feminist Consciousness in Modern Japan* (Stanford: Stanford University Press, 1983), 79.

48. Ibid., 211n.47.

49. Hasegawa Koichi, "Honpō ni okeru fujin rōdō no sūsei to sono kentō," *Shakai seisaku jihō* 135 (1931). I here quote from Akamatsu, *Rōdō*, 462, 465–66.

50. Ōkouchi Kazuo, *Labor in Modern Japan* (Science Council of Japan, 1958), 20. See also Andrew Gordon, *The Evolution of Labor Relations in Japan: Heavy Industry, 1853–1955* (Cambridge: Harvard University Press, 1985), 8–9. Barbara Molony points out, quite correctly, that these labor organizers and historians ignored the "social constraints" on factory women such as "restrictions by management on the economic independence of female workers" and "the workers' own views of what was appropriate behavior for women" ("Activism

among Women in the Taishō Cotton Textile Industry," in *Recreating Japanese Women*, 218).

51. Sievers, *Flowers in Salt*, 79.

52. Hasegawa, quoted in Akamatsu, *Rōdō*, 465.

53. Hosoi, *Jokō aishi*, 342.

54. For the details of the motherhood protection debates and a discussion of other women activists who engaged in them, see Nishikawa Yūko, "Hitotsu no keifu: Hiratsuka Raichō, Takamure Itsue, Ishimure Michiko," in *Bosei o tou: rekishiteki hensen*, edited by Wakita Haruko (Kyoto: Jinbun Shoin, 1985), 2:158–91; Barbara Molony, "Equality versus Difference: The Japanese Debate over 'Motherhood Protection,' 1915–50," in *Japanese Women Working*, edited by Janet Hunter (London and New York: Routledge, 1993), 122–48; and Patricia E. Tsurumi, "Visions of Women and the New Society in Conflict: Yamakawa Kikue versus Takamure Itsue," paper presented at the conference Competing Modernities in Twentieth Century Japan: Taishō Democracy, Maui, Hawaii, 1–5 November 1995.

55. Yamada Waka published "Kongo no fujin mondai o teishō su" (undated) and "Bosei hogo mondai" (*Taiyō*, September 1918). Yamakawa's article, "Fujin o uragiru fujin ron," was published in the August 1918 issue of *Shin Nihon*. Tsurumi correctly points out that "exchanges in print regarding motherhood protection had been going on since 1915, but the argument was hot and heavy" by the time Yamada and Yamakawa jumped into the debate in 1918 ("Visions of Women," 3–4).

56. This passage is in "Bosei no shuchō ni tsuite Yosano Akiko ni atau," which was published in *Bunshō sekai*, May 1916. I here quote from Nishikawa, "Hitotsu no keifu," 167, and use the translation in Tsurumi, "Visions of Women," 5–6.

57. Quoted in Kōzu, *Kyōiku aishi*, 377.

58. *Shinano mainichi shinbun*, 1 October 1919. Alleged lesbian practices among factory women were also reported by Hosoi in his *Jokō aishi*, 370–71.

59. Tsurumi, "Visions of Women," 7.

60. Sheldon Garon, "The World's Oldest Debate? Prostitution and the State in Imperial Japan, 1900–1945," *American Historical Review* 98.3 (1993): 719. A brief history of prostitution in Japan is in order here. Fujime Yuki argues that prostitution after the Meiji Restoration was a "modern" institution, essentially different from the prostitution that existed in the Tokugawa period. What made it modern were the periodic medical inspections of licensed prostitutes that the Meiji government introduced in response to a demand by the Russian Navy. In 1872, under pressure from the international abolitionist community, the government issued a law to liberate prostitutes (Shōgi Kaihōrei). However, immediately after the promulgation of this law, the government made it clear that any woman might practice prostitution of her own "free" will. In 1900, the Rules Regulating Licensed Prostitutes explicitly recognized the right of "free cessation" (*jiyū haigyō*) of prostitutes. Earlier that year, however, the Supreme Court "invalidated the provisions of contracts that bound prostitutes to continue their trade, but it upheld the obligation of the prostitute, family, or guarantor to repay the advance money and other debts that had accumulated during the term of her service" (Garon, "World's Oldest Debate," 713; see also Fujime Yuki, "Kin-gendai Nihon no sei to seishoku tōsei to shakai undō," Ph.D. diss., Kyoto University, 1994).

61. Kathy Peiss, "'Charity Girls' and City Pleasures: Historical Notes on Working-Class Sexuality, 1880–1920," in *Powers of Desire: The Politics of Sexuality*, edited by A. Snitow, C. Stansell, and S. Thompson (New York: Monthly Review Press, 1983), 74–87; *Cheap Amusements: Working Women and Leisure in Turn-of-the Century New York* (Philadelphia: Temple University Press, 1986).

62. Peiss, "'Charity Girls' and City Pleasures," 83.
63. Sievers, *Flowers in Salt*, 103.
64. Fujime points out, however, that early feminism in England was different from the social purists' movement. Josephine Butler, for example, did not attack prostitution or prostitutes per se. She criticized a system that deprived women of the opportunity for education and a decent job and required women to choose to live either as a virtuous wife or a fallen woman. For Butler, prostitutes were "sisters" with whom she should fight against the patriarchal system ("Kin-gendai," 71).
65. Judith R. Walkowitz, "Male Vice and Female Virtue: Feminism and the Politics of Prostitution in Nineteenth-Century Britain," in *Powers of Desire*, 422.
66. Ibid., 424.
67. Fujime, "Kin-gendai," 86.
68. Fujime argues that there were still 1,001 licensed prostitutes working in 396 brothels in twenty-four pleasure quarters in Gunma Prefecture as late as 1913 (ibid., 97–98).
69. Garon, "World's Oldest Debate," 722–23.
70. Ibid., 727.
71. Ibid., 722.
72. Ibid., 726. It is interesting to note that Nazi Germany condoned prostitution in order to fight homosexuality. As homosexuality was believed to be acquired through lack of feminine contact, young men in the cities ("the village happily preserved a healthy attitude toward sexuality") were encouraged to visit prostitutes, who were thus treated generously (Mosse, *Nationalism and Sexuality*, 167).
73. Kumkum Sangari and Sudesh Vaid, "Recasting Women: An Introduction," in *Recasting Women: Essays in Colonial History*, edited by Kumkum Sangari and Sudesh Vaid (New Delhi: Kali for Women, 1989), 18.
74. Ibid., 19.
75. Mosse warns against conflating respectability and sexuality. *Respectability* is a term "indicating 'decent and correct' manners and morals, as well as the proper attitudes toward sexuality" (*Nationalism and Sexuality*, 1).
76. Ibid., chap. 8.

Appendix:
Past Developments and Future Issues in the Study of Women's History in Japan: A Bibliographical Essay

WAKITA Haruko, NARITA Ryūichi,
Anne WALTHALL, and Hitomi TONOMURA

Prewar Studies

Under the influence of the imperial democracy (1918–31), the study of women's history emerged, along with the new awareness of social issues related to women.[1] Meanwhile, ethnological and folklore studies also took up women's history as a major focus.[2] *Joseishi kenkyū* (A Study of Women's History), compiled by the Association for Historical Study (Rekishi Kyōiku Kenkyūkai) in 1937, provided the first set of individual essays grouped by historical periods.[3] The twenty-four essays on society, religion, education, and literature related to women included "Ritsuryōsei no josei" (Women and the Ritsuryō System) by Kitayama Shigeo, "Jōko josei no nōgyōjō ni okeru chii" (The Status of Women in Ancient Agriculture) by Nishioka Toranosuke, "Chūsei bukkyō to josei" (Women and Medieval Religion) by Endō Motoo, and "Kinsei nōmin shakai no josei" (Women in Early Modern Peasant Society) by Inoue Kiyoshi. They initially appeared in a special edition of the journal *Rekishi kyōiku* (Historical Education). Owing to their popularity, they were reissued in paperback the same year. They are excellent even by today's standards and are surely worthy of having marked the starting point for the serious study of women's history. It is worth noting that each of these authors, who in the postwar eras became pillars of their respective areas of historical study, wrote women's history early in their prewar careers. Inoue Kiyoshi, in particular, who in 1948 left a deep impression on the field of social history with his *Nihon joseishi* (Japanese Women's History), began his research in women's history a decade earlier.[4]

In the same period, Takamure Itsue, the doyen of women's history written by a woman, began her research and writing. Her activities were

299

related to women's movements such as the Suffrage Movement. Takamure wrote *Dai Nihon josei jinmei jiten* (Biographical Dictionary of Japanese Women) in 1936 and *Bokeisei no kenkyū* (A Study of the Matrilineal System) in 1938.[5] This was when Frederick Engels's *The Origins of Family, Private Property, and the State* had a strong influence on research in Japanese social systems, including lineage, marriage, and inheritance. Accordingly, Watanabe Yoshimichi wrote *Nihon bokei jidai no kenkyū* (A Study of Japan's Matrilineal Period) in 1932, and Ishimoda Shō published "Kodai kazoku no keisei katei" (The Formation of the Ancient Family) in 1942.[6]

WOMEN'S HISTORY UNDER THE POSTWAR CONSTITUTION

Recognition of gender equality in the postwar constitution set off a stream of new works on women's history that sought to investigate the meaning of equality in history. The most important of these were Inoue Kiyoshi's *Japanese Women's History*, mentioned earlier, and Takamure Itsue's *Josei no rekishi* (Women's History) and *Shōseikon no kenkyū* (The Study of Matrilocal Marriage).[7]

Inoue Kiyoshi interpreted the equal rights extolled by the constitution as granting liberation for women from discrimination and suppression under feudalism. His book was in such great demand at the time that it became a bestseller. He asserted that primitive society had been free and equal but that the appearance of a class society had led to the creation of the nation-state, the political system of which was built upon a patriarchal structure. In the class society, those being governed continued to uphold gender equality in essence while adopting the outward form of a patriarchal family. Peasants and women suffered great discrimination and suppression under this kind of control. Inoue outlined the process of the rising status and eventual liberation of women in terms of their being the wives of different classes of men: first, wives of ancient slaves, then medieval and early modern serfs, and finally modern laborers. His interpretation posited the disappearance of gender inequality in the dissolution of class differences. The problem was that women were viewed in relation to their male keepers, and he provided no explanation of the cultural and literary accomplishments of aristocratic women writers in the Heian period or the drop in the status of women in the early modern period.

According to Takamure's view, the status of women was high in primitive society because it was centered on motherhood, which was

matrilineal, classless, and gender equal. As civilization developed, the status of women fell. In other words, women came to be subordinated under patriarchal authority as matrilocal marriage gave way to patrilocal marriage and the inheritance system became male centered. Takamure adopted the Engelian paradigm that the defeat of women's rights came with the establishment of a state based on patriarchal authority.

The model developed by Takamure, which associates women's high status with primitive and ancient society and their drop in status with the development of civilization, resembles the dualistic model prevalent in past Western scholarship in which men are equated with civilization and women with nature. Takamure's dualistic model was different in that she viewed civilization as harmful to women's interests in contrast to the ideal natural or primitive state. A sentimental idealism in her desire for a return to the primitive characterized her paradigm. She was not alone in holding this view; this idealizing of the primitive has been prevalent from the early twentieth century through modern and postmodern times. Whether or not we support Takamure's idealism, she had a tendency (shared with Beauvoir) to find the origins of women's subordination in their attachment to mysterious spiritual qualities in contrast to men's roles in the male-dominated sphere of work. But is it not the purpose of women's history to locate precisely why women came to be socially subjugated through their identification with mysterious spiritual qualities?[8]

Takamure achieved a major accomplishment in clarifying the pattern of transformation in marriage practices. But at the same time she failed to consider class differences and simplistically compared the status of women at large with that of all men or with men of the ruling class. In the final analysis, her position would hold that women's liberation is possible only with a return to an idealistic primitive society in place of the evils of civilization arising from patriarchal authority.[9]

Takamure's work was also problematic in the way she integrated the Engelian notion of primitive matrilineal society into her understanding of Japanese history. In arguing for an ancient matrilineal system in Japan, Takamure lauded the power of Amaterasu, the ancestral deity of the imperial family. The upshot was that her women's history was couched in the language of the nationalistic traditionalism that was linked to wartime emperor worship and indirectly urged women to cooperate in Japan's war effort.[10] It may be unfair, of course,

to criticize Takamure out of context. This was, after all, a time when Watanabe Yoshimichi also uncritically assumed the descriptions in the *Kojiki* (Records of Ancient Matters) and *Nihon shoki* (Chronicle of Japan) to be historical facts and used them to argue for the existence of a matrilineal society. We must nonetheless be cautious in reading Takamure's women's history based as it is on a fundamental understanding that "equality is primitivism."

Subsequently, general histories of women came to be written by such authors as Hora Tomio, Jugaku Akiko, Ōtake Hideo, and Harada Tomohiko, while Aoyama Nao published research on women's education in the Meiji period as it related to Christianity.[11] Much nonacademic writing on women's history also appeared. All in all, no work was able to break out of Takamure Itsue's framework for the ancient and medieval periods and Inoue Kiyoshi's framework for the early modern and modern periods.[12]

THE STUDY OF WOMEN'S HISTORY IN THE 1970s

At this juncture, Murakami Nobuhiko jolted the field in 1970 by raising a new issue. In criticizing Inoue Kiyoshi, Murakami in his "Joseishi kenkyū no kadai to tenbō" (Issues and Perspectives in Research on Women's History) argued first that Inoue's interpretation stemmed from his emphasis on socialism and social movements, which he took to be an inevitable consequence of historical law. Women's history should be the history of all women's life patterns, of which liberation and liberation movements are only one part. Second, while Inoue explained sexual equality from the perspective of productive labor, it was the Meiji family system, built upon patriarchy, that invited gender inequality even for commoners whose earlier freedom in daily life had depended on the legacy of community principles.[13]

Murakami was criticized by a number of scholars.[14] It seems that he had misunderstood Inoue's main argument, which had pointed out the pattern of female subordination under the patriarchal household system. The difference between the two is that Inoue found the origins of patriarchy in the ancient state whereas Murakami located it in the Meiji state. Either way, they both point to the coercive power of political authority. We must remember, however, that it was not simply the patriarchal pressure of the ruling power that subordinated women. Rather, female subordination should be understood as a result of the penetration of the patriarchal family structure—such as ownership of the means and objects of production—into the lives of

the commoner family. Male-centered community principles, especially those in medieval and early modern times, also helped to reinforce the patriarchal family system, despite Murakami's assertion to the contrary.

Nonetheless, the 1970s saw the introduction of the category of women as an independent entity in mainstream scholarship. In 1975, another work by Murakami, "Fujin mondai to fujin kaihō undō" (Women's Issues and the Movement for Women's Liberation), was published in volume 5 of the trendsetting *Iwanami kōza Nihon rekishi: Kindai* 5 (Iwanami Lectures on Japanese History: The Modern Period). With this, academia began to pay attention to this field, although Murakami was not considered a mainstream scholar. The publication between 1969 and 1972 by Rironsha of Murakami's four-volume history of women in the Meiji period (*Meiji joseishi*), which endeavored to depict women's history from the perspective of everyday life; the publication between 1976 and 1981 by Domesu of a vast, ten-volume collection of documents regarding women's issues in Japan, edited by Ichikawa Fusae and others (*Nihon fujin mondai shiryō shūsei*); and, beginning in 1978, the special annual issue every March devoted to women's history by the journal *Rekishi hyōron* (Historical Criticism) were major events in the study of women's history.[15]

Studies on women's history in the 1970s generally aimed at the historical rehabilitation of women as subjects from the perspective of "life" or "liberation" and used women's issues as their point of departure. They demonstrated that historical knowledge up to that point had been based on an androcentric view of history, and they shook the world of Japanese historical study by producing scholars who specialized in women's history. The study of women's history did not stop at carving out a domain for itself; through its methodological position as women's history, it also exposed the way the study of Japanese history had been monopolized by men and constituted as the study of men's history.[16]

RESEARCH ON WOMEN'S HISTORY IN THE 1980S

Out of the study of women's history in the 1970s there developed a new set of methodological perspectives for the 1980s. Because the position of women and the development of patriarchal institutions are class specific, research had to address class differences in each historical period. In addition, as Murakami said, women's history had to be "the history of the entire lives of women." Finally, the issue of

women's liberation was to underlie all research agendas both implicitly and explicitly. This awareness led to the publication of a five-volume set, *Nihon joseishi* (Japanese Women's History), in 1982. Essays in the volumes address women's positions and functions in the sexual division of labor, marriage, inheritance, and family systems, as well as women's self-perceptions and consciousness for each historical period, from historical times to the present. The volumes also seek to gain a broad understanding of liberation movements for all periods, not only in terms of citizens' and labor movements but in terms of the concrete conditions that shape liberation—household chores, childraising, education for female independence, and women's social contributions in the areas of art and culture.[17]

The 1980s marked a period in which scholars sought to examine a broad spectrum of specific issues in women's history. Burgeoning research resulted in the establishment of new forums for publication. In 1980, *Kazokushi kenkyū* (Studies in Family History) was published, while in 1982 the Nihonshi Kenkyūkai (Japanese Historical Society) chose women's history as the main theme for its annual symposium. In 1985, *Rekishigaku kenkyū* (Historical Studies) also dedicated a special edition to women's history.

Methodologically, the 1980s saw the revival of oral and regional histories of women, methodologies that had been neglected in other fields. Women's circles in various regions, for instance, unearthed enough information to reconstruct local histories by interviewing residents. Although most prevalent in the study of the modern period, this mode of local investigation has also led to the discovery of a surprising amount of early modern historical sources, such as women's diaries, that are invaluable for understanding the concrete conditions under which women led their lives. This type of rapidly accumulating detailed research in local history is having a major impact on our understanding of Japanese women's history in its broadest terms.[18]

Dominant Issues in the 1970s and 1980s

Women's history has consistently focused on the issue of the house (*ie*) and the family (*kazoku*), which form the basic unit of Japanese society. In the area of premodern historiography, Takamure Itsue's earlier research, which documented a transformation in marriage and inheritance patterns from matrilineal to patrilineal, laid the foundation for subsequent discussion on the evolution and establishment of the *ie*. Meanwhile, social anthropologists have introduced bilateral

descent theories. While there is no consensus as to how we should understand the development of the *ie*, much light has been shed on the class-specific inheritance patterns of aristocrats, warriors, and commoners in the medieval and early modern periods. We have a greater understanding of women in rural and urban communities owing to the new focus on women's groups that supplemented the communal associations headed by men.[19]

For the modern period, the connection between the family and the nation; the ideology of the *ie*, which supported the structure of nation and family; theories of women's liberation; and women's education have been major themes.[20] For Murakami, modern society certainly was not built upon the ideal of gender equality since for him patriarchal ideals penetrated farming families only in the Meiji period. In contrast, other authors of Murakami's time blamed the remnants of feudalism, which they saw as the origin of modern sexual inequality. Many believed that gender equality would prevail as modernism overcame the semifeudal and semitotalitarian conditions that existed under the Meiji state. Japan's tremendous industrialization and capitalist growth in the 1970s and the 1980s, however, preserved gender inequality and forced people to realize that modern, even more than premodern, society enforced upon all people—including the commoners—the principle of patriarchal authority based on the sexual division of labor in which men were equated with the sphere of outside work and women with domestic labor.

This new interpretation of modern Japanese society led to a number of related inquiries. First was the issue of motherhood, indispensable in perpetuating the *ie*. The *ie* positioned women as the sex that produces successors and helps to shape blood relations and family connections. From the medieval to modern periods, however, the value ascribed to motherhood changed significantly: from an object of high respect in medieval times, to an explicitly named "borrowed womb" in early modern times, to a "natural" vocation in modern times. In order to investigate the varied and historically specific social constructions of motherhood, an interdisciplinary group of scholars contributed articles to the two-volume *Bosei o tou: rekishiteki hensan* (Questioning Motherhood: Historical Transformations).[21] Women became a major focus in the study of Buddhism as well. A four-volume series, *Shiriizu josei to bukkyō* (Women and Buddhism), greatly advanced our understanding of issues related to salvation, doctrines, and nunhood.[22]

The transformation in women's status in connection with modern changes in lifestyle and the *ie* organization also became an object of inquiry. In the course of industrial modernization, what may be called the "exteriorization of household labor" greatly changed women's lifestyles. As a result of the great rise in consumption, like it or not, women were sent running to the work force. Currently, close to 70 percent of Japanese women work outside the home. Food, clothing, and shelter—the three ingredients of daily life—were transformed in the past in accordance with the needs of each family organization, which in and of itself is a product of historical development. The five-volume *Nihon josei seikatsushi* (History of the Lifestyles of Japanese Women) addressed the issue of changing lifestyles.[23] Earlier studies had focused on the social division of labor centered around men to explain transformations. This study questioned the changing roles of women within the framework of the social division of labor in various classes, age groups, and regions, while also touching on the lives of subjugated groups, the imperial family, and fishing people, to name a few.

It is indeed a one-sided perspective to see childbirth and child rearing as women's only contribution to society. Women have worked and worked, yet historiography has failed to recognize their efforts. This problem of historical interpretation stems from a skewed understanding of historical development. In other words, Japanese historiography has consistently recognized the social division of labor to be the fundamental source of social development, yet it has failed to understand that human beings have expended the majority of their energy in producing daily necessities, such as clothing, food, and housing, and bearing and raising children. Although changes in the social division of labor have continually transformed daily life, before the rise of "women's history" historiography ignored women's roles in these important changes. In the case of premodern families, the problem with this one-sided perspective is even greater inasmuch as premodern households were in essence managerial organizations in which there was no clear division between social and domestic labor. Women contributed to social production as much as to domestic labor. The position of women fell when governmental and corporate organizations grew large, replacing the many functions of the *ie* and relegating to it the task of reproducing daily necessities only. This eventually created the modern situation in which child rearing was considered the heavenly ordained job of women.[24]

From Women's History to the Study of Gender

The many issues and paradigms that built the study of women's history in the 1980s soon led to the transformation that Ueno Chizuko has defined as a move from women's history to the history of gender.[25] What this means is that the emphasis has shifted from understanding the patterns of female subjugation to investigating the roles of both men and women in a changing society. The investigation of women's history from women's viewpoints alone now prompts us to examine men's history from a gendered outlook. We can say that men's history has emerged as a result of the development of women's history.

Sociologist Ueno Chizuko's contribution to a set of essays on the study of Japanese history is in itself one indication of a transformation in the study of women's history. Even earlier, Wakita Haruko pointed out in her epilogue to the five-volume history of women's lives in Japan that its focus was on "the allotment of roles between men and women." In the preface to the two-volume *Jendaa no Nihonshi* (Gender in Japanese History), she noted the authors' common concern with "trying to indicate how our image of history changes when we take gender as our starting point."[26] That is why the word *gender* is included in the title of this publication. Furthermore, the contributors to *Gender in Japanese History* were not confined to those with training in history as a discipline but included researchers in such specialized fields as sociology, religion, anthropology, medicine, linguistics, and literature. Almost half of them live outside of Japan in the United States, Canada, and France.

The broadening of scope and scale that have accompanied the new focus on gender may also be seen in the five-volume series, *Onna to otoko no jikū: Nihon joseishi saikō* (TimeSpace of Gender: Redefining Japanese Women's History).[27] Edited by social critic Kōno Nobuko and sociologist Tsurumi Kazuko, this project began by trying to bring together the insights arrived at separately by the French *Annales* school and Takamure Itsue. Its original intent was to counter the historiographical perception of women as marginalized and discriminated against by drawing on the work by Takamure and Fernand Braudel, which demonstrated that the relationship between women and men in space and time is constantly in flux, just as periphery and center may be seen to be continually changing places. Naturally enough, the essays in these volumes go beyond this starting point to bring new dimensions to this kind of historical study, including architecture, medical anthropology, linguistics, and the sociology of religion.

Incorporating the concept of gender allowed for the expansion of object and scope in the study of women's history in other ways as well. Two books by Kawamura Kunimitsu, *Otome no inori* (A Maiden's Prayer) and *Otome no shintai* (A Maiden's Body), published in 1993 and 1994, illustrate this transformation from the perspectives of "difference" and "the location of speech."[28] Kawamura describes the conditions under which, based on the concept of "maiden," women in modern times produced "an imagined world for an autonomous community" and a new "consciousness of their bodies" (a bourgeois body). In his books, he takes up reading and cosmetics, advice columns and letters to the editor, and he makes visual images and advertisements as well as material objects such as sanitary supplies his objects of analysis. He is able to clarify his points through his concrete analysis of how women's images and their consciousness of their bodies are constructed within the relationship of seeing and being seen.

According to Kawamura, women "affixed to themselves with their own hands the very markers that men—and women who found them to be self-evident—attached to women" (*A Maiden's Body*, 72). He points out that women's "internal image" and "body" were constructed through their relationship with "the other, known as man" (72). Furthermore, as far as women were concerned, this functioned as a magic spell that immobilized them. He argues that women, or more precisely women's feelings and bodies, have been defined and depicted asymmetrically in terms of their difference from men. He describes the process by which women who were originally diverse and various came to be represented uniformly and one dimensionally and demonstrates how this became the norm.

Kawamura's argument could be called the politics of difference, and it also pertains to the politics of "the position of speech" in that it treats the question of how representations of women are constructed in terms of who does what to whom. A similar argument informs Hirata Yumi's work. In her article "Monogatari no onna, onna no monogatari" (The Women of Tales/Women's Tales), published in *Gender in Japanese History*, Hirata asks what women might have been saying about themselves in the spectrum of "the florescence of tales that talk about women" (230). What is inside the tales that talk about women is "woman as the object of desire" (230). In the modern period, in which men control words, it has been impossible for women to possess the stories and words with which to talk about their desires and their lives.

"The Women of Tales/Women's Tales" treats the stories connected with Takahashi Oden, deemed "a heroine among poisonous women," as well as the stories that Oden told about herself to depict the "the two stories' vindictive conflict."[29] What are here offered up for dissection are the journalist who told Oden's story at the time, Kanagaki Robun, who was the author of "Takahashi Oden yasha monogatari" (A Conversation about the Night Attack by Takahashi Oden), and contemporary scholars who have debated Oden within the genre of poisonous women. According to Hirata, to the extent that Oden was represented as a poisonous woman, no matter how much one tries to incorporate a woman's subjectivity it is impossible to retrieve "the stories told by women about themselves." Hirata's aim is to question the "position of speech," and she points out that the creation of Oden as a poisonous woman already embodies modern and male discourse—the gaze that makes woman into an object of desire and the stories that take that gaze as their point of departure. Hirata goes beyond the category of poisonous women and problematizes the position of speech—that is, the point at which all representations are made—and the process by which "the modern," the men who do the representing, becomes transparent.

What this politics of "difference" and politics of "the position of speech" make clear is the complexity and perplexity found in the concept of women's "subjectivity," which up to now has been treated somewhat simplistically. The very words used by women to create their subjectivity are based on male values and imply male norms. Furthermore, the subjectivity thus established becomes a means of self-control. Subjectivity is neither absolute nor uniform; rather, it is relational and versatile. This pertains not only to women's subjectivity but to the questions put to the "subject" known as "woman." Thus, the study of women's history at this turning point constructs an argument that takes the form of questioning what it had previously taken as a given. Rather than take the subject, that is, "the woman who resolves women's issues," as the point of departure for the study of women's history, these approaches question the very notion of women's issues, that is, the way the topic has been established. They assume the concept of "the subject" to be constructed and multifaceted, and they try to reexamine the whole conception of women's history anew.

THE NEW WOMEN'S HISTORY

Several perspectives have been elucidated for the sake of a new women's history. The first is the definition and analysis of a domain

of "women's discourse." In *Senryaku to shite no kazoku* (The Family as Strategy), Muta Kazue defines it as "the entirety of discourse concerning women" that centers on what women themselves have done with their own hands.[30] The second is a reappraisal of "the family," which Muta makes the center of her analysis. Muta sees the family in modern Japan as an apparatus that internalizes the discipline of modern society and constructs itself as "citizen." The discussion regarding the modern family has expanded vigorously and given rise to a number of works, including Ueno Chizuko's *Kindai kazoku no seiritsu to shūen* (Establishment and Last Moments of the Modern Family), Ochiai Emiko's *Nijūichi seiki kazoku e* (Toward the Twenty-First-Century Family), and Yamada Masahiro's *Kindai kazoku no yukue* (The Whereabouts of the Modern Family).[31] All of these works analyze the family as an apparatus that supports modernity.

The third perspective makes the interrogation of modernity into an interrogation of the nation-state. Representative of this is Ueno Chizuko's "Kokumin kokka to jendaa" (Gender and the Nation State), in which she examines the transformation of women into citizens and points out the paradoxical relationship between "woman" and "citizen."[32] When women's history is conceived of in relation to the nation-state, a whole flock of issues, such as nationality and women or women and colonialism, comes to the surface. It seems that the study of modern women's history as practiced heretofore has had a curious affinity for the logic of the nation-state.

Thus, the study of women's history at this juncture is breaking out of the ghettoization of "women's history," liberating itself from "women" per se and from Japan as well. As it sets out in new directions, women's history that takes modern Japan as its object will likely end up with the potential to interact in a global context. Methodologically, we should be aware that modernist approaches have often attempted to explain the entire spectrum of premodern history in terms of stages in progression toward modernity. This is the historical perspective in which the West-inspired modern society, dominated by elite men, represents the culmination of development. Gender relations in other societies at other times must be examined in their own right, not from a modernist perspective that colonizes the past—including images of men and women—in terms of modern society.

NOTES

The editors gratefully acknowledge the help provided by Christina Laffin in translating portions of this essay.

1. See the extensive bibliography on women and gender in Joseishi Sōgō Kenkyūkai, comp., *Nihon joseishi kenkyū bunken mokuroku*, 3 vols. (Tōkyō Daigaku Shuppankai, 1983–94). Some representative works from the early twentieth century include Kawada Tsuguro, *Fujin mondai* (Ryūbunkan, 1910); Sakai Toshihiko, *Danjo kankei no shinka* (Yūrakusha, 1908); and Kida Sadakichi, "Chakusai to honsai, shōsai," *Minzoku to rekishi* 2–3 (1919): 13–16.
2. Iba Fuyu, *Okinawa joseishi* (Izawa Shoten, 1919); Yanagita Kunio, "Imo no chikara," originally published in *Fujin kōron* 10.11 (1925), reprinted in Yanagita Kunio, *Teihon Yanagita Kunio shū* (Chikama Shobō, 1962), 7–22; Origuchi Shinobu, "Saiko Nihon no josei seikatsu no kontei," originally published in *Josei kaizō* 3.9 (1924), reprinted in Origuchi Shinobu Zenshū Kankōkai, ed., *Origuchi Shinobu zenshū* (Chūō Kōronsha, 1995), 2:145–60; Nakayama Tarō, *Nihon fujoshi* (Ōokayama Shoten, 1929); Hashiura Yasuo, *Minkan denshō to kazokuhō* (Nihon Hyōronsha, 1942).
3. Rekishi Kyōiku Kenkyūkai, ed., *Joseishi kenkyū* (Shikai Shobō, 1937).
4. Inoue Kiyoshi, *Nihon joseishi* (San'ichi Shobō, 1948).
5. Takamure Itsue, *Dai Nihon josei jinmei jiten* (Kōseikaku, 1936); and *Bokeisei no kenkyū* (Kōseikaku, 1938). Takamure also wrote *Josei nisen roppyaku nenshi* (Two thousand six hundred years of women's history) (Kōseikaku, 1940), among others.
6. Watanabe Yoshimichi, *Nihon bokei jidai no kenkyū* (Hakuyōsha, 1932); Ishimoda Shō, "Kodai kazoku no keisei katei: Shōsōin monjo shoshū koseki no kenkyū," *Shakai keizai shigaku* 12.6 (1942): 1–70.
7. Inoue, *Nihon joseishi*; Takamure Itsue, *Josei no rekishi* (Insatsukyoku, 1948); and *Shōseikon no kenkyū* (Kōdansha, 1953). Takamure's works are collected in *Takamure Itsue zenshū* (Rironsha, 1966).
8. It was this question that tied together the essays in Wakita Haruko, ed., *Bosei o tou: rekishiteki hensan* (Questioning motherhood), 2 vols. (Kyoto: Jinbun Shoin, 1985).
9. Wakita Haruko, "Kodai chūsei Nihon joseishi oboegaki," *Rekishi hyōron* 335 (1978): 54–64; Wakita Haruko, "Rekishigaku to josei," *Rekishigaku kenkyū* 517 (1983): 68, reprinted in Wakita Haruko, *Nihon chūsei joseishi no kenkyū* (Tōkyō Daigaku Shuppankai, 1992). See also Wakita Haruko, "Marriage and Property in Premodern Japan from the Perspective of Women's History," *The Journal of Japanese Studies* 10.1 (1984): 73–99.
10. This is pointed out by Nishikawa Yūko in *Mori no ie no fujo: Takamure Itsue* (Shinchōsha, 1982).
11. Hora Tomio, *Shomin kazoku no rekishizō* (Itakura Shobō, 1966); Jugaku Akiko, *Onna wa ikiru: namae ga kataru onna no rekishi* (Sanseidō, 1968); Ōtake Hideo, *"Ie" to josei no rekishi* (Kōbundō, 1977); Harada Tomohiko, *Nihon joseishi* (Kawade Shobō, 1965); Aoyama Nao, *Meiji jogakkō no kenkyū* (Keiō Tsūshin, 1970).
12. This has been pointed out by Sekiguchi Hiroko in "Rekishigaku ni okeru joseishi kenkyū no igi: Nihon kodai o chūshin ni," originally published in *Jinmin no rekishigaku* 52 (1977), reprinted in Kojima Kyōko and Hayakawa Noriyo, eds., *Joseishi no shiza*, vol. 1 of *Nihon joseishi ronshū*, edited by Joseishi Sōgō Kenkyūkai (Yoshikawa Kōbunkan, 1997), 3–35; and by Yoneda Sayoko in "Gendai no fujin undō to 'joseishi' no kadai," *Keizai* 83 (1971): 77–88.
13. Murakami Nobuhiko, "Joseishi kenkyū no kadai to tenbō," *Shisō* 549 (1970): 83–95.
14. See, for example, Itō Yasuko, "Dōkō: Saikin no Nihon joseishi kenkyū," *Rekishigaku kenkyū* 376 (1971): 51–56; Inumaru Giichi, "Joseishi kenkyū no

seika to kadai: Nihon kindai joseishi ni tsuite," in *Gendai rekishigaku no seika to kadai II*, edited by Rekishigaku Kenkyūkai (Aoki Shoten, 1982); Koyama Motoko, "Shigaku to shite no joseishi no kakuritsu o: Murakami Nobuhiko *Meiji joseishi* zen yonkan no kanketsu ni yosete," *Rekishigaku kenkyū* 400 (1973): 53–57; and Yoneda Sayoko, "Gendai no fujin undō to 'joseishi' no kadai," *Keizai* 83 (1971): 77–88. Murakami Nobuhiko's rebuttal is in "Joseishi kenkyū no seikaku to hōhō ni tsuite: Itō Yasuko-shi ni taisuru hanhihan," *Rekishigaku kenkyū* 380 (1972): 43–48.

15. Murakami Nobuhiko, *Meiji joseishi*, 4 vols. (Rironsha, 1969–72); Ichikawa Fusae et al., eds., *Nihon fujin mondai shiryō shūsei*, 10 vols. (Domesu, 1976–81).

16. The American historian Joan Scott brilliantly makes this point with her notion of "supplement." According to Scott, by functioning as a "supplement" to historical research, the study of women's history demonstrates its surpluses and insufficiencies and proves that it can never achieve completion. See her "Women's History," in *New Perspectives on Historical Writing*, edited by Peter Burke (Cambridge and Oxford: Polity Press, 1991). This was translated by Tanigawa Minoru et al. as *Nyū historii no genzai* (Kyoto: Jinbun Shoin, 1996).

17. Joseishi Sōgō Kenkyūkai, ed., *Nihon joseishi*, 5 vols. (Tōkyō Daigaku Shuppankai, 1982).

18. A study of women's involvement in notable incidents, such as the Ashio Mining Incident, and women's participation in local politics are two examples of these oral history projects. See Joseishi Sōgō Kenkyūkai, *Nihon joseishi kenkyū bunken mokuroku*.

19. Some representative works on premodern women's history are Sekiguchi Hiroko, "Kodai ni okeru Nihon to Chūgoku no shoyū kazoku keitai no sōi ni tsuite: Joshi shoyūken o chūshin to shite," in Joseishi Sōgō Kenkyūkai, *Nihon joseishi*, vol. 1; Sekiguchi Hiroko, "Kodai kazoku to kon'in keitai" in *Kōza Nihon rekishi*, vol. 2 (Tōkyō Daigaku Shuppankai, 1984); Emori Itsuo, "Kazoku no kigen: Engerusu *Kazoku, shiyū zaisan oyobi kokka no kigen*," in Emori Itsuo, *Gendai minzokugaku* (Kyushu: Kyūshū Daigaku Shuppankai, 1984); Sumi Tōyō, *Zenkindai Nihon kazoku no kōzō: Takamure Itsue hihan* (Kōbundō, 1983); Akashi Kazunori, "Kodai chūsei no kazoku to shinzoku," *Rekishi hyōron* 416 (1984): 5–26; Yoshida Takashi, *Ritsuryō kokka to kodai no shakai* (Iwanami Shoten, 1983); Yoshie Akiko, *Nihon kodai no uji no kōzō* (Yoshikawa Kōbunkan, 1986); Amino Yoshihiko, "Chūsei ni okeru kon'in kankei no ichi kōsatsu," *Chihōshi kenkyū* 107 (1970): 1–24; Suzuki Kunihiro, "Chūsei zenki ichizoku ketsugō no kenkyū shikaku: 'sōryōsei' o dō mondai ni suru ka," *Nihon rekishi* 281 (1971): 13–33; Gomi Fumihiko, "Josei shoryō to ie," in Joseishi Sōgō Kenkyūkai, *Nihon joseishi*, vol. 2; Tabata Yasuko, *Nihon chūsei no josei* (Yoshikawa Kōbunkan, 1987); Tabata Yasuko, "Daimyō ryōgoku kihan to sonraku nyōbō za," in Joseishi Sōgō Kenkyūkai, *Nihon joseishi*, vol. 2; Katō Mieko, "Musume no za kara nyōbō za e: chūsei sonraku to josei," in Wakita, *Bosei o tou*, vol. 1; Wakita Haruko, "Chūsei ni okeru seibetsu yakuwari buntan to joseikan," in Joseishi Sōgō Kenkyūkai, *Nihon joseishi*, vol. 2; Shiba Keiko, *Edo jidai no onna tachi* (Hyōron Shinsha, 1969); and Seki Tamiko, *Edo kōki no joseitachi* (Aki Shobō, 1980). See also the volumes edited by Kinsei Joseishi Kenkyūkai, *Ronshū kinsei joseishi* (Yoshikawa Kōbunkan, 1986) and *Edo jidai no joseitachi* (Yoshikawa Kōbunkan, 1990).

20. Toshitani Nobuyoshi, *Kazoku to kokka: kazoku o ugokasu hō, seisaku, shisō* (Chikuma Shobō, 1987); Igeta Ryōji, "Meiji minpō to josei no kenri," in Joseishi Sōgō Kenkyūkai, *Nihon joseishi*, vol. 4; Kano Masanao, *Senzen 'ie' no shisō* (Sōbunsha, 1983); Hirota Masaki, "Bunmei kaika to josei kaihōron," in Joseishi

Sōgō Kenkyūkai, *Nihon joseishi*, vol. 4; Yoneda Sayoko, "Bosei shugi no rekishiteki igi," in Joseishi Sōgō Kenkyūkai, *Nihon joseishi*, vol. 4; Takeda Kiyoko, *Fujin kaihō no dōhyō: Nihon shisōshi ni miru sono keifu* (Domesu Shuppan, 1985); Nagahara Kazuko, "Ryōsai kenbo shugi kyōiku ni okeru 'ie' to shokugyō," in Joseishi Sōgō Kenkyūkai, *Nihon joseishi*, vol. 4.

21. See note 8. This work includes contributions by specialists in history, archaeology, cultural anthropology, religious studies, folklore studies, and literature.

22. Ōsumi Kazuo and Nishiguchi Junko, eds., *Shiriizu josei to bukkyō*, 4 vols. (Heibonsha, 1989). The activities of itinerant nuns, Kumano *bikuni*, and their role in shaping medieval culture were also clarified in Barbara Ruch's *Mō hitotsu no chūseizō: bikuni, otogi zōshi, raisei* (The other side of the medieval ideal: *bikuni* nuns, *otogi zōshi*, and the afterlife) (Shibunkaku, 1991).

23. Joseishi Sōgō Kenkyūkai, ed., *Nihon josei seikatsushi*, 5 vols. (Tōkyō Daigaku Shuppankai, 1990).

24. These ideas are found in Wakita, *Nihon chūsei joseishi no kenkyū*, 157–64.

25. Ueno Chizuko, "Rekishigaku to feminizumu" (Historiography and feminism), in *Iwanami kōza Nihon tsūshi*, edited by Asao Naohiro, supplement, vol. 1 (Iwanami Shoten, 1995).

26. Wakita Haruko and S. B. Hanley, eds., *Jendaa no Nihonshi* (Tōkyō Daigaku Shuppankai, 1994–95).

27. Kōno Nobuko and Tsurumi Kazuko, eds., *Onna to otoko no jiku: Nihon joseishi saikō*, 5 vols. (Fujiwara Shoten, 1995). Other works that stake out new ground are Yabuta Yutaka, *Joseishi to shite no kinsei* (Azekura Shobō, 1996); and Hayashi Reiko, ed., *Josei no kinsei*, vol. 15 of *Nihon no kinsei* (Chūō Kōronsha, 1993).

28. Kawamura Kunimitsu, *Otome no inori* (Kinokuniya Shoten, 1993); and *Otome no shintai* (Kinokuniya Shoten, 1994). These books can be considered as a single work.

29. The stories of five poisonous women graced the pages of the popular press in the late 1870s. Oden was accused of having strangled her leprous husband and stabbed a rich merchant. See Jay Rubin, *Injurious to Public Morals: Writers and the Meiji State* (Seattle: University of Washington Press, 1984), 37–38.

30. Muta Kazue, *Senryaku to shite no kazoku* (Shin'yōsha, 1996). She devotes one chapter to the analysis of "women's discourse."

31. Ueno Chizuko, *Kindai kazoku no seiritsu to shūen* (Iwanami Shoten, 1994); Ochiai Emiko, *Nijūichi seiki kazoku e* (Yūzankaku, 1997); originally published in 1994; and Yamada Masahiro, *Kindai kazoku no yukue* (Shin'yōsha, 1994).

32. Ueno Chizuko, "Kokumin kokka to jendaa," *Gendai shisō* 24.12 (1996): 8–45.

Contributors

Suzanne GAY
History, Oberlin College

Paul GRONER
Religion, University of Virginia

HOSOKAWA Ryōichi
History and Religion, Kyoto Tachibana Women's University

KATŌ Mieko
Osaka Prefecture, Shimamoto-chō assemblywoman

Gary P. LEUPP
History, Tufts University

NARITA Ryūichi
History, Japan Women's Umiversity

NISHIKAWA Yūko
History, Kyoto Cultural University

OCHIAI Emiko
Sociology, International Research Center for Japanese Studies

Joan R. PIGGOTT
History, Cornell University

Julie ROUSSEAU
History, Columbia University

SONE Hiromi
History, Kobe University

TABATA Yasuko
History, Kyoto Tachibana Women's University

TAKEDA Sachiko
History, Osaka University of Foreign Studies

Mariko Asano TAMANOI
Anthropology, University of California-Los Angeles

Akiko TERASHIMA
History, University of California-Los Angeles

Hitomi TONOMURA
History, University of Michigan

WAKITA Haruko
History, University of Shiga Prefecture

Anne WALTHALL
History, University of California-Irvine

YOKOTA Fuyuhiko
History, Kyoto Tachibana Women's University

Index